Of ARMS

and ARTISTS

BY THE SAME AUTHOR

Samuel F. B. Morse

Of ARMS
and ARTISTS

The American Revolution
through Painters' Eyes

PAUL STAITI

BLOOMSBURY PRESS

NEW YORK · LONDON · OXFORD · NEW DELHI · SYDNEY

Bloomsbury Press
An imprint of Bloomsbury Publishing Plc

1385 Broadway 50 Bedford Square
New York, NY London
10018 WC1B 3DP
USA UK

www.bloomsbury.com

BLOOMSBURY and the Diana logo are trademarks of Bloomsbury Publishing Plc

First published 2016

© Paul Staiti 2016

ISBN: HB:978-1-63286-465-9
 ebook: 978-1-63286-467-3

Library of Congress cataloging-in-publication data is available.

2 4 6 8 10 9 7 5 3 1

Designed by Mary Austin Speaker
Printed and bound in the U.S.A. by Berryville Graphics Inc., Berryville, Virginia

To find out more about our authors and books visit www.bloomsbury.com. Here you
will find extracts, author interviews, details of forthcoming events and the option to
sign up for our newsletters.

Bloomsbury books may be purchased for business or promotional use. For
information on bulk purchases please contact Macmillan Corporate and Premium
Sales Department at specialmarkets@macmillan.com.

For Adrian and Ivana

Contents ⌐⌐

1 ⟲

Art and the American Revolution

PATRIOTS IN REVOLUTIONARY AMERICA WERE FINALLY feeling optimistic in January of 1779. They had not forgotten the summer three years before when the British outmanned, outfought, and overwhelmed the Continental Army in New York, forcing General George Washington and his soldiers to flee, first to New Jersey and then to the banks of the Delaware River. They still had vivid memories of the invasion and occupation of Philadelphia, the capital city, in 1777, and the subsequent escape of the Second Continental Congress into the rural Pennsylvania countryside, followed by the wintering of Washington's army at Valley Forge, where unremitting disease, exposure, and malnutrition ravaged the soldiers, killing 2,500. In those years, America's future as an independent country was anything but auspicious.

But in 1778, history seemed to be turning in the Patriots' direction. Benjamin Franklin successfully persuaded France to forge a powerful military alliance committing the Versailles court to "make all the efforts in its Power" to uphold the liberty, sovereignty, and independence of the United States. That opened the doors to the formidable French army and navy, laden with troops, commanders, and cannons, as well as an ancient and active hatred of Britain. Fearing this new alliance would escalate the war into a global conflict, the British evacuated their stronghold in Philadelphia and hastily sent envoys to the Continental Congress to sue for peace. In June of 1778, Washington broke camp at Valley Forge and took back Philadelphia. In November, a freshly buoyant Congress rejected the British peace overture and declared that from then on any settlement of the war would have to be on America's terms.

Sensing the tide of war had shifted in the northern states, Pennsylvania passed a resolution on January 18, 1779, to honor "those who have rendered their country distinguished services, by preserving their resemblances in statues and paintings." This, the Supreme Executive Council added, was the sort of thing "the wisest, freest and bravest nations" do "in their most virtuous times." Seizing the moment, they appropriated money for a life-size, full-length portrait of Washington,

the commander-in-chief, to be installed in the Council Chamber of the Pennsylvania State House, now Independence Hall.

The portrait—the first piece of public art in the United States—would be an enduring acknowledgment of "how much the liberty, safety and happiness of America in general, and of Pennsylvania in particular, is owing to His Excellency General WASHINGTON and the brave men under his command."[1] It would stand as "a mark of the great respect which they bear to His Excellency," and as the Council made clear in its resolution, there was hope it would accelerate the American war effort by inspiring others "to tread in the same glorious and disinterested steps, which lead to publick happiness and private honour." Two days after the resolution was passed, Washington graciously assented to the Council's request to sit for a portrait and let it be known that their sentiments had made "the deepest impression on my mind."[2]

The person to be entrusted with carrying out the commission was Charles Willson Peale of Philadelphia. Painter, militiaman, assemblyman, and ardent Patriot, Peale had impeccable credentials for the job, both as an artist and as a political and military man. He had not only fought at the Battle of Princeton in 1777, but also had visited Valley Forge, where he painted himself looking remarkably cheerful, given the hunger, disease, and despair afflicting the troops that winter. After Washington reclaimed Philadelphia in 1778, Peale was put in charge of identifying Loyalists in the city and then confiscating their estates, sometimes in a heartless way. He was so hated by some factions in the city

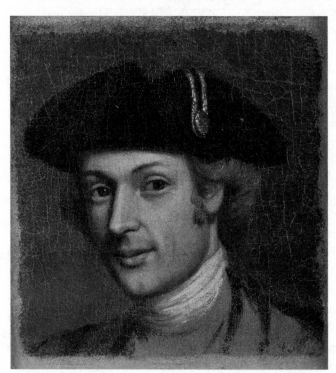

Charles Willson Peale, *Self-Portrait*, 1777–78

that during the last two years of the war he had to walk through the streets with a cane made of seasoned ash, named Hercules, so that he could protect himself from assault.

Peale's credentials as an accomplished artist were equally impressive: three years of study under Benjamin West, the distinguished American painter in London; dozens of portraits of Continental officers, many taken at camp-side; and artistic commissions from congressional leaders, including John Hancock and Samuel Adams.

For the State House portrait, Washington made himself available to Peale for sittings between January 20 and February 2, 1779, at which point the general moved to his military headquarters in Middlebrook, New Jersey. Over the course of those two weeks Peale had to work on the eight-foot portrait at lightning speed.[3] And he had to ask himself, and ask Washington, what the picture should show. The choices were endless. Washington might be depicted in the midst of a battle, and if so, there would be the question of which one. Or he could be seen far from the battlefield, perhaps at field headquarters, or appearing before Congress. There were ample reasons to portray him as a fearless warrior leading troops, but as compelling, he could simply be seen as an exceptional person.

Peale and Washington must have come to an agreement to focus on the decisive Battle of Princeton, which took place a week after the crossing of the Delaware and the Battle of Trenton. One of the most brutal scenes of combat during the Revolution, Princeton was fought on January 3, 1777, and it was won because Washington rallied the demoralized troops by coming to the front and then marching his horse directly into the line of fire. When it was over, the battle acquired special significance, not only because the British lost that day but also because it proved that their army was not invincible. Princeton was the first glimmer that the Revolution was winnable.

A decision also needed to be made on what aspects of Washington's character Peale should emphasize and what messages the portrait ought to broadcast. Since it would be put on display in a building at the heart of American independence, Peale needed to demonstrate the new concept of leadership in a republic. He did that by rejecting the climactic moment when Washington thrust himself into the battle, and emphasizing instead the aftermath of victory when Washington's inner qualities were most visible. Approachable, knowable, understated, calm, benevolent, and slightly ungainly, Peale's Washington looks directly at

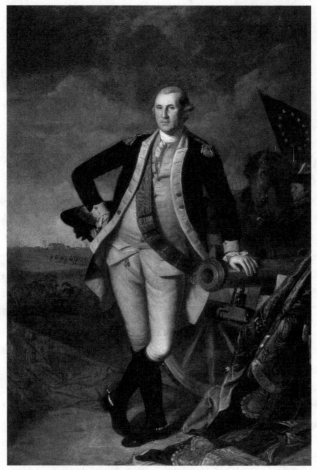

Charles Willson Peale, *George Washington at Princeton*, 1779

his audience and comes across as a man of easygoing refinement and complete confidence.

After Peale put the finishing touches on the picture by traveling to Princeton to check the topography and review the architecture of Nassau Hall, he installed the huge portrait in a prominent place, behind the Speaker's chair in the State House, in majestic celebration of the great man of the new republic of virtue. It hung there until September 9, 1781, a Sunday, when Loyalists broke into the building and slashed it repeatedly with a knife. A Philadelphia weekly reported that "*at night*, a fit time for the Sons of Lucifer to perpetrate the deeds of darkness, one or more volunteers in the service of hell, broke into the State House in Philadelphia,

and totally defaced the picture of His Excellency General Washington."[4] Peale was called in to remove the picture and repair the damage, and over the next two weeks he cut away the damaged parts, patched in new canvas, and repainted those areas to match what had been there before.

Some of the Philadelphia public felt "indignation at such atrocious proceedings." But for the Loyalists, still in considerable numbers, slashing the picture must have been satisfying retribution for a cause that was lost, largely because of Washington. The painting had been left alone for two and a half years, during which time the fortunes of the war shifted back and forth. But when the picture was cut in the fall of 1781, during the siege of Yorktown, Britain's surrender was imminent and some of Philadelphia's Loyalists must have felt the need to strike back against the inevitable, at least in a symbolic way.

The slashing of Washington's portrait tells us that works of art carried extra weight in a time of revolution, and that they could be vivid enough to provoke disfigurement or destruction. If the work of art was an official portrait, such as Peale's Washington, it was doubly vulnerable to attack. And if the artist himself was perceived to be a political ally of the person in the portrait, as Peale was, it was triply vulnerable. That ancient logic had been repeated countless times over the centuries: If you can't kill the person, you can at least mutilate his image and send a strong message to him and his supporters.[5] A symbolic death even had some advantages over the real thing in that it was possible not only to destroy Washington's image, but also to insult the values present in that image: respectability, pride, success, smugness, and anything else that Loyalist Philadelphians saw in it. Loyalists could not do anything to reverse the British defeat at Princeton in 1777, or to fend off the doomed British campaign at Yorktown, but they could at least erase the satisfied look on Washington's face and turn a handsome picture into something repulsive.

The slashing episode in Philadelphia was just one instance in which the defacement or destruction of a portrait underscored the special significance that artworks possessed during the Revolution. Loyalists attacked Patriot images and Patriots attacked monarchical images. During the British military occupation of colonial Boston in 1769, the leading painter in the city, John Singleton Copley, was hired to paint a portrait of the despised British colonial governor of Massachusetts, Francis Bernard. After it was installed in Harvard Hall in Cambridge, radical activists broke in and cut the heart area out of the seemingly banal portrait. A rattled Copley was called in to repair the damage,

prompting one Boston newspaper to comment that "our American limner, Mr. Copley, by the surprising art of his pencil has actually restored as *good a heart* as had been taken from it." The commentator sarcastically added, "upon a near and accurate inspection, it will be found to be no other than a false one."[6] Not even the great Copley, the best artist in America, could fix the heartless Governor Bernard.

In 1770, the British erected a giant equestrian statue of King George III on Bowling Green in New York City, accompanied by toasts, military music, and artillery fire. Covered in shiny gold leaf and surrounded by an iron fence, it was the public assertion of British authority in the city. Six years later, in the summer of 1776, as the British were poised to take the city with an overwhelming force of 32,000 men, Washington gathered his deflated Continentals into defensive positions in lower Manhattan. Though defeat was imminent, on July 9 their spirits lifted when John Hancock sent Washington a copy of the new Declaration of Independence and asked that he inform his men of it.

After dinner that evening, Washington ordered it read aloud on the Commons, on Broadway near present-day City Hall. In unison, the troops shouted "three Huzzas," then raced down to Bowling Green, tore down the statue of the King, dismembered it, and dragged it through the streets of New York before it was recycled into musket balls that were used against the British army.[7] In the logic of the Revolution, the best way for American troops to diminish the King's living power was to destroy his monument and then weaponize the metal for use against him. Works of art were thus capable of arousing potent emotions in times of intense political change, when all the sentiments active in civic disputes and battlefield contests also crystalized around and adhered to paintings and sculptures.

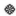

The five great American artists of the late eighteenth century—Peale, Copley, Benjamin West, John Trumbull, and Gilbert Stuart—had started their careers as British subjects, loyal to the Crown. But the Revolution begged them to examine whether they intended to carry forward their inherited status or become contributing citizens in the new republic. As in no previous generation, they lived through a time of breathtaking historical change that deserved and demanded to be painted for the people of their time, and for posterity. They recognized the gravity of the moment and had their futures unavoidably

transformed by the great events of the era: independence, warfare, diplomatic triumph, near collapse, sovereignty, the Constitution, and the rise of the presidency and the federal government. In such a charged environment, their experiences were compelling and captivating at the best of times, confusing and frightening at the worst, and like everyone else they had to confront the inherent incomprehensibility of the events swirling around them. They attempted to make sense of it all by turning to brushes and canvases. Works of art became their means of narrating the Revolution to themselves and to citizens of the new republic.

The striking images they made—of the Declaration of Independence; the battles at Bunker's Hill, Quebec, Princeton, and Trenton; the peace brokered in Paris; and portraits of Washington, Adams, Jefferson, and others—illuminated the era. Because the United States quickly arose from a popular uprising, it was at first unformed and inchoate, and thus in urgent need of images, rituals, and mythologies not only that could replace the old British ones, but that might also bring a disparate population together as a functional union.

For most Americans, the notion of national citizenship was inherently incompatible with the cherished local identities by which they had been defining themselves for generations; each new state was, to some degree, a nation unto itself. While Americans might have comprehended the significance of independence from Britain, they did not necessarily grasp the full magnitude and enduring consequences of their newly acquired nationhood. John Adams articulated the situation with typical acuity:

> The colonies had grown up under constitutions of government so different, there was so great a variety of religions, they were composed of so many different nations, their customs, manners, and habits had so little resemblance, and their intercourse had been so rare, and their knowledge of each other so imperfect, that to unite them in the same principles in theory and the same system of actions, was certainly a difficult enterprise.

Getting "thirteen clocks to strike together," he added, would be an achievement that "no artist had ever before effected."[8]

To be sure, helping Americans unite across region and culture were

the shared rights and laws ultimately articulated in the Constitution, as well as political tracts and philosophical essays that made the case for the republic. But in order to bind together as a union, and not just a weak confederation of independent states, Americans required a cultural understanding of their mutual identity. In such a perplexing and grave situation, persuasive images—of historic events, transcendent heroes, and honored martyrs—could be essential building blocks in the creation of nationhood because they provided a common vision of America for Americans who were far more likely to say who they were not than to embrace who they needed to be. If the United States was to cohere at zero hour, at a time when consensus was nearly impossible, raw republican citizens, reckoning with a newfound identity, needed compelling images that could take hold of their imagination, shape their thinking, and channel their energies.

Indeed, even today our collective understanding of what America's origins look like is still largely dependent on these five artists and their images. Stuart's portrait of Washington, as an example of durability and reach, has been reproduced more times than any other image in history. Besides the hundred or so that he painted himself and the thousands more—copies, prints, and copies of prints—that subsequently saturated American culture, Stuart's portrait has adorned tens of trillions of one-dollar bills since 1869. A full-length, life-size version of his Washington was first hung in the White House in 1800, and each President from John Adams onward has had to measure his own tenure in office against its withering gaze. Even more symbolically, Trumbull's large-scale Revolutionary War pictures, installed under the great dome of the United States Capitol Rotunda, have stood for two centuries as silent witnesses to the most august ceremonies of state and as ancestral sentinels connecting legislators and citizens to America's origins.

The lives of these five artists were as colorful and exceptional as their paintings. Peale, who started life as a Maryland saddle-maker, wielded both a musket and a brush during the war. After the Revolution, he painted more than a hundred portraits of the worthies of his time, eventually installing them in a hundred-foot-long gallery inside Independence Hall. West, born into a Pennsylvania Quaker family, moved to London in 1760 where he became the official historical painter to King George III. An American Patriot at heart, West had to carefully navigate his way through wartime England, waiting for the day that he could express his American sentiments in words and pictures. John Singleton Copley, the greatest painter in

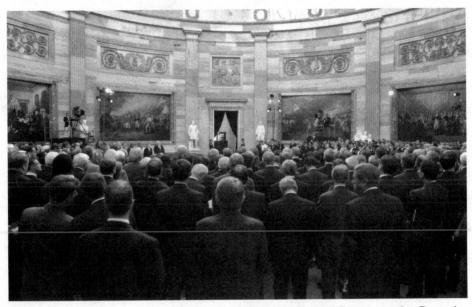

Congressmen and senators at the funeral of President Ronald Reagan in the Capitol Rotunda, 2004

colonial America, so craved political neutrality that he left Boston for London in 1774, where he made a spectacular debut into the British art world. At the end of the Revolution, he dropped his self-imposed rule of avoiding politics when he painted portraits of three American Patriots, including John Adams on an impressive scale. John Trumbull, son of the colonial governor of Connecticut, served as General Washington's aide-de-camp early in the war. After the Revolution, he painted some of the most stirring events from the war: the battles at Bunker's Hill, Quebec, Trenton, and Princeton, and then, while living with Thomas Jefferson in Paris, he began work on his magnum opus, a painting of the Declaration of Independence. He served in Washington's diplomatic corps during the 1790s and afterward was hired by Congress to paint four colossal pictures of the Revolution, which continue to hang in the Rotunda of the United States Capitol. Stuart, born into a penniless Rhode Island family, was the most talented of them all, but also a profligate perpetually courting disaster. He painted just about every person who held power, or who wanted to. A man who never expressed a political allegiance, Stuart was nonetheless responsible for the most memorable and enduring portraits of the Founders.

The story of these artists adds a compelling dimension to the history of the United States. They breathed visual life into historical events and figures, and over the centuries their images have become our indispensable icons, the American equivalents of what the *Iliad* and the *Aeneid* meant to the ancient Greeks and Romans. We have come to believe in them and what they say about the Revolution and the Founders. They serve us as both historical documents and compelling mythology. And without them, Americans would not be able to feel as grounded as they are in their past, or as prepared to sustain their momentum into the future.

2 ⌢⌅

Charles Willson Peale's War

Nothing in Charles Willson Peale's background suggested a future in either art or politics. Born in Maryland in 1741 to a convicted felon who died when he was nine, Peale was summarily pushed into the trade of saddle-making at the age of thirteen so that he could support his destitute family. For seven arduous years he indentured with Nathan Waters of Annapolis, and when his contract was finally up he unsentimentally referred to that time as his "bondage." Newly liberated from his indenture at twenty, he opened his own shop where he specialized in "Saddle Making, Harness-Making, Postering and Repairing Carriages," all of which he said he could do in "the best, neatest, and cheapest Manner."[1] But the costs he incurred while purchasing tools and raw materials for his new business led to a mountain of debt that forced him to look for new ways to make money. And that, in turn, steered him to a few art lessons in the studio of a second-rate portraitist who worked for some of the leading families in the Chesapeake.

In Peale's early logic, painting was no more than a speculation, having less to do with the fine arts as a calling, and more to do with the goal of maximizing revenues. But to become skilled enough to be hired as a portraitist in the rural Chesapeake, he knew he needed more than a few lessons. Lacking money, the only remaining avenue to improvement in a colonial world without art academies was to teach himself through a process of trial and error. He had no choice but to proceed on the untested principle that the fine craft skills he had acquired as a saddler could be transferred to painting. Predictably, his early efforts at painting were awkward, unattractive, and not at all promising. But with a few strokes of good luck, combined with the generosity of others, Peale was able to slowly build for himself a career in the arts.

❀

At the same time that he was making saddles in 1764, Peale plunged into a ruthless Maryland political contest that pitted his favored candidate, Samuel Chase of the Country Party, a firebrand supported by the Sons of Liberty, against George Steuart of the Court Party, a patrician figurehead of the Calvert family that held the royal property rights to the colony. In a campaign of extraordinary invective, Steuart publically denounced Chase as "a busy, reckless incendiary, a ringleader of mobs, a foul-mouthed and inflaming son of discord and faction, a common disturber of the public tranquility." In turn, Chase accused Steuart of broadcasting "the foulest abuse that malice could invent," of possessing a "vanity . . . pride and arrogance," that is "natural to despicable pimps and tools of power."[2]

In the caldron of that degrading political campaign, Peale was called upon to make banners and placards for Chase, who unexpectedly won the knockdown election, eighty-nine votes to fifty-nine. It was a rewarding outcome that, early on, suggested a valuable and enduring lesson to the young artist: that visual propaganda and political success naturally went hand in hand, and that Peale's efforts had substantively contributed to Chase's victory.[3]

But Peale also learned that partisan beliefs had unforeseen consequences. His many creditors from the Court Party had cautioned him not to back Chase, but he did so anyway and immediately had writs issued for repayment of his loans, which he could not afford to fulfill. Facing a jail term, he fled the state, leaving behind his debts as well as his pregnant wife, Rachel. He hastily rode to Virginia, throwing away his paint box and palette along the way, and in July of 1765 he booked passage on a ship carrying corn to Boston, which had become a hotbed of revolutionary activity.

Soon thereafter he transferred to Newburyport, thirty-five miles to the north, just in time to witness street demonstrations in protest of the Stamp Act, under which direct taxes were being levied on everything from legal transactions, licenses, and deeds to playing cards, newspapers, books, and pamphlets. Peale did not need much prodding to get caught up in the revolutionary spirit of New England. "From the time in which G. Britain first attempted to lay a tax on America, by the memorable Stamp act, [I] was a zealous advocate for the liberties of [my] Country." Peale participated in street demonstrations, avidly read James Otis's radical tract *The Rights of the British Colonies Asserted and Proved*, and after acquiring new art supplies he once again turned to paint

brushes, the most potent tool in his political kit, in order to assist "in the making the emblematical Ensigns" in Newburyport, "which showed with what unanimity of detestation the people viewed that odious Act of Parliament."[4]

Returning to Boston late in 1765 and taking a room at the Exchange Tavern on King Street, he met the most accomplished painter in America, John Singleton Copley, who was less than three years his senior. Copley gave Peale advice on art as well as some prints to study and copy, and he also offered him an alluring glimpse into the charmed life of a high-end painter in contact with the great artists of London, then the center of the English-speaking art world. As a fugitive, Peale could not afford to stay long in Boston, and clearly he had no prospects of unseating Copley from his exalted position in the city. He also had a pressing need to get back to Rachel, who had given birth in Maryland to a son, James Willson. He soon booked passage southward, and in the autumn of 1766 he negotiated a deal with creditors in Annapolis that allowed him to return to Maryland, but only on the humiliating condition that he tap his wife's inheritance to repay his debts.

Once reunited with his family, Peale soon departed again, this time because two leading citizens of Maryland, John Beale Bordley and barrister Charles Carroll, put together a fund to finance a few years of artistic study in London under the guidance of Benjamin West, a Pennsylvanian emerging as a rising star in the English art establishment. As a civic leader, Carroll was interested in the improvement of culture in Maryland and was willing to take a gamble on Peale's nascent talent, writing speculatively to an agent in London that he was going to "See what [Peale] can make of his Pretensions and to get some further Insight into the Profession."[5] But Carroll was also interested in exploring the possibility of developing Peale into a political tool for the aims of his radical Whig agenda.

There was no guarantee that Peale possessed the talent to become an effective artist, but if he did succeed, Maryland Whigs like Carroll would have on their side an image-maker to aid their fierce struggle against Tories who wanted to block reform and maintain the ancient state of public affairs.[6] For his part of the mutually beneficial arrangement, Peale accurately recognized Bordley and Carroll's generous offer as a once-in-a-lifetime chance to become a true professional. The offer meant that he would have to leave his tight-knit family, but for a young man seeking a professional career, the potential rewards for an absence of a year or two were irrefutable and irresistible.

Peale arrived in London in February of 1767 and immediately presented himself to the ever-hospitable West, who found good lodgings for his fellow American on Golden Square. As the director of the St. Martin's Lane Academy, West was able to open the doors of the London art world to a man who might accurately be described as an American rube. Peale responded, first by writing poetry and then, as a glimpse into his account book shows, by spending money on the tools of his new trade: "Pallet & Knife," "Piece of canvas," and "Da Vinci's Treatise."[7] He even got the chance, thanks to West's influence, to exhibit four paintings with the Society of Artists in a gallery at Charing Cross, where the semi-amateur pictures by a Maryland saddler were hung in the company of impressive paintings by Thomas Gainsborough and Richard Wilson, two lions of the British art world.[8]

West gave Peale instruction, including lessons in composition, color, form, and history, and he provided his raw student with paintings he could practice copying. Equally important, West encouraged Peale in a way that no one ever had or ever would. The young artist responded by throwing himself so wholeheartedly into painting, sculpture, and printmaking that he "several times had nearly brought himself into a bad state of health."[9] He filled his diary with critical commentary on refined topics, such as the coloring in Titian's pictures and the artistic stature of Sir Joshua Reynolds, as well as praise for West's classical paintings that had learned titles, such as *Venus Relating to Adonis the Story of Hippomenes and Atalanta*, that were unheard of in America.

Looking around London, Peale instantly realized that "the Encouragement of arts [is] so much greater in England than in America."[10] Instead of the one or two substandard artists to be found in a small city like Philadelphia, dozens of accomplished professionals worked in London, all benefiting by the kinds of supports that did not exist in America—academies, galleries, exhibition halls, collections, critics, and patronage. As much as Peale would learn about painting technique, good taste, and professional bearing over the two years he spent with West in London, he also acquired something less tangible but just as lasting when he observed the ways in which the arts were tightly woven into the culture of a city and a nation. Artists were respected, painting was thought to be a dignified profession, and West stood out as the living embodiment of that artistic ideal.

West honored Peale by painting a portrait of his student as a young visionary, and then generously giving it to him to take back to America.

In it, West showed the newborn artist and former saddler holding up a *porte-crayon* in his right hand, the sure mark of a creative person, and he had Peale sit in the mirrored pose of Michelangelo's prophet Isaiah from the Sistine Chapel ceiling. Perhaps West foresaw Peale as a secular version of Isaiah, an emissary destined to carry the word of the fine arts from London into the wilderness of America where he would bring about enlightenment. West never said, but tellingly Peale held on to West's picture for the rest of his life.

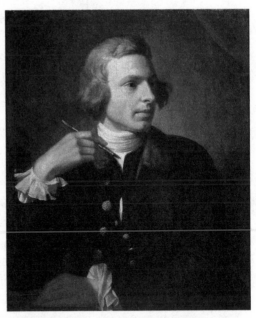

Benjamin West, *Charles Willson Peale*, 1767–69

While in London, Peale was also looked after by John Beale Bordley's half-brother, Edmund Jenings, a Maryland attorney and an ardent American Patriot living near Kensington Square. Jenings arranged for Peale to acquire commissions in 1768, including, quite improbably, an eight-foot portrait of Prime Minister William Pitt, the First Earl of Chatham, who had argued for recognition of the Continental Congress and American say in the matter of taxation. The picture had been requested by Richard Henry Lee of Virginia, who wanted to honor the families along the Rappahannock River who had stepped forward and signed the Westmoreland Resolves during the Stamp Act crisis of 1766. The Resolves asserted, in pugnacious terms, the unlawfulness of British taxation. Signed by 121 men of stature, including Lee and four of George Washington's brothers, the document accused Britain of reducing "the people of this country to a state of abject and detestable slavery," and it openly warned that anyone denying American rights would become "the most dangerous enemy of the community; and we will go to any extremity, not only to prevent the success of such attempts, but to stigmatize and punish the offender." The signers vowed that in executing the Resolves they were "paying no regard to danger or death."

West, a Pennsylvanian, was the logical person to take on the commission. But Jenings instead recommended Peale, whom he described to Lee

as "a young man of merit and modesty."[11] Though the huge scale of the commission was beyond the scope of his raw talent, Peale took the challenge and labored over the picture mightily. The results were exactly what one might expect from a novice in over his head. Aiming for grandiloquence, Peale instead arrived at pomposity by depicting Pitt standing in the pose of Apollo, wearing classical robes, and holding the Magna Carta in one hand while pointing to a statue of Liberty with the other hand.

No subtle political skills were needed to understand the picture as a bald-faced warning to all tyrants wanting to subvert the constitutional rights of Americans. The Westmoreland Resolves were one of many forms of American resistance that would lead to the repeal of the Stamp Act, and Peale's painting, once it arrived in America, was public acknowledgment of the courageous stand of the Virginians, as well as a clear statement of the artist's solidarity with Whig political values. Lee hung the picture in a place of honor in one of the public rooms of Chantilly, his estate near Montross in Westmoreland County.

But before the picture was crated and shipped across the Atlantic, Peale made a duplicate copy because he understood the potential it held for his future career in America. He would eventually take the copy back to Maryland and present it to the state legislature, which paid him one hundred pounds and thanked him for his "genteel present."[12] Seizing the opportunity and thinking entrepreneurially, as he always would, Peale then made prints of his portrait of Pitt so that he could sell them on both sides of the Atlantic. He cleverly marketed the print by writing anonymous newspaper copy that assured buyers that Benjamin Franklin, whom Peale knew in London, vouched for the authenticity of the likeness. In the end, he did not sell many prints, but this early experience set the template for Peale's future career. Though he had been trained by West to believe in the heroic ideals of high art, he instinctively and always kept one eye cocked on the rewards of the marketplace.

Given Peale's politics, he naturally protested the new taxes on America that Parliament passed in 1767, while he was still in London. Known collectively as the Townshend Acts, they aimed to collect money from a half-dozen sources, all without American approval or representation. Included were a tax on imported goods, one to pay for colonial governors and judges, a tax to underwrite the quartering of British troops in America, and a provision to police all the taxes with on-site British customs officials. Seeing this evolve in London, Peale joined the American boycott of English goods. He stopped dressing in the

London fashion, avoided buying English manufactures, donned American homespun instead, and resolved that he "would never pull off his Hatt, as the King passed by and . . . would do all in his Power to render his Country Independent."[13]

❖

When Peale returned to Maryland in 1769 he was a changed man, politically informed, artistically transformed, and sensing his true vocation. His new artistic skills were readily apparent in a remarkable portrait he painted of his own family reunited. Titled *Concordia Animae*, or "Harmonious Souls," it was like no other painting previously seen in the middle colonies. In it Peale demonstrated everything that he had learned in London: subtle coloring, multiple figures, complex arrangement, and an intriguing variety of characters, expressions, and poses. Standing at the far left, by an easel and with a palette in his right hand, Peale bends down to offer pointers to his brother St. George Peale, who is working on a drawing of their mother seated at the opposite end of the table. Second from the left, the youngest Peale brother, James, intently watches St. George's progress and beams with approval. Above him, standing at the highest point, is their wonderfully capable

Charles Willson Peale, *Concordia Animae*, or *The Peale Family*, ca. 1770, finished 1809

sister Jenny. Seated in the middle is Peale's wife, Rachel Brewer, who holds their daughter Margaret. At the far right, posing for her portrait, is the family matriarch, Margaret Triggs Peale, who cradles Peale's winsome daughter Eleanor, and is herself the object of her own daughter Elizabeth's affection. In the right distance stands Peggy Durgan, the faithful family nurse, and next to her, on the mantle, are positioned busts that Peale sculpted in London, of his mentor, West, his patron, Edmund Jenings, and one of Peale himself. The platter of peaches and apples on the table refers to the bounty of the Peale family. The knife lying nearby has been recently used to slice a peel or two from the fruit, a sly play on the Peale family name.[14]

As a professional with London credentials, Peale became the leading artist of the middle colonies, traveling from Annapolis to rural plantations of the Chesapeake in order to work for the prosperous merchants and landed gentry building great houses that needed portraits to fill their spaces. In spite of his experiences with West, who tried to instill in his student the idea that an artist, whatever his situation, ought to conduct his profession as a calling instead of a craft or a job, Peale quickly recognized upon his return to America that if he were going to be successful he would need to appeal to his American customers on their own, sometimes capricious, terms and not on West's idealistic formulations. That meant painting portraits that pleased those who were paying for them, not the allegories and historical subjects that were so valued in London. Peale also understood, from years in the saddlery business, that in order to survive in America he had to drum up business for himself. He could not wait for clients to come to him and he certainly could never expect that patrons or benefactors were lining up to finance his career.

Economic reality in America required Peale to occasionally bully money out of parsimonious customers. When the deputy commissioner of Anne Arundel County failed to pay Peale the thirty-six guineas due on his portrait, Peale sarcastically wrote to him that "Mrs. Peale is in want of money" so that she can pay "the House Rent." When the commissioner ignored the letter, Peale took it upon himself to publish two public notices in the *Maryland Gazette* that bluntly demanded "MR. ELLIE VALETTE, PAY ME FOR PAINTING YOUR FAMILY PICTURE." Though London may have taught Peale how to paint, his years in the trades taught him how to complete a sale by squeezing a customer, sometimes by way of

shame. The miffed commissioner, unaccustomed to such disrespect from a lower-rank tradesman, relented, but not before he replied in kind to Peale's public advertising of the debt that was owed: "YES, YOU SHALL BE PAID: BUT NOT BEFORE YOU HAVE LEARNED TO BE LESS INSOLENT."[15]

The best of business transactions were between Peale and his friends, for whom he could use all the resources at his command and also get paid on time. An impressive example was the political portrait he painted in 1770 of John Beale Bordley, his longtime Maryland friend, who had acquired a plantation on the Eastern Shore. Always interested in agronomy, Bordley used his property on Wye Island to develop innovative strategies for soil improvement and the rotation of crops, and he in turn used Peale to document his agricultural practices. Instead of having himself posed in a traditional setting inside his house or on the porch, Bordley had Peale paint him in the fields, with a flourishing peach tree on the right and some of his sheep in the far distance.

A Whig stalwart of the radical Country Party, Bordley also had Peale record his political interests. Seventeen seventy was the year of the Boston Massacre, a culminating event in the rising conflict between British authority and American resistance to the taxes imposed by the Townshend Acts. This otherwise mild-mannered Maryland planter used the Peale portrait to broadcast his position against British taxation, which he considered tyrannical. Among Bordley's friends, the Philadelphia lawyer John Dickinson had already written the most widely read political argument against taxation.[16] Taking the form of twelve eloquent essays published over the course of 1767 and 1768, "Letters from a Farmer in Pennsylvania" claimed that the colonies were sovereign in their internal affairs, and that as a result any sort of tax upon them was unconstitutional by British law. As much as the "Letters" were a well-reasoned and highly influential legal argument, they were also a warning shot across the British bow, one that sent the message that any further efforts to "annihilate the liberties of the governed" might be met with "resistance by force."[17]

Following Dickinson's lead, Peale's portrait of Bordley is like a "Letter from a Farmer in Maryland." Smuggling politics into portraiture, Peale turned the kindly planter into a country orator antagonized by unchecked Parliamentary power.[18] Portrayed as a defender of American liberties, he leans his considerable weight on a book opened to a page

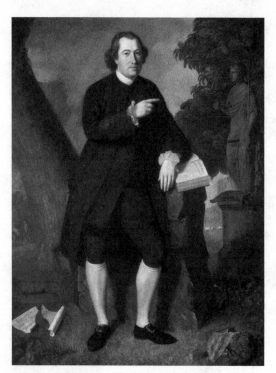

Charles Willson Peale, *John Beale Bordley*,
1770

with the heading *Nolumus Leges Angliae mutari*: "We are unwilling that the laws of England be changed," a bald statement on the unconstitutionality of taxation on Americans who had no say in the matter. A document in the left foreground, titled "Imperial Civil Law," has been ripped in two and thrown to the ground. And in the center, Bordley looks at us squarely as he reaches across his body to point to a statue lurking in the shadows. LEX ANGLI, written on the pedestal, identifies it as a figure of English Justice. Dressed in classical robes, she holds the scales of justice in one hand and a staff topped with a liberty cap in the other, but at the base of the statue a poisonous jimson weed has sprung up and is growing with abandon. Peale explained the actions of the plant, a native American weed that "acts in the most violent manner and causes Death."[19]

Peale shipped the portrait, along with one of Dickinson, to Jenings, who was Bordley's half-brother, as a provocative statement of American rights in the face of British tyranny. It was the perfect political fit for Jenings, who had already been making a public case in London for American rights by refusing to wear English-made cloth. By shipping Virginia wool to London he wanted to "show the Politicians of this Country" that America does not need the overpriced and overtaxed products of Britain. Peale's portrait of Bordley helped bolster Jenings's radical position, and at a commanding seven feet in height it would have made a strong impact in London, even when seen among the great English pictures that graced the city's homes and exhibition halls.

❦

After a series of earthshaking Revolutionary events in 1775—the skirmishes at Lexington and Concord, the British military seizure of Boston, the pitiless Battle of Bunker's Hill, and the forming of the Continental Army under George Washington's command—Peale decided to move from Maryland to Philadelphia, then a city of thirty thousand, which was also home to the Continental Congress. The deepening crisis and the inevitability of war did not deter him from the capital city, which everyone forecast to be the next logical target of the British army. If anything, Peale felt the opposite impulse, writing to a friend in England that "all the people declare for liberty or Death, they are much used to hunting and are all good marksmen, even our Children . . . is it to be supposed that such a people . . . can be conquered by all the Troops England can send here, no it is not probable . . . I hope I am writing to a man who loves liberty . . . I would Recommend to You to come amediately to America."[20]

Instead of seeking refuge from imminent turmoil, which was what a young artist might logically prefer, Peale rose to the challenge of the crisis. Radical politics were propelling him to Philadelphia, where good artistic skills were going to be particularly useful for the production of propaganda. Peale instinctively knew what to do as a political incendiary. When, for example, his friend Mordecai Gist approached him for the design of a battle flag for his Baltimore Independent militia company, Peale came up with an inspired image of "LIBERTY trampling upon TYRANNY, and putting off SLAVERY who is approaching with hasty strides, and taking hold of DEATH."[21] Next to the figure of LIBERTY he placed a column that represented STABILITY, and nearby wrote the motto "REPRESENTATION OR NO TAXATION."

Peale arrived in the capital city with his ever-expanding family in the summer of 1776, in time to witness the frantic mobilizations for war—the boycott of British goods, the raising of local militia companies, the persistent sound of drums and fifes, the building of warships on the Delaware River—all of which was set against the dramatic splintering of Philadelphia into factions of Loyalists, Patriots, and pacifists.

He quickly made friends with Thomas Paine, whose *Common Sense* stoked dissent. On July 8, Peale heard the Liberty Bell toll, proclaiming the Declaration of Independence, whereupon he joined the city's residents at the State House for a public reading of the document, and participated in the removal of the King's coat of arms from the exterior of the building.[22] Revolutionary energies were about to swamp everyone

in Philadelphia, including Peale, who believed that no one was exempt from the political contest. "I believe," he wrote to West, it "is almost a Settled point that those who do not enter [the] fight with us is against us."[23] Instead of shrinking back into the painting studio, he fantasized in a letter to Jenings that if the day should come when he could no longer paint, then "I must take the Musket."[24]

In the end, Peale chose both. One of his diary entries reads, "finished the governors Portrait, the afternoon spent in Exercise of War."[25] Three weeks later he was writing about bullets, rifles, and lengthy experiments on the best way to mix gunpowder. He quickly discovered that the Revolution was an engine of creative work. John Hancock, Joseph Hewes, Thomas Heyward, Samuel Adams, and other legislators hired Peale to paint portraits of themselves or their colleagues, and because he was by this time the most talented artist living in America, Copley having moved to England, political leaders looked at him as a potential resource for the cause.

John Adams took time from the Second Continental Congress to visit Peale's new studio on Arch Street. In a letter to his wife, Abigail, written nineteen days after the signing of the Declaration of Independence, he described the thirty-five-year-old artist as "a tender, soft, affectionate Creature" who "has Vanity—loves Finery—Wears a sword—gold Lace—speaks French—is capable of Friendship, and strong Family Attachments and natural Affections." Adams was entirely taken with Peale, promising Abigail "to penetrate a little deeper into the Bosom of this curious Gentleman, and may possibly give you some more particulars concerning him—He is one of your pretty little, curious, ingenious Men. . . . He is genteel and well bred, and is very social."[26]

Peale showed Adams everything he had: exquisite figures made from clay, portraits in miniature of Hancock and others, larger portraits of Franklin and Mrs. Benjamin Rush, sketches of country estates, including Mount Vernon, and a portrait of Washington that he had just painted for Hancock. Adams thought that Peale's portraits were "very well done," but in his cultivated opinion, still "not so well as Copley's Portraits. Copley is the greatest Master that ever was in America."

Adams was especially struck by "one moving Picture." It was a heartfelt painting of Peale's wife Rachel weeping in front of their dead child Margaret, felled by the smallpox epidemic ravaging the city. Adams had been receiving disturbing news from Abigail in Massachusetts on the

toll that the "King of Terrors" was taking there and the painful measures to forestall its effects via inoculation. When he looked at Peale's picture, the threats to his own family were thrown into high relief. He and Abigail had lost one child, Susanna, in 1770 and would lose another in 1777. Adams wrote that the picture shows Peale's "Wife, all bathed in Tears, with a Child about six months old, laid out, upon her Lap. This Picture struck me prodigiously."

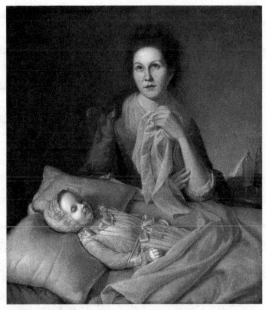

Charles Willson Peale, *Rachel Weeping*, 1776

Hancock, the President of the Continental Congress, actively and purposefully used Peale for political effect, ordering two half-length portraits of Washington and his wife, Martha, when the couple arrived in Philadelphia late in May of 1776.[27] Peale was already acquainted with Washington from 1772 when he traveled to Mount Vernon unannounced and was hired to paint the entire family, including a large portrait of a youthful Washington wearing Virginia regimentals from the time that he was serving as a colonel in the French and Indian War.

The Washington of 1776, however, faced a far graver and more overwhelming task. He had come to Philadelphia to be lauded by Congress after forcing General William Howe's British army to evacuate Boston in March. Washington had maneuvered sixty tons of heavy artillery, recently captured by Henry Knox at Fort Ticonderoga, to Dorchester Heights, a peninsula to the south that had a commanding position above the city. That stroke of strategic genius left the British with no sane military options other than to evacuate. For what was the maiden American victory of the Revolution, Washington was everywhere recognized as the first certified hero of the war. Harvard College bestowed an honorary degree on him. John Jay and Josiah Quincy wrote tributes in his honor. Congress struck a medal showing Washington and his generals on the Heights. And Hancock hired Peale to paint his portrait.

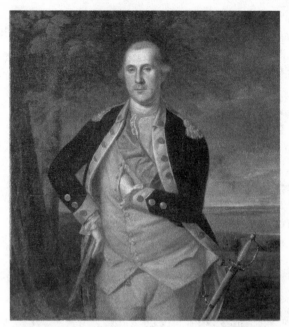

Charles Willson Peale, *General George Washington*, 1776

In it, Washington is a somber military hero standing tall and by himself atop the Heights, his face fixed in a penetrating, forward-looking stare. Peale amplified Washington's unwavering, dead-eyed expression with an officer's sword and scabbard that protrude prominently from the red leather slings attached to a belt beneath his waistcoat. In the distance behind Washington are the harbor and peninsula of Boston, and on the horizon a faint trail of smoke can be seen rising from the still-smoldering ruins of Charlestown, which the British had burned to the ground during the Battle of Bunker's Hill in June of 1775. Dorchester Heights was Washington's retribution for that defeat and Peale's picture was a public commemoration of the general's achievement.

Because it was the first painting to honor an American military success, and because it represented an event soon to stand in graphic contrast to Washington's massive failure to protect New York City from the British invasion a month later, Peale was asked to make copies of it, one of them in miniature for Martha Washington. Hancock then paid Peale extra money to paint a copy of the picture to give to Admiral Comte d'Estaing in 1778, at the time of France's entry into the war, whereupon the Frenchman enshrined the portrait of Washington on board his flagship, the ninety-gun *Languedoc*. A notice in the *Pennsylvania Packet* described one evening on the ship: "The entertainment was highly elegant. A picture of General Washington at full length, lately presented to the Count by General Hancock, was placed in the centre of the upper side of the room, the frame of which was covered with laurels."[28] Though Washington himself could not be present at the event, Peale's portrait served as a satisfying diplomatic substitute that could be praised and even toasted by those on board.[29]

Hancock clearly knew how to use Peale's works of art as political tokens. As the Continental Army was taking shape, Hancock, as President of the Continental Congress, had signed Washington's congressional commission as "General and Commander in Chief of the army of the United Colonies." Under the umbrella of that appointment, Hancock's Congress, with Washington's advice, had the task of selecting thirteen men to serve as generals under Washington's command. When the time came to make those selections, Hancock unabashedly let it be known to Washington that he was available to take on one of those positions. Imagining himself in uniform and never one to let an opportunity pass him by, Hancock may have used Peale's flattering portraits of the general as a means to curry favor with Washington and win a coveted military appointment.

But even with the help of a large portrait paying homage to the Commander in Chief, who did not especially like Hancock, Washington ultimately turned down the request, and for good reason. If anything, the four-foot picture only made Hancock look over-eager, and as Washington knew well, any accolades being heaped on him so early in a difficult war were premature and uncalled for. In addition, Washington knew that Hancock was no more than an ersatz military man who, when he finally got a chance to lead the Massachusetts Militia, directed six thousand men against the British at Newport in August of 1778. The operation was such a fiasco that most of the militia deserted and Hancock wisely returned to the business of government.

At the same time that Peale was painting Washington's portrait for Hancock, he was also being drawn irresistibly into the militia himself. When he saw his younger brother James enlist in the Maryland Line militia in 1776, Peale soon followed by enrolling on August 9 in the Philadelphia City Military Association, better known as the Associators.[30] Within a few months he was promoted to the rank of Lieutenant in the Second Battalion, despite the fact he had no prior military experience. The eighty-one militiamen under his command were expected to defend the city and come to the aid of Washington, who had been chased out of New York City and into New Jersey, ultimately finding winter refuge in Pennsylvania along the Delaware River.

At first, Peale used his new position of authority within Philadelphia to bluntly interrogate the men living in his ward so that he might determine which ones were willing to go into battle "against the Enemy," and "who will not." And if not, hesitant men needed to explain to Peale "their

Reasons."[31] When orders of march finally arrived at the end of 1776, Peale packed up his belongings, led the Associators up the Delaware River, and joined Washington's army. Peale had no inkling of the trials that lay ahead, but he was optimistic enough about upcoming campaigns to think it would be smart to throw some of his painting equipment into his pack, in case he might be hired by one or two of the officers for a portrait.

What Peale saw when he arrived on the banks of the Delaware on December 6, 1776, was like something only Dante could have imagined. It was "the most hellish scene I ever beheld. All the shores were lighted up with large fires, boats continually passing and repassing, full of men, horses, artillery and camp equipage . . . The Hollowing [howling] of hundreds of men in their difficulties of getting Horses and artillery out of the boats, made it rather the appearance of hell than any earthly scene." The Continental Army had been lucky to escape New York after a series of devastating defeats stretching from Brooklyn to upper Manhattan. By the time the army got to the Delaware, it was in a state of ruin.

In the middle of the nightmare scene Peale encountered a frightening stranger. "A man staggered out of the line and came toward me. He had lost all his clothes. He was in an old dirty blanket jacket, his beard long and his face full of sores . . . which so disfigured him that he was not known by me on first sight." In few moments he realized who it was. "Only when he spoke did I recognize my brother James."[32] Ensign James Peale had escaped from New York, staggered into Washington's encampment, and then into the arms of his brother.

Peale nursed his stricken brother, and while they were together along the frozen Delaware they may have listened to Tom Paine's *American Crisis*, which Washington had arranged to be read aloud to the troops on December 23. "These are the times that try men's souls," were the now-famous opening words that the Peale brothers could agree on. But it was in the second and third sentences that they could accurately identify themselves: "The summer soldier and the sunshine patriot will, in this crisis, shrink from the service of their country; but he that stands it now, deserves the love and thanks of man and woman. Tyranny, like Hell, is not easily conquered." The Peales could simply have stayed home and tended to their families, but out of a sense of duty they engaged with the cause and willingly put their lives on the line for the new republic.

Peale's diary entries for late December indicate that he knew nothing about Washington's plan to cross the Delaware on Christmas night. Two days after the crossing and the defeat of the Hessians at Trenton,

Peale forded the river under the command of General John Cadwalader, whom he had painted with his wife, Elizabeth, four years earlier. Peale's unit marched to Burlington, New Jersey, and then joined with Washington's victorious army outside Trenton on January 2, 1777.

Peale's diary entries grew increasingly agitated on the following day when Washington maneuvered his troops around the main British forces and launched a northern attack on the reserves garrisoned at Princeton. "We were marched pretty fast, however the Sun had Rissen just before we See Prinstown."[33] As Peale and the Associators marched toward the town, he was shocked by the sight of terrified American troops from General Hugh Mercer's company "retreating in confusion" toward them. The Continentals, out-fought by the more professional troops of British colonel Charles Mawhood, were running for their lives.

Though Peale knew it was a rout, he was being commanded to forge ahead with his militia. Fortunately for them, Washington, in a desperate effort to save the deteriorating situation, took aggressive command by entering the pandemonium from the rear and charging into the teeth of the battle. As part of the second assault, Peale's militia company was ordered to open fire on the British line, which started to fall back, crumble, and then retreat and run toward Nassau Hall. By the awful, bloody end of January 3, the Americans had their second major victory of the Revolution.

Covered in mud and ice and describing himself as "thin" and "spare," Peale and his ragged militia company staggered away from Princeton and followed Washington's army to winter quarters in Morristown, New Jersey. On January 14, no longer needed, the Associators were released and they began their long cold trek back to Philadelphia. For the remainder of the Revolution, Peale would continue to be called up to patrol areas of central New Jersey or to ferry supplies and ammunition to soldiers engaged in the battles at Brandywine, Germantown, and White Marsh. But he would not witness gunfire again.

He did, however, repeatedly encounter—and would forever remember and take to heart—the painful sight of frightened soldiers retreating in waves from grisly battlefields covered with blood and the unburied dead.[34] In one diary entry he recorded a disturbing encounter in the aftermath of one battle: Watching "the American Army retreating," he futilely tried to turn stragglers back to the front line, and while he saw the troops run away he made repeated attempts to spot his brothers in the crowd. In other entries he noted the awful gallery of human suffering: Colonel John Stone "carried on litter in great pain;" Major Uriah

Forrest who had his leg amputated; and Captain Benjamin Brookes gagging from a shot "lodged in the root of his tongue."[35] Whatever romantic visions of war that he might have ever entertained were chastened by searing experiences of suffering and death.

Peale spent most of 1777 in Philadelphia, where he prepared for the inevitable British invasion. The catastrophic fall of New York City had thrown Philadelphians into a state of panic as they fully expected to be next in line to fall to the redcoat juggernaut. He was put in charge of the home front, removing strategic supplies from the city and rounding up and detaining Loyalists, some of them his friends, who might abet the incoming British. In mid-summer, General Howe and General Lord Charles Cornwallis boarded eighteen thousand troops onto warships in New York Harbor and on August 25 they landed near Elkton, Maryland, en route to Philadelphia. In abject fear the city ground to a halt. Stores closed, gunpowder was horded, militiamen were put on twenty-four-hour alert, and at the end of September the Second Continental Congress decamped for York, Pennsylvania.

Washington tried to make a last stand against Howe's army at the Battle of Brandywine, but he made strategic errors and lost twelve hundred men in his retreat, allowing Howe and Cornwallis to effortlessly walk into Philadelphia on September 26, 1777. Washington retreated to Germantown, where he suffered another stinging defeat, and then he marched the army to Valley Forge for winter encampment. In one British satirical print entitled *The Flight of the Congress*, the British lion thumps one claw down on a map of Philadelphia and roars the word "Howe," scaring away the wildlife, including Hancock the ass, Washington the armadillo, and Sam Adams the fox.

With the British at the gates of the city, Patriot families made their mad exodus, including the Peales, who first went to Haddonfield in New Jersey and then to a farm in Bucks County. "How great the risk," Peale wrote as the British were crossing the Schuylkill River into the city, "and narrow the Escape from being plundered, [my] family abused, [myself] made a prisoner, or perhaps killed for [I] rode armed."[36] After the family settled on the farm, Peale continued to tend to minor military tasks, mostly moving gunpowder stores to safe sites, before his official tour of duty in the militia came to its scheduled end in November.

Happy to be released, he could hardly rest. With winter approaching, he was desperate to make money for his family. The British occupation

of Philadelphia meant that his usual source of revenue from portrait painting had vanished overnight, and so too had his outlook and confidence. His diary entries for the winter of 1777–1778 tell of a man who had entirely lost his footing. At one moment he celebrates the birth of a son (aptly named Rembrandt), then notes the French lessons he was giving relatives and how successful he was at purchasing the works of Ovid, before he turns paranoid in his fear that the "Enemy" is lurking behind every tree.

Ever resourceful, Peale determined to visit Washington's Valley Forge encampment in hopes that officers would want to be remembered in the form of portraits, before the war maimed their bodies or took their lives. However appalled Peale might have been at the sight of Valley Forge, with twelve thousand suffering men camped for a lethal winter that killed a quarter of them by the time it was over, he was at least safe from the British while he was there and he had paying work.[37] Over the course of that dreadful winter he would shuttle back and forth at least five times between the encampment and his home in exile, thirty miles away, and in that time he would paint thirty-two miniatures of officers.[38]

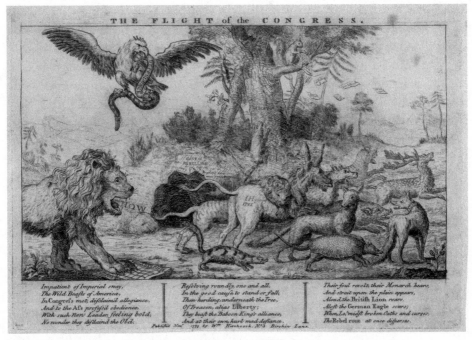

William Hitchcock, *The Flight of the Congress*, 1777

❖

War and art were unlikely but welcome companions. As Peale himself phrased the odd admixture in a diary entry of December 16, 1777, "finished the Miniature of Genl Washington and began a Coppy of it—& Clean my Guns."[39] Most of the miniatures he made for soldiers were inexpensive bust-lengths of officers in their uniforms, smartly groomed, and sporting a slight smile.[40] None of them spoke to the atrocity of war or to the toll that war personally took on individuals. Instead, they were emblems of pride and honor, mementos of service and sacrifice. And in the likely case of mutilation or death, these were to be the last visual records of a loved one who could be forever remembered in a state of composure, both physical and mental, before the battlefield had taken its ugly toll. That would prove to be a pattern throughout the war: extreme anguish stimulated the urge to record and commemorate.

Peale registered in his diary numerous military commissions from the Valley Forge and Delaware River encampments and at other sites during the remainder of the war. One small picture exemplifies the allure of art in the midst of warfare. Ennion Williams, a major in the Pennsylvania Rifle Regiment, hired Peale for twenty-eight dollars to paint his miniature portrait. He had been a part of some of the most awful military action of the war, his battalion having suffered great losses during Washington's unsuccessful attempt to defend New York City in the summer of 1776. The three battalions in his Rifle Regiment had once numbered 1,273 men, but after New York only 777 remained. As Casper Weitzel, a captain in his unit, phrased it, New York was "a wire mouse trap, easy to get in, but hard to get out."[41]

During the siege of New York the British captured the regiment's charismatic leader, Colonel Samuel Miles, leaving twenty-four-year-old Williams in charge of the 182 battalion soldiers who had not been killed or taken prisoner. He and his remaining riflemen survived the battles up Manhattan and the evacuation of New York, the crossing to New Jersey, and the long march south to the west bank of the Delaware, where a contingent of his disaffected men mutinied on September 19 and then deserted. "Their complaints," according to Captain Weitzel's account, "are want of pay, want of clothes, the want of blankets, the not receiving the particular species of rations."[42] Weitzel said

that "there are no clothes to be got here of any kind. I have lost all my shirts and stockings . . . what I shall do for more God knows." He hoped to return home, unless of course some unforeseen event should "kill me before that time."

In the midst of that gruesome experience, Peale painted his portrait of Major Williams, looking fresh and wearing a hint of a smile. It did not matter that the Delaware encampment was a hellish place because portraits were about the only way an officer could experience normalcy, or a family could imagine normalcy for him. That was the common story. In the midst of despondency, sickness, and death, Peale's cheery portraits were a form of reassurance and respite, a welcome excursion into well-being, however fictional that might be.[43]

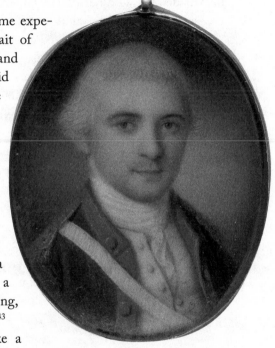

Charles Willson Peale, *Ennion Williams*, 1776

Often a portrait acted like a love letter from the front. Ten days before the crossing of the Delaware, Peale wrote in his diary, "Begin a Miniature of Captn. Bernie." As soon as Bernie paid Peale the twenty-eight dollars for a miniature on December 22, he went "to see his wife 9 miles out of Town," undoubtedly with the purpose of presenting the portrait to her as a gift. The same was true of Lieutenant Peter Bruin of Virginia, who had fought in the disastrous Battle of Quebec in 1775, where he was wounded and taken prisoner. After he was exchanged for a British soldier and released, Peale painted his miniature and "set it in a metal Bracelet" so that his wife could wear it as a keepsake on her wrist.[44]

It is easy to be charmed by the sentiments attached to Peale's miniatures. They salved the misery of war, eased the pain of loss, and replaced it with something wholesome. And often they spoke of love, though in some cases that love was illusory. Colonel Henry Beekman Livingston,

the scion of the most powerful family in New York, approached Peale for a miniature after he had distinguished himself in the field of battle at Quebec, Saratoga, and Monmouth. In 1779 he started to court sixteen-year-old Nancy Shippen, a charming and beautiful socialite living in Philadelphia with her Patriot father, Doctor William Shippen, Chief Physician to the Continental Army.

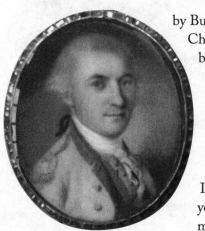

Charles Willson Peale,
Henry Beekman Livingston,
ca. 1780

She was also being wooed, diffidently, by Bushrod Washington, the Commander in Chief's favorite nephew, and seductively by Louis-Guillaume Otto, the sophisticated chargé d'affaires at the French legation a few blocks away. Otto was extravagant in his affections, telling Nancy Shippen that her "image is so entirely present to me, all my thoughts are so entirely directed towards you that I see or feel nothing in the world but you."[45] Otto, who had Peale paint his military portrait in Philadelphia, would compete with Livingston for Nancy Shippen's affections—or, as her brother Tom put it, for "her smiles."[46] To be sure, Otto won her heart with his French finesse and romantic flair, but Livingston was relentless in his pursuit and he was aided by Doctor Shippen, who knew that his daughter was "much puzzled between Otto & Livingston. She loves ye first & only esteems the last."[47] But the observant doctor also recognized that Livingston was very rich and eager to marry, while Otto, though "handsome . . . has nothing now," and "is afraid of a denial." His conclusion was, "A Bird in hand is worth 2 in a bush."

Livingston assisted his campaign to persuade Nancy Shippen to marry him by using Peale's miniature as an agent of love. Set in a frame studded with garnets, Livingston wears the uniform of his New York regiment and looks perfectly reasonable and sincere. On the reverse side of the miniature are two conjoined hearts, a romantic talisman of love. For that, Peale took a lock of Livingston's hair, then chopped it very finely and poured it over a design he had drawn in glue.[48]

Ultimately, the miniature did not carry talismanic power. Nancy tried to slip out of the impending engagement with Livingston so that she could marry Otto, which led Doctor Shippen to quash the romance with the Frenchman and, without knowing much about Livingston, to rush his daughter headlong into marriage two weeks later, a miscalculation that proved to be disastrous. Nancy had not gotten over Otto and certainly did not know she was marrying a man once described as "selfish, imperious, licentious,—the black sheep of his family."[49] As soon as she married, she learned the truth of her husband's "frequent and ungovernable fits of rage," his numerous "amours," and his small collection of bastard children.[50] After two miserable years of wedlock at the Livingston homestead on the Hudson, she ran away with their daughter to Philadelphia where she asked herself, perhaps with Peale's miniature nearby, "Why did I believe [Livingston] when he swore so often he loved me, & that he wou'd make me eternally happy."[51] She was to become embroiled in a prolonged custody battle in the years ahead, then sue for divorce, which was nearly unknown in that era within her class, and eventually became a recluse. All of Peale's military portraits were necessarily fictional in parts, but Livingston's was especially tragic for Nancy Shippen for its power to distort.

The British suddenly evacuated Philadelphia in the summer of 1778, the first tangible result of the Treaty of Alliance that was sending French warships and soldiers to America, and that ultimately tipped the war in the American direction. With the British gone, Washington and the Continental Army returned to the city from Valley Forge, and so did Peale and his family. Peale movingly described the deep emotions experienced during that moment of repatriation: "What pleasure was shown in Whig faces as they Entered the City. What shaking of Hands at their meetings [with] those who had been Scattered over the face of the neighbouring country. What variety of Salutations of those who had stayed, with those who had chosen to fly" from "their Home, nay many their Familys, yes many were Obliged to leave their Wives & Children that were so dear to them, in a poor and pennyless Condition . . . What variety of meeting of Friends that once were Intimate, fearful and distrustfull least they should take one by the hand who had played the Traitors part. Most of them that stayed would amediately . . . begin the doleful Tale of their Sufferings, how the Tories had abused them and how the whole of their Houses were

taken up by either officers or Soldiers, and they dare not say a word but they were called Rebels and threatened with the Prison."[52] As Peale was about to discover, war had transformed the Philadelphia he had once known.

3 ⌇

Philadelphia's Founding Artist

AFTER A YEAR OF EXILE, PEALE ENTERED INTO A NEW line of combat in Philadelphia, for political control of civic authority in the liberated capital city. Radical revolutionaries like Peale, informally known as Furious Whigs, had come to dominate Pennsylvania in the wake of the state constitution of 1776 that enfranchised all white men, whether or not they owned property. Benjamin Franklin, David Rittenhouse, and Tom Paine shaped the document that allowed laborers, artisans, and farmers to rise to power. Persons like Peale and Timothy Matlack, a disowned Quaker and rough-hewn brewer and beer bottler, were suddenly put in control of the government, leaving Philadelphia's Republican Society, or True Whigs—the conservative revolutionaries who were property-owning members of the moneyed ruling class—to feel that the middling and laboring classes had hijacked a government that was their rightful due.

The turmoil in the city between the two Patriot camps was magnified further by struggles with two other groups. The large Quaker population hoped to steer clear of politics entirely, an almost impossible task given the extreme partisanship polarizing everyone else; and the large contingent of Loyalists maintained allegiance to the crown and were, in Peale's opinion, traitors who needed to be suppressed or sent to prison.[1]

In the aftermath of the British departure and the restoration of Whig control, Peale took on the onerous job of punishing the Loyalists who had helped the British army during the occupation. The Chews, Bonds, Redmans, Whartons, Shoemakers, and other prominent Loyalist families had exuberantly celebrated the British arrival in 1777 by opening up their houses and offering their hospitality to the officer corps. Of the many things returning Patriots found objectionable about the Loyalists during the British occupation, the one that stood out as most egregious was the staging of a public festival named the Meschianza, an extravaganza staged in honor of General William Howe on May 18, 1778, on the eve of his return to England. The lavish fête included a regatta down the Delaware accompanied by three orchestras

and a seventeen-gun salute, a mock jousting tournament, and a spectacular fireworks display. In the evening, Philadelphia Loyalists joined with the British at a ball and banquet held at Joseph Wharton's home on Walnut Street. The ladies dressed as Turkish harem girls, the gentlemen as medieval knights, and all of them saluted Britain's triumph late into the evening.

But with the British army evacuated and the Patriots now in charge, Philadelphia Loyalists were doubly vulnerable to censure and punishment, for siding with the Crown and for having consorted with the enemy. The Pennsylvania Assembly appointed Peale and four others to be Commissioners of Forfeited Estates, and for that the commissioners would receive a 5 percent commission.[2] Peale's group had extraordinary power to interrogate suspected traitors, break into houses, remove property, and sell off estates. Writs were issued to seize 118 estates involving 500 "suspitious Charactors," as Peale called those who might "in any manner be aiding, or assisting the British."[3]

Peale plunged into the project. The committee's debut event was the harsh eviction of the wife of Joseph Galloway, the once powerful speaker of the Pennsylvania Assembly and former delegate to the Continental Congress who had chafed at British taxation but had not been able to abide American independence from Britain. After switching his allegiance to the Loyalists, Galloway had joined the British in their governance of Philadelphia, and as the British-appointed police superintendent he had worked to expose the city's Patriots and punish them. When the British left the city Galloway went with them, abandoning his wife, Grace Growden Galloway, who remained in their palatial house at Market Street and Sixth.

Because Joseph Galloway was at the head of the Commissioners' list of traitors, Mrs. Galloway was a prime target for seizure. She thought her husband's remaining business associates and friends would be able to protect her after the British departure, but Peale, along with two other men, were determined to take possession of her house, by force if necessary.[4] They broke down the back door on June 20, pushed their way in, and accosted Mrs. Galloway, demanding her immediate departure. She described Peale as "an insolent wretch" and refused to leave. "He then took hold of my arm . . . took me to the door," and "with a sneer" forced Mrs. Galloway out.[5]

For Peale, the job of dispossessing Loyalists was "the most difficult, laborious and disagreeable task I have ever undertaken."[6] His papers

repeatedly tell the sad story of having to interrogate and evict former friends who resisted the writs levied against them, leaving Peale no choice other than to use force. Sixty seized properties were listed for sale or rent, and with the money made from that the controlling Furious Whigs tried to impose their revolutionary will on the city's prized institutions, such as the College of Philadelphia.[7] They had wrested control of it from a board thought to be made up of conservatives with Loyalist leanings, then used the proceeds from the sale of Loyalist properties to fund a new Whig endowment; and they went so far as to rename it the University of Pennsylvania.

Ultimately, Peale and his committee collected a whopping £886,000 worth of sales and rents from confiscation (and that included a property at Lombard Street and Third that Peale sold to himself). But because currency was so degraded during the Revolution, Peale's individual share of the proceeds was minuscule, forcing him to appeal to the governor for special compensation for the portraits he was unable to paint in that time because he was absorbed evicting Loyalists.[8]

Peale and the Furious Whigs were politically ascendant in the city and state governments. They refused to defer to established leaders like Robert Morris, the wealthiest man in Philadelphia, and turned instead to the mass of white male voters for their support.[9] Some of the Furious Whigs got together in the spring of 1779 to form the lofty-sounding Constitutional Society that operated on the principles of free thought, popular elections, clean and transparent government, and control of runaway prices, all of which were ideas anathema to the old merchant aristocracy.[10] Peale presided over meetings of the Constitutional Society and as a result he heard all the denunciations, grievances, and threats that were aimed in their direction by moderates and conservatives. Benjamin Rush, a liberal thinker and a prominent physician who had tended to Peale's militia company at the Battle of Princeton, was one of Peale's earlier supporters, but he came to believe that Peale's group was changing too much too fast, and had become a pox on society: "They call it a Democracy—a mobocracy in my opinion would be more proper . . . my Country I have long ago left to the care of Timy. Matlack—Tom Paine—Charles Wilson [sic] Peale, & Co."[11]

That government, dominated and run by the Furious Whigs, hired Peale, one of their leading political operatives, to paint Washington for the Assembly Room of the State House early in 1779. It was Peale's first

state commission. To be fair, Peale received the commission for legitimate reasons and not because of cronyism. He was the finest artist in the city and the time had truly come for Pennsylvania to commemorate Washington's signal achievements on the battlefield.

The timeless portrait that came of the commission is nothing less than the first great painting in the history of the United States. It depicts the general at the end of the Battle of Princeton, which was the most significant American victory to that point in the war, one even more outstanding than the Battle of Trenton after the crossing of the Delaware. The picture, also meant to celebrate the liberation of Philadelphia from the British the previous year and to acknowledge the general's stunning military successes in the region around Philadelphia, was undeniably an effort by the Furious Whigs to capture Washington as their man. As the radical thinking went, if they could wrap themselves around Washington's unparalleled prestige and accomplishments, then they could solidify their position in Pennsylvania and make Philadelphia moderates like Robert Morris look like tepid revolutionaries who were not in the forefront of change.

Peale poured all his talents into a complex picture that could easily have descended into visual chaos. He knew from firsthand experience as a militiaman on that battlefield that Princeton had been brutal, a battle heavy in chaos, wounded men, blood-soaked ice, and unburied dead. He might have painted the culminating moment of the fierce fighting when Washington took command on the front line, and that might have been a popular picture. But looking across the arc of his career, it is clear that Peale believed that idealized images of valor in combat were borderline dishonest and perhaps immoral, and that they would have sent the wrong message to the fledgling republic.

Instead, because he was interested in personal character more than battlefield heroics, Peale presented Washington as a man in possession of benign dignity after the severest combat. Though he is shown just after the most defining battle of the Revolution to that point, one that altered the course of the war, he is animated but unperturbed. He has dismounted from his horse and removed his cocked hat, which he holds at his hip. He crosses his long legs and leans an ungloved hand on the barrel of a cannon. Peale further energized Washington by multiplying certain parts, such as the curve of a blue sash that parallels the curve of the edge of his coat, or the dogleg of his right elbow that complements the jutting angle of the tricorne hat held in his right hand. Yet for all the complexities, Washington's

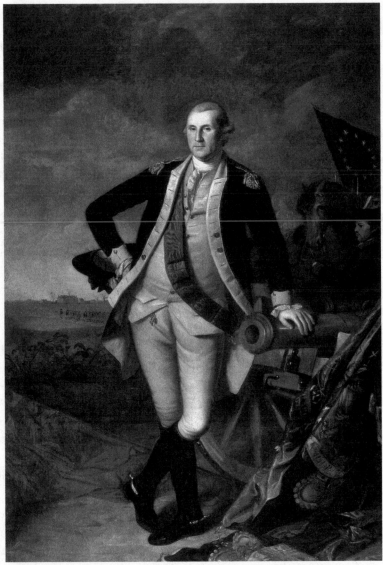

Charles Willson Peale, *George Washington at Princeton*, 1779

upper body is strikingly and simply silhouetted against the brightening sky, and his still and direct expression seems to calm the cluttered picture and draw viewers to his magnetic face.

On the right side, a heap of captured German flags pile up below a jumble of two French cannons, a horse, its groom, and an improvised American flag fluttering in the breeze. On the left side in the middle

distance, the British ensign has been thrown to the ground in front of some fallen branches, and in the far distance can be seen a column of sixteen captured British and Hessian soldiers being led away single file by their Continental Army escorts. Nassau Hall stands in the distance. Overhead, dark skies begin to lift, and on the horizon sunshine breaks through.

Sir Allan Ramsay and Studio, *George III*, ca. 1763

The image is an idealization, but it was welcome and necessary after a colonial world in which images of remote authority and imperial rule were the order of the day. Peale's Washington would be a potent antidote to the portrait the British had planned to install in the State House in 1767: a lavish coronation portrait of King George III, bedecked in silks and ermine. There once had been hundreds of those portraits of the King hanging in colonial capitals and in the homes of his subjects. And though some still hung on walls in Loyalist houses, most had been removed, put away, or destroyed.

This was a new day in the history of America, and Peale had condensed the new order of rule into a single image of Washington. That was the central point of his picture. As presented by Peale, Washington carried symbolic weight as a national icon representing the values and principles of the American republic. Here was the living embodiment of republican virtue, a person of wealth and standing, willing to risk life and limb for a cause he believes in. One glance at Peale's portrait was all that was necessary for citizens to grasp the clear-cut differences between Washington and the King, between America and Britain, between the values of a republic and those of a monarchy, and, above all, between the present and the past.

The picture was of such magnitude that before long Peale had orders

for more replicas of it—eventually more than two dozen—than he could possibly paint. It acquired special appeal in the courts of Europe (copies were to be sent to Spain, Holland, and France) because the general's reputation had spread to the Continent, and because Washington was the man who could defeat the greatest—and most despised—land and sea power in the western world. The picture even turned up on a wall beside Lafayette's bed at his medieval chateau east of Paris.[12]

❦

Peale's stunning portrait of Washington, so self-possessed after a fierce battle, gives the indisputable impression that America's progress in the war was assured, which in fact was mostly the case in the North after 1779. But the battlefield of Philadelphia politics was anything but settled. Peale had positioned himself in the triangular no-man's-land between extremist Whigs such as the schoolteacher James Cannon, the moderate Whigs, among them Benjamin Rush and John Dickinson, and conservative Whigs like Robert Morris. Though they were all on the side of independence, the factions had a pathological ability to subvert each other.

Peale tried to walk a fine line between them, once dispersing a radical mob wanting to attack a conservative who had criticized Tom Paine in the press, and at another moment stopping a bizarre plan to abduct Loyalist wives and their children and ship them to the British in New York City.[13] Yet he could also be the archetypal radical leading the charge against conservative revolutionaries like Morris. At one point, Peale joined Paine, Matlack, and Rittenhouse in an investigation into Morris's financial affairs, one that led to an exposé that badly damaged the financier's reputation. The inquiry was pursued with ideological fervor even though Morris was crucial to the Revolution, both for his international trading network that acted as a spy ring gathering intelligence on the British military, and also for the millions of pounds sterling of his own money that he used to pay for the Continental Army and its munitions, to say nothing of his willingness to absorb three quarters of the expense of running the United States' revolutionary government.

In one way, Peale was like his radical Patriot colleagues in that he believed in the will of the people, rather than the innate rights of the well-to-do. But like his conservative Patriot colleagues, Peale also had an interest in civic stability. What Peale discovered about his hybrid

values was that each one of his positions made him unpopular with some other faction. "The difference of opinion here made [me] enemies of those whom before [I] had been united in the common cause of liberty and progress, looking forward to a growing core of wealth and culture in [our] society. Now freedom and freedom of trade were at odds, patriotism and self-interest incompatible."[14]

The inner war among Patriots in Philadelphia reached a climax in October of 1779 when a group of Furious Whigs conspicuously marched through the city to the home of James Wilson, the respected signer of the Declaration of Independence and member of the Continental Congress, who had defended the rights of wealthy Loyalists and supported the businessmen who had inflated prices so much during wartime that many of the city's poor were close to starvation. Having abducted four of the city's wealthiest men and paraded them through the city, the protesters confronted Wilson and thirty others, including Morris, at Wilson's barricaded house at the corner of Third and Chestnut streets with a plan to tar and feather them. Musket and pistol fire broke out, iron bars and sledges were used to break down the front door, hand-to-hand fighting ensued, and that led to the arrival of the City Light Horse Troop and Continental Dragoons, sabers drawn, to stop the violence. At least three men died, more than a dozen others were wounded, and more than two dozen were arrested.

Before the melee began, Peale, friendly with all the parties, had been asked during a meeting at Byrne's Tavern to lead the radicals into their urban battle against Wilson and his cohort. But Peale wisely refused and stayed at home during the fracas.[15] He might have agreed with the idea of demonstrating against price gouging and profiteering, but he correctly saw that nothing good was going to come from armed confrontation. The Fort Wilson riot, as the insurrection was called, was a political turning point for Peale. Philadelphia had become its own war zone. And because Peale recognized the dangers of unbound radicalism, he decided to forswear the smash-mouth politics of confrontation and violence, and in its place he embraced the idea of urban order within a system of governance.

Citizens noticed. Frightened by the blood sport of radical politics, they turned to Peale for answers because he was now perceived to be a liberal conciliator. In the autumn elections of 1779 Peale was rewarded for his moderation by being voted into the state Assembly. As the chair or member of thirty committees, he was charged with settling boundary

disputes, regulating the militia, corresponding with Patriot groups in other states, controlling inflation, and renovating the Assembly rooms in the State House.

In addition to all that, Peale contributed to political spectacles in the city. The most famous of them, before the elections the following year, was a parade on September 30, 1780, meant to vilify Benedict Arnold for his treason against the United States. When he was still loyal to the American cause, Arnold had served as military commander of Philadelphia after the British evacuation in 1778. During that time he had managed to alienate most Philadelphians with his debauched lifestyle and uncontained avarice. It was so egregious that the state of Pennsylvania charged him with eight counts of corruption and mal-feasance. Peale had had his own run-ins with Arnold over the correct way to confiscate Loyalist property. Their confrontations were so severe that they had gone all the way up to Washington's headquarters for a resolution.

After it was discovered that Arnold had been plotting to turn the American fort at West Point over to the British—an action that, had it succeeded, would have put the Hudson River under British control and thus broken the colonies in two—he became the most despised man in America, and especially in Philadelphia. He was exposed as a traitor on September 23, 1780, but deftly eluded capture and successfully fled into British-held New York on his ship, the *Vulture*. News of his trea-son reached Philadelphia on September 27, and within three days Peale was helping to orchestrate an elaborate urban spectacle meant to forever defame the apostate.

Imitating the longstanding tradition of Guy Fawkes Day, which culminated in the burning of an effigy, a farmer's cart was used to haul around the city a straw-filled, life-size mannequin of Arnold outfitted with two faces. A boy underneath the float operated ingenious machin-ery that rotated Arnold's Janus head from one side to the other and that at the same time raised and lowered his arms, one holding a black mask and the other his commission from the Devil, who stands ominously behind Arnold. A blackened, horned figure, the prince of Hell tempts his protégé with a sack of money in one hand and prods him with a pitch-fork raised in the other hand.

Directly in front of Arnold on the cart, Peale built a box covered with transparencies that, when lit from the inside, broadcast Arnold's crimes and the consequences of his treason. On one transparency, Peale

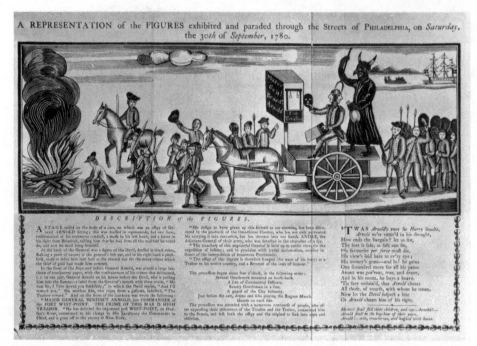

A Representation of the Figures Exhibited and Paraded through the Streets of Philadelphia on Saturday, the 30th September, 1780

drew a picture of Arnold on his knees in front of the Devil who is pulling him into the fires of Hell. A speech balloon emerges from Arnold's mouth with a protest: "My dear Sir, I have served you faithfully." To which the Devil replies, "And I'll reward you." On another side of the same box Peale drew two hangman nooses and the inscription "The Traitors reward."[16]

Fifes and drums, a line of Continental Army officers, a group of city officials, and a mob of fanatical citizens accompanied the procession through the streets of Philadelphia and into the evening darkness. When the procession got to the Delaware River, a bonfire was waiting and Arnold, surrounded by "thousands of Spectatours," was unceremoniously tossed in.[17] Revolutionaries, dancing and cheering as it burned against the night sky, lingered in the pleasure of watching the "effigy and the original . . . sink into ashes and oblivion."[18]

After the rousing Arnold parade that whipped Patriots into a frenzy, Peale confidently ran for reelection to the state Assembly in October of 1780, but this time he unexpectedly lost his seat. Many ordinary Philadelphians were sick of the continuing public spectacle of what

they believed were the divisive politics afflicting the assembly rooms and streets of the city. Not only that, they wanted good management. Instead, the Constitutional party of Peale, Paine, and Joseph Reed, which controlled the state government, had pushed Pennsylvania into bankruptcy by 1780. Though Peale was at heart a moderate who had earnestly tried to muffle extremist voices behind the scenes, he could not escape the rightward shift of an electorate wanting to return to power the old-guard revolutionaries who put stability above democratic values.

For his part, Peale was equally tired of the city's bruising partisan wars, deciding after the election to forswear politics and devote all his energy to painting, "a profession in which [I] could not make any Enemies, and which most probable as well as most satisfactory to [my] feelings, [I] therefore firmly determined no longer to take any active part in Politicks."[19] When he looked back at himself a few years later, he could see that "in our times of Difficulty" he had sometimes been "Rash, Violent, and inconsiderately active."[20] He admitted that "I have strayed a thousand ways, as the impulse lead . . .I drove on with little regard to the result."[21] But at the same time, he found "the party desputes of this State intolerably disagreeable . . . I have been most shamefully misrepresented and accused of Conduct the very reverse of what I acted."[22] As much as the electorate was done with Peale in 1780, Peale was equally finished with party politics.

❖

Peale continued to use his pen and brush for ideological ends. Immediately after the stunning American victory at Yorktown on October 19, 1781, which culminated in the surrender of Lord Charles Cornwallis and in effect signaled the military end of the Revolution, Philadelphia erupted in celebration. Cannons were fired, citizens went to church services "for the smiles of His providence," and in the evening "the whole city was illuminated" as fireworks were exploded. Peale put himself at the center of the celebrations by installing transparencies on the front of his house. These were pieces of paper or canvas joined together, on which Peale applied ink or thin paints followed by a coating of wax and turpentine. Peale's transparencies were designed to be backlit at night when the visual effects would be greatest.

On the occasion of the Yorktown victory, he hung a transparency on the first floor that showed a ship at sea bearing the name *Cornwallis*,

but with the pleasantly jarring sight of the French flag flying over the British flag. On the second floor, he hung portraits of Washington and the Comte de Rochambeau, leader of the French land forces at York-town. Their heads radiated beams of light and were linked together by intertwined laurel crowns. Over them Peale wrote the epigram SHINE VALIENT CHIEFS. He draped the entire width of the third floor of his house with a transparent banner written with the cheer FOR OUR ALLIES, HUZZA! HUZZA! HUZZA! Peale boasted that his display was so dazzling that citizens came out from all over the city to see it. "So crowded were the streets," he reported, "that if a Basket should be thrown out it could not meet with a vacancy to get to the ground."[23]

In November, a month after the Yorktown victory, Washington made his triumphal entry into Philadelphia, where he would reside for the winter at a townhouse on Third Street, within eyeshot of Peale's decorated home a few blocks south on Lombard. One of Washington's goals in Philadelphia was to persuade Congress to raise money for his troops. The Revolution was not officially over but his regiments, lacking pay and provisions, were agitating and there was the threat they might disband prematurely. To make matters worse, Washington heard from Robert Morris that the United States was effectively bankrupt, which meant that not only were the troops to go unpaid but so too were the fledgling republic's creditors, in particular France.

Peale tried to aid the general's lobbying effort by hanging extra transparencies onto his already overdecorated house. He thought they would remind everyone of what the army had done during the war and what debts of gratitude and money were owed them. "That very inge-nious artist," wrote the *Pennsylvania Packet*, put on "brilliant exhibition of a number of transparent Scenes" with the purpose of "celebrating the arrival in this city of our illustrious Commander in Chief" and express-ing "Mr. Peale's respect and gratitude to the conquering Hero." One transparency contained a figure of the "genius of America, trampling on Discord." Her classical clothing was inscribed with the words VIRTUE and PERSEVERANCE. She held a banner with thirteen stripes emblazoned with EQUAL RIGHTS. Another transparency depicted a "Temple of Inde-pendence." At the temple's base was a list of the crimes Britain had com-mitted against America, including the STAMP-ACT, DUTIES ON TEA, & BOSTON PORT-BILL. Above that was a list of key battles the army fought during the Revolution, from Bunker's Hill, Trenton, and Princeton to Monmouth, Cowpens, and Yorktown. Then, moving upward, there was

an inscription, BY THE VOICE OF THE PEOPLE. Thirteen columns rose from that and supported a band with the words ILLUSTRIOUS SENATORS, which in turn was crowned by a gabled top inscribed with BRAVE SOL-DIERY and populated with figures of Justice, Hope, and Industry. Just to drive home his message that Congress ought to allocate money to the army, he drew rays of light traveling from the senators to the soldiers.[24]

All that was crammed into the first level of his paper "Temple of Independence." Above it, on the second story, were niches bearing HEROES FALLEN IN BATTLE. On the third were figures that described the future greatness of America: Agriculture standing by a plow and holding a sheaf of wheat and a sickle; a figure of Painting, representing Peale's chosen craft; and then Sculpture, Architecture, and Commerce. A dome crowned the Temple, and at its highest point was a message to Europe, a figure of Fame "blowing her trumpet to the east, which may easily be comprehended."[25]

In the end, the Yorktown transparencies did not persuade Congress to pay the army. In the summer of 1783, five hundred Continental Army soldiers mobbed the State House demanding payment for their wartime services, threatening that if they did not receive it they would mutiny, which they did when Congress not only refused to appropriate money, but then out of fear of reprisals summarily decamped from Philadelphia to Princeton.

But the Yorktown transparencies were nevertheless so popular with the public that they made Peale into Philadelphia's favorite polit-ical impresario. Success led him to take on a project much larger and ambitious, a gigantic transparency in the shape of an ancient Roman triumphal arch that would hang across Market Street in celebration of the Treaty of Paris that brought the Revolution to a close in September of 1783. Peale was paid six hundred pounds to produce an extravaganza intended to be "the most magnificent that has ever been made in Amer-ica."[26] The goal was to stage *"Public Demonstrations of Joy . . . upon the Definitive Treaty of Peace between* The United States *and* Great-Britain."[27]

Two master builders from the Carpenter's Company, Gunning Bedford and Thomas Nevell, were put in charge of designing the scaf-folding on which Peale's transparency would be affixed, the arch span-ning Market Street between Fifth and Sixth. One side of the arch was attached, ironically, to the former home of Grace Galloway, whom Peale had evicted in 1778, but which was now the residence of John Dickin-son, recently elected governor of Pennsylvania. The design was based on

the fourth-century Arch of Constantine in Rome. And the scale was staggering, fifty feet wide and forty feet high, making it the biggest public spectacle of the century.

Over the central arch, the theme of the occasion was written in Latin: NUMINAE FAVENTE MAGNUS AB INTEGRO SAECULORUM NASCITUR ORDO ("by divine favor a great and new order of ages commences"). Peale drew an array of patriotic figures and catchphrases: a cenotaph for deceased soldiers, the insignia of Pennsylvania, a figure of America leaning on a soldier, a scene of Indians building churches in the wilderness, and a tree with thirteen branches and loaded with fruit. France was duly recognized by fleurs-de-lis, a bust of Louis XVI, and the French sun mingling with America's thirteen stars. And standing as the presiding hero was a figure of Washington, presented in the guise of Cincinnatus and crowned with laurel as he returned home to his plow. Across the top edge of the arch were standing figures representing Justice, Prudence, Temperance, and Fortitude.

Peale planned to illuminate the arch at night with twelve hundred lanterns. At the climactic moment in the festivities, on January 22, 1784, a giant figure of Peace, attached to Dickinson's house by wires, was to descend from the roofline to the top of the arch, whereupon Peale would fire up the twelve hundred lanterns that backlit all the scenes, and at the same moment unleash a shower of seven hundred fireworks meant to explode in the winter sky.

To the horror of everyone, the paper-and-wax arch ignited. One observer said that there ensued the "greatest confusion among the people in the street and the horses and carriages, so that many persons were injured and wearing apparel lost."[28] Within ten minutes the arch was reduced to ash. Bystanders were "wild with terror."[29] One woman was killed by a rocket as the winter "night turned into sorrow."[30] On the roof of Dickinson's house, Peale's brother James and son Raphaelle managed to escape unscathed. But a French servant stationed by the figure of Peace was "much burn't."[31]

Peale was himself caught on the high scaffolding. "Seeing no prospect of extinguishing the fire I endeavored to save myself by desending by a back post & thought myself out of Danger when unfortunately a parcel of Rockets which were below flew on me & burnt my hand [and] head & sett my Cloathes on fire, and drove me from my holt and I fell & received considerable Contussion on my side."[32] After dousing his burning clothes with water, Peale staggered home where he was bedridden for three weeks as he recovered from his wounds and the trauma.

Once he apologized for his massive errors, he dauntlessly prepared a new arch that he unveiled without incident on May 10 in front of the State House, to the delight of "many thousand spectators" who seemed to have entirely forgotten the dangers involved in Peale's enterprise. As an added feature to the festivities, Philip Freneau, the unofficial "Poet of the American Revolution," read a newly composed eighty-nine-line poem, "The Triumphal Arch." It began, "TOWARD the skies/ What columns rise/In Roman style, profusely great!" The entire poem was visionary, though one line spoke candidly to the extraordinary political turmoil in Philadelphia: "And, CONCORD, teach us to agree!" As he closed the poem Freneau stared into the looking glass of the future and made his wish: "May every virtue that adorns the soul/ Be here advanc'd to heights unknown before."

❊

The poem Freneau recited in front of the arch also paid homage to Washington, the tireless warrior, undisputed champion of the Revolution, solid bridge to the postwar republic, and now the man being compared to the ancient general-turned-farmer, Cincinnatus.

> With laurel crown'd
> A chief renown'd . . .
> Neglects his spoils
> For rural toils,
> And crowns his plough with laurel wreaths:—
> While we this Roman chief survey,
> What apt resemblance strikes the eye!
> Those features to the soul convey
> A WASHINGTON, in fame as high,
> Whose prudent, persevering mind
> Patience with manly courage join'd,
> And when disgrace and death were near,
> Look'd through the dark distressing shade,
> Struck hostile Britons with unwonted fear,
> And blasted their best hopes, and pride in ruin laid!

Freneau's poem gave words to Peale's persistent vision of Washington as a man in possession of human attributes so rare that they made him the

ultimate paragon of virtue. Like his Roman predecessor, Washington
was in the process of walking away from power and, in fact, Peale spoke
with the general as he was en route to Annapolis to submit his resigna-
tion to Congress in December of 1783.

There was no doubt in anyone's mind that Washington was the man
of the hour, and for the future. And that meant that Peale, so closely
associated with the general for so long, was flooded with requests to
paint ever more copies and variants of his picture of Washington at
Princeton. To his delight, his home state of Maryland commissioned a
grand portrait for the General Assembly that was to honor Washing-
ton and commemorate the American victory over Cornwallis at York-
town. Peale developed a picture similar to the portrait of Washington
at Princeton, except that he un-crossed the general's legs and tucked his
left hand into his waistcoat. He also moved the venue from the Princ-
eton to the Yorktown battlefield, where Washington stands in front of
his field headquarters marquee. He added portraits of Lafayette, who
sat for the artist in Philadelphia in September of 1784, and of Mary-
lander Tench Tilghman, Washington's secretary and aide-de-camp for
much of the war. Tilghman was the one whom Washington entrusted
to deliver to Congress the news of the British surrender at Yorktown.
In Peale's picture, he holds onto the Yorktown Articles of Capitulation
and looks leftward to the French and American officers escorting away
a defeated British soldier.[33]

When Washington returned to Philadelphia for the Constitu-
tional Convention during the sweltering summer of 1787, Peale pre-
vailed on him for yet another sitting, with the intention of producing
prints and adding Washington's face to a great new gallery project
that he was developing. For five years now, Peale had been putting
portraits on display in a sixty-foot, skylighted addition to his house
at Third and Lombard. What he ultimately had in mind was a hall
of fame that would celebrate Revolutionary War heroes, but, typical
of his Enlightenment thinking, that would expand to include *every-
thing* exceptional about America. As he explained in a newspaper
advertisement that he ran during the Constitutional Convention,
the museum would contain "the Portraits of Illustrious Personages,
distinguished in the late Revolution of America, and other Paint-
ings—Also, a Collection of preserved Beasts, Birds, Fish, Reptiles,
Insects, Fossils, Minerals, Petrifications, and other curious objects,
natural and artificial."[34]

Peale started painting portraits of Washington, Franklin, Lafay-
ette, and others, and, at the same time, collecting vipers, rattlesnakes,
pelicans, iguanas, and beetles, as well as vegetables, minerals, fossils,
and shells. At one juncture he seriously entertained the idea of including
the embalmed corpses of eminent Americans, in particular Franklin's
body, which would have needed to be disinterred.[35] The point of it all
was to tell the story of "what our country alone possessed," and part
of that panoply of the nation's natural wealth included an exceptional
breed of republican hero. The museum was Peale's gift to Philadelphia
and the republic, a "school of wisdom" he would originally title, most
appropriately, "The American Museum."[36]

Two portraits of Washington anchored the museum. One was the
1779 portrait that had once hung in the State House, and that had been
slashed in 1781 and then repaired. For unknown reasons, it was not
returned to its original location after Peale restored the picture, pos-
sibly because the whole project had been the brainchild of the Furious
Whigs, who were no longer running the state government. Because
it was Washington and because it was the largest portrait in Peale's
museum, it must have stood out among the rows of heroes, as if he were
the true ancestral father of all the other Americans on display.

The second picture was the new Constitutional Convention portrait
that Peale painted in 1787 in the middle of the feverish debates over
proportional versus equal representation in the future federal legislature.
Washington had come back to Philadelphia to preside over the drafting
of a constitution that could replace the ineffectual Articles of Confed-
eration that were prolonging disunity between the states. The situation
was desperate and Washington had already been working covertly for
years with James Madison, John Jay, and Alexander Hamilton to see to
it that the Articles would be ripped up and replaced. In Washington's
mind, the Revolution was inseparable from the Constitution, and if the
latter was to be a failure, then the former would be a condemnable waste
of lives.

Though he was a civilian in 1787, Washington presided over the
Constitutional Convention dressed in his old Revolutionary uniform,
as if that might help the hopelessly factious assembly recover the guid-
ing spirit of 1776. By taking his old blue and buff army uniform out of
the closet and wearing it into the Assembly Room of the State House,
Washington hoped to create a visual linkage between two founding
moments, 1776 and 1787.

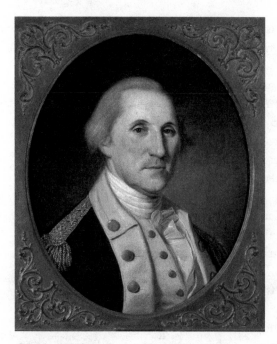

Charles Willson Peale, *George Washington*, 1787

On three mornings a week, Peale took his "Palette & Pencils" to Robert Morris's mansion on High Street, where Washington resided during the convention. Because the republic's future and Washington's legacy were both at stake that summer, Peale was now faced with an old soldier weighed down by political debate he found infuriating and potentially dangerous. At age fifty-five Washington was clearly less buoyant and more solemn than the wartime icon Peale had painted in the past. For the first time, Peale depicted Washington separated from the battlefield settings that usually accompanied the general in his portraits, and in their stead he substituted a close-up conveying a unique sense of sincerity and experience for the man who had seen it all.

The oval "Constitutional Portrait" of Washington was typical of the ones Peale painted over the next forty years for his museum. Most of the men presented in that format have retained their fame over time: John Dickinson, General Horatio Gates, General Nathanael Greene, "Light Horse" Harry Lee, Franklin, Lafayette, Rochambeau. But others, once very significant, have faded from national memory, such as John Hanson, who led Maryland's ratification of the Constitution and became the first president of Congress; General Arthur St. Clair, who fought at Trenton and Princeton; and General Otho Holland Williams, who hailed from Peale's home state.

There were not any women in the museum, nor would there ever be. That was not because women in Revolutionary America were overlooked for their exceptional refinements and accomplishments. One prominent woman, hailed for her example, was Elizabeth Willing Powel, the erudite and captivating wife of a former mayor of Philadelphia. She invited to her home some of the brightest leaders attending the Constitutional Convention, including Washington, who was thoroughly taken

with her intelligence and charm. She was the one who could speak to Washington about the presidency with frankness and prescience, at one point sketching a stingingly accurate prospectus for the man about to be reelected to that office. "Be assured," she wrote to Washington in 1792, "that a great Deal of the well earned Popularity you are now in Possession of will be torn from you by the Envious and Malignant . . . You know human Nature too well not to believe that you have Enemies. Merit & Virtue, when placed on an Eminence, will as certainly attract Envy as the Magnet does the Needle."[37] But for all of Elizabeth Powel's virtues, or those of Abigail Adams and Mercy Otis Warren of Massachusetts, or any numbers of others, only the men of the era were thought to carry the burden of *public* virtue. From the ranks of those men Peale adjudged his heroes of the Revolution.[38]

For his gallery of revolutionary men, Peale paid a surprising amount of attention to all the heroes' scars, warts, and weight. Instead of deifying them, which would have been tempting after a Revolution fought against impossible odds, Peale portrayed them in a plain and unglamorous way. He showed Washington's graying hair and sagging jowl, John Dickinson's famously long nose, Horatio Gates's almond-shaped face, and Nathanael Greene's boxy head and bee-sting lips. John Adams's hair has thinned on top, and Thomas Jefferson's fair skin looks papery and flushed.

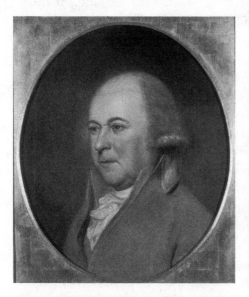

Charles Willson Peale, *John Adams*, ca. 1791

Charles Willson Peale, *Thomas Jefferson*, 1791–92

Peale considered these particulars to be the accurate indicators of each man's inner nature, and thus his true virtue. By being precise, he believed he was capturing the essence of high character, and as he explained his logic to his son Rembrandt, viewers deserved nothing less than exactitude. "Let them have truth," he said, and when it is encountered in portraiture, people will "see nothing of a picture." That is to say the lack of artifice in his pictures stood to win over viewers more successfully than any romanticized image could. The more penetrating the study of the person, Peale's logic went, the more profound the effects of the portrait.[39]

Yet for all the individualism, underlying similarities connected his revolutionary characters.[40] No one wears a wig. They all dress in their daily clothes or uniforms. All the faces have a somewhat elliptical shape. Their eyes express geniality and attentiveness. Their expressions are serene and thoughtful, and often a small smile breaks through. There is rarely a sense of drama or a quality of arrogance. Though the military men had participated in some of the most gruesome warfare humanly imaginable, Peale screened out all of that, preferring to concentrate on openness, affability, benevolence, dignity, and quiet happiness, all of which were the order of the new day. These calm faces were the welcome antidote to the political and military upheavals of the Revolution. Rather than see them as warriors or demagogues or larger-than-life gods ready to be worshiped by a thankful public, Peale insisted that visitors experience the heroes of the Revolution only as enlightened gentlemen, because that was his settled notion of what civic virtue in America looked like. To be sure, that was an idealization, but Peale never inflated his heroes in the way that contemporary Europeans would be busy puffing up Napoleon or Nelson.

These American character traits were meant to be infectious, too. In an essay on happiness, Peale made a case for the profound public effects of facial expression. One memorable face could inspire everyone in the vicinity.[41] Following from that principle, dozens of faces with a similar expression, like those beaming on the walls of his gallery, would cause a veritable epidemic of republican calm, confidence, and sincerity. And if citizens saw enough of Peale's men, or saw them often enough, they would be moved to imitate their temperament and outlook, including their selflessness and good deeds. Though the American Revolution was over and receding into history, Peale hoped he could sustain and multiply its values across the decades, push them deep into the American

psyche, and ultimately channel the thoughts and feelings of his fellow Americans.

But the wild gyrations in Philadelphia politics after the Revolution, which saw factions of every kind viciously competing for power and influence, could not be contained by a museum. Having once operated at the epicenter of the political tornado, and been scarred by it, Peale nevertheless was going to do what he could to paper over differences and create consensus. He tried to use his gallery to make the unifying words that open the Constitution, "We the People," into something real, palpable. But to accomplish that he had to consciously put aside some of the most controversial issues posed by the Revolution and the Constitution, ones that remained troublesome and divisive, such as the sovereignty of states, the centralization of power, the disenfranchisement of women, or, most egregiously, the contradiction of slavery in a nation committed to the rights of mankind.

He also had to overlook the personal differences and antagonisms that were rife among the gallery's strong-minded individuals. Tom Paine spent the war in angry opposition to the more conservative Robert Morris, and the feeling was mutual. Most spectacularly, General Gates had been involved in the Conway Cabal that questioned Washington's competence during the Revolution. He had arrogantly bypassed the normal chain of command when he sent his military reports directly to Congress, and there was barely concealed talk of Gates succeeding Washington as the Commander in Chief.

But under Peale's artistic roof, if nowhere else, all that was put aside as these men seemingly check their differences at the gallery door and join together in harmonious and orderly republican kinship. More than that, Peale made the confraternity look entirely natural, as if the assembled men were pleased to be in each other's company. This, he thought, was the way that things ought to be in the new American republic.[42] "Persons," he announced, "however estranged by each other, by private piques by Religion or by Politicks, here meet, as by accident, and have a concordance of sentiment."[43] With attendance running at 11,000 in 1800 and 47,000 in 1816, Peale could believe he was making a difference.[44]

Displayed shoulder-to-shoulder, these men's portraits ringed the upper tiers of his gallery space like medallions of humble greatness. Peale's goal was and had always been impeccably republican—to remember the "Worthies of my Time" and to excite in the hearts of

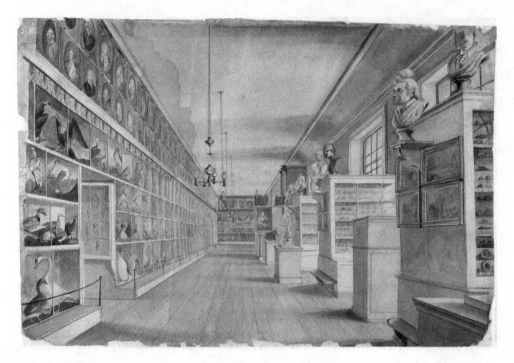

The Long Room, Interior of Peale's Museum, 1822. Peale's portraits line the top two tiers of the room.

Americans "an Emulation."[45] This was his version of the concept of public improvement. "By good and faithful paintings, the likeness of man is perhaps with the greatest precision handed down to posterity; and I think myself highly favored in having the opportunity . . . in forming a collection of portraits of many . . . who have been highly distinguished by their exertions, in the late glorious revolution."[46]

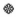

The post-Revolutionary world would not be kind to Peale. He was still in the forefront of public events in Philadelphia, as that was made evident by the parade he helped orchestrate for the ratification of the Constitution in 1788. Known as the Grand Federal Procession, it rolled through the streets of Philadelphia on July 4 with eighty-eight groups and organizations showing their support. At the head of the procession were civic and military leaders, accompanied by American and French flags and a framed replica of the Constitution inscribed with

the words "The People." Citizens came out in force for the eye-popping sights that followed, including the thirty-foot-long federal ship *Union*, complete with its crew and a panel of faux water painted by Peale, all mounted on a lorry and pulled by teams of horses.

Marching groups of pilots, boat-builders, sail-makers, ship carpenters, joiners, and rope-makers were followed by three hundred cordwainers who marched with their float on which they recreated an entire cordwaining shop. Floats represented every craft: coach-painters, cabinetmakers, brick-makers, porters, watchmakers, fringe-makers, wig-makers, whip-makers, bread-makers, victuallers, tobacconists, printers, bookmakers, and barber-surgeons, followed by 250 tailors and 150 coopers.

Peale's float, the crowning event, was named the Grand Federal Edifice, which spoke to the dawning of the new age. It was a three-dimensional version of the Temple of Liberty that had been part of the program of transparencies commemorating Washington's arrival in the city after Yorktown in 1781. As a confirmed federalist wanting to promote the Constitution, especially over the strenuous objections of anti-federalists, Peale made his message clear in a sculpture in which thirteen Corinthian columns stand tall and separate, but all support the crowning dome. Around the base he inscribed the words "In Union the Fabric Stands Firm." Peale's float—and the concept behind it, too—was so large and heavy that ten horses were needed to pull it through the streets of Philadelphia.[47]

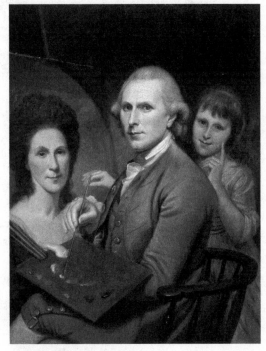

As much as the spectacles expressed his public persona, Peale's penetrating self-portrait of 1785 reveals some of his personal life. On the left, his wife Rachel comes to life as a portrait in progress. On the right, their daughter Angelica stands behind his shoulder and with her right hand

Charles Willson Peale, *Self Portrait with Rachel and Angelica*, ca. 1782–85

reaches around to guide his brush with her fingertips. At the same time, she stops to look out at us, charmingly tilts her head, and points with her left hand toward the heavens, as if to say that her father's talent was an act of Providence. His family was his center, but at the age of forty-four, Peale looks to be a more somber man than the eager militiaman visiting Washington's winter encampment at Valley Forge, happily plunged into the vortex of war.[48]

He had taken personal responsibility for his enfeebled mother and charitably invited needy relatives and friends into his house. His portrait business was declining, and the endless demands of an expanding museum collection were pulling him in a thousand different directions. The future he had once placed confidence in, was now a source of anxiety.

Whigs like Peale had honestly believed that political liberty, once achieved, would stimulate artistic greatness in America. As early as 1771 he wrote to Franklin optimistically that America would inherit the mantle of great art from a degraded Europe that was continually afflicted with "oppression and tyranny." He thought he could detect seeds of change when he reported to the Doctor that "The people here have a growing taste for the arts, and are becoming more and more fond of encouraging their progress amongst them."[49]

When political liberty was achieved, his Enlightenment dreams became lush. He believed a vastly expanded public for art, as well as a federal government clamoring to support patriotic projects, were surely forthcoming. An epoch to rival the Athenian golden age was at hand; after all, how could something as momentous as the Revolution not alter American culture in fundamental ways. His friend Philip Freneau's buoyant optimism in *A Poem, On the Rising Glory of America* mirrored his own: "Hither they wing their way, the last, the best/Of countries, where the arts shall rise and grow." All one needed to do was look ahead to be assured: "what a change is here!——what arts arise!/ What towns and capitals! how commerce waves/ Her gaudy flags, where silence reign'd before!"

Peale imagined for himself a central place in America's rising glory. Because he had committed to the new republic—as a militiaman, an office holder, a political propagandist, a commemorator of events and persons of importance, a director of a public museum containing the "Works of Infinite Wisdom," and the keeper of the Revolutionary flame—he thought he would be subsidized by the federal government

for his singular efforts. For all that he had done he wanted to be recognized as—and paid for being—the official chronicler of America, a republican version of a court artist, something like the position his mentor Benjamin West held in London.[50]

Those visions never materialized. America's cultural ascendancy did not suddenly debut, as Peale ruefully came to realize. Quite the opposite. The arts might eventually have their place, but extravagant visions of sudden apotheosis were misplaced and illusory. And Peale, instead of seeing his career spurred on to new heights, watched it falter. With the war over, he realized that the populist culture of the new American republic was his economic predicament, not his emerging opportunity.

His brother-in-law, Nathaniel Ramsay, confirmed his feeling that taste in the new republic was shifting away from the fine arts that had been the backbone of Peale's career and toward the kinds of curiosities Peale was displaying in the renamed Philadelphia Museum. "Doubtless," Ramsay said, "there are many men like myself who would prefer seeing such articles of curiosity than any paintings whatever."[51] Taste was flattening and Peale finally had to admit that in the new United States "the value of Portraits is only estimable [to] a small number of Individuals."[52] To be sure, Philadelphia's elite continued to purchase pictures, but men like Robert Morris and Francis Hopkinson could only buy so much art. In a revealing exchange of letters with his old friend John Beale Bordley, it was clear that "Portraits are scarce" and "dull of demand."[53]

Peale found himself marooned in a postwar world that was not living up to his cultural expectations. Confronted by the new reality, he had no choice other than to live by his own entrepreneurial wits, which he found tiring and risky. By 1786 he was pleading poverty to a local retailer when he politely asked for an advance of fifteen bushels of coal. From a grocer he requested credit so that he could do "tomorrow's marketing." The arts, he tried to explain to the grocer, "are languishing in our City, at least within the circle of my knowledge. And whether I can live here or not, in a short time will be determined . . . I hope you will befriend and excuse this call."[54] Peale reflected on his situation in a sad 1787 letter to William Pierce, a delegate to the Constitutional Convention. He first congratulated the Georgian on his success in life and then voiced his own lament: "In point of fortune you rank amongst the wealthy—Such ought to have been my condition with the opportunities I have had . . . My Exhibition Scheems have injured me much. I hope you will now pay me a part, if not [con]venient to you to pay off the

whole of what you are indebted to me, and believe me I never was in so great want of assistance as at present."[55]

Peale further expressed his diminished situation in confessional letters to Benjamin West. In one, written during the ratification of the Constitution, he reported that in the six years since peace had been declared his situation had become desperate: "My studies and labours for several years past has been incessant . . . but not always to much profit . . . I now find it necessary to travel to get business sufficient in the portrait line to maintain my family which is not small. I mention these things to shew you that the state of the Arts in America is not very favorable at present."[56] Conceding that his own career was contracting, he politely congratulated West, who was only three years older, for being paid handsomely for massive pictures that brought him all the income and critical adulation that Peale craved. "I now and then have the pleasure to hear that you are still raising in Reputation and constantly employed in the Historical line. That with honors you have Riches, which I hope will continue to you in a long life with every other happiness."[57]

Unlike West, who lived in the cultural capital of London and had an annual stipend from the King, Peale was compelled to navigate through the vagaries of the American marketplace without a financial lifeline. He had to resign himself to the fact that there was not going to be a tidal wave of art appreciation coming from the citizens of the new republic, nor were new sources of support to be forthcoming from the state and federal legislatures that he had strenuously supported. He understandably felt undervalued, underappreciated, and under-compensated for all his strenuous efforts over so many turbulent years.

Rachel died in May of 1790, the cost of her eleventh pregnancy. That left Peale a widower with seven children and forced him back into itinerancy along the Eastern Shore of his native Maryland in search of portrait commissions that could pay the bills. At one low point in 1790, he solicited Washington for a patronage job as Postmaster General, explaining "my business in the Portrait line in this City, is not sufficient support for my family."[58] Rejected in his bid, he had very few options other than to carry on and continue to hitch his career to the new republic, wherever it may lead him. Returning to London was technically a possibility, given his good relationship with West, but practically it was out of the question. He would have to abandon the museum that was infused with his personality, and he would need to leave behind an

extended family and his beloved city of Philadelphia. It was a frustrating time that culminated in his publicly announced retirement from commercial portrait painting in 1794, the stated but transparently false rationale being his desire to turn that job over to his children Rembrandt and Raphaelle, both unconventionally named for famous old masters.[59] He never did fully abandon portraiture, of course, as he continued to paint family members and subjects for his museum, but the artistic energies that had propelled Peale through the Revolutionary period were never to be ignited again.

As it turned out, Peale would never lack ideas: He founded the Columbianum, an academy for art and artists, and he vastly expanded his museum, which by 1799 contained 100 stuffed quadrupeds, 150 amphibians, and 700 birds, plus 1,000 minerals and fossils, plus thousands of insects, in addition to about 100 portraits.[60] Capping the collection were the bones of a prehistoric mastodon that he had excavated from a swampy field in New York State. In 1802 he reassembled and exhibited the skeleton in his new museum gallery on the second floor of the State House, above the room where the Continental Congress had endorsed the Declaration of Independence. Surely, he thought, the mastodon, like the document, would settle the long-simmering debate between Jefferson and the French naturalist the Comte de Buffon over which continent was superior, Europe or the Americas.

Peale married twice more, first in 1791 to Elizabeth DePeyster, a New Yorker of Dutch ancestry with whom he had six additional children, bringing the total to seventeen, of which eleven lived into adulthood. After she died in 1804, he married Hannah Moore, who helped raise the Peale brood. In 1810 he moved with Hannah to a 104-acre farm that he purchased in nearby Germantown. Named Belfield, it was the place where Peale would retire in order to research agricultural methods and cultivate crops with the same zeal with which he had pursued the portrait gallery and the museum. One of the first structures he added to the property was a gazebo that his son Franklin constructed for him. Hexagonal in shape, its domed roof was supported by six columns (the original plan was to have a symbolic set of thirteen), and at its summit Peale installed a bust of Washington.

At the end of one of the many walkways woven through Belfield, Peale built an obelisk, which was the place he hoped to be buried.[61] On the sides of the base he inscribed four aphorisms—the "sacred Laws," in Peale's words—that directed the moral course of his life. "Labour

while you are able. It will give health to the body, and peaceful content to the Mind!" reads one of them. Another admonishes to "Never return an injury. It is a noble triumph to overcome evil by good." But the one imperative most applicable to Peale and his service to the nation simply reads, "Neglect no duty."

After Hannah died in 1821 during a yellow fever epidemic that did not quite kill Peale, he moved in with his son Rubens in Philadelphia, wrote his autobiography, died in 1827 at the age of eighty-five, and was buried in St. Peter's Episcopal Churchyard. Looking back on his extraordinary life, it would be a mistake to think of Peale as a sophisticated political thinker or a purveyor of complex ideas. Instead, he was a painter and a patriot with radical political values, unwavering in his allegiance to America and the republican ideal, and that in itself made him unique. The Revolution had created, almost overnight, a history that was vividly marked by great events and heroic personalities that were etched into American consciousness, and Peale was the first artist to paint the beginnings of that epoch. He was the one who most recognized the historical magnitude of the time in which he lived. He was the one who believed that America was populated with a unique species of virtuous citizens. He thought that personal advancement ought to be subordinated to the common wealth, and felt that independence had set the stage for the emergence of an American golden age, for which Peale strove to be a useful participant.

The elderly artist never let the Revolution drift far from his mind or heart. On an additional obelisk—a "Pedestal of Memorable Events"— located at the termination of a garden walk at Belfield, he inscribed ninety historical dates in American history. In yet another part of the property there stood a side wall of a garden shed he could have left unadorned because it was not a key feature of the estate. But Peale painted it illusionistically to look like a gate, and on its upper panels he irresistibly included several figures and symbols representing all that he believed in. The fasces, indicative of the states of the Union, were wrapped by a rattlesnake that does not want to be disturbed. Nearby was an owl, representing "Wisdom," and a beehive indicative of "Industry," as well as adjacent symbols of "Temperance" and "Truth." But above all, standing on her own pedestal and carrying the scales of justice, was Peale's crowning figure, "America."[62]

4

Benjamin West's Peace

CHARLES WILLSON PEALE KNEW THAT BENJAMIN WEST, a native Pennsylvanian, had long been supportive of the Patriot cause, but he nonetheless must have been shocked at the end of the Revolution to hear that his ever-prudent mentor in London was planning to paint a grand suite of pictures on the subject of the war. Though West was American, he had spent more than a decade in the eminent post of court painter to King George III, who was both his friend and benefactor. During eight years of war West had deftly navigated through the controversies that naturally sprang up around his American identity, and in spite of his conspicuousness as Royal Portraitist and Historical Painter to the King he had successfully avoided public damage to his illustrious career. Given West's Patriot sympathies, emerging unscathed from the Revolution was a political high-wire act of the first order.

When the Provisional Treaty of Peace was signed in 1782, and the conflict was effectively over, West assumed he was liberated from the political and psychological pressures imposed by his position. Eager to do his part to commemorate his countrymen and the great events of the Revolution, he impulsively, perhaps recklessly, decided to put aside the obligations attached to royal patronage. Though Britain and its monarch were still reeling from defeat, West determined to paint a tribute to America's independence.

He wrote Peale of his "intention of composing a set of pictures containing the great events which have affected the revolution of America," and then asked his former student to send him detailed drawings or small paintings "of the costumes of the American Armys, portraits in small of the conspicuous charectors necessary to be introduced into such a work."[1] No longer interested in finessing his delicate position as a prominent American Patriot in London, he now wanted to produce pictures—and hundreds of prints—that would be "most expressive and most pointed." He was interested in every dimension of the Revolution, including "the cause of the Quarel, the commencement of it, the carrying it on, the Battles, alliances &c. &c. &c.—to form one work, to

be given in eligent engraving—call'd the American Revolution."[2] West was envisioning an all-embracing set of connected pictures, which he was eminently capable of painting, printing, marketing, and selling on a global scale.

But before Peale could get back to him with information on soldiers and battles, West decided to begin his history of the Revolution at the end of the story, with the hard-won peace recently brokered in Paris under the auspices of John Jay, John Adams, and Benjamin Franklin.

The treaty negotiations had begun during the fall of 1782 and the resulting document—the Provisional Treaty—was signed on Saturday, November 30, at the Grand Hotel Muscovite in Paris by the American plenipotentiaries and by Richard Oswald, a seventy-seven-year-old merchant who was the Commissioner of His Britannic Majesty. Also signing were Henry Laurens, a South Carolinian who arrived at the last minute; Franklin's grandson William Temple Franklin, who served as secretary to the Americans; and Caleb Whitefoord, a Scottish wine merchant who attended to Oswald. Others participated in the negotiations but were not signatories and therefore were not included in West's painting: Henry Strachey, an Undersecretary of State for the Home Department, came from London to rescue the inexperienced and over-matched Oswald; Alleyne FitzHerbert, the young diplomat in charge of British negotiations with the French, crossed over to the American-British table in the last month of negotiations; Matthew Ridley, representing his trading firm as well as the state of Maryland, became Jay's confidant; and Benjamin Vaughan, a political economist, was sent by Prime Minister Lord Shelburne to soothe relations with the cranky Americans and to help define the trade clauses in the treaty. One commissioner appointed by Congress never made it to Paris—Thomas Jefferson, whose wife, Martha, had died late that summer.

West worked on the picture over the second half of 1783, figuring out the arrangement of figures and taking portraits of the diplomats. He imagined that after completing this picture he would then work backward to the key battles of the Revolution and then finally to the disputes that had led to the war. But as it turned out, West's first picture would also be his last.[3] In 1784 he stopped work on the painting midstream, and for undeclared reasons he decided to abandon the entire project.

❧

Born in rural Springfield Township, Pennsylvania, in 1738, to a British Quaker father and an American Quaker mother, West had studied painting in Philadelphia with William Williams and John Wollaston, itinerant English artists meandering their way through the mid-Atlantic colonies. Thanks to the patronage of a few wealthy Philadelphia merchants, West acquired the resources to travel to Italy in 1760, where he studied antiquities and the old masters for three years before his arrival in London in 1763, which was perfectly timed to ensure a warm welcome. That year Britain won the epic Seven Years' War, fought internationally on the Continent, in India, and in America (where it was known as the French and Indian War), claiming upward of one million lives. When the war ended with the first Treaty of Paris in 1763, American heroics—including those, albeit controversial, of a young Virginia militia commander, Lieutenant Colonel George Washington—seemed to consolidate good relations across the Atlantic and bode well for West's immersion into the rich and heady English art world at a time when the nation was growing its empire.

British artists and critics quickly embraced the up-and-coming American who had come to London from the frontiers of Christendom. As one measure of his rapid ascent into the high echelons of the British art world, West was instrumental in founding the Royal Academy of Arts in 1768, and eventually was elected its President after the death of Sir Joshua Reynolds. His special talent as a painter was for epic historical subjects, such as *Agrippina Landing at Brundisium with the Ashes of Germanicus*, a masterpiece of family devotion and personal virtue set in first-century Rome. Painted in 1768 for the Archbishop of York, the picture attracted the admiring eyes of George III, who would lavish royal patronage—as well as a treasure in pounds sterling—on the American artist for half a century thereafter. Sensing his talent, the English made West one of their own.

In his heart, however, West was an American first and a Briton second, a concealed identity that the revolutionary crisis sorely tested. In order to successfully steer his way through the political minefield of London during the war, West had to scrupulously manage his words and actions to project the image of neutrality. But that façade cracked when the American Revolution ended. Three momentous events liberated him from the political closet: the Provisional Treaty of Peace that gave international legitimacy to the United States; the King's capitulation speech before the House of Lords on December 5, 1782; and the

ratification of the Provisional Treaty by the Continental Congress on April 14, 1783. By June of that year, in the warm aura of peace, West's first ideas for painting the Revolution began percolating in his mind.

But West was still a bought man. His royal salary of £1,000 continued to yoke him to the King, while a lucrative and nonstop stream of mammoth commissions contracted him to the royal court, members of Parliament, and the Anglican Church. Though he might be as free as any citizen to paint anything he wanted, if he strayed too far from the straight and narrow—if at the end of the war he painted American subjects that might further embarrass the already humiliated King—he would surely lose his high position and jeopardize his thriving career. After all, for more than a decade before his painting of the Provisional Treaty he had faithfully produced major paintings glorifying English history and heroes, starting with his debut picture of 1770, *The Death of General Wolfe*, showing the great British warrior expiring near Quebec at the end of the Seven Years' War.

That train of pictures continued on to giant portraits of Queen Charlotte, a stirring 1778 rendition of the Battle of La Hogue (1692) that concluded the Nine Years' War, a flattering 1779 portrayal of George III implausibly tossing aside his crown and ermine robe in order to take personal charge of a British military operation to protect the Channel from a French invasion, and a perfunctory but nonetheless huge *General Monck Receiving Charles II on the Beaches of Dover*, to name but a few monumental works. In return, his position at court gave him power, money, and opportunity. On his deathbed he could honestly describe the King as "the best friend I ever had in my life."[4]

Complicating West's status in London were the émigré American Loyalists, numbering around eight thousand. Seeing themselves as ultimate British patriots, deprived of their land and possessions in America, they publicly protested the King's patronage of West, whom they accused of being a closet Patriot, and thus inherently unreliable, disreputable, and disloyal. The Loyalist campaign against West in London was led by the formidable Joseph Galloway, an articulate and prominent American who for eight years was the powerful speaker of the Pennsylvania Assembly before he crossed the line in 1777 by joining the British army and leading his own militia raids against Patriot provisioners.

Emigrating to England with his daughter in 1778, the Maryland-born Galloway became a British zealot, acquiring power not only among the refugee Loyalists for whom he was their unofficial voice,

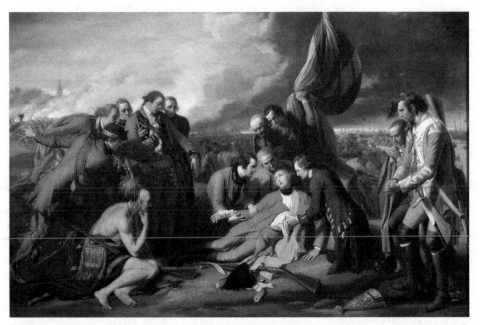

Benjamin West, *The Death of General Wolfe*, 1770

but also with British ministers and members of Parliament, including George Germain, the English Secretary of State for the American Department. Once described by John Adams as a "learned" man, but "cold" and with an air of "design and cunning," Galloway took it upon himself to troll British politics and culture looking for impurity.[5] He was brazen enough to denounce General William Howe, the mastermind of the British attack on New York who nonetheless failed to win back the colonies, and he was successful at convincing the King and ministry that they could recruit thousands of Loyalists in the American South to lead an uprising against the rebels. In fact, Adams thought the British ministry was being "wholly governed" by Galloway.[6]

Galloway also went after Benjamin West. He campaigned against the generous patronage the King annually bestowed on West, whom Galloway accused of harboring patriotic sentiments.[7] He also had a score to settle with West in the form of revenge for Peale's rough eviction of Galloway's wife from their elegant Philadelphia home in 1778. Had West not been the King's favored artist, he probably would not have been subjected to such withering scrutiny. But his status and intimacy with George III made him look treasonous to Galloway and the other American refugees.

The disruption of West's well-manicured neutrality intensified in 1780 when another one of his American students, twenty-four-year-old John Trumbull of Connecticut, was arrested in London for high treason. Trumbull, who had held the rank of Colonel in the Continental Army, had served in Boston as Washington's second aide-de-camp and as General Horatio Gates's deputy adjutant-general in the Northern Department, before he resigned in 1777 over a petty dispute concerning his officer's commission. He briefly returned to action in 1778, but then left the military for good and pursued a career as an artist. His inclination was toward historical subjects in art and literature—mostly classical and always heroic. With a high degree of ambition, Trumbull naturally gravitated to West, even though he acknowledged the tremendous risk a former American military man faced in traveling to London during the war.

Trumbull began study with West, but almost immediately after his arrival in London in July of 1780, Loyalists reported his presence to British authorities, including Secretary of State Germain. From then on, reported Trumbull, the Loyalists "carefully watched my conduct."[8] In short order, Trumbull was declared "a dangerous person, in the service of Dr. Franklin," then was arrested at midnight on November 19, charged with high treason, incarcerated at police headquarters on Bow Street, interrogated, and then remanded to prison with the possibility of execution.[9] One rumor had it that Trumbull was sending the French charts of the English coast and the garrisons stationed there.[10] Another suggested Trumbull was in possession of damning evidence implicating leading British Whigs—among them the Duke of Richmond and Lord Shelburne—in a plot to bring down the Tory government.[11] Yet another, which proved to be correct, accused him of arranging to have British goods shipped via France to the Continental Army.

News of his arrest traveled to West's home at 23 Newman Street in the form of a letter hand-delivered from the Brown Bear, a well-known public house near the Bow Street police office.[12] The alarmed West confronted two pressing issues, his student's protection and release, and an awkward dilemma that Trumbull, reflecting on the situation in his autobiography, quickly grasped: "The moment when Mr. West heard of my arrest, was one of extreme anxiety to him. His love for the land of his nativity was no secret, and he knew the American loyalists (at the head of whom was Joseph Galloway, once a member of Congress from Pennsylvania) were outraged at the kindness which the king had

long shewn to him, and still continued; he dreaded also the use which might be made to his disadvantage of the arrest for treason, of a young American who had been in a manner domesticated under his roof, and of whom he had spoken publicly and with approbation."[13]

West rushed to Buckingham House (now Palace) to control the damage. He requested an immediate audience with George III, which he received, a measure of his position at the court. He assured the King that Trumbull was devoted only to the study of art, not politics, which was a shabby half-truth. And then West tried to shield his own standing with George III, admitting to "his anxiety lest the affair of [Trumbull's] arrest might involve his own character."[14]

Echoing in West's mind must have been an event occurring only three months earlier, also in the company of the King. William, Lord Cathcart, who had fought against Washington at the Battle of Monmouth in 1778 and who had then become an advisor to George III, interrogated West "with the intention of ruining him in the esteem of the king."[15] In a raised voice meant to catch the King's attention, Cathcart asked: "West, have you heard the news [of the British victory at the Battle of Camden in South Carolina]?" "No, my lord; I left home so early that I have seen no one." Cathcart pressed, "I do not know, Mr. West, that the news will give you so much pleasure, as it does to his majesty's *loyal* subjects in general. His majesty's troops have gained a most decisive victory over a strong body of your rebel countrymen, at Camden, South Carolina." According to Trumbull, "West saw the trap which was laid for him in front of the King."[16]

Rattled by the examination, the usually politic West blurted out "I cannot say, my lord, that the calamities of my native country can ever give me pleasure." With tensions ratcheted up, it was left to George III, of all people, to rescue West by touching his shoulder and turning to Cathcart to say that "the man who does not love his native country, can never make a faithful subject of another, or a true friend."[17] The King, remarkably, was West's political cover that afternoon and also for the duration of the Revolution, a stance further infuriating and provoking Loyalists determined to unmask West as a Patriot.

Assured by George III that the Trumbull affair would not alter their relationship, and that Trumbull would be spared execution, though not necessarily a lengthy incarceration, West left the palace and gathered art supplies to deliver to Trumbull to keep him involved in his studies while he was in Tothill Fields Prison. He took books, pencils, and,

as an object of emulation, his copy of Correggio's *Madonna and Child with Saint Jerome*, an unwittingly appropriate choice for Trumbull that included a figure of the fourth-century theologian who lived an ascetic life in a hermit's cell.

Though West had been given assurances from the King that the legal proceedings would be addressed soon, Trumbull languished in prison and suspected that the "interest of the [Loyalist lobby] was more powerful [than West's appeals]."[18] In fact, all of West's considerable efforts to intercede with Secretary Germain failed. But after six months in jail, Trumbull was finally directed by his attorney to Edmund Burke, the influential Whig leader whom Trumbull deemed "a patriot."[19] Burke did not know Trumbull personally, but he was close friends with Reynolds, the President of the Royal Academy where West was a major figure. West had also made an engraving for the illustrated edition of Burke's *Account of the European Settlements in America*.

In helping Trumbull, Burke was acting on both moral principle and political calculation. Burke often spoke of the injustice and oppression Americans suffered under the British yoke, and in interceding on Trumbull's behalf he made a public show of his Whig position. After Burke's direct appeal to the King's Privy Council, Trumbull was discharged from jail in June of 1781, his £400 bail covered jointly by West and John Singleton Copley. He was still considered treasonous in the eyes of the court, but no further action would be taken against him if he left England immediately. He gathered his things and fled to Amsterdam and then back to America, chastened.

❈

In such an overheated environment, West had no choice but to tread softly around politics in the subjects he picked for his paintings during the Revolution. At best, all he could do was to refer to the war obliquely. For instance, the overt subject of his spectral *Saul and the Witch of Endor* comes from the first book of Samuel, in which King Saul of Israel turns to a medium from a Canaanite city to help him find a course of action against the threatening Philistines. Shrouded within a hoary aura worthy of Goya, the witch channels the dead prophet Samuel who predicts, through the ghostly medium, the immediate downfall of Saul, his sons, his entire army, and his kingdom. That was precisely what happened the next day.

In the Old Testament story—and perhaps indirectly in the New World context for West's picture—a bad king is rebuked and his ruin predicted. West had painted his terrifying séance in 1777, only months after Washington led his troops across the Delaware River to defeat British mercenaries at the two momentous battles of Trenton and Princeton. West never got up the courage to exhibit the painting in London, and it was only engraved after the Revolution by William Sharp, a radical republican.[20]

When John Galt wrote West's biography in 1816, he strenuously insisted that West was so "enchanted" by art alone that he could magically float above the "political cabals," "petty enmities of partizans," and the "factious intrigues of party leaders."[21] But that, in fact, was impossible. West's critics thought they merely needed to take the time to inspect his pictures closely in order to detect the British fraud they thought him to be. Disloyalty ought to be discernible. No matter how cautiously the exquisitely savvy West conducted himself at court, in the Royal Academy, or on his canvases, he was a marked man, always being accused of evasiveness, disguise, or impenetrability.[22]

In 1783, "Peter Pindar," the nom de plume of the satirist John Wolcot, mocked West's nationality in a tortured verse that imagined the artist,

> Sublimely towring midst th' Atlantic roar,
> I'll waft thy praises to thy native shore;
> Where *Liberty's* brave sons their Paeans sing,
> And ev'ry scoundrel convict is a *king*.[23]

Adding suggestively that in London West was "snug as thief within a mill," Pindar came back in 1786 to the subject of West's loyalty, anointing him "our *Yankey* painter," an insulting spelling meant to rhyme with *donkey*.[24]

Not only professional jokesters took shots at West. "Roger Shanhagen," a single pseudonym for multiple critics—the architect William Porden, the painter Robert Smirke, and the rhetorician Robert Watson—impugned West's loyalty in their review of the 1779 exhibition of the Royal Academy, where West displayed a picture of the British general Guy Carleton soliciting the Indians of Canada to take up arms. The picture, which no longer exists, was an episode from the siege of Montreal early in 1776, in which Carleton and his agents tried to persuade the Iroquois and Mohawk to break their pledge of neutrality in order

to fight against the American rebels. It was an odd subject. Though the siege resulted in a tactical British victory, there were lurid accusations that American prisoners had been turned over to the Indians and "barbarously murdered."[25] Any atrocities committed by the Indians would of course have been a breach of English etiquette, a deep embarrassment to the Crown, despite the victory.

"We cannot but remark it as somewhat singular," Shanhagen noted of West's choice of topic and his interpretation of it, "that this ingenious Artist, so much favoured by his Majesty, should choose a subject which leads to thoughts his Majesty would wish to have totally banished from his own and his people's minds, and which must surely give him pain to see exposed before them in every possible mode of opprobrium and disapprobation." Shanhagen went looking for trouble in West's picture. He believed, as did many others, that there were always hidden signs of West's true political allegiance: "We see, or we think we see, a contrast between the two groups of Englishmen and Americans, very unfavourable to the former. Imagination assists us so much in deciphering countenances and gestures, that, if those in this work were not exceedingly clear and determinate, we should imagine that it was rather our fancy than the Artist's intention to dishonor a group of Britons."[26]

Cutting even closer to the bone was John Hoppner, West's talented but razor-tongued colleague at the Royal Academy. Writing in the widely circulated *Morning Post, and Daily Advertiser*, Hoppner brazenly imagined the day when the court painter, "covered with gold and jewels" by the King, would be exposed and "reduced" to the posturing mannequin that he was.[27] Using words like "cunning," "artifice," and *"exhibited performances"* to assassinate West's character, Hoppner was calling out West as a British fake.[28]

Hoppner was not incorrect. West had made an art of publicly staying on his message of neutrality and nonpartisanship, but underneath the public image was ample evidence that West's American attachments were strong. Trumbull had spoken of West's "love for the land of his nativity."[29] In 1775, just before hostilities commenced in Concord, West wrote to Peale in Philadelphia that if he were to speak freely he "could dwell long" on the subject of "the right of taxing America." He could "stand forth and speak [his opinion] boldly," if he wanted to. But if he were to do so, it would be "at the risk of my all." Buffering his emotions, West admitted that "prudence and the times will not permit my saying any thing."[30] A man of Quaker heritage believing in accommodation, he

did not view war as a solution to political differences, but nevertheless he was in favor of defending American rights and liberties against the oppressive Tory administration of Prime Minister Lord North and his Secretary of State for the American Department, Germain.

In such an atmosphere, any plan to paint a comprehensive suite of pictures on the Revolution while it was still unfolding would have been, at the least, professionally risky, and possibly suicidal since it would have embroiled West in the partisan debates of the era, proven his critics correct, and compromised his relationship with the King. Indeed, American-inspired subjects taken up by any artist during the American Revolution were doomed from the start in Britain. The Irish artist James Barry, living in London, made a couple of prints on the repressive effects of the British government in 1776 and 1777, but he never continued the project, despite his deep republican sentiments.[31] The young Thomas Stothard designed a print of *The Declaration of Rights* in 1782, but he did not pursue future radical subjects.

But when Cornwallis surrendered at Yorktown in 1781, British politics went into a tailspin, as did all the heartfelt assumptions about certain victory and a joint future with America. Five days after the signing of the Provisional Treaty in Paris on November 30, 1782, West went to the opening session of the House of Lords with his fellow American painter John Singleton Copley and "some American ladies" in order to hear the King concede Britain's defeat.[32] Standing close to the throne, near Admiral Lord Richard Howe, who had once led the British invasion of New York, he waited two hours for George III to arrive. Elkanah Watson, an American businessman and, for a while, a courier between Franklin and the Congress in Philadelphia, described the clashing emotions within the crowd. "Glorious" and "thrilling," "triumph" and "exultation," were the words capturing the Patriot state of mind. "Dejected" defined the mood of the Loyalists in attendance, who now understood the treaty would offer them neither compensation for their losses nor any future back in America. Watson noticed "the anguish and despair depicted on the long visages of our American Tories." "Gloom" characterized the government's mood. And for everyone in the room there was a sense of anxiety.

When he started speaking, George III was clearly "embarrassed" to be announcing Britain's capitulation, so visibly "agitated" that he had to pause to gather himself before continuing.[33] What West and Copley saw was a king who "hesitated, choked, and executed the painful

duties of the occasion."[34] What they heard was extraordinary: the King forcing himself to declare America "free and independent states." But George III went on, saying things that would have been electrifying to West and Copley: "Religion—language—interest—affections, may, and I hope will yet prove a bond of permanent union between the two countries: to this end, neither attention nor disposition shall be wanting on my part."

Instead of hearing about retribution, West and Copley heard the sweet words of reconciliation. Watson "jostled" West and Copley, who were "enjoying the rich political repast of the day."[35] They may have felt, as did Watson, "every artery beat high, and swelled with my proud American blood." Seeing George III metaphorically "prostrate" in front of them, West and Copley could surmise that they did not have to worry about future sanctions that might be aimed against Americans in London.

A Thomas Colley political cartoon published in 1782 mocked the British urge to kiss and make up. It shows the imagined moment of postwar reunion in the form of a matronly Britannia embracing a Native American waving a flag and liberty cap on a pole. Having dropped a shield emblazoned with the words GEORGE FOR EVER, Britannia suggests

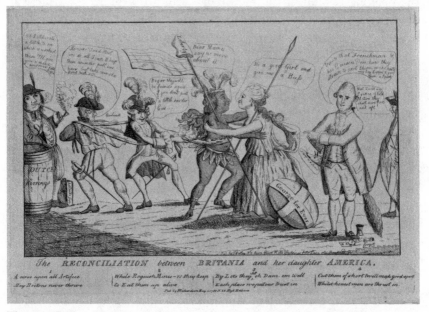

Thomas Colley, *The Reconciliation between Britania and Her Daughter America*, 1782

to her former colony, "Be a good Girl and give me a Buss," while America intones "Dear Mama, say no more about it."

Other seismic shifts led West to believe he was standing on new ground in 1783. The Loyalists in London were in a state of limbo, in terms of both their cultural identity and their political prospects, uncertain as to being deportable aliens, political refugees, or English citizens—in any event without an audience. The British press had already moved on to other war zones like Gibraltar, south India, Indonesia, and the West Indies, all of which underlined the British public's acceptance of the United States as an independent nation.[36] The war having ended, British merchants, along with the economist Adam Smith, were in "high spirits" over the resumption of trade with America.[37] If anything, Britons talked about "the happy Prospect of Preliminaries of Peace."[38] But mostly, the public just wanted to forget the previous eight years.

Major changes were also occurring in the government. The seemingly endless twelve-year Tory rule of Prime Minister North had been replaced in 1783 by a Whig government dominated by Charles Fox, a radical republican whom the King detested, and for good reason. Fox had supported the American Patriots, during the war accusing George III of being a tyrant unaccountable for his own actions or those of his government. Just to make the political point, Fox was in the habit of daily outfitting himself in a waistcoat and suit tailored to imitate the buff and blue fabrics Washington had personally designed for himself and his officers.[39]

The vindicated Whigs, meanwhile, were in the ascendant amid the political chaos. Satirist James Gillray captured the confusion and absurdity of the situation in a cartoon dated May 5, 1783, wittily titled *A BLOCK for the WIGS—or, the new State Whirligig*. Here, government leaders rotate on a merry-go-round, Fox in the lead holding a sack of money and scratching his bottom. Behind him are the demoted North and the skeletal Edmund Burke, dressed as a Jesuit (he was famously impecunious and had often been accused of being a closet Catholic) and engrossed in reading his own *Philosophical Enquiry into the Origin of Our Ideas of the Sublime and Beautiful*. Admiral Augustus Keppel, the hero of Gibraltar, pulls up the rear. They circle a post in the form of an eyeless bust of George III, a literal blockhead who can't see what's going on, but whose skull is the perfect mannequin for the wig hovering overhead. To the left, a tavern sign jokingly trumpets JOHN BULL, GOOD ENTERTAINMENT.

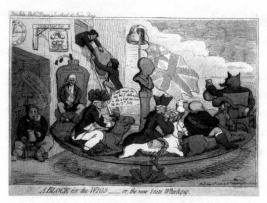

James Gillray, *A Block for the Wigs—or the New State Whirligig,* 1783

With British politics turned upside down, West saw an opportunity to entertain his vision of a suite of pictures on the theme of the American Revolution. That may have been a calculated decision, or it may have been an emotional reaction to the war's conclusion. But either way it was clear to West that the political landscape had shifted, leftward, thus leaving space for an American nationalist project. Even an artist as deliberate as West was in plotting his career moves would have been tempted in 1783 to show his American colors. He seems to have felt cocky enough to submit to the King a proposal for painting *Death on the Pale Horse* for the royal chapel at Windsor Castle. Taken from the Book of Revelations, it was an ironically prophetic choice of subjects. In his chalk sketch, West shows the last horseman of the apocalypse as a crowned king attended to by the demons of Hell as he unleashes divine retribution on mankind in a demented frenzy—the biblical past meeting the Georgian present.

West accurately surmised that a market was opening for new and compelling subjects. He had said to Peale that his plan was to execute pictures of the Revolution on speculation, with the idea that "this work I mean to do at my [own] expence, and to employ the first engravers in Europe to carry them into execution." In West's assessment of future profits he was "not having the least dout [that] all will be interested in seeing the event so portraid."[40] The audience for the prints in America was potentially enormous. In Britain the Revolution could have great appeal among vindicated Whigs. And a sovereign, republican America, triumphant over monarchy, would also have resonated in the Netherlands, where reformers used the example of America as a wedge against the sluggish government of William V, who wanted to limit forms of political representation and prolong the old hereditary system.

West might have also imagined a natural audience in France, not because the government of Louis XVI was about to remodel itself on

the example of the American republic, but because the two nations were indispensable to each other. In the Treaty of Alliance of 1778, America got French ships, troops, military men, and one million *livres*; the French gained the possibility of capturing Canada and the Caribbean. A tremendous market for portraits of Franklin already existed, and French artists were producing prints of the *Assemblée du Congres*, the *Journée de Lexington*, a *Précis de Cette Guerre*, and an allegorized version of the treaty, *Précis du Traité de Paix*, to name but a few images.

From Philadelphia, Peale could also see an expanding international market in 1783. He sent to London a version of his military portrait of Washington at Princeton that was purchased by the publisher Joseph Brown, who in turn had the English artist Thomas Stothard draw a variant that was engraved by Valentine Green and sold by the hundreds. Among Whigs, Washington was a consistently popular figure in England during and after the war and Peale, knowing that, had approached West in April about selling more paintings and prints of Washington in London and on the Continent.[41]

On December 10, 1783, Peale suggested to West some subjects to consider for his suite of paintings.[42] The first was a depiction of the secret meeting that took place early in the war between British admiral Richard Howe and three representatives from the Continental Congress: John Adams, Edward Rutledge, and Franklin. It took place on September 11, 1776, at the house of Christopher Billopp, a Loyalist, on Staten Island. Now commonly referred to as the Staten Island Peace Conference, it was a brief, tantalizing meeting that might have ended the war only two months after the Declaration of Independence.

Adams, Rutledge, and Franklin, arriving together from the Continental Congress in Philadelphia, were skeptical that anything meaningful could come from a meeting with the British, who held all the cards, with 32,000 troops massed nearby and 300 warships in New York Harbor. The Admiral's brother, General William Howe, already had taken western Long Island and would soon begin his assault on Manhattan, pushing General Washington out of the city. The three Americans nonetheless insisted that any negotiation—about blockades, taxes, pardons, or hostilities—had to be preceded by British recognition of American sovereignty; their claim was that the Declaration of Independence had changed the terms of the discussion. Howe's position, however, required that the Declaration of Independence be rescinded in order to proceed. The Americans held firm to the tenet of "independency," as Adams put

it, and the conference went nowhere. Four days later the British army and navy began their heavy bombardment and successful invasion of Manhattan.

It was an inspiring moment of defiance early in the war. But as a potential subject for a picture by West in London, it was an obscure topic. To be sure, the intransigence of the American negotiators, in the face of overwhelming British force, had the power to bring to life some of the most defiant lines from Joseph Addison's *Cato, a Tragedy*, a play so popular during the Revolution that Washington had it performed for his exhausted troops while they were camped at Valley Forge.[43] In it, the Roman republican firebrand stood ready to embrace death before accepting subjugation at the hands of the usurper and tyrant Julius Caesar.

Had West taken the peace conference as a subject, he might have had to cast Adams, Franklin, and Rutledge as American Catos walking into the teeth of the British military to defend their liberty (Adams talked about walking a gauntlet to get into the Billopp house). "A day, an hour of virtuous liberty/ Is worth a whole eternity in bondage," wrote Addison.[44] With no prospects of ever winning the war at that point, the Americans stood their ground. In the last lines of the play, Addison memorably wrote,

> The hand of fate is over us, and Heav'n
> Exacts severity from all our thought.
> It is not now a time to talk of aught
> But chains, or conquest; liberty, or death!

The peace conference may have had some potential as a subject for a painting, but it looked relatively arcane from West's perch in London. Peale's second suggestion to West was more compelling as a potential picture: the "taking of the Hessians at Trent Town," the pivotal battle of December 26, 1776, within a few hours of Washington's crossing of the Delaware River. The two subjects would complement each other.[45] Looking back from 1783, it was clear that the success of the Revolution had been half military and half civil, half action and half contemplation. In Peale's pairing of subjects, the intransigence—arguably the foolhardiness—that the three American negotiators had shown at the peace conference on Staten Island, in the face of the British war machine, turned out to have been prescient after the overwhelming victory in Trenton three months later.

In the end, West would paint neither of Peale's suggested topics, though in some respects West's treaty picture was a reimagining of the idea Peale had floated for painting the 1776 Staten Island Peace Conference—a picture on the subject of diplomacy rather than war. But where the peace conference might be perceived as an obscure and inconsequential event, the Provisional Treaty would be timely and momentous in both Britain and America.

West never came to paint the subjects that he had outlined to Peale in his original letter of June 1783: "The cause of the Quarel; the commencement of it, the carrying it on; the Battles; alliances, etc." For unstated reasons he only started the peace treaty picture, and that was neither a cause, a commencement, a carrying on, a battle, nor an alliance. He would never even make a sketch of the other revolutionary subjects, and he never explained why. But two things seem clear. Battle scenes pitting Americans against the British, or pictures of alliances with the French, were only going to arouse criticism at a time when everyone in London was exhausted from the war, wanting to forget, and eager to move ahead. The most acclaimed pictures at the annual exhibition of the Royal Academy after the war were either rosy images of English military success in the Caribbean and at Gibraltar, or subjects that had nothing at all to do with war.[46] The American theater of war was entirely absent.

Moreover, West decided to turn the project of producing a suite to be titled "The American Revolution" over to Trumbull, who began to "meditate seriously" on it when he returned to London in January of 1784, after a two-and-a-half-year banishment following his imprisonment. The war over, Trumbull could then breathe and paint freely in England. Furthermore, Trumbull knew he would not attempt a career in London, and thus never would have to worry about ruining it by painting scenes from the Revolution. By March of 1785, Trumbull announced to his father in Connecticut that he had found "the great object of my wishes" which was to "take up the History of Our Country, and paint the principal Events particularly of the late War."[47]

Turning the suite on the Revolution over to Trumbull had a lot to do with West's generosity and his faith in a young student. It was also a measure of West's renewed appreciation for the delicacy of his position as historical painter to George III. Whatever the upheavals that may have occurred in the political landscape, his career was still located in London and in the orbit of the royal court. Even if the ultimate goal of

his planned suite on the Revolution was to sell prints widely, in America and across Europe, he recognized the consequences if he should paint the brilliant American victory at Trenton, which would have generated a firestorm of popular hostility throughout England. We can only assume that after the first flush of patriotic enthusiasm, West came to his professional senses and directed his energy to a relatively neutral subject, the peace treaty.

It was unlikely that a picture depicting peace could be perceived by any party as politically charged or inflammatory. To be sure, in choosing a subject involving plenipotentiaries signing off on a peace accord, West had little artistic room for drama or heroics. But as much as it lacked drama, at least British, European, and American audiences could all find a picture about the end of hostilities to be inspiring, acceptable, or at least, inoffensive. Underscoring the new ethos in London, just about every newspaper in Britain that formerly had encouraged the war, now enthusiastically embraced peace with America after years of struggle.[48]

❧

All that is left of West's peace treaty project is the *American Commissioners*, a luscious but unfinished oil painting, three feet in width, showing five of the seven figures that West intended to paint. From left to right, organized around a green baize-covered table, the five are John Jay, John Adams, Benjamin Franklin, Henry Laurens, and William Temple Franklin. Open spaces remain where Richard Oswald and Caleb Whitefoord were meant to be painted. These were the men who signed the Provisional Treaty of November 30, 1782.

Franklin, seated in the middle, and Jay, standing on the far left, were the core members of the American negotiating team. Jay had arrived in Paris in June of 1782 with impeccable credentials. The conscientious and strong-minded lawyer had been the author of the New York state constitution, chief justice of the New York Supreme Court, president of the Continental Congress in 1779, and since then the Minister to Spain. At the peace negotiations of 1782 the completely uncharismatic Jay, "bred to the law," in the words of his British adversary Oswald, spoke a "determined style of language" and expressed complete "disapprobation of our [British] conduct at home and abroad."

The British team had good reason to fear Jay more than the others, so much that they had "little to expect from him in the way of

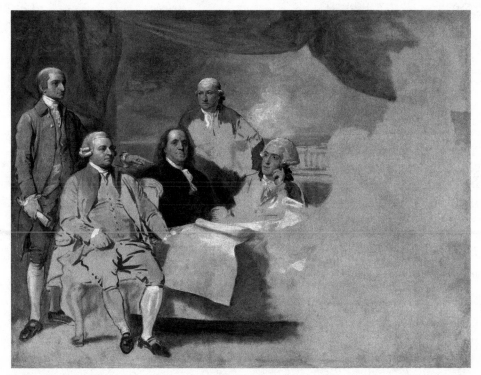

Benjamin West, *American Commissioners of the Preliminary Peace Negotiations with Great Britain*, 1783

indulgence." He was variously described at the conference as "obstinate" and "dogmatical."[49] In fact, Jay, whom West portrayed holding a rolled document like a club and standing remote, tall, and stiff, at the opposite position from his English counterparts, seethed with contempt; he was "as much alienated from any particular regard for England, as if he had never heard of it in his life."[50] Jay was the primary author of the Provisional Treaty, and over the course of five months of negotiations he was the most relentless defender of America's interests.

Jay was appropriately portrayed as a punishing character in a political cartoon of February 24, 1783, that mocked the Provisional Treaty. George III, tethered on a leash, is mindlessly being pulled under a gate along with his Prime Minister, Lord Shelburne, who holds a document signed "Preliminaries." A Spaniard and a Frenchman lead the parade. Behind the King and his minister is Jay, lean and ascetic, dragging along a reluctant Dutchman by a strap while whipping his former masters with a thirteen-branched switch inscribed with the word "America."

Elizabeth Dachery, *Blessed are the Peacemakers*, 1783

Seated in the middle of West's painting was Franklin, the face of America in Europe. To anyone looking at West's picture in the eighteenth century, Franklin would have mattered most in the visual array. He had served as Commissioner of Congress to the French Court since December of 1776 and had been the key figure in winning military and financial support from Louis XVI and Foreign Minister Charles Gravier, the Comte de Vergennes, for the American war against France's ancient rival. He negotiated the Treaty of Alliance of 1778, and in the spring of 1782 he single-handedly started the peace negotiations with Oswald, months before any of the other American plenipotentiaries arrived. If Jay was the unofficial "bad cop," then Franklin was the "good cop," always willing to engage any interested parties in conversation and able to charm them into his thinking. His friendships with the French and the British commissioners proved to be invaluable. But at seventy-six he was hampered by gout, kidney stones, and old age, yet more than anyone else he was thought to be the great eminence presiding over the negotiations.

Because of complexities in negotiating the commercial treaty he had just signed with the Dutch in The Hague, Adams, seated on the left, did

not arrive in Paris until the end of October 1782, at a moment when Jay's draft was already under consideration. Adams's style as a diplomat was litigious and lacking in politesse. His former legal associate, Jonathan Sewell, famously described Adams's diplomatic skills with mocking affection: "His abilities are, undoubtedly, quite equal to the mechanical parts of his business as an Ambassador; but this is not enough. He cant dance, drink, game, flatter, promise, dress, swear with the gentlemen, and small talk and flirt with the Ladys—in short, he has none of the essential *Arts* or *ornaments* which constitutes a Courtier."[51] David Hartley called Adams "the most ungracious man I ever saw," a cruel remark that Adams endorsed.[52]

Adams thought Franklin "malicious" and "cunning."[53] Upon his arrival in Paris, he disclosed to his diary the grim expectation that Franklin "will provoke, he will insinuate, he will intrigue, he will maneuver."[54] Their first, choleric experiences together in Paris, early in 1780, had soured Adams to Franklin, and two and a half years later, everything about Franklin rankled Adams: his grace, his morals, his language, his indirection, his flexibility, his creativity, and the inexplicable fascination of the French for "the Doctor." Though he is seated next to Franklin in West's painting, Adams reported that "I cannot bear to go near him."[55] But Adams found a way to work smoothly with Jay and much of the treaty bears the stamp of those two diplomats.

Laurens, standing in the middle behind Franklin, took a circuitous route to the treaty negotiations. On his way to The Hague in 1780 to serve as Minister to the Netherlands, he was intercepted by the British Navy off Newfoundland. He was taken to London, convicted of high treason, and consigned to the Tower. But Edmund Burke helped Laurens get paroled and Richard Oswald posted the whopping £2,000 bail for his old slave-trade partner, with the stipulation that Laurens remain in London until the end of the war, when he was freed on the last day of 1781.

The fifteen months in the Tower, however, had "shivered a fine Constitution & made me Suddenly an old man," he wrote several months after his release.[56] Laurens was afflicted with seizures, gout, migraines, and fever, and spent much of 1782 in Bath, taking the waters at the spa while he was recovering. He had little opportunity to engage with the peace process, but he did have enough patriotic nerve remaining to advertise in the London *Morning Herald* his offer to the English artist James Barry to paint for Congress "the actions of General Washington."[57] Laurens

was a prickly and belligerent personality. Arriving in Paris in the last days of the negotiations, he quickly embroiled Adams in a vicious argument over the character of Edmund Jenings, Adams's close advisor and Charles Willson Peale's patron, whom Laurens thought was a double agent. Telling Adams he was the dupe in a conspiracy, the agitated Laurens was mostly a distraction to the treaty process.

William Temple Franklin, seated to the right, was the twenty-one-year-old illegitimate son of Benjamin Franklin's illegitimate son, and was not everyone's choice to be the American's secretary. Adams wanted his own secretary, John Thaxer, and thought Temple Franklin was yet another element in Franklin's cunning.

Two empty slots on the far right were intended for the British signatories, Oswald and Whitefoord. Besides arranging Laurens's release from the Tower, Richard Oswald was intimately connected to the Americans by business. He was the grizzled partner with the South Carolinian Laurens in stocking and operating the largest slave-trade house in North America. A co-owner of Bunce Island, the brutal slave-trade prison on the Sierra Leone coast, Oswald and his partners expanded the old fort and built a shipyard to make boats that went deep inland in order to kidnap Africans who were then imprisoned on the island and shipped, hundreds at a load, to Charleston, where the firm of Austin and Laurens auctioned them off at their facility on the Ashley River, near Laurens's estate.[58] In turn, Laurens would ship Carolina rice to Oswald for wholesale trade in London. Both men became rich from the slave trade. Though Laurens had come to repudiate slavery by 1782, he did not manumit his slaves and in fact worked to get a slavery protection clause into the treaty that prevented "Negroes or other property" from leaving the United States.

Oswald was more of a deal-maker than a diplomat. He knew the British had no cards to play in the peace negotiations, and he understood the Americans knew this, too. Willingly entering himself into a diplomatic suicide mission requiring the surrendering of half of North America, Oswald did have two credentials: He had many business contacts in America and he was on friendly terms with Franklin, as well as Laurens. So admiring was Oswald of the Doctor that in the middle of the 1782 negotiations he ordered up two copies of the painter Joseph Siffred Duplessis's 1778 portrait of Franklin.[59]

Lord Shelburne, the Prime Minister, had decided to appoint the "hardworking and gentle" Oswald to the treaty table, and not some

tough diplomat, because America was already lost.[60] The crushing British defeat at Yorktown the previous autumn was so deflating that the negotiations no longer required a hardliner. Oswald was sympathetic to American demands, once declaring the British negotiators "always supposed we must satisfy the Americans in such manner as to have a chance of soothing them into neutrality."[61] To the Americans he "must have seemed like a pliant instrument sent from heaven rather than Whitehall."[62] In fact he was so amenable that Lord Shelburne was forced to send to Paris Undersecretary of State for the Home Department Henry Strachey to bolster Oswald.

The other empty slot in West's painting was to be occupied by Caleb Whitefoord, who served as Oswald's secretary. Whitefoord was Franklin's neighbor in London in the early 1770s and a patron of the arts well known in West's circle, having become the toffee-nosed target of a number of caricatures by satirist James Gillray and the lively subject of a Gilbert Stuart portrait of 1782, taken in the year of the treaty. Whitefoord acquired no less than three portraits of Franklin during 1782.[63]

In the treaty painting, West captured the complex personalities of the principal men.[64] The ever suspicious and mostly ineffectual Laurens, standing in the middle of the picture, looks uncertain and weary. The secretary of the legation, William Temple Franklin, once described by the envoy Arthur Lee as a "young insignificant boy," leans back to admire his grandfather, who was the only reason he had been appointed to the post.[65] Jay, tight, obdurate, and legalistic, stands ramrod straight, as if he had a steel rod implanted in his spine. Adams sits up front, not overlapped by anyone, on full view, unbuffered, without disguise, and seemingly satisfied with himself. Though Adams sits next to Franklin, his nemesis, Jay's intervening arm shields the two men from each other. Meanwhile Franklin, a true courtier known as the Sage of Passy, is the calm hub of it all. He hovers over the document, as if he had hatched it.

A circle of figures—Adams, Laurens, and Temple Franklin—rotate around Franklin, who is also the one looking directly outward from the picture. Jay aims his left hand in the direction of the documents on the table, but, just as pertinent, Jay is pointing his index finger directly at Franklin. Moreover, West painted Franklin in a dark suit and waistcoat. On the day of the signing, it was noted, Franklin in fact came wearing an unadorned black suit.[66] It had long been his signature style to dress down when he was in the position of diplomat in fashion-conscious France. Plainness was the masquerade helping him project an image in keeping

with his new republic's values and ideals. In the treaty picture West used that well-crafted black suit to good effect for the way it stands out against the warm colors worn by the other men: beige, buff, amber, and olive.

A few things can be said about the unfinished figures on the right side of the picture. The outline of the standing figure on the far right, meant to be Whitefoord, complements the standing figure of Jay on the far left. The outline of the seated figure, presumably intended for Oswald, is facing the opposite side of the table; he would have been leaning forward and meeting the eyes of Jay and Adams, who both look rightward. But Oswald would not have been meeting the eyes of Laurens, Franklin, or Temple Franklin, who look off in other directions. The ghost outline of Oswald seems to be holding—or presenting—a document with his left and right hands.

West positioned the entire group on a high perch overlooking Paris. Swags of drapery frame the unobstructed view down to what seems mostly to be an open plain on which stands an imposing classical building. The columns and pediment of a projecting porch suggest that it is one of the *hôtels particuliers* built during the reign of Louis XV. It might in fact be the facade of the Hôtel de Coislin, built in 1758 on the Place Louis XV (now the Place de la Concorde), and designed by Jacques-Ange Gabriel, *premier architecte* at Versailles. That would be appropriate, since the Coislin was the location for the signing of the 1778 Treaty of Alliance between France and the United States that brought the French military into the Revolutionary War.[67]

From his studio in London, West could assemble most of the pertinent details he needed for the picture. He could certainly have debriefed the commissioners, secretaries, and ancillary participants as they passed through or returned to London. He did not need a blow-by-blow account of the treaty's evolution from them, but only verbal sketches of the principal personalities and the signing itself. Like all historical reconstructors, West tried to take life portraits of the participants, or acquire visual sources that sufficiently informed him of a commissioner's likeness. It was a piece-by-piece process.

Laurens, because of his health, left Paris for England on January 11, 1783. He did not go back to France for the signing of the final Treaty of Paris on September 3, 1783, instead remaining in London and Bath until June 22, 1784, when he returned to the United States. West would have had easy access to Laurens, though it is not known exactly when he sat for the artist.[68]

Jay remained in Paris to continue negotiations on the definitive Treaty of Paris, but sailed for England almost immediately afterward, in October of 1783. He stayed in London more than a month, visiting with friends, attending an evening at the Club of Honest Whigs, and watched Sarah Siddons perform at the Drury Lane Theatre. He sat for a portrait by Gilbert Stuart that was not finished until years later by John Trumbull. He must also have sat for West, too, before his departure for Bath in late November; and he returned to Paris in February of 1784.

Adams also remained mostly in Paris through September of 1783. But a lingering illness motivated him to travel to London and Bath, arriving on October 24 with his sixteen-year-old son John Quincy. He stayed until January 5, 1784. He returned to London for a few months later in 1784, and in 1785 he was appointed American Minister to the Court of St. James's. Copley painted a monumental portrait of Adams late in 1783, and it is likely Adams sat for West at that time, too.

Adams came to deeply admire West during his brief stay in London in 1783. That became apparent when he asked West to make arrangements with the King for a visit to Buckingham House and Windsor Castle with Jay, John Quincy, and the Philadelphian William Bingham. The point of Adams's sightseeing trip was not to view English splendor or old master paintings, but to absorb "the great productions" of Benjamin West.

Granted access to every room in the palace, thanks to West's standing with the King, they were astonished by what they saw of their fellow American's work: the *Death of General Wolfe*, the *Death of Chevalier Bayard*, the *Death of Epaminondas*, the *Departure of Regulus from Rome*, the *Wife of Arminium Brought Captive to Germanicus*, the *Family of the King of Armenia before Cyrus*, West's portraits of Queen Charlotte, Princess Augusta, Princess Elizabeth, Prince Ernest, Prince Augustus, Prince Adolphus, Princess Mary, and, perhaps, recently completed pictures of the King's deceased son, Prince Octavius, and the *Apotheosis of Prince Octavius*. Still delirious with pride from the freshly signed Treaty of Paris, Adams admired West's pictures with nationalistic eyes, in spite of their British subject matter: "We gazed at the great original paintings of our immortal countryman, West, with more delight than on the very celebrated pieces of Vandyke [sic] and Reubens [sic]; and with admiration not less than that inspired by the cartoons of Raphael."[69]

Franklin never sat to West for the treaty picture. But because the two men had been close friends during the eleven years Franklin

lived in London as the colonial agent for Pennsylvania, West would have known how to portray him. Some evidence exists in a letter to Franklin from Thomas Pownall that West painted Franklin at that time: "p.s. I am this day made happy by having received and hung up an excellent Portrait of you My old friend—Copied from that which West did for You."[70] That picture is not known today. But such a portrait would have been fifteen years out of date in 1783. Because Franklin remained in Paris until his return to Philadelphia in 1785, West may have turned to another source, one of the 1782 portraits that Whitefoord had commissioned in Paris from one of West's students, Joseph Wright. Whitefoord also handed to West a plaster copy of Jean-Jacques Caffiéri's terra-cotta sculpture of Franklin from 1777, a gift from the Doctor to the artist in April of 1782.[71]

William Temple Franklin also initially stayed in Paris. Writing on behalf of West, Whitefoord approached Temple Franklin in an attempt to acquire a miniature to use as a basis for his inclusion in the treaty picture. But Temple Franklin himself arrived in London in 1784. He sat to Gilbert Stuart for a stunning portrait in which he holds a copy of the Treaty of Paris with the signatures of commissioners and secretaries.

West would have had no difficulty with Whitefoord's portrait, as he was a friend who could always be found in the galleries and drawing rooms of the city. The problem was Oswald. For unstated reasons he never made himself available to West. He may have decided not to be included in a picture that, truly, represented the greatest diplomatic triumph in American, not British, history. The Provisional Treaty was so unfavorable to Britain that it brought down the government of Lord Shelburne. Oswald knew he was assigned to Paris only because no respected British diplomat wanted to sign the treaty or be associated with such a monumental debacle. After his departure from Paris, Oswald avoided London and quickly retired to Auchincruive, his estate in Scotland, where he died on November 6, 1784.

The usual back-up plan for a painter in this situation would have been to use someone else's portrait of Oswald, but surprisingly one did not exist. John Quincy Adams, seeing West's picture again in 1817, said that "Mr. Oswald, the British Plenipotentiary, was an ugly-looking man, blind of one eye, and he died without leaving any picture of him extant. This Mr. West alleged as the cause which prevented him from finishing the picture many years ago." John Quincy added one more

intriguing note about the painting: "Mr. West said he thought he could finish it, and I must not be surprised if some day or other it should be received at Washington. I understand his intention to be to make a present of it to Congress."[72]

But that never happened. West certainly could have invented a face for Oswald in his picture. But anyone who knew Oswald would naturally object to West's inevitable inaccuracy. West may have anticipated that future criticism by designing his picture in such a way as to turn the Oswald figure diagonally away from us, minimizing the exposure of the face. And if he were truly intending to give the picture to Congress, there was no need to be precise in rendering Oswald's features.

By the time the futility of painting Oswald became obvious in 1784, West had acquired commissions for other projects that set his large studio abuzz. He had begun a gigantic, seventeen-foot *Alexander III of Scotland Rescued from the Fury of a Stag* and a touching *Meeting of Lear and Cordelia*. The King wanted West to decorate a new royal chapel at Windsor, encompassing as many as thirty-five pictures. In 1784 West was already at work on a nine-foot *Last Supper*, a ten-foot *Resurrection*, and a fourteen-foot *St. Peter's First Sermon*, all of which pushed the treaty picture to the background.

Driving the project to paint "The American Revolution" farther away was the return to London of John Trumbull, a now more mature person who could—and would—inherit the torch from West. Among the early ideas germinating in Trumbull's mind was a picture of the sequel to the Provisional Treaty, the definitive 1783 Treaty of Paris. He never got beyond an ink sketch for it, as well as painting miniatures of some of the participants, including Adams, Laurens, Jay, Temple Franklin, and George Hammond, the new British secretary.

❉

The picture of the treaty that West almost finished is, at heart, a variation on the informal group portrait, or conversation piece. True to the type, there is a highly calculated candidness in West's picture; sitters' eyes angle to the right, the left, and straight ahead, as if the artist had been unsuccessful in focusing their attention. Figures seem to be pulled toward different things, yet they are carefully grouped. In the center, a pyramid of figures—Franklin, Laurens, and Temple Franklin—anchors the design. The end figures, like parentheses, slope downward from the

right and left edges toward a fabric-covered table that acts like a pedestal for the central pyramid.

West's groundbreaking idea was to transform the traditional look of treaty pictures into an intimate group portrait. Historically, pictures depicting treaties of peace were painted with dozens of figures set into impressive palaces and ceremonial courts. One of the most significant of them is Gerard ter Borch's *The Swearing of the Oath of Ratification of the Treaty of Münster* of 1648. Ending Holland's eighty-year struggle with Spain, it shows seventy-seven men, crowded cheek-by-jowl around a table in the grand Ratskammer of Westphalia. Protocol might have dictated the presence of all seventy-seven but the resulting assembly of lined-up faces ends up looking perfunctory. Even West's own *William Penn's Treaty with the Indians* of 1771 contained more than thirty figures.[73]

By contrast, West has pared his 1783 picture down to the barest minimum of the seven signers and no one else. Whereas other treaty painters typically picked—or invented—the grand, dramatic moment (ter Borch's ambassadors stand together in front of a throng and swear to uphold the treaty), West seems to be quietly slipping us into that room in the Grand Hotel Muscovite, on that afternoon in

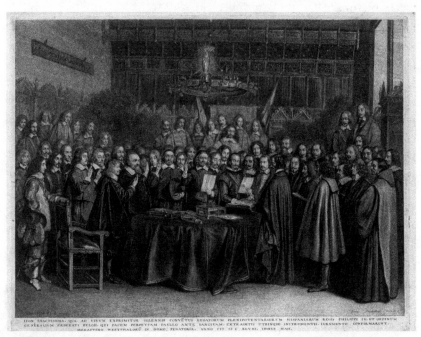

Jonas Suyderhoef, after Gerard ter Borch, *The Swearing of the Oath of Ratification of the Treaty of Münster*, 1648

late November, as the seven signatories display their freshly minted document on the table.

West thus painted something like a quiet family portrait. If we want, we can reconstruct all the personal antagonisms, secret plots, and backroom intricacies cluttering the road to the treaty. Adams described negotiations "between angry nations and more angry factions." He spoke of "the Fury of Ennemies . . . the Subtilty of and Arrogance of Allies, and, what has been worse than all, the Jealousy, Envy, and little Pranks of Friends and CoPatriots."[74] But West painted none of that. Nor was he interested in any of the excesses and grandiosities seen in traditional pictures of peace in which men make pledges, sign papers, or announce their genius.

Instead, he imagined his image of the 1782 peace treaty to be a variation on his own portrait of the West family, including Benjamin himself, standing on the far right observing his wife Elizabeth cradle their newborn son, Benjamin Jr. Solemn and serene, the picture looks like a modern version of the three kings attending the birth of Christ.[75] In a similar vein, West's *American Commissioners* looks like a secular nativity in which the documents that created the sovereign United States

Benjamin West, *The Artist and His Family*, 1772

unscroll in front of Franklin, while the other treaty commissioners act as interested witnesses who quietly attend to the christening of something sacred.

All along, the central metaphor of the British-American relationship—and its rupture during the Revolution—had been the family. Just about every writer in the period framed the bond between the two as a version of family love, the kind of asymmetrical love existing between a husband and a dependent wife, or a father and a young child, the kind of love described as "enlightened paternalism."[76] When the New York lawyer William Livingston wrote about the ideal relationship between a subject and a king in 1752, he used the phrases "Affection of the People" and the "Love of his People."[77] That analogy was still true at the outset of the Revolution when Burke, in an address before the House of Commons, spoke on the family ties that continued to bind America and England: "My hold of the Colonies is in the close affection which grows from common names, from kindred blood, from similar privileges, and equal protection. These are ties, which, though light as air, are as strong as links of iron."[78]

During the war, however, that already potent metaphor could be extended in negative directions. Then, the "family" was frayed, estranged, quarrelsome, unbalanced, squabbling, and in turmoil. The father, embodied by George III, no longer seemed benevolent or deserving of obedience—in the words of Tom Paine, no longer deserving to be thought of as "FATHER OF HIS PEOPLE" because he actually was the "Royal Brute," really no more than a "wretch."[79] Samuel Adams, when talking about the relationship, was fond of using words that might apply to a dysfunctional family today: adjectives such as obedient, abusive, unjust, debauched; nouns such as surrender and servitude; and the verb pervert. Angry children were being worn down by harsh treatment and were now developing their own divergent values. And the "mother country," instead of offering protection, was punishing its offspring by extracting tribute wantonly. "Have not children," asked John Adams, "a right to complain when their parents are attempting to break their limbs, to administer poison, or to sell them to enemies for slaves?"[80] It was no surprise that by 1778 Americans started calling Washington "Father of his country."[81]

Political caricaturists of the period liked to use the broken family as a metaphor for the Revolutionary War. In one popular print appropriately titled "Poor Old England Endeavoring to Reclaim His Wicked American Children," a wizened old peg-leg holds a switch with one

hand while the other tugs on reins attached to five American hooligans who show him no respect. They jeer him; they pump out pellets through air guns; and one insolently moons him.

In another print, Britain, personified by a mature lady, slugs it out with America, personified by a seminude Indian maiden. The older lady grimaces as she threatens, "I'll force you to Obedience you Rebellious Slut." The defiant young maid counters, "Liberty Liberty for ever Mother while I exist." Even more astounding was a cartoon appearing in *The Rambler's Magazine* a few weeks after the Provisional Treaty was signed. In it, Martha Washington, sporting a cocked hat and sword, grabs the hair of a forlorn Britannia and beats her with a thirteen-stranded whip. Mrs. Washington barks, "Parents Should not behave like Tyrants to their Children," while Britannia laments, "It is thus my Children treat me."

Matthew Darly, *Poor Old England endeavoring to reclaim his wicked American children,* 1777

West had been in the habit of expressing family affections and disaffections in many of his biblical and classical subjects. Cordelia comforts Lear. Tobias cures his father's blindness. The Prodigal Son seeks redemption at his father's feet. Often, there are powerful kings abusing their power. In a scene from Arthur

The Female Combatants, or Who Shall, 1776

Murphy's 1772 tragedy *The Grecian Daughter,* West painted young Euphrasia protecting her aged father Evander from the knife-wielding

tyrant who has usurped his throne. In another painting, *Aegisthus Discovering the Body of Clytemnestra*, which was exhibited at the Royal Academy in 1780 during the devastating American defeat at Charleston, West used the gruesome family tragedy of Sophocles' *Electra* in order to raise a set of moral questions that could also be asked of the deteriorated relationship between America and Britain.

During the Trojan War, Aegisthus had begun an affair with Agamemnon's wife, Clytemnestra, and she in turn had murdered Agamemnon, allowing Aegisthus to take the throne. In revenge for such unspeakable evil, two of her children, Electra and Orestes, slay Clytemnestra and leave the body for Aegisthus to discover. Orestes then takes it upon himself to slay Aegisthus. Though West was not proposing any answers one way or the other, the questions raised were timely: What are the moral limits of rule? When are bonds of family affection annulled? What is the true nature of loyalty? When is the murder of a parent justified?

The classical family scenes most pertinent to West's original project to paint the American Revolution were Roman tales from the life of Agrippina, the granddaughter of Augustus and the wife of the general and statesman Germanicus. She was so compelling a subject that West devoted two of his greatest pictures to her: *Agrippina Landing at Brundisium with the Ashes of Germanicus* of 1766 and *Agrippina and her Children Mourning over the Ashes of Germanicus* of 1773. At the end of the Revolution, West planned a third picture. During a turbulent military operation in Ubiens, near modern Cologne, a rebellion in the Roman legions had forced Germanicus to order the pregnant Agrippina to flee camp with their children. But the pathetic scene so moved the troops that they gave up their revolt and begged her to stay. In an ink and oil sketch, West showed the moment when the Roman soldiers invoke the heavens, lay down their shields, beseech forgiveness, and do everything possible to persuade Agrippina that there is no longer any reason to divide the family.[82]

This drawing, of a family being wrenched apart amid a rebellion, was the one West gave to Charles Willson Peale in exchange for the war artifacts he wanted to acquire for his projected pictures on the American Revolution.[83] In the logic of exchange between the two artists, one image of a classical family drama equaled one package of Revolutionary remains. If the American Revolution was, to West and many others, a domestic drama with all the tortured elements of estrangement, hostility, loss, and mourning, then the peace treaties

of 1782 and 1783 were the gateway to tranquility, respect, harmony, amity, and reunion.[84]

The moderately minded West, who believed in American rights but never wanted war, made his treaty painting into a portrait of a family reconciled, with Christian overtones—two sides of the same clan brought back together under new terms of mutual adult friendship. In place of the recurring stories of fathers and their dependent wives and children, or of Sophocles' tale of family revenge, or of Agrippina's family threatened by the vicissitudes of conflict, West's postwar picture of peace is an ideal vision of consensus and conciliation, a civil union of equals sharing the same stage.

In West's visualization of the peace process, the American and British commissioners quietly sit and stand around a shared table, witnessing the same birth. They are not arguing over the nine articles of the Provisional Treaty, or signing the document, or shaking hands, or swearing to uphold the tenets of the treaty. Instead, they cohere as cordial figures at a family reunion that fulfills the promise of friendship in Article 7 of the Provisional Treaty: "There shall be a firm & perpetual Peace between his Britannic Majesty & the said States, and between the subjects of the One and the Citizens of the other."

West has placed Franklin, Adams, Jay, and company on an airy balcony, diplomatically banqueting together. It was not the actual site of the treaty on the Rue des Petits-Augustins, about which West would have known nothing. Instead, it is a chamber of the imagination that seems to have lifted off from the shrinking *palais* below them, leaving the pedestrian world behind. On an impossibly high balcony floating above the city of Paris, they are like those daring lighter-than-air passengers who climbed aboard the brothers Montgolfier's decorative hot-air balloon in 1783, hovering slightly above the ordinary and seeing the world from unexpected angles.

It is tantalizing to imagine what the unfinished treaty painting could have been had West pressed ahead. If he had completed it he might have made and sold engravings for the market. He might have also tried to paint a larger version for public exhibition. Or he could have converted the subject of the painting from the Provisional Treaty of 1782 to the definitive Treaty of Paris of 1783. The two treaties were nearly identical,

and the cast of characters was only slightly different. Jay, Franklin, and Adams—the principle American actors—remained in Paris through the summer of 1783 and signed the final document on September 3. West could have retained those figures as well as Temple Franklin, just as they were in the unfinished painting. The figure of Laurens could have been scraped off. For Oswald's intended slot, West could easily have substituted the new plenipotentiary, David Hartley, a friend of Franklin and a Member of Parliament, whose *Letters on the American War* (1778–79) had proposed reconciliation between America and Britain. Once described by Adams as "talkative and disputatious," Hartley would have added an interesting new character to the group portrait.[85] And for the position intended for Caleb Whitefoord, West could have painted in twenty-year-old George Hammond, the new British secretary.

But after the war, West still was—and he knew it—a court painter, a modern artist who was a throwback to his court ancestors: Charles Le Brun, Diego Velázquez, Giulio Romano, and Raphael. He may not have needed permission to operate outside the court, as Andrea Mantegna did when he painted for the Gonzaga family in Mantua during the late sixteenth century, but West's annual salary and colossal royal commissions did, ultimately, cement him firmly to the King and his court. Though the peace settlement might have been considered a benign subject to most, it was a point of humiliation to George III. If West had completed the picture and gone on to market engravings of it worldwide, he would have exposed the King by broadcasting a national disaster. Peace had awakened West's enthusiasm for American independence. But after the initial flush of delirium faded, it was inevitable that he would reawaken to the hard truth of his position as a courtier.

The only realistic way West could have painted the entire project unencumbered would have been to return to America. There, he could have operated freely and been guaranteed an enormous audience. But in London, with the war lurching into British memory, all the drive West had put into imagining "The American Revolution" as a comprehensive suite of pictures dissipated. Nonetheless, West had taken a momentous step in defining the Revolution as the most compelling project an American artist could possibly undertake. And by 1785, only two years later, his protégé, John Trumbull, would discover the full potential of the Revolution and begin to act on it decisively.

5

John Singleton Copley's Patriots

BENJAMIN WEST AND JOHN SINGLETON COPLEY WALKED
out of the House of Lords on December 5, 1782, a Thursday afternoon,
quietly intoxicated by George III's declaration that the seven-year war
with America was truly over and that the former colonies were thence-
forth to be regarded as "free and independent States." West went his
own way. Copley left with the young American merchant Elkanah Wat-
son, and together they went back to his studio on 12 Leicester Square,
a residential district north of Parliament, a few yards from Sir Joshua
Reynolds's home and cattycorner from the Holophusikon, a giant natu-
ral history and ethnographic curiosity museum.[1]

Watson's patriotism was conspicuous that day. Hailing from a fam-
ily of "zealous and active Whigs," he had spent the Revolution ferrying
money and "despatches of the utmost importance," as he phrased it,
between the Continental Congress and Benjamin Franklin, who was
minister to France.[2] Using six transatlantic merchant ships loaded with
Virginia tobacco, Watson had the unique ability to slip by the British
warships patrolling the American coast. Then toward the end of the
war, when peace negotiations were finally under way in Paris in 1782, he
started delivering diplomatic communiqués from the American pleni-
potentiaries to the British government of Prime Minister Lord Shel-
burne. The London newspapers dubbed him the "messenger of peace."[3]

The ever-entrepreneurial Watson also used his time in London to take
commercial advantage of the impending settlement of the war. Knowing
that any treaty with Britain would repair the Anglo-American trade that
had come to a halt during the Revolution, he toured the English country-
side looking for speculative business opportunities for his merchant firm.
While passing through London in the summer of 1782, he encountered
Boston-born Copley for the first time, dined at his house, and then hired
him to paint "a splendid portrait of myself" for one hundred guineas. For
that much money Watson got in return an impressive picture, five feet
high, a truly mammoth scale for a twenty-four-year-old, and entirely
indicative of Watson's enlarged sense of himself at that time.

If we take his memoirs to be accurate, Watson had a hand in devising his own image in the expensive picture. In a lengthy passage in which he talked about his experience in Copley's studio, Watson made a point of describing how he coauthored some of the details, in particular how "Copley and myself designed to represent a ship" in the left background.[4] That ship, a brig fully rigged and pitching to starboard as it vigorously sails toward a radiant sun on the horizon, was the perfect emblem for a young merchant reveling in the success of his business. Copley had no problem with that suggestion, but Watson got into an argument with Copley over the flag to be attached to the gaff of the brig. It might logically have been the house flag of his firm, Watson and Cassoul, or perhaps a French merchant flag, or there could have been no flag at all. But the patriotic Watson insisted on "our glorious *stripes*" that "shine with the luster of a rainbow after a thunder-storm."[5] He thought the brig in his picture was not just a commentary on his own commercial triumph, but also a loud pronouncement on the American diplomatic triumph of 1782. To Watson, the ship is "bearing to America the intelligence of the acknowledgement of Independence, with a sun just rising upon the stripes of the union."[6]

The ever-cautious Copley, who had tried to appear nonpartisan to Britons ever since his arrival in London in 1774, balked at Watson's suggestion, fearing there would be professional repercussions if he started splashing American flags across his paintings. As Watson put it, "All was complete [in the picture] save the flag, which Copley did not esteem prudent to hoist under present circumstances, as his gallery is a constant resort of the royal family and the nobility." But the King's concession speech on the fifth of December, "receiving and recognizing the United States of America into the rank of nations," was enough to persuade Copley to be less strategic and more unconstrained, for once. Just before dinner with Watson, the King's speech still echoing, Copley "invited me into his studio and there with a bold hand, master's touch, and I believe an American heart, attached to the ship the *stars and stripes*."[7]

"I believe an American heart." Even Watson had trouble seeing through Copley's political masquerade. When he was the leading painter in Boston before the Revolution, at a time when the social and political fabric of the city was rapidly deteriorating and the population

was increasingly balkanized into Tory and Whig camps, Copley's politics were calculatingly obscure. Ever since the Stamp Act of 1765 and the Townshend Acts of 1767, which both led to nonimportation protests, harassment of Tory merchants, attacks on British officials, and finally the Boston Massacre of March 5, 1770, Copley had made it a policy to keep his head down, his politics quiet, and his career on track.

That became a high-wire act when he married Susanna Clarke in 1769. Known affectionately as Sukey, she was the daughter of Richard Clarke, a Tory who was the Massachusetts consignee for the British East India Company, the colossus of English commodities trade that shipped a half million pounds of tea to America in 1773. Tea was a taxable item and thus an icon of British economic control of the colonies. Particularly inflammatory to Bostonians was Clarke's direct access to East India tea, a right allowing him to undersell other colonial merchants who had to pay taxes and middlemen.

In November of 1773, broadsides were posted that called the tea consignees "odious Miscreants and detestable Tools to Ministry and Governor; . . . those traitors to their Country, Butchers, who have done, and are doing every Thing to Murder and destroy all that shall stand in the Way of their private Interest."[8] A mob, infuriated by the East India Company's tea monopoly and tax exemptions, stormed Clarke's warehouse on King Street, demanding that he resign as consignee. Clarke refused and locked the doors, but the mob broke in and laid siege. After a scuffle Clarke escaped. But a few days later, another crowd confronted Clarke at his home on School Street, smashed the windows, and demanded the tea be returned to England. When the first of Clarke's transatlantic ships, the *Dartmouth*, arrived in port late in November, Samuel Adams held a series of mass meetings to consider what actions should be taken on the subjects of tea, tax, and consignees like Clarke.

In a state of panic, Copley scrambled to protect his Tory in-laws. Putting aside his well-cultivated neutrality, he conspicuously spoke up in front of Adams and the crowd, reporting back to his father-in-law, "I made use of every argument my thoughts could suggest to draw the people from the unfavourable oppinion of [the Clarkes]."[9] He claimed the Clarkes were not in collusion with the royal governor and would have gone to the meetings themselves, were it not that "the People had drawn the precise Line of Conduct that would sattisfy them."[10] Short of renouncing the King and abandoning the tea trade entirely, there was really nothing the Clarkes could do. After his address, Copley imagined

he had successfully mollified the crowd and the worst was past. But on December 16, eight thousand Bostonians listened to the exhortations of Adams at South Church, and afterward a group of about a hundred, including Paul Revere, whooped like Mohawk warriors and brandished weapons as they boarded the tea ships and dumped all 342 casks of Richard Clarke's tea into the harbor.

The Boston Tea Party traumatized the Copley and Clarke families. In an atmosphere of fear and uncertainty, the city became hostile territory for them. Soon, British warships began filling the harbor and former crafts groups, like Revere's Mechanicks, were converted into organized resistance movements. Like it or not, Copley was intimately linked with the Loyalist Clarkes, even though his own position on revolutionary matters was hard to identify. In many ways he was sympathetic to the voices of rebellion. He attended a Sons of Liberty meeting in Dorchester in August of 1769, privately lamented British taxation and military rule, and painted portraits of Revere, John Hancock, and Samuel Adams, three of the most radical revolutionaries of the era. In the 1772 portrait of Adams, Copley depicted the firebrand angrily pointing with one hand to the charter of independence issued to Massachusetts in 1691 by King William and Queen Mary (and revoked by George III

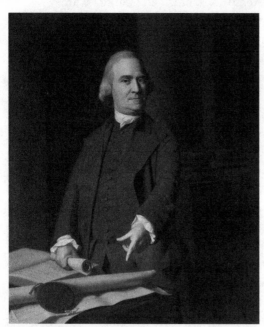

in 1763), and with the other hand grasping a 1764 petition from aggrieved fellow citizens who protested the new taxes imposed by Parliament.[11]

While Copley most likely painted Adams on commission from Hancock, and thus according to the demands of both radical sitter and radical patron, Copley nonetheless allowed some of the portrait's massive political weight to hang on himself. The image is electrifying, urgent, and defiant, and everyone knew that Copley had painted it and been paid for it. After Revere made an unauthorized political print of the painting in 1774 with

John Singleton Copley, *Samuel Adams*, 1772

Adams's head surrounded by allegorical figures, and then distributed it in a Patriot magazine, it no longer represented just Adams at the forefront of revolutionary politics, it was Copley's image of Adams widely broadcast as propaganda.[12] And to make matters worse for the nonaligned Copley, Revere flanked Copley's Adams on the left with a figure of Liberty holding a staff with a liberty cap on top while stomping on a book of "Laws to Enslave America."

All Copley needed to freeze up at Elkanah Watson's suggestion that an American flag wave from the ship in his picture was to recall the vortex of politics that had engulfed him in Boston. Pictures and patrons were never neutral in wartime, but Copley had tried to appeal to all sides in the pre-Revolutionary storm. During his American career, he could attribute a substantial portion of his large annual income of three hundred guineas to portrait commissions from prominent Whig and radical Whig sitters, such as Sarah and Thomas Mifflin, Jeremiah Lee, Moses Gill, Mercy Otis Warren, Samuel Adams, Hancock, and Revere.

But a larger portion came from Tories. Copley painted Isaac Winslow before revolutionaries burned his Roxbury mansion to the ground in 1775; he and his wife took Copley's portrait and escaped to Halifax with the retreating British army. William Vassell abandoned his portrait by Copley when he fled Boston for London in 1775. Miles Sherbrook had Copley paint his portrait, but he was imprisoned as a British sympathizer during the war. A few years after his portrait was painted by Copley, Samuel Quincy was banished from Boston for having "joined the enemy." And Ezekiel Goldthwait, who converted from Whig to Tory and was as a result described by John Adams as a "dunghill Cock," took his and his wife's portraits with them when they fled their North End house.

Copley was playing with fire when he portrayed British officers and officials. In 1768 he painted Lieutenant General Thomas Gage, commander in chief of British forces in North America during the American rebellion against the Townshend Acts. Perhaps Copley thought he was being politically circumspect by representing Gage as a calm professional, even though he is in full British military regalia and standing on a military field as he points to the mounted dragoons and armed battalions of British infantry in the background.[13] But with British warships starting to fill Boston Harbor, the very image of Gage would have been perceived as partisan, however neutrally Copley might have wanted to portray him. The fact that Copley agreed to paint him, take

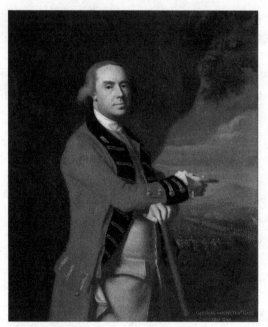

John Singleton Copley, *Lieutenant General Thomas Gage*, ca. 1768

his money, and represent him in a dignified manner that reinforced his authority in America constituted a political statement.

Politics haunted the apolitical Copley. In 1769, during the military occupation of Boston, radical activists cut the heart area out of Copley's seemingly banal portrait of Governor Francis Bernard, which was hanging in the dining room of Harvard Hall in Cambridge.[14] Five years later, after the Tea Party debacle, a band of Patriots banged on the front door of his house on Beacon Hill, demanding he tell them the whereabouts of Colonel George Watson, who was a friend and former subject, but who was a "Rogue and Villin" to the intruders.[15] Copley said the men warned him that if he did not comply, "my blood would be on my own head." "What a spirit!" the shaken Copley wrote to the Clarke family, who had taken refuge on an island in Boston Harbor; "I must either have given up a friend to the insult of a Mob; or had my house pulled down and perhaps my family murthered." Such was the logic of radical politics in Boston.

Copley must have been astonished by the attack on his picture and the threats to his life, for his aim always was to keep his images and friendships scrupulously clear of partisan political taint. He never spoke sanctimoniously about revolt nor did he defend English rule. Believing caution was the only safe path forward, he also tried to steer his young half- brother, Henry Pelham, away from Loyalist politics. But refusing to listen to his older brother, Pelham remained avid in his affection for the Crown and considered the English "great Benefactors" who had showered "Justice and Gennerosity" on America and, until the outbreak of hostilities, brought the "blessings of Peace."[16] Copley strenuously ordered him to never take up arms, and to stop his Tory rhetoric; "be neuter at all events," for "God Sake," he commanded.[17] But Pelham would eventually produce maps of Boston for

General Gage's military and dine at General William Howe's table in Charlestown.

Copley's half-brother and father-in-law, like other Tories, thought that good Anglo-American relations were recoverable and that the rebellion was the work of a few crazed men. But Copley knew better. His actions and words suggest that he wished the clock could be turned back to a less agitated time. Nothing was ever going to be the same, and he seems to have understood that a political balancing act like his, in a precariously unbalanced world, would be impossible to maintain. In the 1770s, taking sides was obligatory, and if one did not take sides then a side would be assigned. As Pelham explained it to his half-brother, "The People in the Country have made it a Rule for a long time Past to brand every one with the Name of Tory and consider them as Inimical to the Liberties of America who are not will'g to go every length with them in the Schemes however mad or who show the least doubt of the justice and Humanity of all their measures, or even entertain an Idea that they may not produce those salutary effects they profess to have in View."[18] If Copley remained undeclared, he would technically have become a Tory, defined as a person thought to side with the Crown because he was not on the side of rebellion; and no one, not even an artist claiming life for art's sake, could hide behind an apolitical stratagem.

Copley was exhausted by the turbulence and tired of being an isolated artist in a provincial town at the far edges of the English-speaking world. As early as 1766 he had imagined the "happy effect of leaving ones native Country," of breaking the "schackels" of the cramped Boston art world, and of traveling to Europe to be "heated with the sight of the enchanting Works of a Raphael, a Rubens, Corregio and a Veronese."[19] He had sent two pictures, in 1765 and 1767, to London for exhibition at the Society of Artists, soliciting a professional critique of them from West and, indirectly, from Reynolds. In what amounted to a correspondence course on English art, Copley heard lots of praise, but also the kinds of criticisms on his technique that told him what he was lacking in Boston. His pictures were too hard, too cold, too neat, too minute, too bright, too opaque—in short he was too provincial in the eyes of his English peers. They advised him to move to London before "the Force of your Genius is weakened, and it may be too late for much Improvement."[20]

Copley took the advice to heart, and that led to letters to London that lament the provinciality of Boston. The little city was starting to

look like a backwater possessing "neither precept, example, nor Models" of good art. The citizens were "intirely destitute of all just Ideas of the Arts." A "taste of painting is too much Wanting." Art there was "no more than any other usefull trade, as they sometimes term it, like that of a Carpenter tailor or shew maker . . . Which is not a little Mortifiing to me. While the Arts are so disregarded I can hope for nothing, eithr to incourage or assist me in my studies but what I receive from a thousand Leagues Distance, and be my improvements what they will, I shall not be benifitted by them in this country, neighther in point of fortune or fame."[21]

Leaving his family behind for the moment, Copley boarded ship for London on June 10, 1774, nine days after the brutal Boston Port Act barricaded commercial traffic in the harbor, leading to the slow starvation of the citizenry. What had been a prosperous city at the beginning of Copley's career had become a place where "thousands are reduced to absolute Poverty . . . Business of any Kind is entirely Stop'd."[22] He still thought that a "Civil War," as he accurately termed it, was an evil greater than English taxation or control of American affairs.[23] Putting "this land of Ruin and Distress" behind him, he looked to London for a new life.

❈

In the eight years between his departure from Boston and his painting of the American flag on Watson's ship in 1782, Copley vigorously pursued his artistic career. He maintained his policy of silence on political issues and remained committed to both sides of the political divide. Writing to his wife back in Boston, he said he planned to "avoid engaging in politics, as I wish to preserve an undisturbed mind and a tranquillity inconsistent with political disputes."[24]

But the temptation to break that rule was great when Copley traveled to Italy later in 1774 in order to inhale the old masters in a single breath, at the advanced age of thirty-six. There he would write about the war with the sort of free speech he could have never exercised in Boston or London. Now distanced from the shadow of war, he wrote to Sukey that "it is very evident to me that America will have the power of resistance until grown strong to conquer, and that victory and independence will go hand in hand."[25] After the devastating American defeat at Bunker's Hill in June of 1775, he further predicted that "all the power of Great

Britain will not reduce [Americans] to obedience."[26] He even imagined a day when America would "imerge from her present Callamity and become a Mighty Empire."[27] But at the same time he estimated that "Ocians of blood will be shed to humble a people which they never will subdue . . . and after [the English] have with various success deludged the Country in Blood the Issue will be that the Americans will be a free independent people."[28] And when it is finally over, "years of sorrow will not dry the orphans' tears nor stop the widows' lamentations."[29]

In Italy he painted a politically charged portrait for the wealthy South Carolinians Ralph and Alice DeLancey Izard, who were in the midst of their grand tour of the Continent. Izard had been an unofficial American envoy in London, lobbying the British government for the rights of his countrymen, and when the war broke out he served in the American diplomatic corps. He was the kind of Patriot who was more than willing to put his money behind his politics, offering at one point to pledge the value of his entire estate toward the purchase of American warships. Copley traveled with "this accomplished Pair," as John Adams described them, in Naples during the spring and summer of 1775, toured Paestum and Rome, and commented in letters home that his "very Valuable Friend . . . Would pay all my expences, and has shewn the greatest desire possible to render me every service in his power."[30]

In the largest portrait of his career, Copley situated the couple in an opulent Roman setting with a view of the Colosseum in the background. Politics is seemingly remote. But the charms of Italy failed to distract Izard from his growing agitation over the first anguished months of the war back home. When he wrote from Italy to a friend in America who was waffling over the rightness of the war, Izard could not stop himself from ranting that England must be "looked upon as the bully" for wrongly "attempting to take our money from us without our consent, and in persisting to do it after we had shown how humiliating and distressed a situation we should be reduced to."[31] Given the highly emotional Izard's unabated anger over the broken trust between America and England, Copley's portrait became an opportunity to make a political statement.

The central action is the couple's conversation that transpires across a luxurious gilt table.[32] A Hellenistic sculpture prominently stands on a pedestal behind the table, but given the way Copley positioned it, the sculpture seems to be on the top of the table between the Izards, perfectly bisecting the picture down the middle and standing at the apex

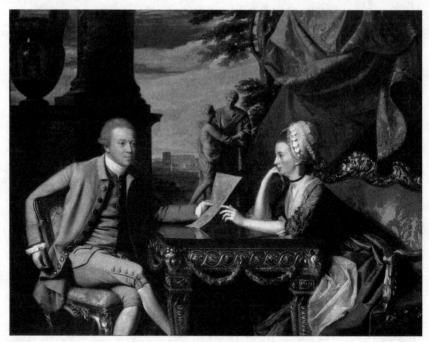

John Singleton Copley, *Mr. and Mrs. Ralph Izard*, 1775

of a triangle with the couple at its base angles. So as to double the significance of the sculpture, Izard himself holds a drawing of it in his left hand while Mrs. Izard touches it with her left index finger. Copley's design draws everyone's attention—both the sitters' and the viewers'—to the drawing and the sculpture of *Papirius Praetextatus and His Mother*, which was in a Neapolitan collection at the time.

The inescapable presence of the *Papirius* group in the painting may have something to do with Izard's ongoing interest in antiquity, especially since he was collecting art in Italy. But set in the context of the budding Revolution and Izard's obsessive and ongoing anger over British abuses and American subjugation, the antique subject matter became a commentary on the rebellion against British control.[33]

Papirius is depicted in the sculpture as an adolescent boy still devoted to his mother, whom he embraces. But he was also a young adult approaching the threshold of majority, at which point he was expected to enter the Roman Senate independently. One day, after he had accompanied his father to the Senate, his meddlesome mother incessantly quizzed him on that day's debate, which he was forbidden by Senate rules to reveal. Rather than obey his mother and dutifully answer

her questions, he followed his moral duty to his country, and as a result history hailed him as a hero.

As Copley presents it, Papirius' dilemma literally inserts itself in the middle of the Izards' conversation, which while perhaps concerned with the beauty of the sculpture, is no doubt a dialogue over political ethics. Papirius was like America, with the option of being obedient to his mother, who would reward him with benevolence if he conformed to her rule, or of deceiving his mother because he had an obligation to a higher authority. For Ralph Izard, the time had come for Papirius—and America—to break juvenile ties and move on toward independence.

Copley left the Izards in October of 1775 and returned to London, where he reunited with his recently arrived wife, children, and in-laws a few weeks after George III proclaimed the colonies to be in a state of open rebellion, a de facto declaration of war. Many of his former sitters from Boston were now émigrés in London: Joseph Green, Samuel Quincy, Thomas Flucker, the Isaac Winslows, the Benjamin Pickmans, and the John Amorys, to name a few. His closest friends in London were the Hutchinsons, the family of the despised former English governor of Massachusetts, Thomas Hutchinson, whose house in the North End of Boston had been ransacked during the Stamp Act crisis, but for whom Copley had signed a petition of support at the time of his departure.[34] Copley joined a club of American Loyalists in London, but when they became too political he abandoned them. Americans aroused suspicion in London, and as a result, Copley found it difficult to make friends with certain Tory artists, such as Allan Ramsay, who painted portraits for George III.[35]

Copley occasionally painted American Loyalists in London. The grandest portrait, exhibited at the Royal Academy in 1778, was *Sir William Pepperell and His Family*, a happy image of an American family that was in reality so devastated by hardship that the painting borders on fiction. The Pepperells had had to flee their estate in Maine in 1774 after the local Whig-oriented congress moved that Sir William thenceforth be "detested by all good men."[36] Then, in sequence, the family had sought asylum with the British in Boston, Lady Pepperell had died, Sir William and the children had escaped to England during the British occupation of the city, and, in 1778, Pepperell's vast American properties had been confiscated. In 1779 he was elected chairman of the Loyalist Association in London. Nonetheless, in the fictive space of Copley's picture the Pepperells, including the deceased Mrs. Pepperell,

carry on, seemingly untouched by death and the vicissitudes of the war. Like all accomplished portraitists, one of Copley's skills was the art of persuasive denial.

Copley's spectacular *Watson and the Shark*, also shown at the Royal Academy in 1778, had its own Tory political dimensions. The theatrical canvas chronicles a harrowing event from the life of Brook Watson when he was a fourteen-year-old orphan in 1749. Copley's original title describes the entire narrative: *"A boy attacked by a shark, and rescued by some seamen in a boat; founded on a fact which happened in the harbor of the Havannah."* Adapting poses and compositional elements from religious pictures—countless old master paintings of the Archangel Michael smiting Satan, as well as Raphael's *Miraculous Draught of Fishes* and *Transfiguration*, which he studied in Italy—Copley aggrandized Watson's personal adversity, raising it to the dramatic level of heroic valor, with Christian overtones.

By any historical measure the event did not warrant that treatment. Could a picture of personal misfortune rise to the benchmark

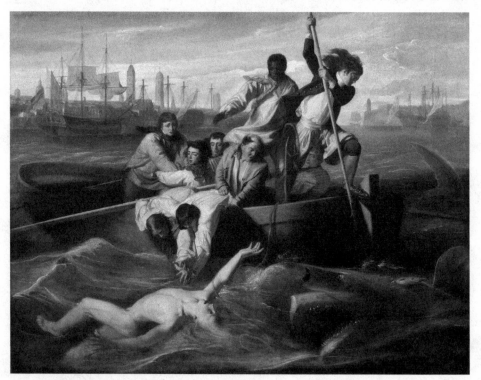

John Singleton Copley, *Watson and the Shark*, 1778

for historical painting set by Benjamin West's *Death of General Wolfe* a few years earlier? Though surely Watson was a victim, his suffering was not that of an authentic hero living in a selfless, exemplary way for the benefit of others. Instead of a story of consummate heroism, this was histrionic excess. A "beautiful boy" meets a "ravenous bloody Monster," according to the *St. James's Chronicle* of April 25, 1778. "Compassion" mixes with "Horror" in a drama so combustible and dreadful that "the Beholder must tremble for Fear."[37] In his staging of Watson's ordeal, Copley tried to elevate trauma to the status of virtue.

The picture did, however, call attention to Brook Watson (no relation to Elkanah Watson), who as an adult was driven by opportunity, not virtue. By most American Patriot accounts, Watson was not a person who should command sympathy. Before the Revolution, the Tory government hired him to canvass political opinion in America, which provoked him to label Patriots "despicable wretches."[38] Early in the Revolutionary War, after the siege of Montreal in 1775, Watson took Ethan Allen in chains to Pendennis Prison in England. Allen described Watson as "a man of malicious and cruel disposition" so excited by "the exercise of his malevolence" that he relished treating Allen in ways "derogatory to every sentiment of honor and humanity." Then, as soon as the ship carrying Allen arrived in England, Watson greedily raced to London "expecting the reward of his zeal" from the ministry.[39] When Watson commissioned Copley to paint the picture in 1778, he was a transatlantic merchant and aspiring Tory politician in London making his money by selling fish waste to plantation owners in the West Indies, who in turn fed it to their black slaves.[40]

Not accidentally, the prominent figure at the apex of *Watson and the Shark* is black, but tellingly, in a preparatory chalk-on-paper drawing for it, that figure is white.[41] Copley himself had nothing at stake in making that racial substitution. But if Watson called for it—he was the one who was paying for the picture—one wonders why he might have wanted a black seaman.

Perhaps the man had been in the boat and Watson was merely requesting historical accuracy. But given the racial codes of white society in the eighteenth century, the placing of a black figure at the apex of a major painting suggests something much more audacious than that was at work. More likely, the inclusion of the black seaman was a cynical propaganda stunt meant to show Watson's Tory argument that the Declaration of Independence—and the central claim that all men in

America are created equal—was at heart a lie, never minding the fact that Watson profited from sales of inedible refuse-fish to slave owners, and one day would publicly announce that slavery was "merciful and humane."[42] Watson—the budding Tory politician—might have wanted to expose the hypocrisy at the heart of American independence by referring to the fifteen thousand African-American refugees who had escaped slavery during the Revolution and found freedom by crossing over the British line. Many found freedom in British Nova Scotia and London's East End.[43] Watson would go on to further burnish his Tory credentials when he became commissary-general in British-occupied New York at the end of the war. There, one of his most daunting tasks was to provide food, clothing, and shelter to the thousands of Loyalists who sought refuge and clamored to emigrate to London.

Thanks to Copley's impressive painting, the politically ascendant Watson could grandiosely wrap himself in false humanity and create an image of personal courage, as well as sympathy for his own childhood misfortune. He could even imagine himself being rescued by that black man who has tossed Watson a rope that loops around his arm. For a rising politician like Watson the picture was a log-cabin myth, a youthful episode shamelessly inflated in order to dramatize his core character, whether or not it represented anything close to the unvarnished truth. And now, in the spring of 1778, almost thirty years after that eventful day in Havana, and exhibited in the shadow of the devastating news that France had entered the American Revolution against Britain, everyone in London—royalty, aristocrats, military officers, artists, writers, and politicians—could view the self-indulgent spectacle of Watson's childhood nightmare in the grand salon of the Royal Academy. For Watson, the would-be politician, the opening gala at the Academy, in front of the eyes of the city, was the political equivalent to a debutante ball.

But to William Dunlap, an American student of Benjamin West, Watson was nothing more than a scourge who worked in opposition to "our independence" as well as "the abolitionists of the slave trade," and as a consequence he must be aligned with "the enemies of God." Writing in his epic history of American art, Dunlap contemptuously noted that during the hostilities between America and Britain Watson "ingratiated himself with many leading Americans, obtained as much information of their designs as he could, and transmitted it to his chosen [British] masters."[44] In effect, Watson worked for the British Army as a spy.[45] As for Copley, an artist Dunlap otherwise admired, he too was

condemnable for unscrupulously portraying Watson as a tragic figure, for having immortalized "a traitor," an enemy of the state.[46] To Patriots, Watson was the monster, not the shark.

Copley may have talked of maintaining neutrality in London, but much of his business as a master imagist was understandably bound up with making English Tories, American refugee Loyalists, Tory and Whig members of the government, and the King's family look good, and on their own terms. They all recognized Copley's talent and used their money to hire the artist who, in turn, was eager to accept pounds sterling in return for the flattering images that he was willing to confect for them, even as these were steeped in politics and far from neutral.

Certainly, when he chose in 1779 to paint on speculation the statesman William Pitt, the Earl of Chatham, suddenly felled the previous year by a stroke on the floor of the House of Lords while in the midst of a speech urging the British to not give up on their war effort in America, Copley was immersing himself in politics. Copley unconventionally put the picture on display in 1781 at a solo exhibition in Spring Gardens, near Vauxhall on the south side of the Thames. And after a successful run there, he moved the ten-foot canvas to a room on the second floor of the Royal Exchange, located in the commercial heart of the city, a most appropriate setting for the endlessly entrepreneurial Copley. The picture was so popular with the American Loyalists who frequented the nearby New-England Coffee House that Copley offered free "Perpetual Tickets" that allowed them to admire the great statesman who fought for American rights but tried to keep America within British rule.[47]

Copley was in over his head. He failed to understand that painting a tribute to a prominent Whig statesman would provoke resentment among those who opposed that statesman in Parliament, including the Prime Minister.[48] Benjamin West had thought about painting the same subject, and got as far making an oil sketch in 1778. But the more politically shrewd West walked away from a project filled with booby traps. Copley somehow did not realize the dangers of wading into a shark-infested picture of fifty-six politicians responding to—or ignoring—the fatal collapse of the most polarizing figure in British politics at that time. Nothing could have been more impolitic than painting Chatham's lifelong antagonist, William Murray, the Earl of Mansfield, sitting by himself on the far left side, eyes averted downward, and ostentatiously unresponsive to Chatham's crisis that day. Copley had turned the powerful Mansfield into a modern Judas.

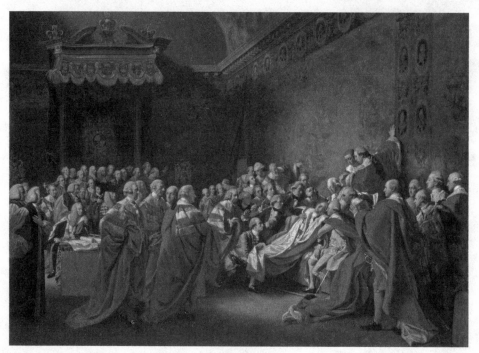

John Singleton Copley, *The Death of the Earl of Chatham in the House of Lords, 7 July 1778*, 1779–81

❈

The year after *The Death of the Earl of Chatham*, Copley moved from English parliamentary drama to the imposing three-quarter-length portrait of Elkanah Watson standing in front of a pair of colossal columns, one fluted, one smooth, and both interlaced with jade-green silks. The picture hums with theatrics. Though Watson is hundreds of miles away from his home and office in Nantes, he seems to be caught at a moment of reflection in his study. He holds a cocked hat tightly in his lowered right hand, as if he had just taken it off or were about to put it on. In his left hand he clutches a letter, perhaps a diplomatic communiqué, which seems to have caused him to pause and look away. To his right, a carpet-topped table is covered with the work of a successful merchant: inkwell, quill pen, ledger book, and stack of papers. Dangling off the table and highlighted for the audience is a letter from John Brown, his mentor and fellow merchant from Providence. A second letter, tilted up next to the inkwell, announces to us who he is and where he comes from: "Mess. Watson & Cassoul, Nants."

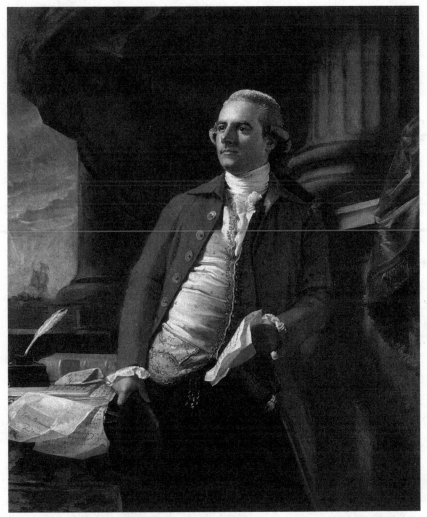

John Singleton Copley, *Elkanah Watson*, 1782

Watson himself practically jumps out of the picture. Copley flooded his head and body in a brilliant light that contrasts his hot red jacket against the cool, dark tones of his surroundings. As much as the light targets Watson's sculpted head and white jabot, it also draws attention to the cleft in his chin, the slope of his nose, and the curve of a bulging stomach cinched by a yellow court vest decorated with French embroidery, the one he had worn for his presentation to the Duc d'Orléans at the Château de Saint-Cloud.[49]

A preliminary drawing in black and white chalk on blue paper,

however, shows that Watson was, in fact, a lean man. Copley's original design was to have a youthful Watson standing full-length, leaning against a plain column, his head tilted horizontally instead of upward, and his jacket buttoned over a flat stomach. But that first idea must have met with disapproval, and, either the result of a request from Watson or a suggestion by Copley, a decision was made to turn him into the preferred image of an older, fatter merchant whose belly speaks to his success. Copley added to the walking stick in his left hand a letter, which helps to convert the image from that of a squire or traveler to that of an active man of commerce.

Copley altered the angle of Watson's head from the drawing, rotating it up toward the light, suggesting that Watson's mind rises above the here-and-now as he considers the implications of the letter, or something else entirely, perhaps the future of America. In the leap from drawing to painting, Copley had turned a young man's swagger into a mature man's contemplation, giving a callow twenty-four-year-old the inspired look of a visionary. It was precisely the image Watson strove to project. As James Warren assessed him in a letter to John Adams, Watson was "A Young Gentleman" of "very good Character" who "seems to be possessed of A Laudable Ambition to be taken Notice of by Gentlemen of distinction."[50]

Watson's portrait was the second of three large portraits of Patriots that Copley painted at the end of the Revolution. The first, executed earlier in 1782, was a striking image of the American diplomat Henry Laurens. As in the case of Watson's portrait, in order to paint such a partisan American picture the habitually anxious Copley must have been confident that he would not be punished for it by scornful critics and the unforgiving marketplace. For the American flag that he boldly pinned to Watson's ship, that reassurance came in the form of the King's capitulation speech that decisively ended "the great drama," as Watson phrased it, and that guaranteed Anglo-American peace and harmony in the future.

To paint Laurens a few months earlier, Copley could have acquired confidence a number of ways, two of which would have been *The Death of the Earl of Chatham*, a painting that had made him a celebrity artist in London, and the crushing British surrender at Yorktown in October of 1781, a disaster provoking Britain to come to terms and causing Prime Minister Lord North to cry "Oh God! It's all over!"[51] North's Tory government was thereafter forced out of office by the dubious distinction of

being the first ministry to receive a motion of "no Confidence." The press mercilessly ridiculed him, his ministry, and his corpulent body. There was even talk that he should be brought to public trial for mishandling the American war.[52] Copley would also have been encouraged because the American Loyalist community, once in possession of considerable political clout in London, had lost much of its power. Some had died, others had moved away from London, and all of them were anxious in 1782 that Britain was going to lose the war, which meant they would be denied access to their American properties and disallowed reparations for their losses.

When Copley painted the fifty-eight-year-old Laurens, the South Carolinian had just been released from the Tower of London, where he had been a political prisoner for more than a year. The British Navy had captured Laurens in September of 1780, on the high seas off Newfoundland, while he was serving as America's Minister to the Netherlands. Laurens tried to destroy all the diplomatic papers he was carrying when his vessel was seized, but the British recovered among his effects documents confirming their suspicions that the Americans were seeking Dutch banking loans and that the supposedly neutral Dutch were already secret collaborators with the United States, trading arms, munitions, and naval stores for American tobacco and indigo. Laurens was transferred from the American packet *Mercury* to the British cruiser *HMS Vestal*, taken to England, accused of treason, and remanded to the Tower. A former President of the Continental Congress, Laurens was the highest-ranking American to be imprisoned during the war.

He was incarcerated for more than a year, and was only released on December 31, 1781, because of Yorktown and the interventions of both Edmund Burke, who had also interceded for John Trumbull's release from Tothill Fields prison six months earlier, and Richard Oswald, the elderly Scot who was Laurens's partner in the slave trade. As noted by Laurens himself, Oswald even "offered to pledge his whole fortune as surety for my good conduct."[53]

Laurens's stature as a Patriot would be enshrined by Benjamin West when he painted the Provisional Treaty negotiations of late 1782. But when Copley met Laurens earlier in 1782, he was the closest thing to a living American martyr to be found on the eastern side of the Atlantic. He had endured hardships and privations during his incarceration in the Tower, which was run by its notorious governor, John Gore. Besides the petty cruelties, Gore had given agents of the British government

access to the physically eroded Laurens so that they could entice him to renounce the United States and declare allegiance to Britain and the Crown in exchange for his freedom. Though James Madison came to believe that Laurens had indeed cooperated, Laurens insisted at the time that all the temptations dangled in front of him by the British "shall not shake me" from a steadfast commitment to the American cause.[54] When it came time for his discharge proceedings in front of King's Bench, he leveled a defiant parting shot, appending to Lord Chief Justice Mansfield's invocation of "Our Sovereign Lord the King" the wisecrack, "not my Sovereign Lord."[55]

Incarceration had taken its toll. By the time he was released on bail Laurens was crippled by gout, headache, "shivering fits & alternate fever."[56] Remarkably, less than two weeks later Copley announced in the *Morning Chronicle* his plans to paint Laurens: "The artist who painted the celebrated picture of the death of the late Earl of Chatham" is "engaged to paint the portrait of Henry Laurens, Esq. late president of the American Congress" and partnered with the engraver Valentine Green to produce an engraving of "that distinguished character," to be "published and sold by J. Stockdale, Bookseller, no 181, opposite Burlington House, Piccadilly."[57]

Given all the specifics in the newspaper item and the nearness of the announcement to Laurens's release from the Tower, a deal for the painting, print, and print sale must have been arranged while Laurens was still in prison. That meant the four parties—Copley, Laurens, Green, and Stockdale—agreed that the print was always their original objective. Clearly, Laurens did not commission the picture because he returned to America in 1784 without it, and eventually bought a print from Stockdale. He then hired Charles Fraser of Charleston to make a new painting based on the engraving after Copley's painting.

Ultimately, the project was not meant to put any significant money into the pockets of any of the four principals. A prominent painting and print would go a long way in helping Laurens define and secure his place in history, and it also stood a good chance of burnishing Copley's already stellar reputation after the accolades he had earned for *The Death of the Earl of Chatham*. But that was secondary. Instead, this project was intended from the outset to be a benefit sale, the proceeds from the print going to alleviate the extreme conditions that captured American sailors were being subjected to in English prison ships, mostly at Forton in Portsmouth and Mill in Plymouth.[58]

Prisoner relief was high on Laurens's political agenda. While he was still in the Tower he had tried to call attention to his situation—and the situation of all American detainees—by sending clandestine letters to English newspapers and magazines.[59] After his release from the Tower, Laurens continued to work hard to rally support for American prisoners, numbering around six hundred, who were suffering from starvation and disease. From the government he obtained "access to the Forton and Mill captives," and was given clearance "to relieve their necessities."[60] He met with Prime Minister Lord Shelburne to lobby for humanitarian relief and to negotiate exchanges of American and British prisoners of war. He donated £200 of his own dwindling accounts for their welfare. And he worked with Copley, Green, and Stockdale on the print sale to benefit these men.

Concerning the potential British market for a print to benefit American prisoners of war, Copley, Laurens, Green, and Stockdale would have known of the widespread sympathy for the sufferings of American detainees and of the Britons who had organized relief efforts for them.[61] Laurens himself was on close terms with British leaders of the relief movement, among them David Hartley, the future plenipotentiary at the 1783 Treaty of Paris, who visited American prisoners at Forton and solicited money for their support. The Reverend Thomas Wren of Portsmouth also worked with "unwearied attendance" to provide comfort, instruction, advocacy, and refuge for some escapees (which qualified as treason).[62] Laurens was so grateful to Wren for his ministrations that he commissioned a portrait of him in 1784. He also encouraged Benjamin Franklin to persuade Congress to send official thanks to Wren and to arrange for him to receive an honorary doctorate in 1783 from the College of New Jersey (now Princeton).[63]

There were also surprisingly good reasons that a portrait of the president of the American Congress would be popular in Britain in 1782. If anything, Laurens's high-profile imprisonment in the Tower had drawn attention to him in the press, which noted divergent political sentiment.[64] "One party sentences him to the scaffold," wrote the *Morning Herald*, while "the other would vote him into Parliament."[65] To some, his treatment was a symbol of barbarism. Burke thought the British had been "less humane than the Turk, the savage Arab, the cruel Tartar, or the piratical Algerine."[66]

In addition to Laurens's prominence in Britain, the project to sell benefit prints was encouraged by an existing market for stories and pictures of internationally renowned Americans who had achieved celebrity

status. Washington, for example, was already widely commemorated; that he had humiliated Lord Cornwallis at Yorktown did not matter because in the arena of public opinion he was admired as the American Cincinnatus, a man of valor and dignity. In *The London Chronicle* and elsewhere were feature stories on the "Life and Character of Gen. WASHINGTON."[67] Specialty publications also celebrated Washington. One, a *Poetical Epistle to His Excellency George Washington*, published in London in 1780, was created "for the charitable purpose of raising a few guineas to relieve in a small measure the distresses of some hundreds of American prisoners, now suffering in the gaols of England."[68] It was not uncommon to hear the British press singing praises for Washington and other American generals who had outwitted their British counterparts, while at the same time savagely assailing British leaders such as General William Howe and General John Burgoyne for incompetence in the American theater of war. The *Westminster Magazine* cheekily titled one essay on the American general Nathanael Greene "His Superiority over General Burgoyne."[69]

Images of American heroes were also popular. Enterprising London publishers, such as John Morris and Thomas Hart, printed and sold collections of portraits featuring the officers of the Revolution.[70] Josiah Wedgwood, the famous pottery industrialist and radical sympathizer with America, produced a cameo of Washington in jasper ware.[71] In 1780, William Sharp, an English artist who supported the Revolution, cut and sold engraved portraits of Washington as "Commander in Chief of ye Armies of ye United States of America."

All over the nation Britons were obsessed with following the lives of famous people, past and present, both British and American, and they avidly collected prints of them. The interest in portrait prints had originally been sparked in the 1760s by the Reverend James Granger's popular biographical histories, which he illustrated. But the war—and all the interesting personalities emerging from it—amplified the habit into an enthusiasm, as ordinary citizens looked to acquire prints of "distinguished characters." Collecting portrait prints was so rampant that "Grangerizing" became the colloquial term used to describe the compulsive finding and acquiring of new illustrations that could then be interleaved in the Reverend Granger's already-illustrated books. The print of Laurens was meant to tap into that biographical craze.

Valentine Green, who had engraved *Watson and the Shark*, was hired to produce the mezzotint engraving, and John Stockdale, the publisher,

would release it at his shop in Piccadilly on November 12, 1782. Stock-
dale was a new sort of publisher and bookseller, more like a partisan
political activist than the traditionally disengaged man of letters. The
Reverend William Hamilton, in a brutal biographical profile published
in his *Intrepid Magazine*, tried to discredit Stockdale by calling him
ignorant, biased, dishonest, and malicious, among other epithets in his
right-wing essay of 1784. But he also offered a backhanded compliment
to Stockdale's outsize influence in London when he acknowledged that
"this man is certainly important not only as a bookseller but as a poli-
tician."[72] Hamilton got Thomas Rowlandson to produce a caricature of
Stockdale as a crude smithy who kept a donkey tied up in his shop, an
image meant to be an embarrassment to someone in the book trade. But
at the same time that Rowlandson satirized Stockdale, he also made
him into a modern Hephaestus—the blacksmith to the Greek gods—no
longer forging charmed metal weapons, but now hammering words into
political tracts with the divine power to influence public opinion.

The rough-hewn Stockdale
had built himself a political pub-
lishing house rivaled only by his
teacher John Almon, who pub-
lished *The Remembrancer*, a series
of monthly reports on events in
America during the Revolution.
When Stockdale launched his
business in 1780, he too used
his print and book shop to pro-
file, sometimes with seditious
intent, the larger-than-life fig-
ures involved with the American
cause. He became the English
mouthpiece for American revolu-
tionary writers, and often he was
their friend.[73] Stockdale had been
involved with Laurens during his
incarceration in the Tower, pub-
lishing the American's smuggled
prison accounts in the *London
Courant*.[74] When Laurens was
released, Stockdale offered him

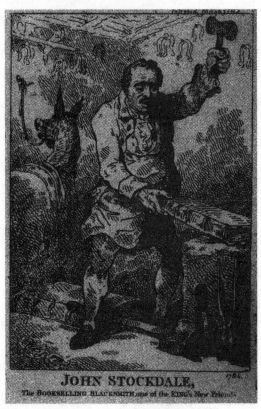

JOHN STOCKDALE,
The BOOKSELLING BLACKSMITH, one of the KING's New Friends

Thomas Rowlandson, *John Stockdale*, 1784

lodging over his shop in Piccadilly, the first of his four stays with the printer. Laurens in turn thought that Stockdale was "an honest Industrious Man, & has been uniformly our Friend, and an active friend too, from the beginning of the Persecution," a reference to the incarceration. Laurens went on to tell a fellow Patriot that Stockdale "deserves a preference by every virtuous American."[75]

Understandably, Laurens recommended Stockdale to John Adams when he arrived in London in October 1783 with his son John Quincy. Adams rented the same rooms at Stockdale's and used his shop as the London outlet for marketing a medal commemorating Dutch recognition of the United States in 1782. Two years later, Stockdale published Adams's *History of the Dispute with America, from its Origin in 1754*, to be followed in 1787 by Adams's three-volume *Defence of the Constitutions of Government of the United States of America*. Adams in turn introduced Thomas Jefferson to Stockdale when Jefferson arrived in London in 1786. Stockdale sold him books and published the first English edition of his *Notes on the State of Virginia*.

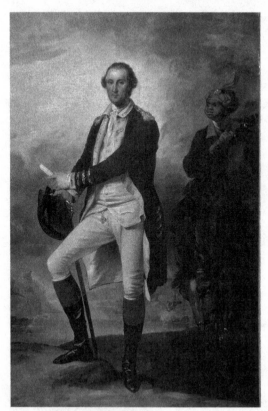

John Trumbull, *George Washington*, 1780

An unauthorized edition had appeared in France in 1786, which the disappointed Jefferson found "inverted, abridged, mutilated, and often reversing the sense of the original."[76] In 1787 Stockdale printed the *Notes* the way Jefferson wanted the text to read, and that solidified Stockdale's credentials as London's most radical publisher.

Stockdale's plan was to sell the prints of Copley's *Laurens* in tandem with Green's 1781 print after John Trumbull's *George Washington*, a portrait painted from memory during the artist's abbreviated first trip to London, just before he too was jailed for treason. Each print was fifteen

shillings.[77] Trumbull's Washington stands high over the Hudson River with his servant Billy Lee, who tends to his horse. Across the river is the strategic American fortress at West Point, which Washington used as his headquarters against the British who were occupying New York City.[78] Stockdale tried to optimize sales by having Copley install his original painting of Laurens in the bookshop, and by timing the release of the prints to coincide with the conclusion of the Provisional Treaty in November of 1782 when all the London newspapers said it was in its last stages in Paris. Together, the benefit prints of Washington and Laurens were a souvenir of the two faces of the new American republic, one military and the other legislative.

The inscription on the print of Laurens tells us he is being presented as "PRESIDENT OF THE AMERICAN CONGRESS,"

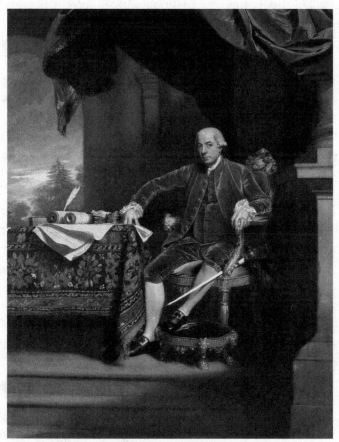

John Singleton Copley, *Henry Laurens*, 1782

not as the diplomat who was Minister to the Netherlands, or the recent political prisoner. The stacks and rolls of documents that Copley piled up on the table's Holbein carpet constitute his legislative résumé as President. The roll farthest away from Laurens bears the inscription "Confederation July 1778," a reference to the eight states that ratified the Articles of Confederation during Laurens's presidency. Closer to Laurens is a second roll, marked "Ratification Treaties May 1778," referring to the month in which Congress ratified twin accords with France—the Treaty of Alliance and the Treaty of Amity and Commerce—that brought French troops, commanders, warships, goods, and money to America, a diplomatic breakthrough recognized as the tipping point of the war when Copley painted the portrait.

A third document, the middle of three that cascade in front of the table, also highlights the new coalition with France; it is a portion of a warm letter to Laurens from Louis XVI: "We pray God, very dear friends and allies to take you in His holy keeping. Louis." Below it, the heading of another cascading document reads "In Congress 22 April 1778 Resolved." On that day under Laurens's leadership, Congress had formally rejected a remarkable British overture to negotiate for peace and reconciliation with its former colonies. The overture had been tentative, but the congressional reply had been powerful, and for good reason. General Gates had defeated British general Burgoyne at the Battle of Saratoga in the fall of 1777, taking prisoner all five thousand of his troops, a humiliation that had echoed across Parliament and the English press. That in turn had encouraged the French to consider recognizing the sovereignty of the United States, which the British understood would mean another declaration of war and another brutal—and now global—fight that could alter the balance of power in both Europe and North America.

The April 22 congressional rebuff of the British proposal oozed with contempt because, for the first time, the tables had been turned. Congress wrote about the "weakness and wickedness of the enemy"; how Britain had arrogantly ignored every previous American request to be "considered as subjects, and protected in the enjoyment of peace, liberty and safety," and was now waging "a most cruel war" in which they "employed the savages to butcher innocent women and children."[79]

Laurens's legislature had refused to countenance any overture until Britain "either withdraw their fleets and armies, or else, in positive and

express terms, acknowledge the independence of the said states." And if any person or state should try to negotiate with Britain on its own it "ought to be considered and treated as open and avowed enemies of these Unites States."[80] To reinforce the new American swagger, on that same remarkable day, April 22, 1778, in the port of Whitehaven, England, John Paul Jones had led an American naval detachment from the USS *Ranger* that had set fire to three British ships, and then, that afternoon, he had maneuvered across the Solway Firth to Scotland and attempted to kidnap the Earl of Selkirk, two brazen acts that had created panic on shore, dread in the British Parliament, and near hysteria in the British press.

Notwithstanding Congress's flat rejection of the British reconciliation plan, Prime Minister North, desperate to forestall a world war with France, had sent a peace delegation to Philadelphia to see if shuttle diplomacy might persuade Laurens and the truculent Americans to come to terms. The three negotiators' names are inscribed on the top document that hangs off the table in Copley's picture: "June 1778 . . . Carlisle . . . George Johnstone . . . W. Eden." They were Frederick Howard, the Earl of Carlisle; George Johnstone, a colonial governor of West Florida; and William Eden, the British Undersecretary of State.[81]

Parliament had instructed them to offer Congress the repeal of all the legislation contested by the colonies since 1763, a halt to all taxation, the offer of home rule to America, and even possible representation in the House of Commons. The treaties with France had been ratified a month before the Carlisle group arrived in Philadelphia, and despite the flowery letter that the British group addressed to Congress, Laurens had bluntly replied that the United States demanded, once again as a prerequisite for any discussion, "explicit acknowledgement of the independence of these states, or the withdrawing of [the King's] fleets and armies."[82]

The Carlisle Commission had returned to London empty-handed, to the jeers of the British press. The West End satirists Mary and Matthew Darly made a mockery of the commissioners on their knees obsequiously begging forgiveness from an uninterested Indian maiden who sits on barrels of tobacco and indigo ready to be shipped to America's friends in France, Spain, and Germany. On the right, the contrite commissioners acknowledge, "We have lock'd up your ports, obstructed your trade with the hope of starving ye, & contrary to the Law of nations compelled your sons to war against their Bretheren."

They confess they "ravaged your Lands, burnt your Towns, and caus'd your captive Heroes to perish by Cold, pestilence & famine" (a reference to the British treatment of American prisoners). They apologize for "deriding your virtue and piety," and for having "ravish'd, scalp'd, and murder'd your People, even from Tender infancy to decrepid age" even when they were "supplicating for Mercy." But having confessed, they nonetheless express sly confidence that America still has a "willingness to submit yourselves again to receive the same, whenever we have power to bestow it on ye."

The dispatch of the British was tough and uncompromising, and that is the way Laurens appears in Copley's portrait. But to create that look, Copley had the daunting task of making Laurens younger and healthier, of turning the clock back four years and erasing the punishing effects of his time in the Tower. His solution was to aggressively pull Laurens forward in his high-backed Chippendale chair and fiercely challenge his viewers point blank with a penetrating expression. His left hand grabs the chair's arm, which is carved into a gilt ram's head—an appropriate creature for the headstrong Laurens. His right arm arcs over to the table, where he emphatically drops his fist onto the documents advancing American independence.

Laurens's legs fidget below. His left one, pulled up onto the teal upholstered stool decorated with another set of ram's heads, restlessly nudges a court sword toward the foreground. Overhead, a canopy crowns his achievements and, at its far left end, the tip points downward to draw attention to the documents on the table. Copley had to invent the interior of Laurens's legislative office, creating a fantasy of the fugitive capital when Congress was forced to the courthouse in York, Pennsylvania, during the British occupation of Philadelphia in 1778. The imaginary plinth and column, the balcony with an exterior arch, and the scruffy American conifers in the background provide the dramatic set for the viewer's confrontation with Laurens.

Though his setting is fancy, Laurens himself is austere. His red-ochre velvet suit is plain by British standards of the day. The only bits of ornament are the gilt buckles on his shoes and the ruff of his shirtsleeve. Laurens would never be confused with an English aristocrat or a London macaroni. Long ago he had repudiated lavish living and ornamental dress.[83] Given the opportunity to be seen internationally in Copley's picture, he advertised himself as a no-nonsense American Patriot, a humble man of resolve and unadorned virtue, in simple and plain clothing, doing the good hard work of the American state by defending independence with vigor and determination. In the eyes of the British ministry, no picture painted

in London could have been any more of a filial betrayal than this one, with its references to American treaties with France, a sovereign constitution, a failed British overture, and a personal note from the King of France.

Laurens's portrait remained with Copley in London after it was exhibited at Stockdale's bookshop. Around 1790 it was acquired by John Bagwell of Clonmel, Ireland, where it probably hung in Marlfield House, which he had built in 1785.[84] Seen in a country still under the English yoke but inspired by the model of the American Revolution, a portrait of Laurens had special interest.[85] Bagwell was the chairman of the Clonmel Independents, a political organization striving for Irish constitutional rights. He was also a key supporter of the Dublin Protestant Henry Grattan, who successfully secured self-rule for the Irish parliament from a weakened English government in 1782, making that year almost as eventful for Irish independence as it was for American independence.[86] Though there is no written evidence to verify it, it is easy to imagine why the Irish and Bagwell in particular would have been attracted to Copley's portrait of Laurens and why Irish Nationalists would have lionized Laurens who, like Grattan, had risked everything to achieve the civil liberties due his people.

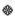

Copley was at the summit of his career in the early 1780s. Nine years after his emigration from Boston in 1774, and now fully assimilated into English culture, he had the money to move from Leicester Square to 24 George Street, near Manchester Square in trendy Mary-le-bone, a district being built up with terraced houses designed by the Scottish architect Robert Adam. The house accommodated an expanded family that included his wife, Sukey; father-in-law, Richard Clarke; daughters Elizabeth, Mary, and Susanna; and sons John and Jonathan; and it also contained a skylighted gallery for the display of his pictures. His portraits of Laurens and Watson were but two of many outstanding works from that period. Pictures for British naval lieutenant John Loring, Chief Justice Lord Mansfield, and Midshipman Augustus Brine were exceptional by any British standard. And with the spectacular success of his historical pictures he was being commissioned to execute even bigger paintings. The City of London hired him in 1783 to paint a scene from the recently ended British siege of Gibraltar, a vast picture that consumed nearly five hundred square feet of canvas.

John Singleton Copley, *Self-Portrait*, ca. 1782

With a new studio at the back of the house and flush with success, he began outlining grandiose plans for future paintings. But one of the most compelling pictures of this period was also one of the smallest, his own beautiful self-portrait. In it, Copley is mentally adrift, seemingly taking a pause from his hectic schedule in order to quietly reflect. Unlike almost all self-portraits, in which artists look back directly at the audience, the result of having to stare into a mirror in order to paint themselves, Copley figured out how to see himself while looking away. Whatever the arrangement of multiple mirrors that he may have used in order to create such a unique effect, it gave Copley the poetic opportunity to admire himself without seeming to stare at himself.

One of Copley's Patriot sitters from his old life in Boston, a selectman and Son of Liberty, John Scollay, had written from America in 1781 to congratulate his old friend on the success of the *Chatham*, which he had heard about. He praised Copley's "blaze of prosperity," but then, concerned that his friend may have gone over to the other side or just stopped thinking about his humble origins and the struggles of his brethren to achieve independence, he advised Copley to "not forget your dear native country, and the cause it is engaged in, which, I know, lay once very near your heart, and I hope it does still."[87]

Scollay's words may have echoed in Copley's head in 1782 when he painted Watson and Laurens and participated in the benefit sale to aid captured Americans, and Copley no doubt heeded Scollay's admonition when in 1783 he took on a commission from John Adams to paint the famous American diplomat who had arrived in London exhausted and triumphant from the final push that resulted in the definitive Treaty of Paris, signed on September 3 at the Hôtel d'York. Adams had known Copley from Boston in the 1760s and naturally he turned to his countryman for a commemorative portrait. What Copley ended up producing turned out to be a picture so audacious and epic that neither man could have anticipated its consequences.

6

John Adams's "Piece of Vanity"

WHEN THE FORTY-EIGHT-YEAR-OLD ADAMS WALKED INTO the forty-five-year-old Copley's studio on George Street, in November of 1783, the two New Englanders were at the summit of their careers. Adams had just arrived from Paris, where on September 3 he, along with Jay and Franklin, had signed the remarkable Treaty of Paris that all at once sealed American victory, promised American sovereignty, and heralded the debut of the United States on the world stage.[1] Over the previous eighteen months he had helped hammer out the Provisional Treaty with Britain; single-handedly negotiated a treaty of amity and commerce in The Hague with the Dutch, prior to which he had persuaded the Dutch to recognize the United States as a sovereign nation; negotiated a loan of five million guilders from Dutch banking syndicates; and in Amsterdam established the first American embassy abroad, which he dubbed the Hôtel des États-Unis d'Amérique.

While he was in London posing for Copley, Adams was in the midst of a long and heated argument with himself over the proper role of the fine arts in the new United States. It was a persistent and vexing debate that bedeviled him during a turbulent decade, from 1778 to 1788, spent as a diplomat in the courts of Europe and England. At stake for Adams was nothing less than America's emerging identity as a modern republic that needed to be sheltered from what he sincerely thought were the harmful influences of the Old World. At the same time, he knew that the arts had the attractive potential to embody republican values, commemorate heroic virtue, and vividly pass the lessons of the Revolution on to future generations of Americans. The two sides to the argument never clashed quite as violently as when Adams himself was being monumentally commemorated in Copley's studio.[2]

On the one hand, the flinty John Adams railed against anything that smacked of aristocracy and luxury, especially works of art in the service of tyrannical power. "The more Elegance, the less Virtue, in all Times and Countries," he stated unequivocally in 1778, during his first diplomatic trip to France. "I fear that even my own dear Country wants the

Power and Opportunity more than the Inclination, to be elegant, soft, and luxurious."[3] Writing to his wife Abigail in Massachusetts, Adams rhetorically asked, "My dear Country men! how shall I perswade you, to avoid the Plague of Europe? Luxury has as many bewitching Charms, on your Side of the Ocean as on this." If only he were the one in charge of protecting a fledgling American republic capable of backsliding any day into despotism, he "would forever banish and exclude from America, all Gold, silver, precious stones, Alabaster, Marble, Silk, Velvet and Lace."[4] To that prescription Adams added, "It is not indeed the fine Arts, which our Country requires. The Usefull, the mechanic Arts, are those which We have occasion for in a young Country . . . I must study Politicks and War" so that future generations have the liberty "to study Painting, Poetry, Musick, Architecture, Statuary, Tapestry and Porcelaine."[5]

Art was dangerous, in Adams's opinion, in so far as it had unmatched power to persuade—and thus dupe—citizens into thinking that a tyrant is beneficent, that monarchy is natural, and that an oppressed life is God's will. But if the fine arts were properly engineered in the new United States, they might keep a developing nation on the straight and narrow path to virtue. For the United States to succeed, according to Adams, the arts needed to be used like buttresses reinforcing republican citizenship. That was a philosophical position he backed up with actual policy when he helped charter the American Academy of Arts and Sciences during a return to Boston in 1779. Unlike all European academies, the American Academy aimed "to cultivate every art and science which may tend to advance the interest, honor, dignity, and happiness of a free, independent, and virtuous people." In achieving those goals, art should be, in Adams's view, classical, disciplined, idealistic, historical, accurate, ethical, didactic, inspirational, and devoted to timeless truths. In short, Adams wanted his puritan ethic made into a national aesthetic.

When there was a debate in the Continental Congress over the design of the new Seal of the United States, Adams tellingly proposed the Neapolitan artist Paolo de' Matteis's *The Choice of Hercules*, which shows the "the Hero resting on his Clubb," trying to decide whether to turn in the direction of Pleasure, who sprawls hedonistically on the ground, or Virtue, who points the way to a rocky path that leads to distant mountains. In de Matteis's Baroque painting, Hercules, who was often used as a metaphor for the United States, ignores the seductive charms of Pleasure and looks thoughtfully in the direction Adams preferred.[6] Looking around from his diplomatic perch in monarchical

Paolo de' Matteis, *The Choice of Hercules*, 1712

France during his second trip in 1780, Adams wrote Abigail that "Hercules marches here in full view of the steps of Virtue on one hand, and the flowery Paths of Pleasure on the other, and there are few who make the Choice of Hercules. That my Children may follow his Example, is my earnest Prayer."[7]

In addition to setting a moral tone for the new republic, he hoped the fine arts could be a form of journalism. In a letter to Abigail from Philadelphia in 1777, he thought "that not only History should perform her Office, but Painting, Sculpture, Statuary, and Poetry ought to assist in publishing to the World, and perpetuating to Posterity, the horrid deeds of our Enemies. It will shew the Persecution We suffer in defence of our Rights—it will shew the Fortitude, Patience, Perseverance and Magnanimity of Americans, in as strong a Light, as the Barbarity and Impiety of Britons, in this persecuting War."[8] In Adams's formulation, the arts had the unmatched capacity—the special responsibility—to promote and persuade, to graphically tell the world of outrage, as well as of American courage. And because paintings, prints, and sculpture

were not ephemeral, once they were fixed as correctly as possible they were not as vulnerable to the vagaries of human emotion as personal reminiscence and political cant were.

What Adams ultimately wanted for art in America—to simultaneously record history with exactitude and promote American virtue with timeless sentiment—bordered on the impossible. But while he was in the moment, Adams could imagine art in constructive partnership with history. During the awful privations caused by the Boston Port Act of 1774 which shut down all commerce in the city, Adams wished he could obtain "a proper Set of Paintings of the Scenes of Distress and Misery" so that posterity would 'Tingle.'"[9]

Even more fundamentally, he thought that designing the American republic was analogous to designing a good painting. Just as the "perfection of the portrait consists in its likeness," so too a representative government must accurately reflect the people who constitute it.[10] American statecraft was a form of art: "Wise statesmen, like able artists of every kind, study nature, and their works are perfect in proportion as they conform to her laws."[11] To Adams the Founder, the arts were destined to play a crucial role in American life, but only in so far as they did not stray into luxury, vice, and the propagation of power.

John Adams also had an authentically sensuous side; as an international diplomat he took every opportunity to tour European collections, discern excellence, and feel exhilarated by great paintings. He may have wanted the American Hercules to choose the rocky path to Virtue, and he unquestionably wanted the same for himself, but sometimes the Hercules living deep inside Adams irresistibly turned his head in the direction of Pleasure. "The Delights of France are innumerable," he gushed to Abigail in 1778.[12] "If human Nature could be made happy by any Thing that can please the Eye, the Ear, the Taste, or any other sense, or Passion, or Fancy, this Country would be the Region for Happiness."[13] Though "Reason holds the helm," he knew that "passions are the gales."[14] What he considered bad for America, was at times good for John Adams.

He always had a keen eye for things. After a spirited dinner in January 1766 to discuss the Stamp Act at Nicholas Boylston's elegant home on School Street in Boston, Adams wrote an astonishingly detailed recollection of what he had seen: "Went over to the House to view the Furniture, which alone cost a thousand pounds sterling. A Seat it is for a noble Man, a Prince. The Turkey Carpets, the painted Hangings, the

Marble Tables, the rich Beds with crimson Damask Curtain and Coun-
terpins, the beautiful Chimny Clock, the Spacious Garden, are the most
magnificent of any Thing I have ever seen."[15] His visual judgment was
sound and sophisticated.

It was further evident in the summer of 1776, during a visit to the
Philadelphia studio of Charles Willson Peale. He regaled Abigail with
descriptions of Peale's recent portraits of Washington, Franklin, and
Benjamin Rush, his miniature of John Hancock, his sketches of Mount
Vernon, his clay figures, as well as his collection of books on art theory.
He thought that Peale's portraits were "very well done," but in his cul-
tivated opinion "not so well as Copley's Portraits. Copley is the greatest
Master that ever was in America." The visit also got Adams to admit to
Abigail that if he were not so consumed with legislative necessities, it
would be rewarding to study the "ingenious Arts of Painting, Sculpture,
Statuary, Architecture, and Musick." To be sure, "A Taste in all of them,
is an agreeable Accomplishment."[16]

While he was in France he toured the palace of Versailles with
Franklin. In his diary he wrote that he had been "shewn the Galler-
ies, and Royal Apartments, and the K's Bedchamber." Instead of being
repelled, Adams said "the Magnificence of these Scaenes, is immense.
The Statues, the Paintings, the every Thing is sublime."[17] His swoon
over art did not stop there. The next month he dined at the home of
Jacques Barbeu-Dubourg, a friend and protégé of Franklin, who had
embraced the new neoclassical trend in French art, which appealed to
Adams. In his diary, Adams noted paintings on the subject of Antiochus
and Stratonice, as well as the Continence of Scipio. But perhaps nothing
ever captured Adams's imagination as much as a painting of Hector's
farewell to Andromache. "The passions were so strongly marked that I
must have been made of Marble, not to have felt them and been melted
by them." Thinking of himself as a modern Hector forced to leave Abi-
gail behind while he was in France doing diplomatic battle, Adams said
that he "had not forgotten Adieus as tender and affecting as those of any
Hector or Andromache that ever existed . . . With Feelings too exquisite
to produce tears or Words, I gazed in Silence at every Line, at every light
and shade of this Picture."[18]

In his travels to and from the Netherlands between 1780 and 1782,
he and John Quincy took every opportunity to study the art of the
old masters. They went to the Pieterskerk in Leiden where they saw
Lucas van Leyden's magnificent three-paneled altarpiece on the Last

Judgment.[19] Even in 1782, when Adams was being urgently ordered back to the treaty table in Paris by Franklin and John Jay, he took a day to study paintings in Antwerp. The first stop was the Baroque work of Peter Paul Rubens, who, Adams would have known, had been a skilled diplomat responsible for brokering peace between England and Spain in 1629. In the cathedral, Adams admired Rubens's *Assumption of the Virgin Mary* and *Descent from the Cross*, and was especially attracted to the triptych of the *Raising of the Cross*. "The Figures and Colouring," he effused, "are beautifull beyond description." Adams never said anything about what attracted him for so long to Christ on the cross (at the age of eighty-two he was still writing to John Trumbull about it).[20] While not the sight of a Catholic altarpiece, it may have been that Adams related to the heroic sacrifice of Christ, pinned to a cross after a public humiliation, then taken down and buried.

Adams's fascination with Rubens took him to the artist's tomb in the Jacobskerk, and then to the private collection of J. B. van Lancker, where he saw a remarkable painting by Rubens of *Christ Surrendering the Keys to Peter*. Adams fixated on the flaring eyes of the apostle in the middle background who is *not* selected by Christ to continue his holy mission. Often feeling that he, too, was overlooked in favor of others, especially the elderly Franklin, and frequently miffed over not being awarded the diplomatic assignments he thought he deserved, Adams rather transparently wrote in his diary that "There is a Jealousy very remarkable in the face."[21]

Adams could think in pictures, often describing or remembering events as if they were paintings, or as if he were painting them. He recalled the day in 1776 when Joseph Hewes, a delegate to the Continental Congress from North Carolina and an opponent of independence, suddenly reversed himself and voted for the Declaration of Independence, much to the despair of the Loyalists in the room. In Adams's visual memory, Hewes "started suddenly upright, and lifting up both his hands to Heaven, as if he had been in a trance, cried out, 'It is done! And I will abide by it.'" It was a sublime pictorial moment, full of gesture and loaded with meaning. "I would give more for a perfect painting of the terror and horror upon the faces of the old majority at that critical moment," Adams wrote later in life to William Plumer, the Governor of New Hampshire, "than for the best piece of Raphael."[22]

"My imagination runs upon the art, and has already painted, I know not how many, historical pictures."[23] If only he had talent, he wrote to his

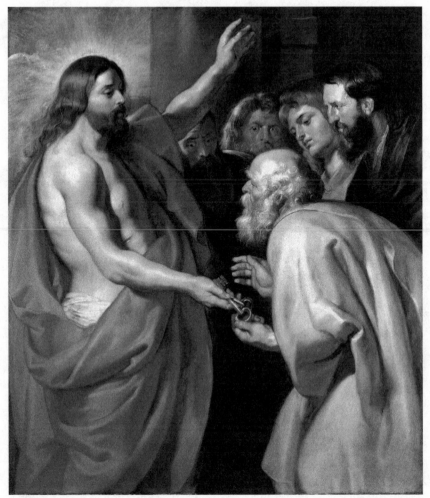

Peter Paul Rubens, *Christ Surrendering the Keys to Peter*, 1614

friend William Tudor in 1818, he would have painted Samuel Adams confronting Lieutenant Governor Hutchinson after the Boston Massacre in 1770. "Now for the picture," he wrote, then sketched out a detailed visual design that would have pleased Sir Joshua Reynolds or, going back to the origins of history painting, Leon Battista Alberti in the fifteenth century. The setting would be a large assembly hall, Adams imagined, its walls lined with "glorious portraits of king Charles II and king James II," plus "little miserable likenesses" of the colonial governors "hung up in obscure corners of the room." The despised Hutchinson would be at the head of the council table, flanked by twenty-eight counselors. "Let

me see, what costume? What was the fashion of that day, in the month of March? Large white wigs, English scarlet cloth cloaks, some of them with gold laced hats, not on their heads . . . but on a table before them." On the other side of the table would be "SAMUEL ADAMS" making a speech worthy of "Thucydides, Livy or Sallust."

John Adams pictured his cousin—"in his common appearance, he was a plain, simple, decent citizen, of middling stature, dress and manners"—in possession of "an upright dignity of figure and gesture . . . the more lasting for the purity, correctness and nervous elegance of his style."[24] "The painter" of this picture "should seize upon the critical moment, when Samuel Adams stretched out his arm, and made his speech," which was an electrifying rebuke to Hutchinson and an adamant demand for the immediate removal of English troops from Boston. "It will be as difficult to do justice as to paint an Apollo; and the transaction deserves to be painted . . ."[25]

With the war dying down, and especially after it ended, legislators, diplomats, and generals, as well as painters, printmakers, book publishers, and journalists, thought the imperative of the moment was to recall, acknowledge, and record, as well as to idealize, fictionalize, and allegorize the events and persons that had made it happen.[26] The time had come to write or paint or sculpt something about the Revolution for posterity—or for the market.

The State of Pennsylvania had already set the template for heroic size and noble purpose when it commissioned Peale in 1779 to paint his life-size, full-length portrait of Washington after the Battle of Princeton, celebrating a newfound man of virtue for a newly minted republic. At the same time, Peale began developing his own gallery of distinguished personages, eventually coming to number nearly 250 bust-length portraits.[27] Nearby, Pierre Eugène Du Simitière, a Swiss émigré living in Philadelphia, was engaged in a similar project. He produced thirteen portraits of American heroes of the Revolution that were made into engravings offered for sale in Paris in 1781, and in London in 1783, at the moment that Adams was living on Piccadilly next door to the publisher's shop.[28] The prints were said to be of those Americans "Who have rendered themselves Illustrious in the REVOLUTION of the United States of North America," specifically "GENERALS, MINISTERS,

MAGISTRATES, MEMBERS OF CONGRESS, AND OTH-
ERS."[29] The roster of heroes included Washington, Henry Laurens, John
Jay, Gouverneur Morris, and General Horatio Gates, among others.

Thomas Jefferson keenly understood by 1783 that the Revolution
was being propelled into history and its heroes were requiring due rec-
ognition. Anticipating his residency in Paris as Minister to France, he
took it upon himself to purchase a portrait of Washington by Joseph
Wright, the son of the American wax sculptress Patience Wright, which
he would strategically display in the new American embassy.[30] During
his time as Minister, he acquired one of Peale's full-length portraits of
Washington and one of Joseph Siffred Duplessis' portraits of Franklin,
plus a Jean Antoine Houdon bust of Franklin, one of seven sculptures
he obtained from the French master, including busts of John Paul Jones
and the French philosophers Voltaire and Turgot, as well as four of him-
self.[31] While he was in France, Jefferson wanted the State of Virginia to
build a pantheon to American heroes in the new capital building he was
designing for Richmond. There, Jefferson imagined, Americans would
be inspired by portraits of Washington, Franklin, Lafayette, General
Gates, General Nathanael Greene, and the Comte de Rochambeau.[32]
Jefferson's plan for a state-sponsored gallery of worthies never went any-
where, though he did make arrangements for Houdon to sculpt Wash-
ington full-size for the state capitol's rotunda.

In place of his original idea for a Virginia hall of fame, Jefferson
initiated his own temple of fame, first at his headquarters at the Hôtel
de Langeac in Paris, then at his residence in Philadelphia while he was
Secretary of State, and finally on the walls of his home at Charlottes-
ville. Adams not only endorsed Jefferson's project, he thought Jeffer-
son could expand it to include leading American figures in the arts.
In a 1786 letter to his brother-in-law, Richard Cranch, Adams com-
mented that "Jefferson might have added to his Catalogue of American
Genius's, Copley, West, Stuart, Trumbull, and Brown as painters," as
well as portraits of the poets Timothy Dwight and Joel Barlow.[33] After
years of collecting American worthies, Jefferson ended up with nearly
thirty life-size paintings and sculptures, and more than fifty miniatures.
The best men, or, in Jefferson's phrase, those who populate a "natural
aristocracy" based on talent and virtue, needed to be seen. And once
seen they needed to be emulated if future leaders were to emerge from
humble origins. It was a compelling idea being massively played out in
contemporary American culture.

And yet, pictures, commemorations, celebrations, and enshrinements of Adams were nowhere to be seen. There had been a small show of appreciation in the Netherlands in 1782 when Reinier Vinkeles, the secretary of the Amsterdam Drawing Academy, cut a print of Adams that was used as the frontispiece to the Dutch publication of Adams's *Novangelus*, a series of essays on the history of the "dispute" with Britain and a systematic argument against British imperial policy.[34] The transplanted Frenchman Chavannes de la Giraudière dedicated to Adams his epic poem of 1783, *L'Amérique Délivrée*, a tortured updating of Tasso's *Jerusalem Delivered* from 1581.[35]

Otherwise, in the great groundswell of commemoration occurring on both sides of the Atlantic, Adams was rarely featured. For a person whose Olympian vanity was so mightily interested in posterity's judgment, he was frustrated knowing that he had helped reset the clock of history, but that no one was rushing to canonize him. Not indifferent to the ability of art to create icons, he understood that posterity was being assembled in the here and now by artists and writers, rather than in some far-off time by impartial judges in heaven. More than anyone, Adams grasped the unparalleled significance of this moment in history and the significance of his place within it.

Over and over again he tried to convince himself he had done the right things, acted with supreme virtue, "run Risques and made Sacrifices, in the discharge of duty," and fought so hard that he was now "maimed, scarrified and out of Breath."[36] Scanning nearly two decades of service to American liberty, going back to his protest of the Stamp Act in 1765, he pictured himself as a barefooted man running a gauntlet lined with "the horrid Figures of Jealousy, Envy, Hatred, Revenge, Vanity, Ambition, Avarice, Treachery, Tyranny, Insolence," taunting him and "lashing him with scorpions all the Way."[37] But, he imagined, if he had been less obstreperous, not quite as tenacious and ferocious, if he had not pestered the French so nakedly for more aid, or fought for American fishing rights in the treaties, or insisted on possession of Illinois and Ohio, "I might have had Gold snuff Boxes, Clappings at the Opera," had "millions of Paragraphs in the Newspapers in praise of me," plus "Visits from the Great, Dinners, Wealth, Power, Splendor, Pictures, Busts, statues, and every Thing which a vain heart, and mine is much too vain, could desire."[38]

Itching for recognition and feeling self-righteous, it is not surprising that Adams commissioned Copley to paint him on the heroic scale

usually reserved for royalty, that he would rush headlong into the needs of that vain heart that was intent on the "Pictures, Busts, statues" that were the outward signs of public importance in eighteenth-century societies. They were, in his own estimation, his rightful due. Once upon a time, the puritan Adams had believed that virtue was the unrequited application of morality to public affairs. "Truth, Justice, and Liberty" were sufficient rewards for one's efforts. But his eye-opening experiences among diplomats in France—Americans and French alike—had taught him that "Modesty is a Virtue that can never thrive in public." Writing in 1778 to James Warren, an old friend from Plymouth and the husband of Mercy Otis Warren, he complained that "you and I have had an ugly Modesty about Us, which has despoiled Us of almost all our Importance . . . We have delighted in the shade." Adams fumed that the new rules of the game demanded that "a Man must be his own Trumpeter." The new public man "must get his Picture drawn, his statue made, and must hire all the Artists in his Turn to set about Works to Spread his Name, make the Mob stare and gape, and perpetuate his Fame."[39]

While he was condemning the pride and arrogance of others, Adams was also perfectly capable of excusing the same traits in himself. "If I could bring my Feelings to bear it," he half-jokingly added, "I would Undertake . . . to become one of the most celebrated, trumpeted, Admired, courted, worshiped Idols in the whole World in four or five Years."[40] He insisted that all he really wanted was a private life back home in Massachusetts. But if he were going to continue with a public life, there would be no more invisibility for John Adams.

Though Adams did not name any names in his unhinged rant to Warren, the repulsive person he was talking about, comparing himself to, and aspiring to be, was Franklin. Adams had long been tortured by Franklin's fame, and in 1780, when both men were envoys to the French court, he felt he had been betrayed by the Doctor. Troubled by Adams's bull-headed style, Franklin had taken it upon himself to send a devastating indictment of his colleague to Congress. "Mr. Adams has given Offence to the Court here," were the blunt words the usually gracious Franklin used to describe Adams's unrelenting demands for more French assistance.[41] Behind Adams's back, he informed the legislators in Philadelphia that Adams's "diplomacy" was

improper, unbecoming, and hurtful to the American cause. The rift provoked Adams to reassign himself to the Netherlands to raise money for the United States. But he was ordered to return to Franklin's sphere in 1782 in order to participate in the preliminary peace negotiations with the British. Adams loathed the prospect of once again working with Franklin, who was now more popular than ever in France.[42] The "stern and haughty" Adams privately used words like indolent, dissipated, cunning, duplicitous, and sordid to describe Franklin.[43] But for the sake of America, Adams put his feelings aside in order to work professionally with the exalted Doctor.

Adams suffered through the spectacle of Franklin's deification in France.[44] Indisputably, the Doctor had single-handedly brought French arms, troops, sailors, and money into the war. But Franklin had done more than convince the French; he had conquered the French. In the wake of the 1778 Treaty of Alliance, Franklin was a French celebrity, inspiring artists to apotheosize him in paintings, prints, and sculpture.[45]

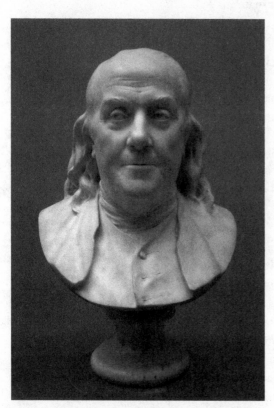

Jean-Antoine Houdon, *Benjamin Franklin*, 1778

Busts of Franklin were carved by Jean-Jacques Caffiéri, the *sculpteur du roi*, who exhibited one at the state-sponsored Salon of the French Royal Academy, where it was critically hailed. Franklin bought seven copies of it in plaster in order to present them to friends and admirers. Houdon, the greatest French sculptor of the century, carved Franklin in marble and exhibited a terra-cotta version at the 1779 Salon, where it was exhibited near his stunning busts of Voltaire, Rousseau, and Molière and seen by upwards of fifty thousand people. Houdon then produced life-size, miniature, and oversize plaster casts of the bust; he gave four to Franklin.

Prints allegorized Franklin as the American Zeus or a

classical philosopher. In an erotically suggestive 1778 engraving dedicated to the American Congress, Franklin is crowned by a laurel wreath, laying his right hand on the bare shoulder of a nude America in order to defend her while she is crouching at the foot of a statue of Liberty. On the right, Courage bludgeons Britain. The print was the work of Antoine Borel, who also specialized in explicit pornographic albums. In another hero-worshiping print, drawn by the renowned Jean-Honoré Fragonard and dedicated "To the GENIUS Of FRANKLIN," the Doctor is enthroned in heaven where he protects a crowned America and directs Mars to smite Avarice and Tyranny. Adams might have seen the print in the November 15, 1778, issue of the *Journal de Paris*. Or he might have spotted an engraving after Étienne Pallière's dramatic watercolor commemorating the 1778 Treaty of Alliance between France and America. A delirious fiction, it shows Franklin and Louis XVI conferring at a seaside quay while Neptune and Vulcan manufacture cannons and swords for the French army and navy that is heading to America. Off to one side Hercules clubs the British lion.

There was seemingly no end to the French love affair with Franklin.[46] Duplessis, a favorite at the French court, made a living from the dozens of copies he made after his original 1778 portrait of a homespun Franklin, which was acclaimed at the Salon of 1779. Duplessis outfitted his painting with a frame bedecked with symbolism. At the top, a laurel wreath circles over a "Don't Tread on Me" rattlesnake, while at the bottom a liberty cap and a lion skin, the latter a symbol of Hercules, flank a cartouche. Boldly spelled out is the Latin word for man: VIR. No other identification was necessary.

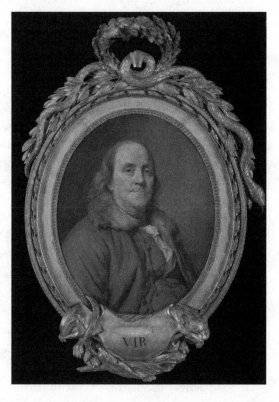

Joseph Siffred Duplessis, *Benjamin Franklin*, 1778

In addition to witnessing all that idolatry, Adams had to watch the infuriating spectacle of Richard Oswald, the aged British plenipotentiary at the 1782 peace conference, and his secretary Caleb Whitefoord fawn over Franklin during the negotiations and then, toward the end, purchase for themselves a total of five Duplessis portraits of Franklin, both originals as well as copies by Joseph Wright, to take back to Britain as gifts.

Franklin was everywhere. Medals were struck, tortoiseshell snuffboxes were fabricated, miniatures were nested in women's décolleté, wallpaper was hung, rings were fitted to pinky fingers, Quaker-style hats appeared on men's heads, and "lightning-conductor" dresses were designed with steel points connected to wires dragging on the ground.[47] Souvenir Sèvres medallions of Houdon's bust were sold at Versailles, "directly under the eyes of the King."[48] And one night when Adams went to the theater, a portrait of Franklin was put on display for the audience during intermission. Adams was so revolted that he left the theater, pretending to be sick, which in a psychological way he was.[49]

Adams knew from firsthand experience how deft Franklin was at managing his own everlasting image. How the Doctor meticulously, but seemingly naturally, fashioned himself for visual effect—the beaver hats, the natural hair, the plain speech, the folksy aphorisms, the simple clothing—and that effect was multiplied by paintings, prints, sculptures, and his own autobiography, where we encounter the Franklin that Franklin wanted us to encounter. Adams said bitterly that Franklin had "a Passion for Reputation and Fame, as strong as you can imagine, and his Time and Thoughts are chiefly employed to obtain it, and to set Tongues and Pens male and female, to celebrating him. Painters, Statuaries, Sculptors, China Potters, and all are set to work for this End."[50] And he knew how much Franklin reveled in the adulation. Franklin crowed to his daughter that hundreds of medallions cast with his profile, along "with the pictures, busts, and prints, (of which copies upon copies are spread every where) have made your father's face as well known as that of the moon."[51]

By contrast, Adams was not well served by his daily exchanges, diplomatic conversations, and personal letters in which he often seemed to be suffering from a charm bypass. He did not have Washington's battlefield acumen and disciplined self-control, nor did he possess the general's imposing physical stature and public presence. He had neither Franklin's calculated grace nor his intellectual ease. But at the same

time, Adams knew perfectly well, and also did not like, the fact that
image—the projection of character into the public sphere—contributed
to a person's effectiveness in the diplomatic world and his future admit-
tance to the temple of fame. In a telling sign of how much Adams was
affected by the culture of self-promotion, he made a half-hearted effort
to improve his wardrobe at the time of his return to the French court
in October of 1782, after his masterful negotiations with the ascetic
Dutch. He summoned a tailor to cut new clothes, a wig-maker to fit
him for a new peruke, and a shoemaker for fancy new buckles.[52] He even
took a bath in the Seine in order to freshen up.[53]

As he approached Versailles in November, during negotiation of
the Provisional Treaty of Peace, he wondered how he would be received:
with "an expostulation? A reproof? An admonition? Or in plain vulgar
English, a scolding?"[54] But instead of condescension he was exalted at
the French court for the first time. The war won and Britain defeated,
bygones were now bygones. At a dinner in the Salon de Guerre, Adams
was momentarily showered with previously unheard-of compliments:

> "When Dinner was served, the Comte [de Vergennes] led
> Madame de Montmorin, and left me to conduct the Comtesse
> who gave me her hand with extraordinary Condescension, and
> I conducted her to Table. She made me sit next her on her right
> hand and was remarkably attentive to me the whole Time. The
> Comte who sat opposite was constantly calling out to me, to
> know what I would eat and to offer me petits Gateaux, Claret
> and Madeira etc. etc.—In short I was never treated with half
> the Respect at Versailles in my Life."

He recorded every compliment in his diary: he had secured indepen-
dence, procured loans, and even "moved the world."[55] If that were not
enough, it was topped by the most spectacular tribute imaginable to an
American: "vous êtes le Washington de la Negotiation." Adams con-
fessed to his diary that the compliments "would kill Franklin if they
should come to his Ears."[56]

Tasting fame for the first time, Adams knew that he would have
to address his charisma deficit if he were to make himself less invisible.
After the heady celebrations of peace at Versailles, he spent most of
1783 in Paris sounding flat, unmotivated, irritable, and at loose ends.
In letters to Abigail he said that the definitive treaty with Britain was

turning out to be so like the Provisional Treaty of 1782 that the final push to closure felt anticlimactic, no more than a minor adjustment to what was already a diplomatic triumph. Knocking around Paris "Day after day, Week after Week, Month after Month," changing a few words in the treaty here and there and going through the motions of polite diplomacy, was just "idle, useless Time."

What he wanted in the autumn of 1783 was for Congress to send him on another urgent assignment to achieve something "of great importance."[57] His mind was spinning with possibilities: a commercial accord with Britain, perhaps, or negotiating a treaty with Portugal and Denmark, and maybe Russia, too. It could be an appointment to replace the ailing Franklin as Minister, or another foray to the Netherlands to make the case for a new loan. Or maybe there would be a command to just go home. The Congress might need him in Philadelphia, and certainly after four years' absence Abigail needed him back at Peacefield, their farm in Massachusetts. After signing the Treaty, he could "go home with infinite Pleasure."[58]

But he heard nothing. He had become accustomed to racing headlong through history, but admitted that now "I don't know what to do with myself."[59] Without orders or word of a new post from Philadelphia, he was paralyzed in the capitals of Europe, all of which required an official title—envoy, minister, ambassador—in order to accord him any diplomatic respect. He was betwixt and between, in a "ridiculous state of Torture."[60] Adams could not stop himself from reading Congress's inaction as professional disregard, a "Slur," an "affront," a personal insult that lessened his "Reputation and Influence."[61]

While they were neglecting him, legislators might at least have sent him some thanks—some "Smiles of Admiration"—for all his gritty work and breakthrough accomplishments over the previous three years.[62] But that too was absent. He felt wounded, betrayed by a Congress so riven with "Faction, Finesse and Intrigue," he wrote to Abigail early in 1783, that it could not organize itself around the simple task of acknowledging Adams and all that he had done.[63] "Stained and soiled" from the neglect, he was, for once, a man without purpose or cause, unmoored in a foreign land "with nothing to do but Think of my Situation."[64]

Adams knew he was in a black mood and complaining too much, which moved him to engage in some strained cheeriness. He resolved that he would look on the bright side. Surely, "when all is known," there would be "Laurels, Ornaments and Trophies" forthcoming.[65] He

speculated that he might make a "Tour to London."[66] He had never fully recovered from the malaria he had contracted in Amsterdam, for months complaining of being "feeble, low and drooping," suffering from swollen ankles, "Weakness in my Limbs, a Sharp humour in my Blood, lowness of Spirits, Anxieties."[67] His physician in Paris, James Jay, advised him to take the waters at Bath.

❖

His head swirling with conflicting thoughts—about art, nation, image, vanity, posterity, and the ever-irksome Franklin—Adams arrived in London on October 27, 1783, at first taking rooms at Osborne's Adelphi Hotel, a handsome neoclassical building designed by Robert Adam and set below the Strand near Covent Garden, with a commanding view of the Thames and the city. Perhaps, he wrote Abigail, he could convince her and their daughter Nabby to cross the Atlantic to visit him. He suggested there would be ample opportunities to "improve your Taste, by viewing these magnificent Sceenes. Go to the Play. See the Paintings and Buildings."[68] He did not know where his family might land, nor where he might be at the time, but he pictured himself hiring a hot air *globe aerostatique* from the intrepid Montgolfier brothers. He would just hop in, and "fly in one of them at the Rate of thirty Knots an hour" to meet her.[69]

After paying a visit to John Jay, who had also traveled to England after signing the Treaty of Paris, he moved out of the pricey Adelphi and resettled on October 29 in rooms over John Stockdale's bookshop on the south side of Piccadilly. Henry Laurens, his fellow plenipotentiary in Paris in 1782, had recommended it as a place hospitable to Patriot Americans. For Adams, Stockdale had impeccable credentials. He had printed and published the mezzotints after Copley's portrait of Laurens. Moreover, through his newspaper, the *London Courant*, Stockdale had a history of issuing American-oriented accounts of the Revolution, and his shop had been an undercover post office of sorts for communiqués between Americans and sympathetic Britons during the war. To a bibliophile like Adams, there was nothing quite as delicious as living over an English bookshop.[70]

Adams had imagined how unpopular he would be in postwar London. He had forecast that "Vanity, Pride, Revenge" would make his life among the defeated British a "Purgatory to me."[71] A few years earlier

he had written Abigail that the English press had it in for him; "They make fine work of me—fanatic—Bigot—perfect Cypher . . . Aukward Figure—uncouth dress . . . No Character—cunning hard headed Attorney."[72] But if anything, Britons were indifferent to Adams in 1783. Despite everything that had happened over the previous eight years, including the peace treaties he negotiated with Britain, the leading Whigs—Edmund Burke, Charles Fox, David Hartley, and the Duke of Portland—were only interested in offering Adams "cold formalities."[73] And only a few radicals, such as John Jebb and Richard Price, had enthusiasm for him.[74] It was a milder version of the sense of obscurity he had felt in 1778 when he first arrived in France and everyone thought he was "Le fameux Adams"—that is, Samuel Adams.[75]

He quickly discerned that in London the only notable American was Washington. Though many Britons had despised the Patriot leaders, especially the radical New Englanders who were thought to be raving fanatics, Washington was the object of genuine public admiration both during and after the war. The Whig press was adept at overlooking the fact that Washington had been lethal to Britain's North American empire and portrayed him instead as a brilliant and gracious gentleman-soldier in possession of virtues that were dear to Britons.[76] A January 1782 issue of the *London Chronicle*, for example, declared that Washington would "certainly be received by posterity as one of the most illustrious characters of the age in which he lived."[77]

Amid all the discordant thoughts swirling through Adams's fiercely anti-British head while he was in England, he was also proud to be renewing a friendship with his countrymen who had triumphed at the high end of the London art world. Adams had known and admired Copley since the 1760s in Massachusetts. He was familiar with the Copley portraits hanging in the homes of his friends and family, especially those of James and Mercy Otis Warren, John and Dorothy Quincy Hancock, John and Hannah Fayerweather Winthrop, Nicholas Boylston, and Samuel Adams.[78] In a diary entry dating back to August of 1769, he reported that "In the Morning I went to take View of Mr. Copelys Pictures"—portraits of Abigail Adams's aunt, Elizabeth Storer Smith, and her husband, Isaac Smith, a wealthy merchant in Boston whom Adams admired.[79]

Adams discovered when he got to London that Copley's stature was immense. Disgusted with the indifferent reception he had received from Britons, he was delighted to find that Copley and Benjamin West

"had more influence at court to procure all the favors I wanted."[80] West took him on a private tour of Buckingham House, and Copley obtained an invitation to the House of Lords to hear the King's speech at the opening of Parliament. Together, he wrote, the two painters did "so much honour to our Country."[81] Sixteen-year-old John Quincy Adams, who traveled with his father, visited Copley's studio, as well as those of Joshua Reynolds, Robert Edge Pine, and Patience Wright. To him, Copley's *Death of the Earl of Chatham* was "the most Remarkable of the Paintings We saw; it is very Beautiful."[82] West took the Adamses on two occasions to the Royal Academy, where they toured the antiquities gallery and attended a life class. To their shock, "there was a naked man standing and about 25 or 30 students taking his figure, either in drawing, or in plaister."[83] West then had Adams sit for his painting of the commissioners of the Provisional Treaty.

Adams could have left it at that with Copley, a rewarding renewal of a friendship with a fellow New Englander. During his brief time in the city, he could have commissioned a small portrait as an adequate souvenir, something to take home or to offer as a token of appreciation to the Dutch or the French. But Adams used Copley to achieve something else.

Adams knew what he was doing when he hired Copley to paint a colossal eight-foot-tall, full-length portrait for the price of one hundred guineas.[84] Abigail Adams recalled being told when she arrived in London in 1784 that Copley had approached her husband for the portrait, and that the picture was Copley's property.[85] But a 1783 receipt with Adams's signature on it, plus all subsequent events in the picture's history, reveal that Copley may only have asked for the honor of being retained to paint his distinguished compatriot's portrait.

Adams was ripe for persuasion. He had become a student of art by the old masters during his diplomatic missions in Europe, had thought long and hard about the appropriate role of art in a republic, and had reached the conclusion that for him invisibility was no longer a virtue, especially after all the homage showered on Franklin. Emotionally agitated and professionally at loose ends, Adams put self-discipline aside and threw himself into the project of creating honor for himself, of rectifying the snubs of the past, of indulging his orbiting vanity.

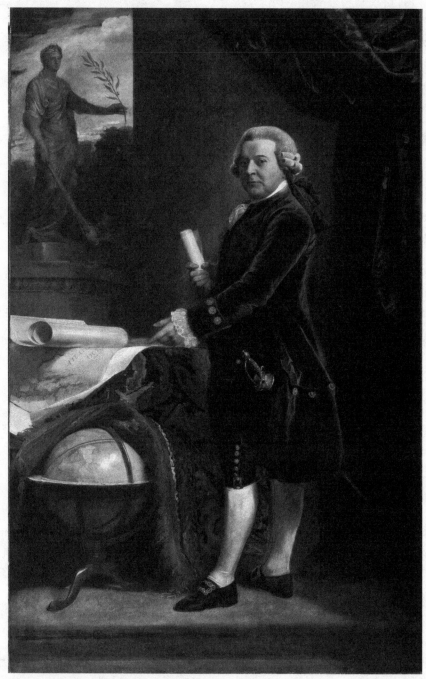

John Singleton Copley, *John Adams*, 1783

What emerged from the collaboration with Copley was a mammoth portrait spectacularly broadcasting Adams's significance. No one could overlook a picture so grand, nor now ignore the man who had valiantly waged peace abroad. For the once-in-a-lifetime event of having a portrait painted by "the greatest master that ever was," especially on the occasion of the peace Adams had helped broker, and seven years after the Declaration of Independence that he had helped write, the question of how he should look and be remembered was not a small one. Beneath a canopy of jade-green drapery, Copley's Adams stands full-length and sideways on a low platform, his head turned to us in an expression penetrating, proud, and determined, bordering on challenging. Light streams in overhead from the right to highlight his broad forehead, blue eyes, rounded cheeks, a cleft chin, and slightly downturned mouth. In his right hand he holds a small rolled document, perhaps a copy of the Treaty of Paris that he had just signed, or a copy of his memorial to the Dutch republic.[86]

As if interrupted in the midst of his diplomatic negotiations, he pauses for a moment to show a map of North America that is distinctively colored, pink for British territory, yellow for Spanish, and green for French. It is a freehand variant of the huge, four-by-six-foot *Map of the British and French Dominions in North America* that was published by John Mitchell in 1755 and that American and British plenipotentiaries used and repeatedly drew on in order to debate and define the contours of the new United States. Other documents, both rolled and partially unfurled, loll on top of the map. Below, a "Turkey" carpet has been hiked up and folded over to unveil a globe showing the vague contours of eastern North America gleaming in the rising sunshine of a new day.

Behind the table, a classical statue of Peace stands gracefully on a plinth before a cloud-streaked sky.[87] Adapted from ancient Roman coins Copley could see in the British Museum, Peace strides forward and extends an olive branch with her left hand, and with the right she reaches down with her torch to ignite the instruments of war: arms, armor, and shields.[88] Her pose aptly mimics that of Adams, one arm up and one arm down.

Though the setting is extravagant, Adams himself is dressed modestly. On the solemn occasion of a commemorative portrait, painted on a monumental scale for a diplomat who was the face of the United States in Europe, Adams deliberately chose for himself a plain but polished style—unmistakably a political decision. Ever since the First

Continental Congress, where he clashed with more elegant representatives who were tethered to high-style British taste, he was aware that dress had the unique power to broadcast messages about person and party, as well as character and class, and that every nuance of clothing and accessory was a marker of identity.

In one of his rants to Mercy Otis Warren he said that monarchies "produce So much Taste and Politeness, So much Elegance in Dress, Furniture, Equipage, So much Musick and Dancing, So much Fencing and Skaiting; So much Cards and Backgammon; so much Horse Racing and Cockfighting; so many Balls and Assemblies, so many Plays and Concerts that the very Imagination of them makes me feel vain, light, frivolous and insignificant."[89] Americans, he argued, needed to be inoculated against all that, and because "vanities, levities and fopperies . . . are real antidotes to all great, manly and warlike virtues," he made a case for reviving old sumptuary laws that regulated behavior and dress.[90] If Americans wished to live in a republic, "Virtue and Simplicity of Manners, [would be] indispensably necessary."[91]

Yet, when he was a diplomat in Louis XVI's France, the only way to gain traction at court was to accept fashion as the indispensably necessary. Franklin had consciously played to French expectations of Americans as eccentric or rustic by forgoing wigs and wearing simple "ditto" suits, all three parts of which were cut from the same piece of plain cloth. Adams, on the other hand, grudgingly caved in to the mode. "This nation has established such a domination over the Fashion, that neither Cloaths, Wigs nor Shoes made in any other Place will do," he noted in his diary.[92] His daughter Nabby noticed that in France her father, even with all his "firmness and Resolution," had to acknowledge "the mode."[93] When Abigail arrived in Paris, she confirmed the rule that "Fashion is the Deity every one worships in this country and from the highest to the lowest you must submit."[94]

In London, however, having no diplomatic agendas to pursue, Adams was free to have his one hundred guineas portray him the way he wished to be represented. On his head he wears a short wig, with his own hair tied up with a black bow. A lifelong observer and wearer of wigs, Adams had made note of the regional variations in European wigs upon his arrival in Galicia in 1779.[95] Working as a diplomat in the French court had forced Adams to be fastidious about grooming wigs, as evidenced by numerous account entries for 1779 and 1780 indicating

that he spent as much as forty-eight French *livres* to a "Peruquier, for dressing Mr. Adams's Wig, for Six Months."[96]

His court suit is expensive but subdued. Made out of brown velvet, it features large pockets, wide cuffs, and a flaring skirt, all of which was about ten years behind current English fashion. The only fancy items to be seen are the gold buttons and buckles, the quietly embroidered silk stockings, and a moderate amount of lace at the neck and wrist. That was plain when compared to the English standards of the day for a foreign secretary or diplomatic plenipotentiary. For an equivalent portrait, Adams's British colleagues were typically decked out with garter ribbons, contrasting waistcoat, red and gold trim, and medals of honor. But not Adams, in part because he did not have such things, but also because any sort of regalia would undermine the preferred look of a simple man of the new republic.

As much as any of the Founders, Adams was an avatar of the philosophy that plain living was the outward sign of high thinking.[97] When, for example, young Elkanah Watson arrived in Europe for business and diplomacy in 1780, Adams advised him to "cultivate the Manners of your own Country, not those of Europe," which necessitated "a Manly Simplicity in your Dress, Equipage and Behavior."[98] When Adams himself went to Versailles for the first time in 1778, in order to negotiate with Foreign Minister Vergennes, he proudly wrote in his diary that he wore "my American Coat."[99] It was a distinctly un-European look, one that tossed aside the imperial pageantry once seen in all the portraits that hung in civic buildings and private homes in every colonial capital of America. But with Britannia now vanquished, the time had come to unveil the new republican temperament of the United States and its plain-style leaders.

Washington told a young nephew that he should "not conceive that fine Clothes make fine Men, any more than fine feathers make fine Birds. A plain genteel dress is more admired and obtains more credit than lace and embroidery in the Eyes of the judicious and sensible."[100] No pomp, no opulence, no splendor. In reality, such a utopian goal would prove to be elusive in the postwar "scramble for wealth and status" in America.[101] But for the American diplomat abroad, it was imperative to project a distinct American style of etiquette and protocol.[102] And for Adams specifically, Copley's studio provided the opportunity to make visible the American idea of republican discipline. As Abigail once put it, better to wear the "plain vestures of our own Manufactury" than to be seen "in all the gaudy trapings that adorn the slave."[103]

At Adams's hip is a gilt-trimmed sword, the kind that dignified gentlemen wore as an accessory, especially at diplomatic occasions.[104] It is nothing out of the ordinary; a similar one is worn by Henry Laurens in Copley's portrait of 1782. But Adams's sword gets special attention within the constellation of objects in the picture. Its long scabbard balloons out the backside of his coat. The polished hilt, by far the most finished passage in the entire picture, glistens against the dull brown of his suit. The line formed by the sword is also a part of a diagonal that links up with the torch held by the statue of Peace, which in turn intersects another line running from Adams's shoulder, down his left arm, and along the edge of the unfurled map of the United States. Together, the two diagonals form a large X at the center of the picture.

The extra attention accorded his sword discloses Adams's faded dream of being a military man, instead of a lawyer and diplomat. During the French and Indian War, at a time he was occupied as a Latin teacher in Worcester, he "longed more ardently to be a Soldier."[105] He could have joined, but never did, which he thought was a sure sign of his worthlessness and inadequacy, proof that he lacked manliness and courage. That feeling cropped up again after the skirmishes at Concord and Lexington when Washington arrived in Congress wearing a striking blue and buff uniform. "Oh that I was a Soldier!" he lamented to Abigail. "I will be.—I am reading military Books.—Every Body must and will, and shall be a soldier."[106] Adams never did enlist because he did not actually want to experience battle. But he talked about being a warrior a great deal. He said he would join the Massachusetts militia, defend Philadelphia from the British invasion of 1777, and "meet them in the Field" of battle, if necessary.[107] But deep down, he was always going to be a civilian, a man of mental instead of physical action.

What was attractive to him about the military was not the chance to experience danger or bravery or victory. It had more to do with the prestige and glamour that came with being an officer. The uniform, the "Pride, Pomp and Circumstance of Glorious War." The "Gun, Drum, Trumpet, Blunderbuss and Thunder." As he imagined it, it was all "Grand and sublime."[108] Tellingly, he rode with Generals Washington, Charles Lee, and Philip Schuyler for "a little Way" on their mission to Boston to engage the British in 1775. And then he rode back to his desk in Philadelphia and wrote to Abigail: "The Three Generals were all mounted, on Horse back . . ." He could see how his fellow Congressmen bid them farewell, marvel at the adulation pouring out from the citizens

of Philadelphia, and be stirred by the fifes and drums that played as they departed. "Such is the Pride and Pomp of War," he penned to Abigail with guilt and envy. "I, poor Creature, worn out with scribbling, for my Bread and my Liberty, low in Spirits and weak in Health, must leave others to wear the Lawrells which I have sown."[109] Abigail, seeing the three generals upon their arrival in Massachusetts, wrote back to console her desk-bound husband, whom she understood perfectly. "I pity your Embaresments," she empathized, but surely "there is a future recompence of reward" to those who work behind the scenes.[110]

Nonetheless, Adams carried the scars of his humiliation, resentment, and longing into Copley's studio. He had convinced himself that he had been a warrior of a different sort, one who was "running dayly Risques of my Life" as a diplomat and legislator. Some months before he arrived in Copley's studio, he breathlessly wrote to Cotton Tufts, a physician in Massachusetts, about "what storm, what Chases, . . . what Mountains and Valleys, what Fatigues, Dangers, Hair Breadth scapes, what Fevers and Gouts, have I seen and felt!"[111] His fight had been on the diplomatic front lines in Amsterdam and Paris, and in his portrait he flashes his gilt court sword as if it were like one of Washington's forged-steel battle swords, a public emblem of honor and fame. He knew that Congress was busily awarding honorary swords to the great military men of the Revolution in recognition of their valor. One went to the Marquis de Lafayette, and another, with a gold hilt, to Baron von Steuben.[112]

In planning his epic portrait of Adams, Copley drafted his first ideas on a nineteen-by-fourteen-inch piece of blue paper that is squared so as to make transfer to the large canvas easier. Worked in pencil and chalk,

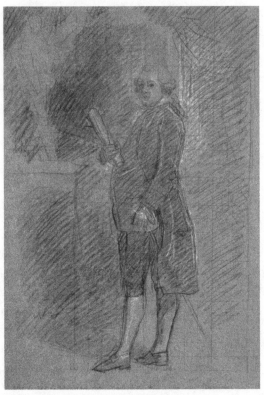

John Singleton Copley, *John Adams*, 1782

the drawing tells us that he had originally planned to cover the sword hilt with Adams's left hand, which is dropped to his side. That means the decision to highlight the hilt was made during conversations that took place after Copley showed the sketch to Adams. Other key changes were also made at that time, including the addition of the table, map, and globe. He enlarged Adams's head and tightened his waist. He also changed the angle at which the sword hangs. Instead of dropping limply toward the floor, it shoots backward so vigorously that it lifts up his coattails.[113]

By raising Adams's left arm and pointing to the map, Copley converted him from a passive to an active pose. Moreover, he changed the expression on his face, subtly moving the look from diffident and shy to self-assured and engaged. In making those changes, Copley dipped back into his portfolio of works from Boston and resuscitated the design of his fierce portrait of Samuel Adams. Side by side, the cousins both hold rolled documents in their right hands, point left index fingers at more documents on a table, and rotate their heads toward the left shoulder so as to look the audience square in the eye. As a stunning result, Copley connected the two men, both as blood relatives and as ideological kin. One was the firebrand of the revolt that pushed America toward independence, and the other was the mastermind of the diplomacy that brought America recognition and peace. Together, they were the formidable bookends of the American Revolution.

A dams should have been pleased by the picture. He paid Copley the one hundred guineas on December 10, 1783, and for that he got a portrait that convincingly made the case for Adams's defining significance in American history and world diplomacy, enough of one that it ought to have quelled his considerable vanity and envy. He could also have been pleased by the accuracy of the image. Copley had gone to some length to get the proportions of the anatomy as correct as possible. According to John Quincy, he had used calipers to measure "every part of the face with care, and also the length and thickness of the arms and legs and the body generally. He took great pains with it."[114]

For any accomplished portraitist, getting it right was part of achieving believability. In the scientific thinking of the eighteenth century, that degree of precise measuring was reserved for the metrics of a great

man. Whether that was Washington's forehead or Adams's cleft chin and round head, the proportions of the face were thought to be the visible expression of enduring moral character.[115] Copley may have made a few adjustments to Adams's measurements here and there, but no less an authority than Abigail confirmed the physical truth of the portrait, declaring it a "very good Likeness" and "a most Beautifull painting" when she arrived in London in 1784.[116]

In short order, however, Adams became disenchanted with his colossal picture. From Holland in 1784 he instructed his son to have Copley "get a Frame made for my Picture," and then John Quincy ought to "give him the Money" for it. Adams asked for a special frame capable of being broken down into pieces "so that it may be removed to The Hague or to Boston," presumably as a gift to the Dutch or to take home for public display. But in the end, he left the picture where it was, abandoning it to Copley, who held it in his studio, where it would remain until his death in 1815. "Thus," Adams wrote to John Quincy, "this Piece of Vanity will be finished. May it be the last."[117]

The issue was not the quality of the work or Adams's vanity gone unfulfilled, but rather his epic vanity being monumentally broadcast to the world. Instead of signaling civic virtue, the portrait ended up advertising personal achievement. Statecraft was stagecraft, and Adams knew the regal staging of his image was proclaiming the low trait in public men that he had decried in his political writings. In even the best societies, Adams was forced to conclude, there was among ambitious men a *"passion for* distinction. A desire to be observed, considered, esteemed, praised, beloved, and admired" throbbed "in the heart of man."[118] Though the suit of clothing he wears in the picture may have been appealingly modest, the full-bore Baroque setting spoke volumes about Adams's sense of his own importance. It was eight spectacular feet of compensation for all the neglect he thought he had suffered. But now that he had it, he could see his ego leaking out conspicuously.

Perhaps he would have reacted differently to the same portrait if it had been commissioned by a state legislature or someone assembling a gallery of fame. But Adams could not escape the fact that he had laid out one hundred guineas for his own deification, that he was the stage manager of his own gaudy commemoration. Having scanned hundreds of European portraits over the past five years, he knew by contrast that a republican portrait conveyed selflessness, virtue, and civic spirit, qualities in short supply in Copley's aggrandizing image. "Did you ever see a

portrait of a great man," he asked Jefferson years later, "without perceiving strong traits of pain and anxiety?"[119] In his own portrait there were no visible signs of the concerned, humble, sacrificing man of simple but honest values who could legitimately claim to be the embodiment of republican virtue.

Copley's painting, accurate as it was in capturing Adams's inner needs and outer physique, did not depict the man John Adams wanted to be, or wished to be remembered as. However much he resented his invisibility, especially when compared to the honors heaped on Washington, Jefferson, and Franklin, he ended up with an image of postured falseness and conspicuous grandiosity that ultimately seemed wrong to his eyes and heart.

❊

In spite of Adams's desire to forget the picture, it had numerous afterlives. The first was in prints. In 1786 *The New London Magazine* engraved the figure from the waist up for a two-page biography of Adams. A few years later, Copley himself politely asked for Adams's consent to make his own engraving. He assured Adams that the politics of the times had changed so as to "insure it an honourable reception *in this Country*, as well as America."[120] But nothing came of the project. In 1793 John Stockdale was getting ready to publish the first British edition of then Vice President Adams's three-volume *Defence of the Constitutions of the Government of the United States of America*, in which he made his argument for a bicameral legislature and a system of checks and balances. Stockdale asked Adams if he could reproduce Copley's portrait on the frontispiece. Adams quickly recognized the irony that would result from a book in which classical political theory meets Baroque image of the author. He consented, but only grudgingly, telling Stockdale that "I should be much mortified to see such a Bijou affixed to those Republican Volumes."[121]

In 1796, Copley sent the eight-foot portrait to the annual exhibition of the Royal Academy. There was no commentary on the picture in the London press, though John Williams, a satirist writing under the pseudonym of Anthony Pasquin, surveyed the rows upon rows of heroic pictures and wickedly concluded "Fame *is a Lyar!*[122] That was something Abigail already knew and had warned her vulnerable husband against in 1781: "I know the voice of Fame to be a mere weathercock," she wisely counseled, "unstable as Water and fleeting as a Shadow."[123]

Adams may have been done with Copley's portrait, but he was not

done with Copley. If anything the relationship between the two men deepened when Adams returned to London in 1785 as Minister to the Court of St. James's. Adams and his family dined at the Copleys' George Street home, where he could revisit his giant portrait. He sympathized with his friends' recent loss of two children, and made a point of mentioning Copley by name in the preface to his *Defence of the Constitutions*. Abigail had gone to see Copley's *Death of the Earl of Chatham*, which moved her to write two lines of verse adapted from Alexander Pope: "Copely! By heavn and not a Master taught/ Whose Art was Nature, and whose pictures thought."[124] She and Susanna Copley became close friends, their visits together affording Abigail an opportunity to complain about being snubbed at court and forced to hand-stitch John's shirts because Congress was too cheap to pay him properly.[125] Adams had Copley paint his daughter Nabby's portrait, and when she became engaged to Colonel William Stephens Smith, only the Copleys were let in on the secret.[126] At the wedding ceremony in the summer of 1786, the Copleys, whom Abigail described as friends of "delicate manners, and worthy good people," served as witnesses.[127]

In 1796, Copley painted a handsome portrait of twenty-eight-year-old John Quincy Adams while he was in London courting Louisa Catherine Johnson. Susanna Copley had commissioned it as a "token of remembrance and regard," to be sent to Abigail Adams in the United States.[128] John Quincy recalled seven sittings with Copley, during which the conversation with the artist was "political, metaphysical, and critical," though perhaps "not accurate," yet nonetheless "well meaning."[129] Abigail was surprised by the gift, which arrived in 1797, at the outset of John Adams's presidency. "It is allowed to be as fine a portrait as ever was taken," Abigail wrote, "what renders it peculiarly valuable to me is the expression, the animation, the true Character."[130]

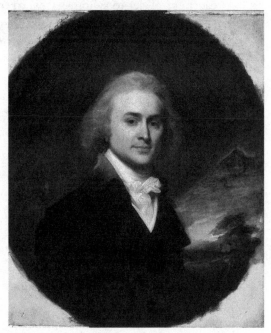

John Singleton Copley, *John Quincy Adams*, 1796

❧

Copley's studio was something of a destination for other Americans coming to London. Jonathan Jackson, a New Englander described by Abigail Adams as a "Gentleman in the Mercantile line" and "possessed of a most amiable disposition," had been a supplier to the Continental Army and a delegate to the Continental Congress. [131] In 1783 he went to London on business, renewed his friendship with Copley, and had his portrait painted. Winslow Warren, the son of Adams's dear Patriot friends, James and Mercy Otis Warren, who were both painted by Copley in Boston, went to London and had his portrait painted in 1785. Abigail Bromfield, the wife of Boston merchant Daniel Denison Rogers, was described by Abigail Adams as having "too much of 'the tremblingly alive all over' to be calculated for the rough Scenes of Life."[132] She went to London "in Hopes of reestablishing her Health which has for a long Time been much impair'd," and had Copley paint her a spectacular portrait.[133]

For the most part, however, Copley would let his American identity recede into the background in the late 1780s. As well as anyone, he could see that Britain's crushing defeat at the hands of the Americans was causing politics to swing sharply to the right. Those who had failed the empire—General Thomas Gage, General William Howe, Lord Cornwallis, General Henry Clinton, and others—had become loathsome and soon were forgotten.[134] But those who succeeded at Gibraltar and the Caribbean were celebrated because they proved that Britain was not a crippled empire, that it still had effective leaders and cultural willpower.

With the notable exception of Joshua Reynolds's portrait of Lieutenant Colonel Banastre Tarleton, whose tactics in South Carolina were dazzling, brash, and cruel, British artists avoided subjects from the disastrous North American theater of war, instead focusing their attention on the collateral conflicts with France and Spain. The 1784 exhibition at the Royal Academy was loaded with subjects from British victories in every place except America.[135] Admiral George Brydges Rodney, who first defeated the Spanish fleet at Gibraltar in 1780 and then broke the French navy in the Caribbean in 1782, was lionized in pictures by Thomas Gainsborough, Joshua Reynolds, Robert Edge Pine, and George Carter.[136]

General George Eliott, later Lord Heathfield, who had successfully defended the British fortress at Gibraltar, became an English hero on

the same magnitude as General Washington in America. In 1783, the city of London offered Copley a commission to depict General Eliott's defense of Gibraltar on a scale that was nothing less than gargantuan. Not finished until 1791, the picture shows the last moments of the siege when Eliott, on horseback, rides to the edge of the battlements, and in a humanitarian gesture directs the rescue of defeated Spanish sailors.

While Adams was having his portrait painted by Copley, he would have seen Copley's British masterpiece, *The Death of Major Peirson*, take shape in the George Street studio. An extremely bold and vigorous picture, it shows the British successfully repelling the French invasion of the island of Jersey in 1781, a uniquely European episode of the American Revolution.[137] The picture created a sensation in London when it was exhibited in 1784, in part because of Copley's stunning ability to "excite pity and horror in the mind of the spectator like the tragedies of Shakespeare," according to the *General Evening Post*.[138] Copley adroitly aroused the dormant pride of Britons by spotlighting the heroics of Major Francis Peirson, who impulsively led his garrison against the invading French and died a martyr protecting British soil. The picture was the perfect antidote to the lingering self-incriminations that had followed Britain's stunning failure to hold on to its prized American colony.

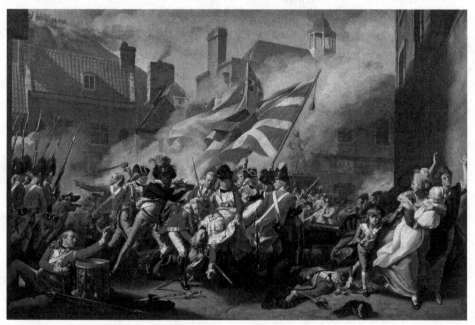

John Singleton Copley, *The Death of Major Peirson, 6 January 1781*, 1783

Its exhibition was such a rousing event in London that even Abigail Adams could not resist its allure. She joined the crowds that went to see it in July of 1784 while it was hanging in the Great Room at 28 Haymarket, and was nothing less than overwhelmed by the experience. "I never saw a painting more expressive than this," she wrote to her sister back in Massachusetts. "I lookt upon it untill I was faint, you can scarcly believe but you hear the groans of the sergant who is wounded and holding the hankerchief to his side, whilst the Blood Streams over his hand. Grief dispair and terror, are Stongly marked, whilst he grows pale and faint with loss of Blood . . . But my discriptions, of these things give you but a faint resemblance of what in reality they are."[139]

If there were any lingering questions about Copley's British credentials because of his patriotic portraits of Adams, Watson, and Laurens, the *The Death of Major Peirson* put them to rest. The painting made Copley the toast of the town. Given his squeamishness over politics, he predictably closed the door on any further patriotic American gestures. With all the hyper-nationalism gripping Britain in the 1780s, it would have been foolhardy to risk his reputation by continuing to paint or exhibit American subjects in London.

Copley was certainly free to return to Boston. He was the greatest artist ever seen in America and there would be no artist of his stature to paint in that city until Gilbert Stuart's arrival in 1805. If he had gone back, he would have received countless commissions for portraits and the opportunity to paint the Revolution for a national audience. But after a decade abroad he was not quick to abandon his high position among the great painters of London, the capital of the English-speaking art world.

Nonetheless, in the 1790s Copley began experiencing setbacks. Despite his successes, he was never able to fully integrate himself into the clubby atmosphere of the Royal Academy, which led to persistent friction with West, who had become its second president in 1792. The splash he had made in the London art world in the 1770s and 1780s, with *Watson and the Shark, Chatham,* and *Peirson,* seemed to dissipate in the 1790s because of the nine long years it took to paint his grand and interminable *Gibraltar,* which was followed by two more years of squabbling with the Corporation of London over his fees for the picture. He hoped to make money from the print of the painting, but that too was endlessly delayed. Another ambitious historical picture, of Charles I accusing five members of Parliament with treason, took fourteen years

to complete and when it was unveiled it met with public indifference. Money became scarce, his George Street home was heavily mortgaged, his family was growing up, and he started thinking about the possibility of returning to America.[140]

When his son John Singleton Copley Jr., who later became Chancellor of Great Britain, toured America in 1796, his primary objective was to recover Mount Pleasant, the family's eleven-acre estate on Beacon Hill, with the idea that the Copleys could return to it.[141] The elder Copley asked his half-brother, Henry Pelham, for a surveyor's map of the property, and asked his son to investigate how he might now become "a subject of the United States."[142] Lawyers were hired, money was exchanged, deeds prepared. Young Copley assured his father that in America "you would find your profession more profitable than in England . . . the state of society and of government would be more congenial to your inclinations, and nothing but the difficulty of moving seems to stand in the opposite scale."[143]

His letters to London painted an enticing picture of an America much changed from the one Copley knew before the Revolution. Young Copley wrote about watching Charles Bulfinch's Massachusetts State House go up, witnessing the debate over the controversial Jay Treaty in Philadelphia, relaxing in refined company, glimpsing the nascent "federal city, Washington," celebrating the Fourth of July with "sports and rejoicings," and spending a week at Mount Vernon with Washington and a visiting party of Catawba Indians.

Young Copley might also have reported to his father on the changed state of art in America. Gilbert Stuart had returned to America in 1793 in order to paint Washington on the same scale on which Copley painted Adams. The son could have told his father the tale of Trumbull's portraits of war heroes being commissioned by the cities of New York and Charleston. Or of Charles Willson Peale's expanding gallery of great Americans in Philadelphia. Or of efforts to start up art academies. When Copley finally put his *John Adams* on display at the Royal Academy in 1796 and began an effort to get a print engraved for the American market, he was in effect laying the groundwork for his return to Boston. But in the end, Copley's son was never able to reclaim the Beacon Hill property. Other locations were discussed, but Susanna Copley announced her preference for life in London, leaving Copley to resign himself "with deep pain and mortification" to finishing his career in England.[144]

It is impossible to speculate on what Copley might have painted had he returned to America. But surely he would have taken his portrait of Adams with him. The painting would have logically been one of the works to be showcased in a new Boston studio as part of his second American act. Adams had been elected president in 1796, in the same year that Copley's son scouted properties in New England, and if the picture had crossed the Atlantic then, it would have been the irresistible companion for the other great American portraits of the Revolution and Founding: Peale's *Washington at the Battle of Princeton* of 1779 and Stuart's full-length *Lansdowne Washington* of 1796. Together they would be the new faces of America: the military commander who achieved the impossible by defeating the British war machine, the diplomatic warrior who fought for American prestige and sovereignty in the capitals of Europe, and the first president of the new republic.

Instead, Copley remained in London, his skills declining after 1800. According to John Quincy Adams, Copley's portrait of his father spent sixteen years in the print shop of James Heath, an engraver in London. In 1811, John Quincy thought it should be shipped to Boston and "placed in a large hall of a public building."[145] But it was not until 1817, two years after Copley's death, that his widow shipped it via the *Galen* to Boston, where it was hung in the home of Ward Nicholas Boylston because the Adams house in Quincy could not accommodate its height. Boylston in turn bequeathed it to Harvard College in 1837.[146]

7 ⌒৵

John Trumbull's Martyrs

JOHN TRUMBULL OF LEBANON, CONNECTICUT—TWENTY-SEVEN
when the Treaty of Paris was signed—had no ambivalence about the
rightness of the Revolution, no conflict over his identity as an American,
and little temptation to shut down his strong political sentiments for the
sake of advancing an artistic career. His Patriot credentials were impec-
cable. His father, Jonathan, the only colonial governor to support the
Revolution, was a friend and advisor to George Washington. At Gover-
nor Trumbull's death in 1785, Washington eulogized him as "amongst
the first of Patriots."[1] One brother, Jonathan Jr., served as Paymaster to
the Continental Army for the first part of the war, and then as Comp-
troller of the Treasury and military secretary to Washington. Another
brother, Joseph, was Commissary General, assigned the daunting task
of provisioning the Continental Army. One sister, Faith, married Jedi-
diah Huntington, who fought at Bunker's Hill and became a Brigadier
General. Another sister, Mary, married William Williams, a delegate
to the Continental Congress. The family name was so thoroughly syn-
onymous with the United States that a newly commissioned thirty-gun
frigate was christened the *USS Trumbull* in 1776.

Trumbull drew pictures as a child, despite blindness in his left eye,
the result of a fall when he was five or six. At the age of fifteen, on his
way from the family home in Lebanon to his freshman year at Harvard
College in January of 1772, Trumbull made a visit to John Singleton
Copley's house, where he met "an elegant looking man, dressed in fine
maroon cloth, with gilt buttons—this was dazzling to my unpracticed
eye!" Even more impressive was the sight of the paintings hanging in
Copley's Beacon Hill home, which "riveted, absorbed my attention, and
renewed all my desire to enter upon such a pursuit."[2] Trumbull's father
had wanted his youngest son to prepare for a respectable life as a minis-
ter or a lawyer, both thought to be learned careers infinitely more secure
than the uncertainties experienced by the average American painter
who moved from one hire to another in ragged sequence. Governor
Trumbull had warned his son's Harvard tutor that he was aware of the

boy's "natural genius" for painting and that he "frequently told him [it] will be of no use to him."[3] But Trumbull's infatuation with Copley and the possibilities of painting were just beginning.

At Harvard, he quickly discovered the many Copley portraits hanging in the "Philosophical Chamber," and took extracurricular steps toward an international career as a painter by surreptitiously studying French with an Acadian family in Cambridge and by reading books on art theory and ancient Greek sculpture.[4] He copied Copley's portrait of Harvard President Edward Holyoke, made a watercolor from a Peter Paul Rubens print of the Crucifixion, and had enough nerve to show Copley his rough version of a French painting of Rebecca, a subject taken from *Genesis*, which he said the master "commended."[5] Trumbull even audaciously proposed to his father that family money could be saved if he dropped out of college altogether and apprenticed himself to Copley instead.

While he was in the Boston area, Trumbull also took unofficial seminars in the school of radical politics. He had arrived in the tense aftermath of the Boston Massacre of 1770, which soon led to the spectacular trial of the offending British soldiers and officers, who were successfully defended in British court by John Adams and Josiah Quincy. While he was at Harvard in the summer and fall of 1772 he could see the news in the local press about the repercussions from the Sons of Liberty burning the *HMS Gaspée*, a reviled customs ship policing New England ports. Later that year, the streets of Cambridge and Boston were cluttered with broadsides from Samuel Adams's new Committee of Correspondence, which demanded the British respect "the rights of the colonists, and of this province in particular, as men, as Christians, and as subjects." One of the Committee's most radical members was Dr. Joseph Warren, who issued a "List of Infringements and Violations of Those Rights." Trumbull would devote a future painting of the Battle of Bunker's Hill to Warren's valor. In the semester before graduation in 1773, Trumbull heard the public outcry in Boston and Cambridge over the new Tea Act, which gave consignees of the East India Company, one of whom was Copley's father-in-law, exclusive right to sell tax-free tea in America. Political agitation grew by the week, leading to the convulsive and decisive Boston Tea Party of December 16, 1773.

Trumbull was hooked. While Copley was booking passage for London in 1774, Trumbull "sought for military information; acquired what knowledge I could." Back home in Connecticut, he formed a small

militia company of his own. "We taught each other, to use the musket and to march, and military exercises and studies became the favorite occupation of the day."[6] His father, still technically a British official at that point, invited his son to gatherings at which Patriots engaged in "ardent conversation" over what course of political action to take against the Crown.

At the same time that he was becoming politically aware, Trumbull discovered the compelling analogies between the gathering crisis of America and the stories of the Roman republic that he had studied at Harvard. By far the best educated of all the artists of the Revolutionary generation, he instinctively turned his classically trained mind to thoughts of Roman leaders like Lucius Junius Brutus, who founded the republic and was killed protecting it. Moreover, he believed that visual images went hand-in-hand with revolutionary politics—so much so, that for his first independent painting in 1773 the subject he chose was the mortally wounded Lucius Aemilius Paullus giving up his horse to a tribune so that he might reach Rome in order to alert citizens to the deadly threat posed by Hannibal and his invading army. That kind of self-sacrifice would soon become a hallmark of the Revolution and his paintings of it. While the painting of Lucius Paullus is small, the action stilted, and the technique amateurish, as might be expected from an untrained artist, Trumbull's ambition was colossal.

Trumbull said later in life that after the skirmish at Lexington in April of 1775 "the blood of our brethren cried from the earth."[7] Within the Trumbull family, political talk quickly turned into military action. His father began procuring guns and ammunition for Connecticut, and his brothers entered the war effort as civilian contractors. Trumbull himself joined the Connecticut First Regiment, which deployed to Roxbury, Massachusetts, a location with clear sightlines eastward to British-occupied Boston and Massachusetts Bay.

While standing guard on June 17 he was startled to hear cannon fire coming from the British warships in the harbor. Twelve hundred American soldiers had been spotted on the hills of Charlestown, to the north of Boston. The American advance toward Boston prompted the British to unleash their 128 shipboard cannons in a devastating firebombing of Charlestown, followed by a massive land assault up toward Bunker's Hill that was directed by Generals William Howe, John Burgoyne, and Henry Clinton. The horror-struck Trumbull could hear the British cannonade and with field glasses he could see that "the blazing ruins of the

town formed altogether a sublime scene of military magnificence and ruin."[8]

That same devastating attack caused Abigail Adams, nine miles to the south, to climb to the top of Penn's Hill in Braintree with seven-year-old John Quincy to watch the arcing fireballs and listen to the "constant roar of the cannon," which was "so distressing that we can not Eat, Drink, or Sleep." She knew, as did Trumbull, that "perhaps the decisive Day is come on which the fate of America depends." Unlike the skirmishes at Lexington and Concord, the Battle of Bunker's Hill not only demonstrated the awesome power of the British military, it also announced the British willingness to use it wantonly against their own people. This was the real start of the Revolutionary War. May "Almighty God," Abigail wrote to her husband in Philadelphia, "cover the heads of our Country men."[9]

A month after the British pushed the Americans out of Charlestown, Washington arrived in Cambridge to take command of the Continental Army. Thanks to family connections, Trumbull was given the task of providing Washington with views and plans of the British installations protecting occupied Boston on its vulnerable south end. That set off a series of promotions and assignments for Trumbull: appointment to the position of Washington's second aide-de-camp, and then to major in a regiment stationed in Roxbury, followed by a mission to join Washington's troops in the tactical seizure of Dorchester Heights that in turn forced the British to evacuate Boston.[10] When reassigned to New York City, he joined the army of General Horatio Gates, was promoted to colonel, and proceeded to Albany, Crown Point, and Fort Ticonderoga at the south end of Lake Champlain, where he and Thaddeus Kosciuszko rebuilt the old fortress into "the Gibraltar of America." He then joined Washington before the crossing of the Delaware, got reassigned to the mercurial General Benedict Arnold, and continued with him to Providence in order to liberate Rhode Island. He was twenty years old.

And then he abruptly resigned in February of 1777 over a misunderstanding with Congress about the true starting date of his commission as a colonel. Feeling "*Insulted*," he vowed he would "lay aside my cockade and sword" unless Congress did something to redress his grievance.[11] Congress wrote back, applauded his "Manly Sensibility," told him that "General Gates is attached to you," then explained the unintentional confusion and agreed to accept Trumbull's demand that his commission be backdated to June 28, 1776, if, and only if, he abandoned the arrogant

and insubordinate "style and manner of your demand."[12] Trumbull flatly refused to do so, adding in a letter that "there is not a sentiment or word which I wish altered."[13]

Washington was alerted to his resignation and Congress tried to placate him again, but Trumbull was too miffed to overlook the supposed "affront," having mistaken his petulant ego for true honor.[14] And with that retort, he ended a promising career in the military, just as the most defining events of his era were unfolding. As he walked away from it all, he shot a final riposte to Congress, claiming his military service was "a subject now of perfect indifference to me," a false statement coming from a man who would forever wrap himself in the aura of his Revolutionary service and wish to be called Colonel Trumbull.[15]

In short order he put on his civilian clothes and moved to Boston, which he had helped liberate only recently. There he founded a politics-and-literature club with Rufus King, Royall Tyler, and other Harvard graduates, and picked up his painting career. Renting a studio on Queen Street once belonging to John Smibert, a Scotsman and the first British-trained artist in America, he made drawings and paintings after European pictures, some of them historical and others of timely subjects, such as a portrait of Benjamin Franklin in a fur cap and a copy of the 1776 Charles Willson Peale portrait of Washington hanging in John Hancock's Beacon Hill mansion.[16]

Looking around, he felt that war had made Boston into a city deranged by political hysteria. Loyalists were being persecuted, citizens were obsessively singing psalms, conspiracy theories filled the air, and all that drumbeating, he said, was being carefully orchestrated by Hancock and Samuel Adams.[17] Political agitation in the city must have had an effect on Trumbull because he suddenly decided to re-enter the military, feeling a "deep and settled regret" over how he had left the field of battle. As a volunteer aide-de-camp, he saw action late in 1778 against the Hessian troops at the inconclusive siege of Newport, notable for its "Black Regiment" of eighty-eight former slaves, but his involvement was short-lived. Just as quickly as he joined the militia he left it, doubling back once again to painting.

After his final tour of duty, Trumbull produced portraits of himself, his parents, and his brothers which in format and style are like amateur versions of Copley's pictures. He also painted a significant military portrait of the sixth-century commander of Justinian's Byzantine army, Belisarius, a famous general who defended Constantinople from the invading Bulgars

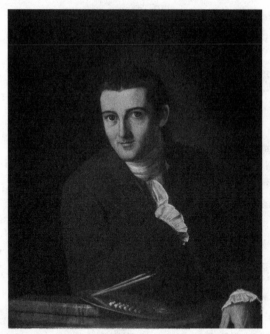

John Trumbull, *Self-Portrait*, 1777

and who wrested the old Roman Empire away from the occupying Ostrogoths, but who was then falsely accused of corruption, blinded for his crime, and forced into beggary.[18] Such was the fleetingness of wartime fame.

From an early age, Trumbull had come to the conclusion that many tragic turns of fate occurred during wartime, and later in life he recalled the heartbreaking episodes he witnessed on the battlefield. He saw the French Colonel Louis Toussard get an arm blown off while quietly standing near a field cannon, and Lieutenant Richard Walker felled by a musket ball that ripped through his body, yet able while dying to offer Trumbull a "melancholy farewell." He watched a friend at first avert a cannon ball, only to have another ball roll over his foot and crush all the bones. These episodes proved his heartfelt belief that "there is a providence which controls the events of human life."[19]

With the Revolution at its apex in 1779, Trumbull decided to travel to George III's London in order to study painting with Benjamin West.[20] Improbable as that sounds, Trumbull was so set on the idea that he was willing to walk away from the theater of war and hazard the risk of living in England in the year after the British were left reeling from the grotesque marriage between their American colony and their archenemy, France. That was an unspeakable betrayal to the British. Trumbull's curious timing also coincided with the expansion of the war across the globe, spreading to the Caribbean and India, as well as across North America. Trumbull was anything but naïve. He could not have been oblivious to the perils to be encountered in London by a former American military man with English blood on his hands. But he had assurances from Bostonians who had connections to the British Secretary of State George Germain that he would be "unmolested" if he scrupulously restricted his activities to the fine arts.

Even with the promise that he would have the status of a toler-
ated rebel, Trumbull was warned by British authorities that he "must
remember that the eye of precaution would be constantly" observing
him, and that he must avoid "all political intervention."[21] To forestall any
accusations that he was a combatant or a spy, he equipped himself with
a discharge letter from Washington describing the scope of his former
duties. At the same time, he hatched a business plan for exporting goods
from Connecticut to France and Holland that, in turn, could be bar-
tered into military clothing, woolens, and linens that he would then ship
back to America and channel into the Continental Army.[22] He seems to
have been arrogant enough or courageous enough to overlook the fact
that in the eyes of the British the outfitting of American soldiers might
constitute "political intervention."

Traveling on the twenty-eight-gun French ship *La Négresse*, he arrived
in Nantes in mid-June of 1780 and headed to Paris, where he consulted
with Franklin and John Adams. One of Trumbull's biographers has evi-
dence suggesting that he had been hired to deliver something—money or
documents—to Benjamin Franklin, which was precisely the kind of diplo-
matic ferrying that Elkanah Watson was performing at the same time.[23] He
then moved on to London with his traveling companion John Steel Tyler,
a former major in the Continental Army. Graciously welcomed into West's
studio, he made a lifelong friendship with the artist's chief assistant, Rhode
Island-born Gilbert Stuart, who helped acclimate Trumbull to London.
Feeling safe in West's orbit of influence, Trumbull put political caution to
the wind and wasted no time declaring his nationality by painting a full-
length portrait of Washington standing triumphant on a bluff overlooking
the Hudson near the strategic American fortress at West Point.

For accuracy, Trumbull had to rely on his memory of Washington
from 1775 and on various kinds of print images circulating in London.
When he finished the portrait, he imprudently let the London publisher
John Stockdale make prints that were sold, along with Copley's of Henry
Laurens, in order to funnel relief to the American soldiers who were
incarcerated on British prison ships. Before long, Trumbull's image of
Washington multiplied across Britain and Europe, cropping up in Bel-
gian books, French histories, and Irish magazines.[24] It even found its way
into cotton mills, being used as a design for wallpaper and bed hangings.
In one "scenic toile" fabric, an allegorical figure of Peace plants her right
foot on a fallen British shield as she ushers Trumbull's Washington to the
Altar of Liberty, where he is to be crowned by Fame.[25]

Trumbull's patriotic activities came at a time when a British conspiracy to capture West Point was being exposed. The American general Benedict Arnold had been plotting for months with the British Major John André to surrender West Point to General Henry Clinton and the British army. Five months into Trumbull's trip abroad, on November 15, 1780, word of Arnold's treason and the disturbing news of André's arrest and subsequent hanging in upstate New York arrived in London, fundamentally altering the climate for Americans there, and especially for the young artist who had once held the rank of colonel in the Continental Army. A firestorm ensued. The hanging was an event so vivid and appalling to the British—so far outside the polite codes of military conduct—that it stiffened government resolve and became mythology overnight. George III immediately ordered the Scottish architect Robert Adam to design a monument in André's memory at Westminster Abbey. The sculpted panel on its front shows George Washington listening to a last-minute plea to spare André, while André himself is led to the gallows. The story was so compelling that Edward Barnard included André's hanging among more predictable prints of George III, Oliver Cromwell, and the execution of Charles I when he published his comprehensive *History of England* in 1783.[26]

Out of retribution for André's execution, two Loyalists who had been spying on Trumbull since his arrival in the city filed affidavits alleging treasonous activity. The police seized Trumbull's papers and arrested him at midnight on November 19, 1780, accusing him of being a spy in the employ of Franklin, who, more than any American, had the capacity to arouse suspicion in British government circles.[27] John Adams was immediately alerted to the situation by Thomas Digges, his undercover agent in London, who wrote that subsequent to news of André's execution in "Rebel Washingtons Camp nothing has been talkd of here but 'making Example,' acts of retaliation, etc. etc. A person of the name of Trumbull was taken up for high treason on Sunday night."[28] Digges went on to say that the government was also investigating Stuart, Laurens, and Digges himself. Writing from Amsterdam, an alarmed Adams passed the bad news on to Franklin in Paris, adding that he was "vexed and grieved beyond measure at the Fate of poor Trumbull."[29]

Trumbull was taken to police headquarters on Bow Street, where government officials Sir Sampson Wright and Justice William Addington interrogated and then remanded him, first to New Prison Clerkenwell and then to Tothill Fields Bridewell, with the promise of execution

hanging over his head.[30] Digges understood the gravity of the charges. "It is impossible to say to what length they will go against Mr. Trumbull—report says that the affadavits of two Refugee N. England men and his own papers are quite sufficient to hang Him, and hang him they certainly will if they can, for my Countrymen seem to thirst after blood most exceedingly since André's execution."[31]

The only hard evidence against Trumbull was a letter of introduction from Franklin to West, letters to and from Congress regarding his resignation from the Army, and letters from Trumbull to his father exposing the "palpable corruption" and "meanness of intrigue" in the British government, as well as portending that the American "sword must finish what it has so well begun."[32]

Trumbull specifically blamed his arrest on the "base acts" of "vindictive and malignant" refugee American Loyalists, specifically Joseph Galloway, West's bête noire.[33] Benjamin Thompson, a Loyalist from Massachusetts who was Germain's undersecretary, explained the ministry's logic of revenge: "Government could not with any consistency suffer this person to walk the streets of London in security, while so many of his majesty's loyal subjects were driven from their estates in America."[34] A London newspaper said "the Rebel Colonel John Trumbull, son of the Rebel Governor of Connecticut" had been arrested because "Loyalists lamented that treason should be suffered to appear abroad unmolested."[35]

According to Trumbull, the Loyalists would "exquisitely relish" draining his blood, and he accurately observed that Major André's execution had now given "a new edge to the vengeful wishes of the American refugees."[36] André was their martyr, and Trumbull could see that in their passion to avenge that wrong "there is no villainy to which they would not stoop." Trumbull understood that in the logic of war his arrest was the "perfect *pendant*" for André's death.[37] When he wrote to his father back in Connecticut, he accused the Loyalists of hatching the vendetta: "the arts [that the Loyalists] had for a long time used to no effect, now succeeded . . . The occasion [of André's execution] united with their wishes, and the resentment of government marked me as an expiatory sacrifice. I had no idea of the storm."[38]

Trumbull testified and spent decades afterward claiming he had been an "innocent, abused, and ill-treated man" in London, but he actually had been covertly seeking out radical British supporters of the Revolution.[39] And he must not have been subtle about it since one London

newspaper said that toasts were being hoisted in London coffeehouses in honor of Trumbull and other "transatlantic serpents."[40] Trumbull had, in fact, flagrantly ignored the warning to avoid "political intervention" in a number of ways. Incriminating letters to his Patriot father, submitted into court evidence, mocked "the celebrated fabric of British liberty," exposed the "inequality of representation" in government, and talked about his admiration for American sympathizers such as John Temple, David Hartley, Richard Price, and Edmund Burke.[41]

Even more palpable and dangerous, Trumbull had also gotten tangled up with Digges, a British citizen secretly being sent money from Franklin in Paris in order to provide relief for American prisoners in British jails, and, when possible, to arrange for their escape to the Netherlands. A letter from November of 1780, written in coded language full of aliases, exposed Trumbull's liaison with Digges and William Brailsford, a Massachusetts merchant, on an even more daring plan to illegally ship British cloth goods across the Atlantic to "a certain Army" via France, "our dear and great ally."[42]

Trumbull and his American cohort were suddenly featured in London newspapers. The *Evening Post* reported the arrest and the treasonous plot, and the November issue of the *Political Magazine* claimed that Trumbull had lied about the true nature of his collaboration with Brailsford.[43] While Trumbull tried to shield Brailsford, he did not attempt to protect the more important Digges, which in effect unmasked Franklin's agent as a traitor and threatened the entire American undercover operation in Britain. As one commentator put it, the "Young Men" had inadvertently provoked "a general hunt after Americans."[44] The blown plot to ship goods to America also engulfed the Dutch banker Leendert de Neufville, whose family was helping to bankroll the United States. De Neufville was taken before a London magistrate because of that and the fact he was the one who had commissioned Trumbull's *George Washington* in 1780.[45] De Neufville was forced to flee to Amsterdam.

The well-meaning "Young Men," including Trumbull, had inadvertently ruined the secret network that provided humanitarian aid to prisoners and that could have furnished critical supplies to the Continental Army. In a letter to General Horatio Gates, the Reverend William Gordon speculated that Trumbull was a decent young man embroiled in a plot in which he "may be thought to have played the fool."[46] An Adams communiqué of December 6 suggested that Trumbull's trip to London,

via France, had been not for art lessons alone, but also to play the role of junior spy. Arrest and charges of high treason, Adams speculated, "will cure the Silly Itch of running over to England."[47] Digges agreed. He was "very sorry for [Trumbull] because He is the only prudent and discreet Amn. [American] I have seen here for a long time back," but "I wish to God" that Americans "woud not permit their fools to come abroad."[48]

Trumbull's arrest forced Digges, who was essential to the success of covert operations in England, into hiding, and fatally compromised his relationship with Franklin and Adams.[49] In America, rumors spread that Trumbull had been executed, just like André.[50] But interventions by West, who pleaded with George III for leniency, and by British political figures Burke, Temple, John Lee, and Charles Fox led to Trumbull's release in June of 1781. West and Copley posted half the bail.[51] Galloway, who had orchestrated Trumbull's arrest, "expressed his astonishment."[52]

Trumbull's primary crime in 1780 had been over-ambition, and his seven-month jail term at Tothill Fields Bridewell prison was not a surprise to anyone, except to Trumbull.[53] His half-year in jail was privileged by the standards of the day. He had his own private room, walked in the garden, wrote letters home, and drew life figures that he sarcastically inscribed "Tothill Fields Academy." Gilbert Stuart visited, entertaining him with gossip and stories, and started a portrait of "Bridewell Jack," as he liked to call Trumbull, in his prison cell, windows barred, thoughtfully drawing on a sheet of paper.[54] After his release, Trumbull quickly found asylum in Amsterdam, a haven for American prisoners, where he visited with Adams and lived with the de Neufville family. Shortly thereafter he left for America via Spain with Adams's young son Charles in tow, but not before making an unsuccessful request for loans from Dutch banking syndicates in order to help Connecticut.

After some months recuperating at his father's home in Connecticut, Trumbull spent the winter of 1782–83 in New Windsor, New York, where he helped his brother David provision the encamped Continental Army. He reacquainted himself with Washington, and on the side he found a few moments to make some ink drawings.[55] But he threw all of that aside when he heard the news from Paris of the Peace Treaty late in 1783. Trumbull immediately left his job and took passage on the ship *Mary*, arriving in London on January 16, 1784, full of gratitude to those who had helped him out three years earlier.

❧

Trumbull could not help but notice how much London had changed in three years. The King had sacked the Ministry that had been so harsh with him and named twenty-four-year-old William Pitt the Younger to the post of Prime Minister. The Loyalists who had spearheaded the drive to jail Trumbull were now in disarray because the Ministry was no longer in thrall to them and because the finalized Peace Treaty did nothing more than "recommend" to the states that Loyalist property in America be restored, a suggestion largely ignored. There was even the odd sight of an English artist, Robert Edge Pine, packing his bags in order to emigrate to Philadelphia, where he planned to paint "Patriots, Legislators, Heroes and Beauties," as well as, in Washington's own admiring words, "some of the most important events of the War."[56]

Trumbull's return to London in 1784 was inconsequential to Pitt's Ministry and as a result no government surveillance of his whereabouts and actions was undertaken. But at the same time that war tensions had subsided, he could see ample evidence of a great upsurge in British nationalism as artists and citizens made a widespread search for those heroes and events that could make Britons feel some pride after their stunning defeat. British nationalism was visible at Westminster Abbey, where a stir was created by a recently unveiled memorial dedicated to Major André. The monument became a touchstone for sentimental Britons looking for examples of stoic bravery and tragic sacrifice. Pilgrimages were made to see Robert Adam's cenotaph, and poetry was written about André's bravery and beauty.[57] But to Patriot Americans, the memorial evoked an equally strong and opposite reaction. While Copley was painting his great portrait of John Adams, Adams and his son John Quincy visited the André monument. In a letter written soon after, John Quincy reported, "I felt a painfull Sensation, at seeing a superb monument, erected to Major André, to reflect how much degenerated that Nation must be, which can find no fitter Objects for so great an honour, than a Spy, than a man whose sad Catastrophe, was owing to his unbounded Ambition, and whose only excuse for his conduct, was his Youth; as if youth, gave a Man the right to commit wicked and Contemptible Actions."[58]

Trumbull's first order of business in London was to visit his supporters. Surely he called upon Copley, who had posted part of his bail and who was now living a few doors down from Trumbull's former residence

on George Street. In the master's studio he would see the freshly com-
pleted portrait of Adams and the electrifying *Death of Major Peirson*,
which Copley was preparing for a rousing for-profit public exhibition in
May, accompanied by *Watson and the Shark* and a Gilbert Stuart portrait
of Copley.[59]

Trumbull's most important destination, however, was West's
home on Newman Street, where he resumed his long-interrupted
training, which involved painting technique, but also the instillation
of the idea that artists ought to value momentous historical events over
other kinds of subjects, such as portraiture, still life, or landscape. The
"Great Style," as Sir Joshua Reynolds postulated it and West prac-
ticed it, required that artists choose an historical subject that "power-
fully strikes upon the publick sympathy," and that is composed with
strict decorum, which meant that historical accuracy could be waived
in favor of what one theorist called "decency of manners."[60] The key
instructional words that Trumbull heard in the eighteenth-century
studio were *majesty, superiority, character, intelligence*, and, above all,
virtue.

Trumbull could see proof for that abounding in West's studio in
1784. West was working on a huge picture that shows a chieftain of the
Clan Mackenzie rescuing Alexander III, the thirteenth-century king of
the Scots, and he was continuing to produce biblical pictures for the royal
chapel at Windsor. While he was there, Trumbull could also see West's
American Commissioners of the Preliminary Peace Negotiations, unfinished
and waiting for portraits of the British plenipotentiary Richard Oswald
and his secretary. It must have come as a shock to Trumbull to see such
an American subject coming from the brush of the official painter to
George III, even though Trumbull knew perfectly well that West had
harbored Patriot sentiments all along. Not only had West painted that
American-oriented picture in the three years that Trumbull was away,
he had also made plans to paint a "Great Style" suite on the subject
of the entire American Revolution. There could be no clearer sign to
Trumbull that the political climate for American painters in London
had changed dramatically since he had left in 1781.

Just as Trumbull's indoctrination in the "Great Style" was super-
intended by West, so too was his social life in London. West took the
young painter into his wide circle of artists, writers, diplomats, and
members of Parliament. Copley also was instrumental in Trumbull's
acclimation. He met up with West and Trumbull at Windsor Castle,

where they sketched, walked, and drank tea together. Probably through Copley, Trumbull renewed his friendship with the Adams family when Abigail briefly stayed in the city in the summer of 1784, and then after the entire family moved to London for John Adams's tenure as Minister to the Court of St. James's in June of 1785. The Adams residence on Grosvenor Square was a magnet for the Americans living in and passing through the city, and that included Patriots as well as British sympathizers and former Loyalists. Because the Copleys were the Adamses' best friends, Trumbull was often invited to dine with the London cohort of transplanted Bostonians.[61]

Trumbull was especially attracted to Abigail, Nabby, and John Quincy Adams, who animated the Adams household. The letters they exchanged brim with descriptions of card playing, gossiping, levees, teas, breakfasts, flirtations, and evenings watching *Othello*, *Romeo and Juliet*, and especially the performances of the great Sarah Siddons as Lady Macbeth. But Trumbull found John Adams insufferable. "There is too much constraint, too much of the great and the wise to admit anything sporting, familiar, or relaxing," he wrote to his brother Jonathan. "I hate a person who is always wise, serious, intent. 'Tis well enough when business presses, but even business should be confined as much as possible within the Closet & there is a time when 'tis ridiculous to be wise."[62] Trumbull never fully acclimated to Adams or to London, never could "feel . . . at home in this Country." He longed for his family and looked forward to the day when he would return home.

By day Trumbull assisted in West's studio, replacing Stuart, who had moved into his own independent practice; and by night he attended drawing classes at the Royal Academy with the supremely talented English painter Thomas Lawrence.[63] In his spare time he started painting portraits of men who supported the Revolution. Two were members of the Tracey family, Patrick and Nathaniel, both Newburyport merchants in London on business, both importers of West Indian goods and builders of American warships. Copley was painting a portrait of their business partner, Jonathan Jackson, at the same time. Another was a portrait of Jeremiah Wadsworth of Connecticut, who was routing through London after reporting to the French about his wartime provisioning of Rochambeau's army in America.

Trumbull became friends in London with John Temple, a controversial figure who was born in Boston but spent the early years of the war in London trying to counterbalance the extreme rhetoric spouted by

the Ministry and the American Loyalists, especially by Joseph Gallo-way. Temple, a British subject, was vilified in the London press for sup-porting the United States. But Trumbull had nothing but good things to say about a man who had tried to do "what he could to serve Mr. Trumbull" while in prison and after he was released in 1781.[64]

Trumbull returned the favor by painting a four-foot portrait of Temple. And to emphasize the point that he unequivocally supported Temple, Trumbull put the painting on display at the juried 1784 exhi-bition of the Royal Academy, which teemed with self-congratulatory pictures showcasing British triumphs in the Caribbean and Gibraltar.[65] One wall of the Academy featured a large canvas of Captain James Cook as he was attacked and killed in Hawaii in 1779; another wall show-cased Joshua Reynolds's nine-foot portrait of the Prince of Wales; and yet another was devoted to James Northcote's giant picture of Captain John Inglefield leading the survivors of the HMS Centaur onto a lifeboat in the midst of a hurricane after the Battle of the Saintes in 1782.

In such an atmosphere of British renewal, Trumbull's picture of an American sympathizer must have clanged. Trumbull seems to have been interested in launching an American reply to all the British self-con-gratulation, as it was being amply demonstrated by the Academy's show, and by the lachrymose André monument and the stirring pictures of British martyrdoms. In the midst of such an avalanche of chauvinistic sentiment, Trumbull may have discovered his own identity in the world as a counterweight to the growing tonnage of British historical art. Someone, he must have figured, needed to paint the equally compelling events and exceptional figures that had shaped the United States.

His second picture at the Academy's 1784 show in Somerset House, on the subject of the Roman senate presenting to Cincinnatus the com-mand of the army, was seemingly neutral. But Cincinnatus was code for Washington. In the fifth century B.C., Cincinnatus was called from his farm in order to assume dictatorial control of Rome during a war emer-gency, and then he walked away from power when the crisis was over. Washington did the same when he resigned his commission on Decem-ber 23, 1783, an event lauded in every British newspaper and magazine at the time of Trumbull's arrival in London.[66] Though the painting is now lost, Trumbull said in a letter to his brother Jonathan that he gave the figure of Cincinnatus the features of Washington, and added the observation that in the wake of Washington's resignation, which would be the subject of one of Trumbull's future Revolutionary pictures, his

painting struck a chord with Britons because it showed "a Conduct so novel, so inconceivable to People, who, far from giving up powers they possess, are willing to convulse the Empire to acquire more."[67]

The analogies between the Revolution and antiquity, Trumbull discovered, were endless. In his mind, it was as if Homer or Virgil were in charge of assembling American heroes and events for commemoration. Trumbull plunged further into the classics in the fall of 1785 when he painted one of the most moving scenes in the *Iliad*, the passage where King Priam returns to Troy with the body of his son Hector, who has been killed by Achilles.[68] In Trumbull's interpretation, the spotlight is on Hector's beautiful body, framed by the columns of a portico and the two bearers of his corpse. A secondary theme is the sorrow of the elderly Priam, who holds his hand to his heart as he touchingly looks rightward to Hector's grief-stricken wife, Andromache. A tertiary theme is the comprehensive registry of emotions, from despair to disbelief, rippling over the faces of the Trojan soldiers, women, and children, who frame the composition on the right and left sides.

When Trumbull showed the painting at the 1786 exhibition of the Royal Academy, after three months of labor on it and about a year of planning, one critic accurately commented on his newfound maturity.[69]

John Trumbull, *Priam Returning to his Family with the Dead Body of Hector*, 1785

In every way—theme, design, and complexity—this was a sophisticated picture eclipsing anything he had ever done. Trumbull had not only learned the lessons of painting in a "Great Style" that "powerfully strikes upon the publick sympathy," he had also taken his visual cues from the great artists of the past, especially from Raphael, whose exquisite 1507 picture of Christ being transported from Calvary to his burial was the mirror image of Trumbull's painting.[70] Thinking metaphorically, Trumbull's Hector was a stand-in for Christ and also for every Revolutionary War victim, while Priam and Andromache doubled for their grieving American fathers and wives.

Trumbull was not alone in his vision of American history mingling with ancient stories. In epic poetry, popular songs, and sentimental ballads, Americans compared Washington to Joshua or David or Moses, as well as to Cincinnatus and Marcus Aurelius.[71] Likewise, the American fight for independence from Britain was seen as a modern revival of the struggle of the Israelites against Egyptians, or the Christians against the Romans, or the Greeks against the Trojans. And fallen American soldiers like Dr. Joseph Warren, Richard Montgomery, and Hugh Mercer, who would soon be featured in Trumbull's paintings, were commonly perceived to be modern versions of classical heroes, of slain Old Testament figures, or of Christ himself.[72] Trumbull, who saw the war as a titanic battle between good and evil, from this point onward would suffuse his own visions of the American Revolution with all the overtones of Christian faith and classical history. He wished to see the American Revolution as the modern version of the epic stories told in the *Iliad*, the *Aeneid*, and the Bible.

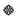

"The late War," Trumbull insightfully wrote from London to his brother Jonathan in the spring of 1784, "opens a new and noble field for historical painting."[73] In November he announced his intention to "execute the plan I have in view—of painting the great Events of the revolution."[74] That idea came from West, who had originally planned his own suite of "the great events of the American contest" but, aware that his fortunes came from being the official historical painter to George III, had instead recommended the project to Trumbull.

Early in 1785 Trumbull began mapping out his pictures. The initial plan called for five scenes: "The Battle of Bunker's Hill," the bloody 1775

battle that Trumbull witnessed from his post in Roxbury; "Trenton," Washington's 1776 attack on the Hessians after crossing the Delaware; "7th of October," the 1777 battle of Bemis Heights, near Saratoga, at which Benedict Arnold rallied the American troops, two years before he turned traitor; "Saratoga," the surrender of General John Burgoyne to General Horatio Gates, an event that encouraged the French to join the war; and "Yorktown," the defeat of Lord Cornwallis and his seven thousand soldiers in 1781, effectively ending the war.[75] All of them were military engagements. That decision was in part dictated by the precedent of West's *Death of General Wolfe* and by all the British military pictures hanging at the annual Royal Academy exhibitions. Trumbull's attraction to military themes was also entirely predictable for a former soldier whose wartime experiences had taken him from Bunker's Hill to Ticonderoga to the Delaware River.

Trumbull began work on the first picture, *The Death of General Warren at the Battle of Bunker's Hill, June 17, 1775*, in the autumn of 1785, a decade after the event itself. When it was completed early in 1786, West hailed it as "the *best picture* of a modern battle that has been painted . . . *no Man* living can paint such another picture . . . "[76] That was not just a teacher's enthusiastic praise for his leading student. Other than Copley's *Death of Major Peirson*, from which Trumbull borrowed a few effects, no picture better captured the chaos, valor, and tragedy of battle. It was so vivid to Abigail Adams, seeing it for the first time while in London, that she said "my whole frame contracted, my Blood Shiverd and I felt a faintness at my Heart."[77]

The *Death of General Warren* was the first "Great Style" picture to escort its audiences to front-row seats in the terrifying new theater of the American Revolution. It was exactly the picture West would have wished for himself, had he not been the King's artist. Abigail relayed Trumbull's achievement to her husband. "He is the first painter who has undertaken to immortalize by his Pencil those great actions; that gave Birth to our Nation." She realized that with this picture and the ones that would soon follow, "He will not only secure his own fame, but transmit to Posterity Characters and actions which will command the admiration of future ages and prevent the period which gave birth to them from ever passing away into the dark abiss of time."[78]

Trumbull staged the chaotic scene in a pattern of slashing actions. From the right distance, where the *HMS Somerset* can be seen in the harbor and beyond it the British installation at Copp's Hill in the north end of Boston, British troops surge upward and to the left in the form of a

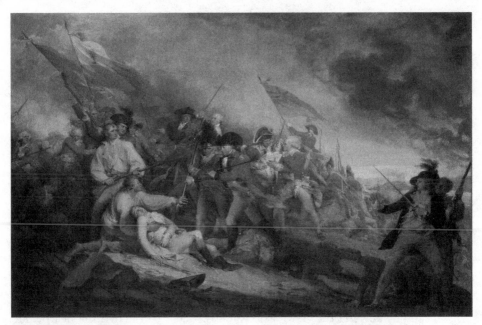

John Trumbull, *The Death of General Warren at the Battle of Bunker's Hill, June 17, 1775*, 1786

wedge, toward retreating American militiamen. Like a battering ram, the red-coated soldiers are unstoppable. Overhead, three regimental flags, two American and one British, angle to the left and parallel the ominous smoke blowing up from the fires of Charlestown burning, just off-canvas to the right. On the ground, sunlight and shadow alternate in diagonals that draw attention to some actions and cast others into semidarkness.

Within the whole picture, there are three subplots that Trumbull adeptly calls to attention. On the far right, Lieutenant Thomas Grosvenor and an African-American servant, both in shadow, flee from the British, but not before taking one last look back at the dying Joseph Warren.[79] Where other figures angle to the left, Grosvenor leans right in a note-worthy counter-flow. At the dead center of the picture, sunlight picks up another figure falling right—British Major John Pitcairn, mortally wounded and dropping into the supporting arms of his son, Lieutenant William Pitcairn, who turns away from the ongoing battle to comfort his father. Son and father, face to face, it is one of the most touching human passages in a picture otherwise devoted to the fury of war.

The theatrical centerpiece of the painting is Joseph Warren, prostrate and dying in front of the tidal wave of British troops. Trumbull ingeniously

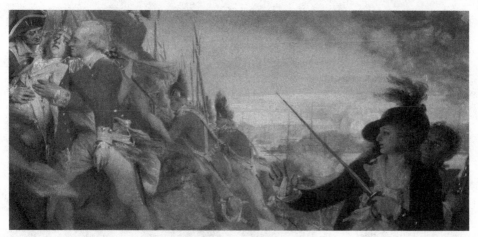

John Trumbull, *The Death of General Warren at the Battle of Bunker's Hill, June 17, 1775,* 1786 (detail)

drew attention to Warren, first by placing him in a pool of summer light and by keeping the view of him unobstructed by the fighting nearby. He smartly positioned Warren at the intersection of two descending lines that form a large V, drawing viewers to his plight. One starts at the upper left with the two militia flags and the hands holding them aloft. Appearing below the fluttering flags are the heads of the American Reverend Samuel McClintock and Major Willard Moore, as well as the officer who commanded the militias, Colonel William Prescott, seen wearing a wide-brimmed hat. More prominent in his blue jacket and large cocked hat is Major Andrew McClary, holding aloft his upside-down musket in order to signal retreat. In front of him is Captain Thomas Knowlton, dressed in a white shirt and pointing a musket at the advancing redcoats, and kneeling in the foreground is an unidentified barefooted militiaman, who holds up Warren's limp body with his right arm.

The second arm of the V initiates on the British side with the white-haired General Henry Clinton, seen exhorting his troops by raising his saber in the air. Next to him in a black cocked hat is General William Howe, who commanded the British assault. Below them and close to Warren are two key figures. One, a grenadier whose rank is identified by his bearskin-fronted mitre hat, raises his Brown Bess musket to the vertical with the intention of bayoneting Warren and delivering the deathblow that will retaliate both for Pitcairn, dying behind him, and for Colonel James Abercrombie, who has fallen at his feet. But he is halted, twice, not only by an American, but also, to

the right of the grenadier, by British Major John Small, who climbs over Abercrombie—that is, over one of his own dying soldiers—in order to grab the grenadier's musket barrel with his bare hand and save Warren from butchery. The second action comes from the unidentified American militiaman who reaches out with his left arm to avert the grenadier's bayonet.

Amid the carnage that includes three other dead soldiers scattered across the foreground, mercy takes center stage in the painting. Trumbull's vision of warfare may have been accurate enough to terrify Abigail Adams, who actually did see the smoke of the battle and hear the thunder of the bombardment. But at the same time, Trumbull called attention to acts of humanity and codes of gentlemanly behavior that know no national boundaries. Abigail acknowledged to her husband that Trumbull's painting was, ultimately, a moral lesson, even though her "Blood Shiverd." To her, Trumbull "teaches mankind that it is not rank, or titles, but Character alone which interest Posterity." When the Day of Judgment comes, there will be "a just estimate . . . made both of principals and actions," which will include "Instances of Patience perseverance fortitude magnanimity courage humanity and tenderness."[80]

West had drummed into Trumbull the idea that history should be altered for the purpose of demonstrating a moral lesson or virtuous behavior. "There can be no other way of representing the death of a Hero but by an *Epic* representation of it. It must exhibit the event in a way to excite awe & veneration . . . A mere matter of fact will never produce this effect."[81] Early prints of the battle exemplify West's point that factual displays cannot adequately tell the tale. Robert Aitken, the publisher of the *Philadelphia Magazine*, engraved a "Correct" but undramatic view of the battle, with troops in action, British ships in the harbor, and the village of Charlestown. Another print showed the cleared hillside after the battle.

John Trumbull, *The Death of General Warren at the Battle of Bunker's Hill, June 17, 1775*, 1786 (detail)

For top-flight artists like West, Trumbull, and others, that kind of documentary approach was philosophically insufficient.

Following West's advice, Trumbull took artistic license in a number of ways.[82] When he watched the battle from Roxbury, he knew perfectly well that Generals Howe and Clinton would never position themselves in the middle of a bayonet charge. But for dramatic effect they needed to be prominently positioned in the picture. Pitcairn, whose dying moments echo Warren's, was actually killed at the base of the hill. Trumbull also knew he would not be able to take life portraits of all the participants that day, thus forcing him to rely on portraits made by other artists, or to invent portraits.[83] He tried to get General Howe to sit for him in London, but when Howe refused he had to recruit West, who knew Howe, to paint the general's portrait directly into his picture.[84] The most prominent example of an entirely made-up figure is the barefooted American militiaman who props up Warren's body.

Equally fictitious, Warren did not die a romantic death on June 17. During the British charge and the American retreat, a musket ball to the back of the head killed him instantly, and his body was abandoned. Rumors, all eventually refuted, said the British spat "in his Face jump'd on his Stomach," then "committed every act of violence upon his Body," and finally resolved to "sever his Head from his body, and carry it in triumph to Gage, who no doubt would have 'grin'd horrible a gastly smile.'"[85] Though the precise truth is debatable, it is generally agreed that his body was thrown into a shallow grave with an anonymous soldier.

Moreover, no acts of mercy and kindness were reported that day. No British officer stepped over the dead to protect a dying American. In fact, a preliminary drawing, which flips the composition right to left, indicates that Trumbull's first thought for the figure occupied by Major Small was instead a second grenadier intent on stabbing Warren in the neck with his bayonet. The idea of Small's charity toward Warren came later.

If anything, the savagery on June 17 was unremitting. The British had already made two failed linear attacks on the American redoubt perched atop sixty-five-foot Breed's Hill (Bunker's Hill was the higher glacial drumlin behind the redoubt). For the third attack, Howe ordered a bayonet charge guaranteed to cause the most chaos and the most carnage. It is that hand-to-hand combat that Trumbull painted. But his picture is not nearly as savage as the actual event. If Mathew Brady could have visited the battlefield, his camera would have recorded nothing less than a slaughter, with 1,500 dead, dying, and mutilated

bodies scattered across a blood-soaked hillside. One British soldier said he could not find adequate words to describe "the Horror of the Scene ... 'Twas streaming with Blood & strew'd with dead & dying Men, the Soldiers stabbing some and dashing out the Brains of other."[86] Surgeons were overwhelmed by the number of amputations they had to perform because the Americans, low on ammunition, had loaded their muskets with broken glass, nails, and scrap metal.

The terror of Bunker's Hill traumatized Trumbull's sister Faith, who joined the large crowds gathered on Beacon Hill to watch the spectacle. Like everyone else, she imagined it would be something grand and honorable. Instead, she heard the cries of men ripped apart by grapeshot and saw the canopy of cannon and howitzer ordnance raining down on Charlestown. She soon sank into a sobbing depression, and the day after Thanksgiving went to her bedroom and hanged herself with a small rope.

Trumbull's emphasis on the concordance between American and British values may seem strange in view of the carnage and the fact that in 1775 Patriot Bostonians thought the British were imperial brutes intent on enslaving Americans. Joseph Warren himself had issued a broadside after Lexington and Concord declaring the British guilty of "the barbarous murders of our innocent brethren," and demanded that Americans raise an army to protect their wives and children "from the butchering hands of an inhuman society." Trumbull too had mobilized, coming from Connecticut to fight against the British.

But it was now 1786. Americans and Britons alike were eager to move ahead. Trumbull was being received well in London, and his mentor, West, had just painted the peace commissioners on the theme of a formerly broken family now reconciled. Showing the British to be a band of savages would have been an outdated sentiment. Instead, Trumbull's goal with *The Death of General Warren*, besides portraying Warren's bravery and sacrifice, was to demonstrate shared values across English-speaking nations. Mercy was possible, even amid barbarity. Trumbull believed that there was—or ought to be—a code of gentlemanly conduct that transcends loyalties.[87] As important as bravery and death in his painting are the values of humanitarianism and generosity, compelling rhetoric in the new post-Revolutionary world.

The picture is still slanted American. Trumbull elevated Warren to the position of American martyr, and while British Major Pitcairn's death is also included, it is in a reciprocal role, as if to show that Britons also bled.

The great model for every inspiring picture of a dying national hero was West's groundbreaking *Death of General Wolfe*, showing the general in extremis on the Plains of Abraham during the French and Indian War. Copley had reimagined that picture in his *Death of Major Peirson*. And Trumbull Americanized it in his *Death of General Warren*. Following along the lines set by West, Trumbull's Warren is an American Christ. His stretched-out body and limp arm purposefully echo hundreds of paintings and sculptures of Christ's passion, from the time he was taken down from the cross to the mourning over his body and eventual entombment.

In Trumbull's painting, the analogy to Christ's passion extends across the entire scene. The British bayonet is the modern equivalent of the ancient Roman lance used to pierce Christ's chest. Breed's Hill is a version of Calvary. The unnaturally bright patch of sunlight surrounding Warren suggests a holy site. On the far right, Lieutenant Grosvenor's bandaged hand, which he conspicuously holds up, recalls the wounds inflicted on Christ when he was nailed to the cross. Even the improbably barefooted militiaman figures into Trumbull's Christian parable. Of course he might have lost his boots during the battle because militiamen were irregulars who came from farms and wore whatever inadequate shoes they owned. But it is no accident that he is the only soldier without boots. This militiaman, the one who cradles the martyred Warren, is barefoot because Trumbull has cast him in the special role of compassionate follower, an American version of the barefooted disciples who can be seen in countless old master paintings supporting Christ's body on sacred ground after the Crucifixion.

In point of fact, the American leader that day was not Warren, who was neither a member of the militia nor an authentic general. Three days before Bunker's Hill the Provincial Congress, over which Warren presided, had promoted him all at once from citizen to major-general in recognition of his civilian leadership and out of respect for his position as the leading physician in Boston. There was never any expectation that he would fight, let alone lead soldiers into battle. The true commanders in Charlestown were Colonel William Prescott,

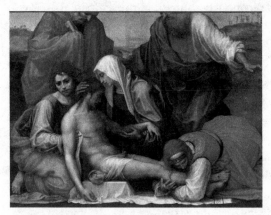

Fra Bartolomeo, *Lamentation*, 1511

Major General Israel Putnam, and Major John Stark. Warren's background was patrician. As portrayed by Copley in a portrait of 1765, elegantly dressed, seated on a Queen Anne side chair, and accompanied by an anatomical drawing, Dr. Joseph Warren was a man of the highest refinement and education.[88]

But on the battlefield at Bunker's Hill, Warren's presence was unexpectedly electric. That morning he was in Cambridge attending an organizational meeting of the Provincial Congress. When he heard of the British attack he rode to Charlestown, where he had to talk his way into the front lines so that he could fight with militiamen. He was completely unprepared but believed that

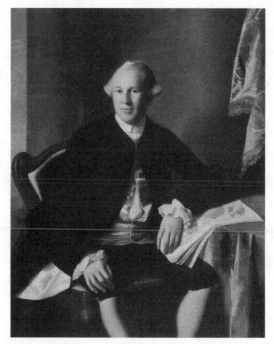

John Singleton Copley, *Doctor Joseph Warren*, 1765

political conviction would protect him. In Trumbull's painting, Warren's light blue silk suit and dress boots, as well as an ineffectual dress sword at his side, tell audiences that his transformation from gentleman into soldier was so sudden that he did not take the time to put on gear more appropriate for field combat.[89] No image about the American fight for rights could be more revealing than the sight of the highborn Dr. Warren dying in the arms of a rough-hewn militiaman whose trousers identify him as working class. John Adams may have talked a lot about fighting, but Warren actually picked up a sword.

Death was pervasive that day. One hundred and forty other Americans died on the hillside, but Trumbull took the liberty of showcasing Warren over all of them. Much of Trumbull's reasoning had to do with his understanding that Warren was already a popular hero. He had been the magnetic center of Revolutionary propaganda in Boston for years, a firebrand on par with Samuel Adams, a patrician who eloquently expressed the hatreds of the working class. In 1774 he drafted the Suffolk Resolves, a dress rehearsal for the Declaration of Independence. In April 1775 he had

sent Paul Revere on his ride to warn Samuel Adams and John Hancock that General Thomas Gage was marching British troops toward Lexington. Among the leading New England advocates for American rights, among them Josiah Quincy, James Otis, and the two Adamses, Warren was notable as the most emotional, an expert at animating the dejected and baiting the British. John Adams admired his "undaunted spirit and fire," but was wise enough to know that Warren's invective had the power to "stir up" citizens and push them "to revenge and bloodshed."[90] That Trumbull posed him like a dead Christian martyr was natural since Warren was a demagogue whose life and death resembled those saints who proselytized for Christianity, and were killed because of it.

Trumbull knew about Warren's rhetoric from his Harvard days, and he likely read one of the many printings of Warren's spellbinding speech of 1775, on the fifth anniversary of the Boston Massacre. Wearing a Roman toga, and standing in a "Demosthenian posture" behind a black-draped pulpit in the overflowing South Meeting House, Warren had pulled on heartstrings. "Approach we then the melancholy walk of death," he had implored his audience.[91] "Let me lead the tender mother to weep over her beloved son; . . . behold thy murdered husband gasping on the ground; . . . bring in each hand thy infant children to bewail their father's fate." Fix your "streaming eyes" on the "ghastly corpse" of a fallen man. And when you do, *"your feet slide on the stones bespattered with your father's brains."* The speech was an eerie premonition of Warren's fate three months later, his own skull exploded and his four children left orphaned. Warren ended his screed by blaming the deaths of American sons, husbands, and fathers on the British "fiend, fierce from the depths of hell."[92]

Dr. Warren did not need military skills in order to be remembered as the first martyr of the Revolution and as an *exemplum virtutis* to every Patriot. Nor did he need Trumbull. By the time Trumbull painted his picture more than a decade after his death, Warren had already been canonized. It started the day after the battle when James Warren (a distant relation) wrote to his wife Mercy that Dr. Warren was the American James Wolfe.[93] She replied with a poem in which the doctor "greatly fell, pierc'd by a thousand wounds/ That seal his fame beyond time's narrow bounds." She touchingly spoke of his gentleness, courage, and humanity, convinced that in his last moments he "breath'd blessing to his land."[94]

Warren quickly rocketed to fame in verse, orations, almanacs, broadsides, pictures, and public ceremonies.[95] In public eulogies up and down

the Atlantic seaboard he was compared to Cato, Cicero, and Scipio.[96] Only weeks after the event, the Salem publisher Ezekiel Russell printed "An Elegiac Poem, Composed on the Never-to-be-Forgotten Terrible and Bloody Battle Fought at an Intrenchment on Bunker Hill." It recognized "this CAESAR of the age," an "honorable, renowned and magnanimous Hero, MAJOR-GENERAL JOSEPH WARREN," whose "loss is felt in ev'ry part/Of vast *America*."[97]

The next year, his body was dug up from the Charlestown dirt and then reinterred at King's Chapel before a "vast Concourse" of Bostonians. In 1777, Trumbull's famous cousin, also named John Trumbull, began an ode, *The Genius of America*, with

> The vales of Charlestown, sooth'd in bliss no more
> Sad wars affright and groans of parting breath
> Their grass shall wither in the streams of gore
> And flow'rs bloom sicklied with the dews of death.

He then turned to "my Warren." Though a "ghastly wound" has cut short his life, "Liberty resounds thy name/ First martyr in her cause, and heir of deathless fame!"[98]

Hugh Henry Brackenridge, a poet, lawyer, and teacher, wrote about Warren's death in his play of 1776, *The Battle of Bunkers-Hill*, as if it were a reenactment of the Peloponnesian War: "Like those three hundred at Thermopylae," the brave American militiamen temporarily fended off the massive British assault. Toward the battle's end, Warren, "mortally wounded, falling on his right knee, covering his breast with his right hand, and supporting himself with his firelock in his left," delivers a spectacular final oration, like the expiring Leonidas. "A deadly ball hath limited my life," he announces just before meeting the "Great Brutus" in the afterlife. "But O my Countrymen, let not the cause, The sacred cause of liberty, with me, Faint or expire."[99]

Already, only a year after the event, historical accuracy was being eagerly manipulated for the sake of rhetorical impact. Dying for the republic was a tragic necessity in both art and literature. After all, a patriotic death could never be, as West put it, "a mere matter of fact." That would never produce the "awe & veneration" that audiences expected. Instead, artists, poets, and playwrights of magnitude needed to convert naked fact, which was truly repellent in the case of Bunker's Hill and Warren's death, into West's formulation of "*Epic* representation."[100]

❖

Because of Warren's unrivaled fame, it was predictable that Trumbull picked Bunker's Hill as the first subject for his plan to depict the battles of the Revolution. Equally predictable, he turned to the second martyr of the Revolution for the companion picture, *The Death of General Montgomery in the Attack on Quebec, December 31, 1775*. He worked on the painting in West's studio during the first half of 1786, finishing it in June.

The daring American siege of Quebec had ended in failure, extinguishing any hope that Canada might be drawn into the revolution against Britain. Richard Montgomery, an Irishman who once fought in the French and Indian War and then became a protégé of Edmund Burke, had led his New York troops to startling victories over the British in the autumn of 1775 by attacking and seizing Fort Saint-Jean and then capturing Montreal. Joining with forces under the command of Colonel Benedict Arnold in December, he developed an elaborate plot to take the heavily defended city of Quebec, a plan that would allow Canadians to join Americans against British rule.

Three weeks into the siege, in the middle of the night, during a blizzard that provided cover but also created mighty obstacles, Montgomery took his battalion of three hundred soldiers to the wooden palisades of the Lower City. After his men sawed through it at six A.M. on December 31, Montgomery went to the front to personally lead the charge through the opening, his sword drawn and reportedly shouting, "Come on my good soldiers, Your Genl. Calls upon you to come on."[101] Whereupon he was immediately met by a fusillade of cannon and musket fire, and instantly killed by grapeshot that shattered his thigh and head. His body, as well as those of Captain John Macpherson and Captain Jacob Cheesman, was abandoned, and on January 4, 1776, the British buried him inside the walls of the city.

In Trumbull's dramatic staging of the event, the mortally wounded Montgomery is being eased toward the ground by Major Matthias Ogden. At his feet lie the dead Cheesman and Macpherson. Behind Ogden, three American lieutenants—John Humphries, Samuel Cooper, and Duncan Campbell—form a protective wall, while the allied Mohawk warrior Akiatonharónkwen raises a defiant tomahawk as he runs to Montgomery's defense. Though it is nighttime in the middle of a blizzard, an intense light miraculously breaks through the blackened sky to illuminate that central group of eight figures.

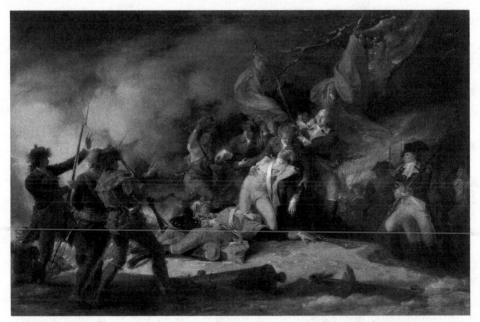

John Trumbull, *The Death of General Montgomery in the Attack on Quebec, December 31, 1775*, 1786

Trumbull was an experienced soldier who understood how chaotic and desperate it must have been that night. But in a brilliant effort to make his picture and Montgomery's death an *"Epic* representation," following West, he structured the melee into something compelling. Flanking the divinely lit central group on both sides are two smaller groups of figures. On the far right Colonel William Thompson of Pennsylvania, rifle in hand, freezes in his tracks upon seeing the fallen Montgomery. On the far left, three riflemen in frontier clothes—Jonathan Meigs, Samuel Ward, and William Hendricks—physically recoil from the awful sight of Montgomery's spotlighted corpse. Their hunting shirts and buckskin leggings identify them as Americans.[102]

That overall design, marked by a central tableau set off by lateral responses, is Trumbull's tribute to West's renowned picture of Wolfe dying in 1759 at the earlier battle of Quebec, only a mile away from the site of Montgomery's death. Also, like West's Wolfe and his own picture of Bunker's Hill, Montgomery's death evokes centuries of paintings that depicted Christ's descent from the cross after his crucifixion, an audacious analogy meant to link modern martyrs to the original Savior.

As in the case of the *Death of General Warren*, Trumbull worked hard to present some of the facts of the battle accurately. The American

troops were so irregular, for example, that some of them, such as the three riflemen standing on the left, wore backcountry clothes, while others, such as Ogden and Lewis in the middle, wore their regimental red uniforms. Montgomery had recognized the possible hazards if his troops were not able to identify their own countrymen during battle in the middle of the night. So as to distinguish the Americans, he had his men attach twigs of hemlock to their hats, a clever device that is visible in Trumbull's picture. Also accurate, in the gap between the central group and three men on the far left, Trumbull included scaling ladders carried by the troops in anticipation of breaching the city's formidable walls. Working in West's London studio, Trumbull could obtain these and other details of the siege from published firsthand accounts, or from the information and artifacts that Charles Willson Peale was ferrying to West.[103]

But otherwise, Trumbull altered, embellished, and idealized the tragic scene. The location of Montgomery's death was not on the crest of a hillock but along a sliver of land by the St. Lawrence River, beyond the cliffs at Cape Diamond. Montgomery did not die in anyone's arms, and should he have, it would have been those of Captain Aaron Burr, who was Montgomery's aide-de-camp. Ogden, to whom Trumbull gave that honor, was actually with Arnold's battalion on the other side of the city. Trumbull also did not suggest the foolhardiness of Montgomery's attack, which was initiated under the worst possible conditions. Its chances of success were so minimal that afterward John Adams was provoked to write General Henry Knox about the way that risk was trampled by impulse, yet rewarded by destiny: "We have had Some Examples of Magnanimity and Bravery, it is true, which would have done Honour to any Age or Country. But those have been accompanied with a Want of Skill and Experience, which intitles the Hero to Compassion, at the Same Time that he has our Admiration. For my own Part I never think of Warren or Montgomery, without lamenting at the same Time that I admire, lamenting that Inexperience to which, perhaps they both owed their Glory."[104]

As in the death of Warren, the thirty-seven year-old Montgomery's ascent to the status of American martyr had a lot to do with a passion for liberty so great that he threw all caution to the wind. He was immediately mourned in Philadelphia, where Thomas Lynch of South Carolina expressed the sadness that swept over the Continental Congress: "Never was any City so universally Struck with grief, as this was on hearing

the Loss of Montgomery. Every lady's Eye was filled with Tears . . .
Poor gallant Fellow; if a Martyr's sufferings merit a Martyr's Reward
his claim is indisputable."[105] His memory was now "embalmed in the
Heart of every good American."[106]

Within a month of Montgomery's death, Congress commissioned
Dr. William Smith, the Provost of the College of Philadelphia (later
the University of Pennsylvania), to compose a fitting eulogy. On the day
it was delivered, the entire Continental Congress processed a half-mile
to the German Reformed Church, escorted by militiamen who had to
control the crowds overflowing the church and lining the street. Smith
compared Montgomery to General Wolfe and to Cincinnatus, and
while he spoke the music written for the occasion evoked the drama of
the siege of Quebec. At the same time, Congress put Benjamin Franklin
in charge of commissioning a monument to Montgomery. When he was
sent to France late in 1776 he had Jean-Jacques Caffiéri carve a marble
and limestone altar replete with obelisk, liberty cap, plow, broken sword,
Herculean club, and a martyr's palm.[107]

In literature too, Montgomery was deified. Tom Paine wrote a
political dialogue between Montgomery's ghost and a congressional
delegate. Poems, sermons, and orations repeatedly compared him to
Scipio, Cato, Hannibal, and, most frequently, to Wolfe. In one eulogy,
"Millions of seraphs, cloth'd in robes of gold" escort Montgomery to
heaven, where he is received by Joseph Warren.[108] John Trumbull the
poet wrote of Montgomery's "ardent warriors" braving the lacerating
cold as they crossed "Abraham's hapless plain" where "Wolfe's immortal
spirit took its flight." In London, the Whig press praised Montgomery.
Edmund Burke and Charles Fox sang his praises, and even General
John Burgoyne, who would soon be sent to reinforce the British garrison
at Quebec, had good things to say.[109]

The most artistic rendering of Montgomery's death came within a
year of the battle, when Brackenridge wrote a blank-verse propaganda
play meant to provoke revolutionary passions.[110] Purposively straying
far from the truth, he made British commander Guy Carleton into a
sadist who hangs Montgomery's corpse from the walls of Quebec and
demands surrender from the Americans. When they finally capitu-
late, he subjects them to "whatever shape/of suffering horrible, can be
devis'd." He turns three soldiers over to Indians who butcher them "with
every pain." None of that was true, nor was Montgomery's forty-four-
line death soliloquy or the scene in which General Wolfe returns from

the dead to chastise the British and then envision that one day "the grand idea of an empire" would emerge in America, governed by "clear independence and self-ballanc'd power."

Brackenridge admitted in his prologue that his Shakespearean play was not history. It was a "Dramatic Composition," as was Trumbull's painting. But there was a difference. Brackenridge's goal in 1777 was to exaggerate action and emotion in order to stir up patriotic sentiment, define allegiances, and encourage self-sacrifice during the Revolution, even if that meant turning the British into blood-lusting savages. As General Nathanael Greene wrote to John Adams on the value of monuments, poems, plays, and pictures to the revolutionary cause, "Patriotism is a glorious principle—but never refuse her the necessary Aids."[111] Nearly a decade later, Trumbull reconfigured history for a different reason: to enshrine the martyrs of the Revolution into an American Valhalla, or a secular version of the Stations of the Cross. Soldiers, like Christian saints, die for a worthy cause and are then canonized in print, paint, and the collective memory of Americans.

The last of Trumbull's martyrs was Brigadier General Hugh Mercer, a Scottish-born physician who had fought in the French and Indian War before he joined Washington's beleaguered army in New York during the summer of 1776. Mercer arrived in time to witness the massive assault unleashed on the city by General William Howe and his brother Admiral Richard Howe, with the goal of splitting the American colonies in two. Hopelessly outmaneuvered, outmanned, and outgunned, Washington and his army miraculously escaped from Brooklyn to Manhattan, retreated northward, first to Harlem and then to White Plains, and then fled across the Hudson River into New Jersey with General Lord Cornwallis in pursuit.

Winter forced the British and Hessian troops into camps scattered across northern New Jersey, from Brunswick to Trenton. Their hibernation allowed Washington the chance to execute a surprise attack that began with the crossing of the Delaware River late on Christmas day, and ended with the capture of the Hessian base in Trenton. Washington then moved his army north toward Princeton, where the British rear guard was stationed. Approaching from the southwest on January 3, 1777, General Nathanael Greene instructed Mercer, his second in command,

to lead the Third Virginia Regiment on an interception route toward the British troops commanded by Lieutenant Colonel Charles Mawhood. The British first exchanged musket and cannon fire with the Americans, followed by a frenzied bayonet charge. Mercer's gray horse was shot out from under him. Swarming British grenadiers then knocked Mercer down with the butt of a musket and demanded surrender, thinking for a moment they had captured Washington, the ultimate prize. Mercer refused to surrender, raised his sword, and lunged at the British, who then bayoneted him seven times and left him for dead. The battle was fought in a fruit orchard covered in snow; one British soldier recollected that "the ground was frozen and all the blood which was shed remained on the surface," frozen into sheets.[112]

In Trumbull's outline sketch of 1786, which represents his first thoughts on how he would depict the battle, Mercer is on the right side struggling on the ground by his fallen horse. Two grenadiers lunge at him with bayonets. Meanwhile, on the opposite side of the picture, a second drama unfolds that actually occurred at a different time. There, Lieutenant Charles Turnbull, who was part of the artillery corps, pushes his back on to a cannon as he raises a sword against a single grenadier who is about to jab a bayonet into his chest. A third event, visible on the far right horizon, happened later in the day. Tiny figures advance in a column toward Nassau Hall, about a mile and a half away from the fruit orchard. Led by Brigadier General John Sullivan and including Captain Alexander Hamilton, they are about to attack the British Fifty-fifth regiment, which had sought refuge on the campus of the College of New Jersey (later Princeton).

Unlike the method Trumbull used in his previous two paintings, both close to being "snapshots" of a single moment in battle, he now had the urge to compress time and space in his drawing of the Battle of Princeton. Events looking to be simultaneous in the sketch were in fact stretched across the day, and those seeming to occur within yards of one another were actually scattered over miles of countryside. Trumbull may simply have been overreaching, trying to pack many things into a single visual display. Or, he may have thought the Battle of Princeton did not contain the sort of single defining event that marked the action at Bunker's Hill and Quebec. Mercer's death produced nowhere near the outpourings of sentiment that followed in the wake of the killing of Warren and Montgomery. As an historical figure he lacked the fierce and reckless drive that motivated his martyred compatriots. Moreover,

John Trumbull, *The Death of General Mercer at the Battle of Princeton*, 1786

his death was mostly an instance of bad luck. He was felled early in the battle and in fact survived the vicious bayonet attack that day. He was taken to a field hospital at the eastern end of the battlefield, where he was attended to by Dr. Benjamin Rush, and lived for nine more days before dying. His wounding may not have been enough to carry a painting all on its own.

The fourth and crowning event in the sketch is the arrival of Washington on the battlefield, in the center of the picture. Washington had been in a rear position in the approach to Princeton. By the time he arrived at the battle site, Mercer was already devastated and the inexperienced Americans were in complete disarray. But he rallied the young and confused militiamen, including Lieutenant Charles Willson Peale, and broke the British line, pushing them back toward town and then four miles northeast to Kingston. Firsthand accounts said that Washington was fearless, marching his frightened horse directly into the lines of fire without hesitation.

That was precisely the image Trumbull aimed to capture in his sketch. While tumult reigns everywhere around him, Washington rides his horse across the battlefield with serenity and confidence, ever believing he can single-handedly turn certain defeat into an American victory.

It is the visual version of what Benjamin Rush wrote a few months before Princeton, when he observed that Washington "has so much martial dignity in his deportment that you would distinguish him to be a general and a soldier from among ten thousand people. There is not a king in Europe that would not look like a *valet de chambre* by his side."[113]

This sketch is the third of twelve known drawings for the Battle of Princeton in which Trumbull tested out ideas for the composition.[114] Some are in ink or pencil. Others are in wash, in which diluted ink is applied with a brush. And a few use all three media. Trumbull struggled with the location of the three main scenes—the attack on Mercer, the attack on Turnbull, and Washington's entrance—which he swapped with one another over and over again. Sometimes Mercer was on the right, or in the center. Turnbull started out on the left and was moved to the right, and then back to the left. Washington was high in the middle, then moved to the right distance, and was finally put back in the middle behind Mercer.

Trumbull never explained why he found it so difficult to create a satisfying design for the three staged events. But we can speculate that he was showing each sketch to Benjamin West, whose friendly advice kept leading Trumbull down a new path. Trumbull had begun the project in May of 1786, and two years later, on the eve of his return to the United States, he had gone through nine iterations, the last being a beautiful oil sketch that pushes the three main protagonists to the left half of the picture. Mercer and Turnbull form the base of a pyramid of figures with Washington at its apex, a strategy that further emphasizes the general, who is silhouetted by a white plume of smoke and whose head is symbolically threatened by the gnarled branch of an old tree that hovers menacingly overhead.

That was where Trumbull stopped. It would take him another forty years to produce a finished painting that is, in the end, unconvincing, the tortured result of endless reworking and rethinking.

The Battle of Princeton understandably loomed large, both Trumbull and Peale recognized. After the tragic defeat at Quebec and the humiliating loss of New York, the Battle of Princeton planted the seed of the idea that this war was winnable. As Trumbull himself put it, "In the short space of nine days, an extensive country, an entire State, was wrested from the hands of a victorious enemy, superior in numbers, in arms, and in discipline, by the wisdom, activity, and energy of one great mind," Washington.[115]

John Trumbull, *The Death of General Mercer at the Battle of Princeton*, 1786–88

Trumbull's prolonged struggles with the design for the picture were interrupted by the arrival of Thomas Jefferson in London during the spring of 1786. Jefferson was Minister to France, and in March of that year he sailed to London to visit Adams, then Minister to the Court of St. James's. Their joint task was to negotiate a commercial treaty with Britain, but the King, the ministers, and most of Parliament assailed the idea. Jefferson complained to James Madison that the English had "now decided that they intend to do nothing with us . . . They sufficiently value our commerce; but they are quite persuaded they shall enjoy it on their own terms. The political speculation fosters the warmest feeling of the King's heart, that is his hatred to us."[116] Making a bad situation worse, the English obnoxiously asked Jefferson whether the United States, operating under the feeble Articles of Confederation, even had the power to broker treaties, and perhaps would like to petition for readmission to the Empire. With their commercial mission failing and nothing else left to do, Adams and Jefferson made an enjoyable tour of English country houses and gardens instead.

Festering in Jefferson's nationalistic mind in 1786 was a chronic irritation that the United States was not being taken seriously in Europe. He had evidence all around. The British government rejected their

commercial entreaties, Barbary pirates were seizing American ships and demanding ransom, Dutch bankers were threatening to increase the interest rates on their loans to the United States, and, adding insult to injury, George III ostentatiously ignored Jefferson when he was presented at court.

Even the French were treating America in a diminutive way. Jefferson could make no progress toward a commercial treaty with them either, and he spent mountains of time defending the United States from the arguments of a French naturalist, the Comte de Buffon, who was claiming everything in the New World was smaller and inferior to the equivalent in Europe. In letters home, Jefferson repeatedly expressed the conviction that America was *superior* to Europe in many ways, both culturally and politically, but that he could not get much traction for that idea abroad.

That mounting irritation, seeing and hearing his country trivialized, even by its principal ally, led Jefferson to commission works of art that honor the heroes of the Revolution—portraits of Washington and Adams, busts of Franklin and John Paul Jones, and plans for a gallery of heroes in America and at his diplomatic residence in Paris.[117] He commissioned Houdon to sculpt a life-size, full-length portrait of Washington and supervised the casting of French medals to be given to officers of the Revolution. And of unexpected importance while he was in London, he was introduced to John Trumbull, looked at his newly painted pictures, heard about his ambitious project, and then invited him to Paris. Their brief meeting would swiftly change the course of Trumbull's career.

8 ⌥

Thomas Jefferson's Invitation

SHORTLY AFTER JOHN TRUMBULL MET THOMAS JEFFERSON in March of 1786 at the diplomatic residence of John Adams on Grosvenor Square, he showed him his pictures of Warren at Bunker's Hill and Montgomery at Quebec, which magically brought the decade-old Revolution back to vivid life. Over the course of the next few weeks, the two men discovered that they had a lot in common, in addition to their classical educations and experiences of the war. Both were fierce nationalists deeply troubled by the dim perception of America abroad. Both possessed a prideful patriotism that led them to measure the growing divergence between the systems and cultures of the Old World and those of their own new republic. And both recognized in each other a boundless faith in the bright prospects for the new United States.

Their conversation turned to the leading American artists in London, which led to Trumbull escorting Jefferson to the studios of John Singleton Copley and Benjamin West, where they would see two pictures of special interest to Jefferson: the colossal portrait of Adams and the unfinished picture of commissioners of the provisional peace treaty.[1] On the suggestion of Adams, Jefferson had his portrait painted by Mather Brown, an American, in which he looks like a mournful Parisian wearing a full wig and fancy jabot beneath a simple *frac* jacket. Nearby, a statue of Liberty coyly glances over her shoulder at him.[2]

Jefferson also took the opportunity to engage Trumbull in a

Mather Brown, *Thomas Jefferson*, 1786

conversation over the sculpture of George Washington that he had commissioned Jean-Antoine Houdon to carve in Paris for the new Virginia State Capitol in Richmond, which Jefferson himself had designed with the French draftsman Charles-Louis Clérisseau. For a building Jefferson intended to be a temple of liberty, the question was whether Washington should be dressed in antique clothing, giving him a timeless quality, or more appropriately be seen as a modern leader wearing his regimentals. Jefferson needed a concept to guide Houdon's work. After some debate, Trumbull and Jefferson agreed on modern dress for a new man of a new age.[3] By including a farmer's plow and unhitching Washington's sheathed sword from his waist, Houdon invoked the honored past and turned the great American into a new-world Cincinnatus, an idea that Trumbull could enthusiastically endorse.

In the course of conversation, Jefferson made Trumbull an unexpected offer to stay with him at the Hôtel de Langeac in Paris. It was a tempting prospect. It would give Trumbull the opportunity to explore rich old master collections in the city and to experience the contemporary French art world, which was on a different, more classically-oriented track than London's. Jefferson's invitation could even solve an issue of pressing concern to Trumbull: finding and hiring a printmaker who could make engravings of his pictures of the Revolution so that they might be published and marketed by subscription. Trumbull's future income hinged on engraved prints that could be sold by the dozens or hundreds, but securing a printmaker in London was proving to be impossible. In print-mad Britain, finding an available English engraver of quality willing to put his name to an American nationalist project was difficult. On Benjamin West's recommendation, Trumbull had contracted Antonio di Poggi, a London publisher, who suggested that France would be the best place to find an engraver. The French were already commemorating their contribution to the American Revolution and were avidly making and buying prints that celebrated victory over their archenemy, Britain.

Besides the artistic logic of visiting Paris, Trumbull had for some time been angling for an introduction to Jefferson. James Monroe had recently advised Jefferson that Trumbull was "desirous of being known to you & as I hear from every person who knows him a fair & respectable character."[4] In the same post, Monroe indicated that Trumbull was especially interested in diplomatic work, having lost out to William Stephens Smith in a bid to become secretary to Adams in London. An interlude in Paris might open up a new career path for Trumbull.

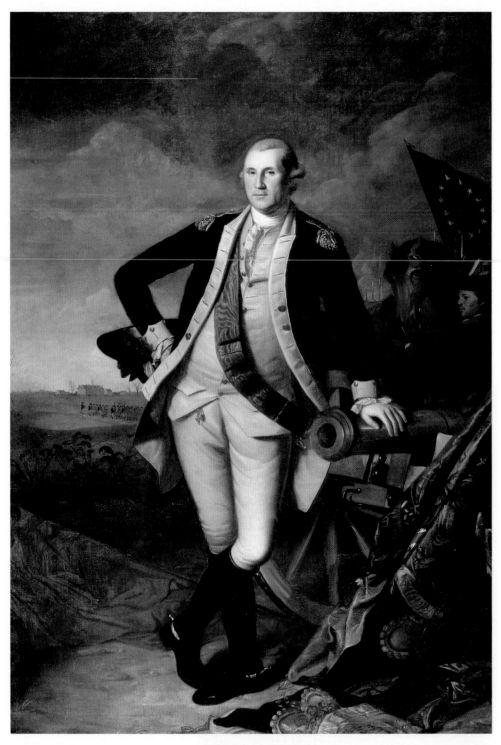

Charles Willson Peale, *George Washington at Princeton*, 1779

The Long Room, Interior of Peale's Museum, 1822. Peale's portraits line the top two tiers of the room.

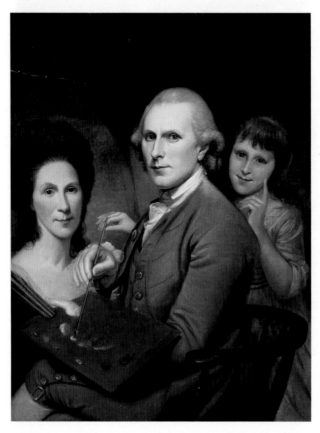

Charles Willson Peale,
*Self-Portrait with Rachel
and Angelica*, ca. 1782–85

Charles Willson Peale,
Thomas Jefferson, 1791–92

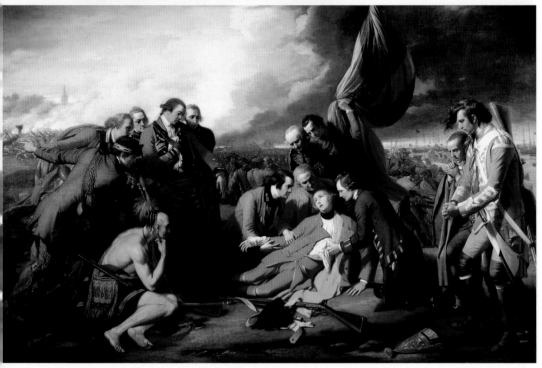

Benjamin West, *The Death of General Wolfe*, 1770

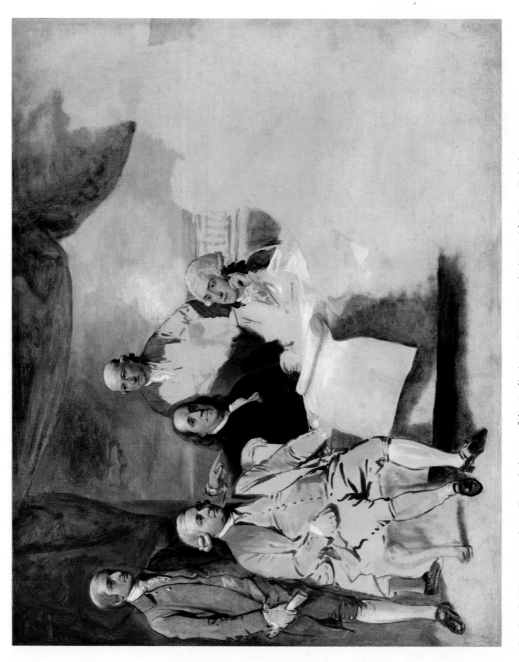

Benjamin West, *American Commissioners of the Preliminary Peace Negotiations with Great Britain*, 1783

Gilbert Stuart,
Benjamin West, 1781

John Singleton Copley,
Samuel Adams, 1772

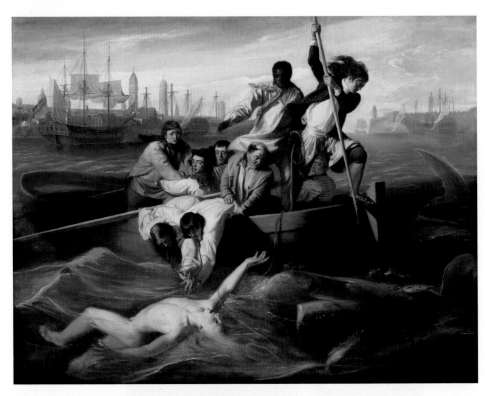

John Singleton Copley, *Watson and the Shark*, 1778

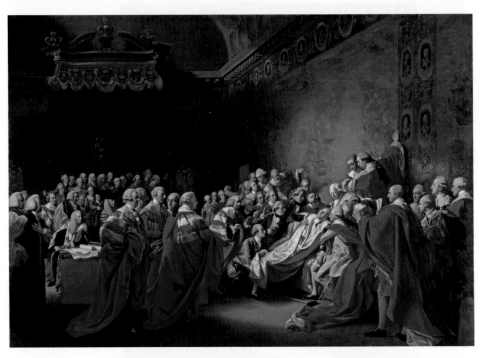

John Singleton Copley, *The Death of the Earl of Chatham in the House of Lords, 7 July 1778*, 1779–81

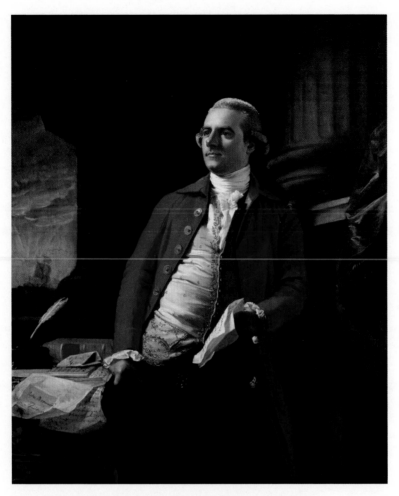

John Singleton Copley, *Elkanah Watson*, 1782

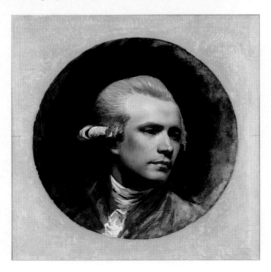

John Singleton Copley, *Self-Portrait*, ca. 1782

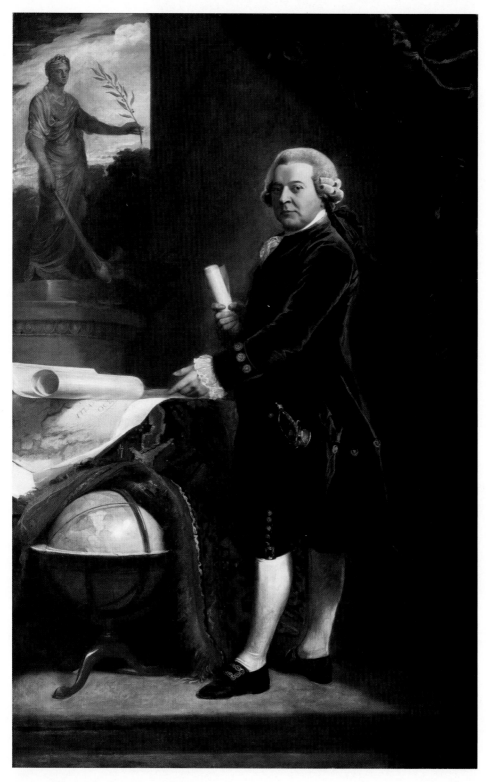

John Singleton Copley, *John Adams*, 1783

John Singleton Copley, *Henry Laurens*, 1782

John Trumbull, *Self-Portrait*, 1777

John Trumbull, *The Death of General Warren at the Battle of Bunker's Hill, June 17, 1775,* 1786

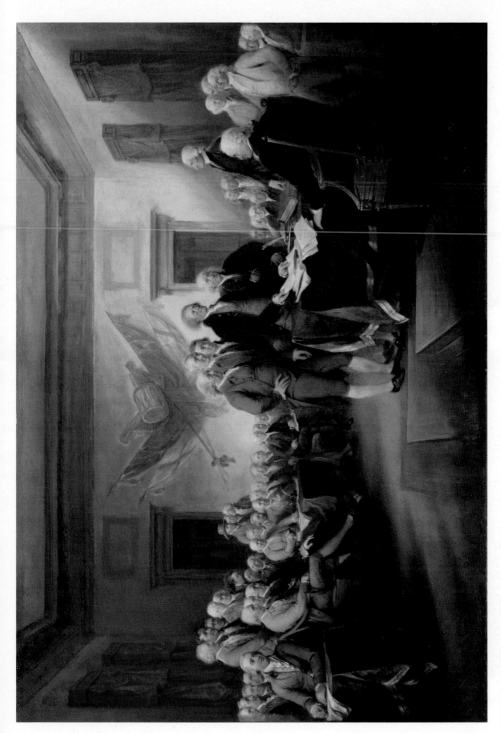

John Trumbull, *The Declaration of Independence*, 1786–1820

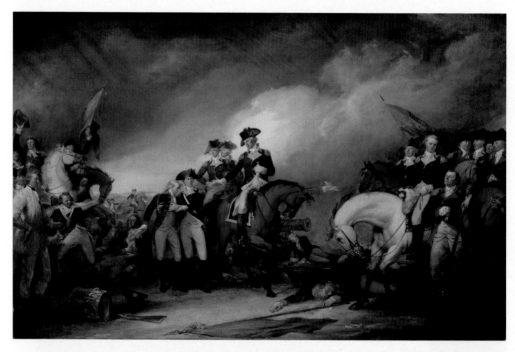

John Trumbull, *The Capture of the Hessians at Trenton, December 26, 1776,* 1786–1828

John Trumbull, *The Death of General Montgomery in the Attack on Quebec, December 31, 1775,* 1786

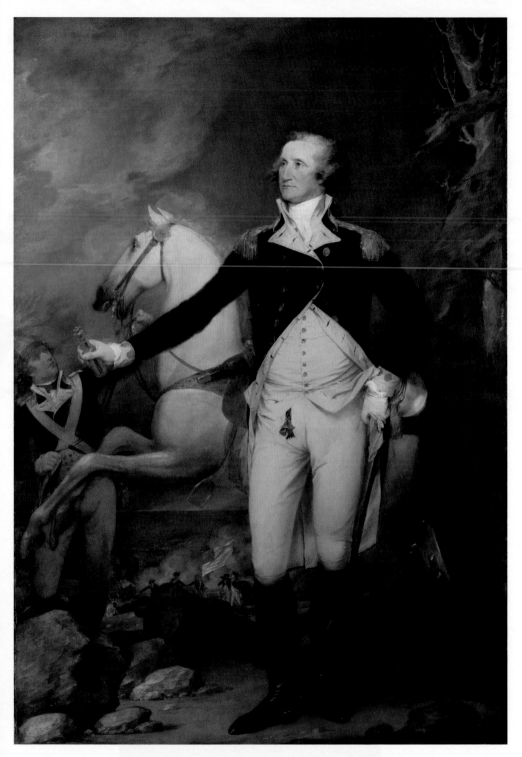

John Trumbull, *George Washington at Trenton*, 1792

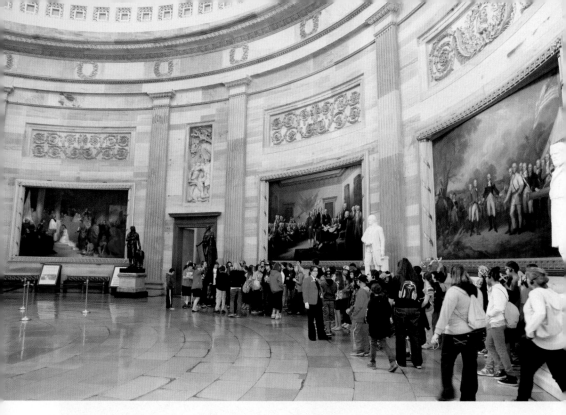

Tourists view John Trumbull's *The Declaration of Independence* and *The Surrender of Burgoyne at Sar* (AT RIGHT) in the United States Capitol Rotunda

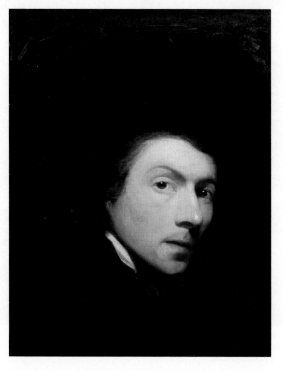

Gilbert Stuart, *Self-Portrait*, 1778

Gilbert Stuart, *George Washington*, 1796

Gilbert Stuart, *Thomas Jefferson*, 1805–07

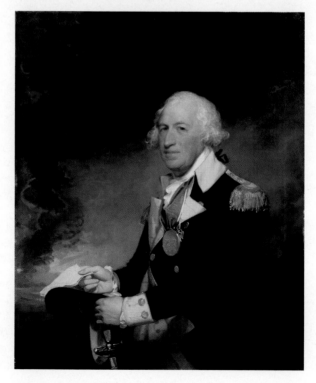

Gilbert Stuart, *Horatio Gates*, 1793–94

For Jefferson, Trumbull's presence in Paris stood to be a welcome distraction for the recently widowed and still grieving envoy, who was revitalizing himself by embarking on a study of European art and architecture, past and present. Jefferson often walked to the new Place Louis XV at the end of the Tuileries, where he was so captivated by Jacques-Ange Gabriel's noble buildings that he would one day recommend that style to the architects designing the new District of Columbia. He liked to visit the renovated Palais-Royale, once Cardinal Richelieu's residence. A descendant, the Duc d'Orléans, was converting it into a pleasure emporium with arcades, gardens, bars, and respectable entertainments, plus cafés, clubs, underground publishers, gambling halls, and brothels. Jefferson prudently restricted himself to the chess club, bookstalls, and theater, but wondered whether some version of a public mall might be inserted into the new Virginia state capitol. Jefferson's emerging enthusiasm for art blended with his pride in America. He was turning the Hôtel de Langeac into a gallery of notable Americans and he even made arrangements to have one of Charles Willson Peale's portraits of Washington shipped across the Atlantic so that it could hang prominently in the diplomatic residence.[5]

A very different aspect of his newfound interest in art took the form of an uncontrollable urge to spend money he did not have on art objects in Paris, ranging from chairs, carpets, and silver plates to candlesticks and decorated harpsichords. He bought pictures at auction and prints from the stalls at the Louvre, and he would eventually take back to his home at Monticello an odd assortment of paintings that included the Virgin Mary weeping at the death of Jesus, a copy of Raphael's Vatican *Transfiguration*, and a picture of Salome carrying the head of John the Baptist on a platter.[6] He bought items from the sale of the late Dupille de Saint-Séverin, including pictures of Saint Peter weeping, Democratis and Heraclitis debating the follies of mankind, and a penitent Mary Magdalen he incorrectly thought was the work of the Spanish painter Jusepe de Ribera. He ordered portrait busts from Houdon of Voltaire, Lafayette, and the Marquis de Turgot. All that manic buying was just the start of the impecunious Jefferson's unquenchable thirst for art.

At heart, though, Jefferson was still an unsophisticated Virginia country boy. He knew that when it came to the arts he was an enthusiastic amateur governed more by impulse than sophistication. With more than a small amount of flirtatious disingenuousness, he once confessed to the artist Maria Cosway that "I am so little of a connoisseur . . . I am

but a son of nature, loving what I see and feel, without being able to give a reason, nor caring much whether there be one."[7] Houdon and Clérisseau alternated as his cicerone, schooling his tastes and pointing him in the right directions. But ever better was having Trumbull in residence in his own house, an accomplished painter whose critical eye might guide him in his education, a fellow Patriot, one who spoke French fluently and who was in the midst of painting the first great gallery of scenes from the Revolution.

Jefferson returned to Paris on April 26, 1786, after six diplomatically unrewarding weeks in England. Trumbull followed on July 22, taking along his canvases of Warren at Bunker's Hill and Montgomery at Quebec. Both needed an engraver and each acted as his professional calling card in the city. Upon arrival he proceeded directly to Jefferson's residence, the Hôtel de Langeac, a twenty-four-room *petite maison* designed in 1768 by the neoclassical architect Jean-F. T. Chalgrin at 92 avenue des Champs-Élysées, not far from the Place de l' Étoile. The household was not like Adams's in London, which was bustling with family. Jefferson's fourteen-year-old daughter Patsy was mostly away at a Catholic boarding school and his younger daughter, Polly, would not arrive until 1787, escorted by Sally Hemings, the young mixed-race half-sister of his deceased wife, Martha. The household staff was manned by Sally's older brother James Hemings, who became an accomplished chef, and Adrien Petit, the maître d'hôtel who had previously worked for John Adams. Colonel David Humphries of Connecticut was secretary to the American legation. William Short of Virginia served as Jefferson's personal secretary, a position Trumbull would be offered in 1789 but would then reluctantly decline because of his project "commemorating the great Events of our Country's Revolution."[8]

Jefferson wrote Francis Hopkinson in Philadelphia that "our countryman Trumbull is here, a young painter of the most promising talents."[9] To Parisians he hailed Trumbull's "natural talents" as "unparalleled."[10] Trumbull's two pictures, on display at the Hôtel, were "the admiration of the Connoisseurs," including the influential Baron de Grimm, "the oracle of taste at Paris," who came by just to see the young American's productions and pronounced them preferable to the work of contemporary French artists.[11] Madame de Bréhan, an amateur painter and member of the royal court, visited and ordered a copy of one part of his *Death of General Warren*.[12] The famous antiquarian painter Hubert Robert and the future Minister to the United States, the Comte de

Moustier, also made pilgrimages to Trumbull's studio at the Hôtel, as did Jacques-Louis David, the preeminent painter of the era.

Trumbull had never experienced such praise before, so much of it echoing around him that he sensed his "brain half turned by the attention which had been paid to my paintings."[13] Thanks to Jefferson, who made him his unofficial artist-in-residence, Trumbull entered the highest realms of Parisian society, including its best thinkers and artists. Houdon took him around to private collections, and at the home of the painter Élisabeth Vigée Le Brun, "one of the most charming women I ever saw," he met "all the principal artists and connoisseurs in Paris."[14] He paid calls on David at his apartments in the Louvre, admired his enormous *Oath of the Horatii*, and was flattered by his offer to visit "all that related to the arts, in Paris and its vicinity."[15] On his own he ravenously toured the city, filling his diary with observations on paintings, sculptures, buildings, and theater. After an evening with Jefferson at a production of Pierre-Augustin Beaumarchais' *Mariage de Figaro*, he spent a day viewing the Bibliothèque du Roi, the Palais-Royal, and the Panthéon, where he marveled at Jacques-Germain Soufflot's great dome that was still under construction.

❧

On most trips, Trumbull was accompanied by Jefferson and a couple from Britain, Richard and Maria Cosway, both accomplished artists. Trumbull would have known, or known about, the Cosways in London. Richard Cosway, the principal painter to the Prince of Wales, had been invited to Paris by the Duc d'Orléans to paint his wife and children. His Florentine-born wife of five years was one of the leading women exhibiting in London. She and Trumbull both made their public debuts at the Royal Academy in the early 1780s and both were interested in classical themes. Her brother, the architect George Hatfield, was Trumbull's classmate at the Royal Academy, and Trumbull most likely was a guest at one of the many musical events that the relentlessly social Cosways sponsored at Schomberg House, their residence on Pall Mall.

Trumbull and the Cosways were inseparable in Paris and their pace was exhausting. On August 12, they traveled to Versailles with Poggi and Charles Bulfinch, the young architect from Boston. In Trumbull's words, the palace was "most splendid; the material, solid variegated marble; the ornaments are bronze gilt, the statues marble, and very

fine; the view from the windows, magnificently beautiful."[16] The group stopped at the apartments of the King's children, met the dauphin, and walked miles through the famous gardens, and into the Orangerie. They surveyed the collections and into the twilight hours discussed works by Leonardo, Veronese, Titian, Raphael, Rubens, and a bottomless list of other masters. A day later, Jefferson reported to Hopkinson in Philadelphia that Trumbull "returned last night from examining the king's collection of paintings at Versailles, and acknowledges it surpasses not only every thing he had seen, but every idea he had ever formed of this art."[17]

Maria Cosway was also a famous beauty, whose looks, charm, accomplishments, and refinements became irresistible to the widowed Jefferson. Trumbull had introduced Jefferson to the Cosways at the Halle aux Blés, the grain market topped by a majestic dome that Jefferson thought was "the most superb thing on earth."[18] Trumbull was not intending anything more than an interesting social introduction to like-minded, English-speaking people who were involved in the arts. But in the months ahead, Jefferson experienced a double intoxication as he chased down hundreds of works of art and architecture with Trumbull and the Cosways, while also chasing twenty-seven-year-old Maria Cosway across Paris. The four of them, Jefferson's "charming coterie," went to the Luxembourg Palace, David's studio, Notre-Dame, the Invalides, the Louvre, and the Académie de peinture et sculpture, to name but a few stops. They breakfasted, lunched, and dined together, attended highbrow and lowbrow amusements, and took romantic excursions to the Château Madrid, Château de Saint-Cloud, and the Désert de Retz landscape garden at Marly. Whatever the venue, they observed and debated an endless supply of paintings, sculptures, and buildings.

Richard Cosway, *Maria Cosway*, 1785

The coterie sometimes included others possessing equally polite refinements, but who also led private lives that many Americans would have then considered scandalous. The ever-present Baron d'Hancarville was a brilliant but bankrupt classical scholar who stole from his patron, abandoned his pregnant mistress, and in order to make money resorted to writing and illustrating, in the most graphic way, pornographic tales of the sex lives of the twelve Caesars.[19] Sometimes the troupe included the Comte de Moustier, a diplomat who became Minister to the United States, where he arrived with his sister-in-law—who was also his mistress—Madame de Bréhan. James Madison would one day write alarming letters to Jefferson about the feelings of moral repugnance that their "illicit" relationship incited in America.

Trumbull had a fair idea of how much "dissipation & nonsense," as he phrased it, abounded in Paris.[20] But Jefferson was blinded by Maria Cosway, and for years he used the trustworthy Trumbull to ferry intimate correspondence between them. Jefferson saw in her what he wanted to see, but on closer examination it was possible to observe the moral cracks and fissures in the life of the Cosways. They were not entirely what Jefferson believed, people "of the greatest merit," in possession of "good sense, good humour, honest hearts, honest manners, and eminence in a lovely art."[21] The artist Thomas Gainsborough might have lived in one wing of their home in London, and William Blake, Gouverneur Morris, or James Boswell could have been seen at dinner, but Richard Cosway also painted pornographic snuff boxes for the Prince of Wales, as well as saucy portraits of his mistresses.[22] The Cosways had a fondness for the Chevalière d'Éon, a transvestite and former spy who liked to demonstrate fencing technique at their home, as well as for the Scottish sexologist James Graham, who in another wing of the Cosways' building launched the Temple of Hymen, featuring the Celestial Bed.

Richard Cosway was a very talented, successful, and vain portraitist who was more fashionable than he was serious. Because of his height and his foppishness he was wickedly caricatured in the London press as the "Tiny Cosmetic" or the "Miniature Macaroni." Blake referred to the Cosways satirically as "Mr. and Mrs. Jacko," Jacko being a famous monkey in the circus, and Richard Cosway's appearance and movements were frequently likened to a small primate's. In the painter Johan Zoffany's group portrait of the artists of the Royal Academy, Cosway is the little man preening on the right, his face in profile, poking his walking stick into the crotch of a prostrate female mannequin.

Maria was the "goddess of Pall Mall," talented in music and art, but also mercurial and ostentatiously Catholic. At one party in London, she was seated next to Nabby, John Adams's daughter, who was quite critical. "She speaks English Italian and French vastly well, it is said, Plays and sings, well, but has nevertheless, the foibles, which attend these accomplishments." Maria Cosway conspicuously sang and played for the crowd, which Nabby thought inexcusable in a person so lacking in "Wit and good Humour." Cosway "is one of those soft gentle pretty Women" with "Airs." After an event at the Cosway household, Nabby gave up at the "attempt to describe the various Characters that were present . . . When one wishes to see singularity in all its forms it is only necessary to visit this family."[23]

Maria was widely caricatured, once as "Maria Costive" or Maria Constricted, taking the form of a slightly mad artist in an asylum. In another wicked caricature, *A Smuggling Machine, or a Convenient Cosway for a Man in Miniature*, little Richard Cosway emerges from big Maria's hooped petticoat, a reference to his shrunken size and her expanding fame. On the back wall can be seen a tiny man climbing up a ladder mounted on a giant woman's bare breasts. She was accustomed to flirtatious men and came to expect their attentions, having once been characterized by Boswell as a woman who treats "men like dogs."[24] The circling dogs included d'Hancarville, the Prince of Wales, the collector and rake Charles Townley, the Corsican patriot Pasquale Paoli, and the guileless Jefferson, whose "easy credulity" allowed him to overlook harsh realities.[25] In the European arena of love and sex, Jefferson was in over his head.

Trumbull was deeply involved in Jefferson's romance with Maria Cosway over the course of three years. He knew all that was going on between them, but like an apprentice diplomat he unshakably kept his silence and stayed true in

H. Humphrey, *A Smuggling Machine, or, a Convenient Cosway for a Man in Miniature*, 1782

his devotion to Jefferson, who asked him to be not just his go-between, but also his romantic proxy. In one exchange of letters after both Trumbull and Cosway returned to London in 1787, Jefferson had Trumbull go to her in person. "Tell Mrs. Cosway she is inconstant. She was to have been in Paris long ago, but she deceived us."[26] Jefferson instructed Trumbull to scold her, but also, "in the meantime, lay all my affection at her feet . . . kneel to Mrs. Cosway for me and lay my soul in her lap."[27]

When Cosway told Jefferson that she would be returning to Paris without her husband in the autumn of 1787, Jefferson begged Trumbull to join them, in an effort to recuperate the happiness he had experienced with his "charming coterie" the previous year.[28] Jefferson even sent Trumbull the catalog of the recently opened *Salon*, the giant biennial art exhibition, just to entice him. "The best thing," he reported to Trumbull, "is the Death of Socrates by David and a superb one it is." He thought Trumbull would want to see Hubert Robert's picture of the Pont du Gard and Vigée Le Brun's huge portrait of Marie Antoinette and her children. "You should not miss it. Come & take your bed here. You will see Mrs. Cosway. She arrived two days ago."[29]

But Trumbull was too tied up with painting the American Revolution in London and, in the end, Jefferson's romance with Cosway faded during their second act. The letters between them continued, as did Trumbull's agency, but Jefferson's departure from France in September of 1789, two months after the siege of the Bastille, ended the possibility of ever courting Maria Cosway again.

As much as Trumbull was implicated in Jefferson's love obsession, Jefferson was deeply implicated in Trumbull's painting of the Declaration of Independence, by far the most recognized icon of the American Revolution. Trumbull had absolutely no plans to paint that subject when he first left England for Paris. For him, the suite of revolutionary pictures was only going to encompass raging battlefields and heroic valor. Scenes of legislative actions, peace treaties, and high-level meetings were not prominent features in Trumbull's mental landscape, and he knew they were extremely difficult subjects to paint in an interesting way. He would have been correct to think that, as a subject for art, the events of the summer of 1776 in Philadelphia were unlikely candidates for fulfilling Benjamin West's dictum that an historical subject ought to

be *"Epic."*

But while West was whispering in one of Trumbull's ears, Jefferson was whispering in the other. He was the one who persuasively made the case for including the Declaration of Independence in Trumbull's suite. Jefferson helped Trumbull by sketching a barebones outline of the Assembly Room of the Pennsylvania State House (now Independence Hall), and also by providing a firsthand narrative from his notes of the summer 1776.[30]

Jefferson could describe many possible scenes that Trumbull might have then fashioned into a picture. On May 10, Congress had passed John Adams's resolution instructing the colonies to write their own constitutions, absolving them from all future allegiance to Britain. On June 7, Richard Henry Lee of Virginia had presented a formal resolution calling for independence from Britain, along with a proposal for the confederation of the colonies. On June 11, the Continental Congress had appointed a Committee of Five to compose a declaration of independence. On June 28, that committee had turned Jefferson's draft of the document over to Congress. On July 2, Congress had approved Lee's proposal for independence. On July 4, Congress had formally endorsed the Declaration of Independence. On July 12, John Dickinson of Pennsylvania had submitted a written plan for the confederation of the thirteen colonies. And on August 2, fifty-five members of Congress had signed the Declaration of Independence.

From that list of momentous events, Trumbull picked June 28, when the Committee of Five, consisting of Jefferson, Adams, Franklin, Roger Sherman of Connecticut, and Robert Livingston of New York, had turned the first draft of the Declaration over to Congress, which would edit the document and bring it forward for endorsement. That was the one

Thomas Jefferson, *Pennsylvania State House*, 1786

event from the Founding that put the sharpest focus on Jefferson, Trumbull's host, mentor, and benefactor.

At the time, it was still not widely known that Jefferson had been the primary author of the Declaration.[31] In fact, Jefferson himself had not previously attached any special importance to the document he had drafted, since independence from Britain had in effect existed since May 10, when Congress had instructed the colonies to write their own constitutions. The main point of writing the Declaration was to issue a paper explaining that decision to America and the world, and in making the colonies appear to be speaking with a single voice and thus worthy of recognition and, most importantly, deserving of financial aid from France.[32]

But while Jefferson was in Paris more than a decade later, witnessing the widespread and deeply ingrained human rights abuses inflicted on the population, he came to realize the full and enduring importance of what he had written. The "contagion of liberty," as Jefferson put it, was about to arrive in France and Jefferson's Declaration stood to be an agent of change. He would actively argue for and then draft a French Charter of Rights. A cross between the American Declaration of Independence and the future Constitution, it called for and guaranteed that ordinary French men and women be entitled to lead lives they could call their own, free from dictatorial authority. Lafayette would then take Jefferson's Charter and use it as the basis for the Declaration of the Rights of Man and of the Citizen, which he presented to the National Assembly in 1789. Echoing Jefferson, it began: "Men are born free and remain free and equal in rights." For French liberals, Jefferson's Declaration had special status. Lafayette even took the step of having it engraved in gold for the entry hall of his home, which was attended to by his young Oneida acolyte, Peter Otsiquette.

Trumbull also took an accelerating personal interest in the events leading up to the French Revolution. He saw the repressions of the French government, the wretchedness of the masses, the censure of the press, the government monopolies, and the excesses of the aristocracy, all of which Jefferson called the "monstrous abuses of power under which this people were ground to powder."[33] On one of his later trips to France, at the start of the Revolution, Trumbull would gather information on the storming of the Bastille and the entry of Louis XVI into Paris surrounded by sixty thousand armed citizens. Like Tom Paine, Trumbull thought in the back of his mind that 1789 was going to be

a replay of 1775 in Boston, that one day the French Revolution might become the subject of a suite of pictures, and when joined with his suite on the American Revolution Trumbull would have chronicled the modern history of human rights and republican government.[34]

The Reign of Terror of 1793–94 would bring to a crashing end his romance with the revolutionary movement in France and put a stop to any contemplated paintings on that subject. And because Jefferson remained a Francophile throughout the period, it would also destroy Trumbull's friendship with him.

Trumbull's paintings of the Declaration of Independence, both the Yale version that was part of his original suite on the Revolution and the colossal late version that hangs in the United States Capitol Rotunda, would make three things clear: that the document was the legislative and philosophic centerpiece of the Revolution, that Jefferson was its author, and that if a single Founder ought to be identified with the modern concept of inalienable human rights, that person also was Jefferson. Though the road to American independence was infinitely more complex than the paintings suggest, Trumbull distilled the summer of 1776 into a single image. That well suited the interests of Jefferson, who in later life considered his greatest achievement not to be his two-term presidency or his time as Minister to France, but rather what he decided to have inscribed on his gravestone in 1826: "Author of the Declaration of American Independence."

Trumbull started the painting in Paris under Jefferson's influence, developed it further under West's aegis, and finished it years later in America on his own steam. In Trumbull's reconstruction of the events of June 28, as they were first narrated to him by Jefferson in Paris, the Committee of Five stands in the middle before the assembled Congress and submits the Declaration to a seated John Hancock, who sits behind a draped table that is a few steps higher than the floor of the Assembly Room. The overall emotional tenor of the Congress is what Trumbull himself called "silence and solemnity." Quiet and orderly, his congressmen reverentially witness Jefferson place the Declaration onto Hancock's cluttered desk, as if they were attending church and this was the holy sacrament.

But the record of the Continental Congress indicates that June 28 was in fact a day of frantic activity, with the Declaration just one item sandwiched in between dozens of other pieces of business. Congress agreed to pay Thomas Thomson 750 dollars for lumber and another 117 dollars to

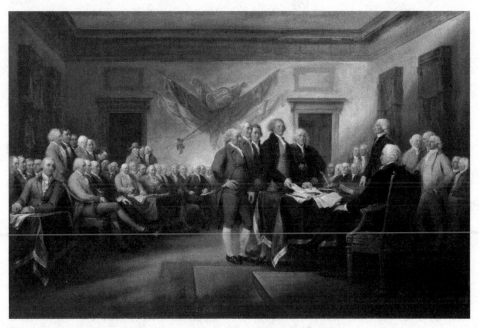

John Trumbull, *The Declaration of Independence*, 1786–1820

Thomas Mayberry for plated iron. A slate of new congressional delegates was given instructions "for supporting the just Rights and Liberties of America" and "declaring the United Colonies independent of Great Britain." The Chevalier de Kermorvan was hired to build Fort Billingsport on land that Congress had purchased on the Delaware River. Then, as the congressional record shows, "the committee appointed to prepare a declaration, etc. brought in a draught, which was read." The reading took about fifteen minutes. It was then ordered to "lie on the table" whereupon Congress turned its attention to other pressing items, such as the manufacturing of sulphur and the printing of more money.

Trumbull admitted that his picture was not perfectly accurate. It was highly unlikely, he said, that the entire Committee of Five would have approached the President. Instead, custom dictated that the head of any committee merely "rise in his place" when "reporting an act."[35] Trumbull also confessed that he "took the liberty of embellishing the background by suspending upon the wall, military flags and trophies." He said it was possible that booty from Richard Montgomery's successful siege of Fort Saint-Jean and Montreal might have made its way to Philadelphia, but that was not known for a fact.[36] In reality, there were very few American victories to commemorate by mid-1776. Even as the

Declaration was being submitted and endorsed, General William Howe and his brother Admiral Richard Howe were invading New York City with a strike force of 32,000 men.

Instead of the wide Venetian blinds covering the windows, Trumbull hung heavy curtains. Instead of the simple Windsor chairs furnishing the Assembly Room, he used upholstered armchairs and gave Hancock a gilt chair in the style of Louis XVI furniture. Among the dozens of portraits he so diligently included, there were still more that he could not acquire, in most cases because the congressman had died. Even Jefferson's footprint drawing of the Assembly Room was itself inaccurate: Instead of the one door at the back of the room, Jefferson indicated two. Only ten years after independence, Jefferson himself was habitually misremembering dates, details, and the sequence of events, and Trumbull's research for the painting only extended as far as Jefferson and Adams.[37]

Trumbull's central grouping—Adams, Sherman, Livingston, Jefferson, and Franklin facing Hancock and, to his right, Secretary of Congress Charles Thomson—was in roughly the same configuration that West had pioneered in his *American Commissioners*.

Trumbull made a point of having Jefferson stand out, in part the result of his red vest and his height, but also because his head is the only one in pure silhouette against the back wall. Adams, Trumbull's other friend and informant, stands dead-center in the picture and is the only figure clearly seen full-length, short in stature but in a swaggering pose. Where Jefferson stands in an elegant écarté, his right heel picked up, Adams looks like a bulldog, feet flat and right arm akimbo. The other committee members look secondary, and in fact they contributed much less to the writing of the Declaration than did their colleagues.

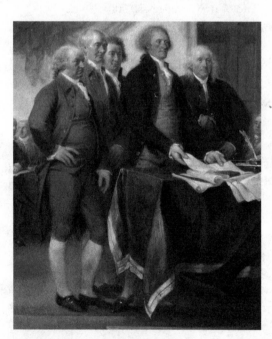

John Trumbull, *The Declaration of Independence*, 1786–1820 (detail)

Though Trumbull could rely on Jefferson and Adams for

firsthand accounts, the dozens of portraits to be included presented an almost insurmountable obstacle. He was able to take Jefferson's in Paris, and Adams's in London. But the others had to be painted in the United States after he returned in 1789, an arduous and exhausting task that forced him to track down former legislators a dozen or more years after they served in the Second Continental Congress. Trumbull's travel diary when he got back to the United States reads like that of a migratory worker: "I returned through Connecticut to Philadelphia, to which place Congress had adjourned from New York. In February I went to Charleston, S. C., and there obtained portraits of the Rutledges, Pinckneys, Middleton, Laurens, Heyward, etc. . . . thence rode to Williamsburg, and obtained a drawing of Mr. Wythe for the Declaration; thence to Richmond, thence to Fredericksburg . . ."[38]

Sometimes he carried the canvas from place to place and painted a portrait directly onto it. Other times he made pencil sketches or exquisite oil miniatures on site and added the figures to the canvas later. His progress was further slowed when he took a decade away from painting, between 1794 and 1804, while he served as a diplomat for the Washington and Adams administrations. In the end, he only completed his most famous painting after the War of 1812, at which point he reported to Jefferson that he had painted thirty-six portraits from life, copied nine from the work of other artists, painted one from memory, and one from a description.[39]

Trumbull was consumed with five projects that he successfully began but ended up juggling on and off for years. Hard as he tried, he still could not find a satisfying resolution to all the studies he had made for the *Death of General Mercer at the Battle of Princeton*, which in effect tabled that project. After starting the *Declaration of Independence* in Paris, he continued with it in London, where he spent the year 1787, and then put that project aside until he could start taking portraits in the United States. In London he began to make studies for his fifth and sixth scenes from the Revolution, *The Capture of the Hessians at Trenton, December 26, 1776* and *The Surrender of Lord Cornwallis at Yorktown, October 19, 1781*. Unexpectedly, he also added one more picture in the summer of 1787, a large canvas on *The Sortie Made by the British Garrison of Gibraltar*. It was a painting of a British triumph that West insisted Trumbull paint

in order to curry critical favor in London and to compete with John Singleton Copley's own giant painting on the same subject.

Trumbull had gotten close to the pivotal Battle of Trenton at the end of 1776 when he was a colonel under General Horatio Gates, who led his brigade south from Ticonderoga to Newtown, Pennsylvania, where Washington was encamped. But before the crossing of the Delaware and the surprise attack on the Hessian garrison in Trenton, Trumbull had been reassigned to Rhode Island with General Benedict Arnold.

Unlike the fiercely waged Battle of Princeton eight days later, a subject that Trumbull was already painting, the action at Trenton was not full of heroics because Washington had caught the Hessians off guard after he led his 2,400 troops, along with artillery and horses, across the Delaware in ferries and Durham boats on Christmas night. Trumbull did not consider the crossing itself to be a potential subject, and in fact it would not become attractive until Thomas Sully painted it for the state of North Carolina in 1819 and Emmanuel Leutze immortalized it in 1851. Instead of the crossing, Trumbull focused his attention on the aftermath of the battle, a decision that allowed him to extend the narrative thread he had begun with his picture of Mercer at the Battle of

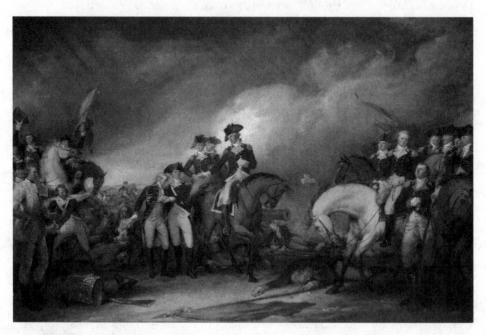

John Trumbull, *The Capture of the Hessians at Trenton, December 26, 1776*, 1786–1828

Princeton, namely the exemplary character of Washington. As Trumbull explained in his autobiography, he "composed the picture, for the express purpose of giving a lesson to all living and future soldiers in the service of [their] country, to show mercy and kindness to a fallen enemy,—their enemy no longer when wounded and in their power."[40]

In Trumbull's narrative, the fighting has ended. Washington, on horseback and followed by his two military secretaries, Captain Tench Tilghman and Colonel Robert Hanson Harrison, is approached by the mortally wounded German commander, Colonel Johann Gottlieb Rall, who is escorted by Major William Stephens Smith. (At the time that Trumbull painted Smith he was recently married to Nabby Adams in London.) Washington responds to the dying Rall's honorable approach by extending his right hand in a gesture of compassion.

Legend and history mingle in this moment. Though Trumbull devoted years to achieve accuracy by tracking down and then painting life portraits of as many participants as he could, including Washington's, he also decided to fictionalize the moment depicted. The scene never occurred that way. While Washington did order his men to show kindness to the 848 Hessian prisoners, according to the testimony of the Hessian Captain Ernst Altenbockum, Rall was shot twice in the side while on horseback. Aides helped him off, carried him into a church, and put him down on a bench, where he died in the evening.[41]

In Trumbull's retelling, the suffering Rall has the wherewithal to stand in a classical pose for his meeting on the battlefield with Washington. Propped up by Smith, he politely yet desperately requests quarter for his troops, which would allow them to be taken as prisoners, instead of being killed. Washington in turn reassures Rall that quarter will be extended, allowing Rall to die in peace. Such a meeting never took place.

Complete historical accuracy would have obscured the point of the painting as a character study of Washington. Trumbull has made him into nothing less than an American Marcus Aurelius. The second-century emperor was often depicted on horseback, extending mercy to those he conquered. Besides the famous equestrian bronze on the Campidoglio in Rome, the linkage to Trumbull's Washington is most evident in a large Roman panel showing the good emperor after his triumph over the Germans in the year 170, compassionately listening to the pleas of the "barbarians" he had defeated.[42] As Washington pauses in Trumbull's painting and turns away from his victory march in order

to reassure the fatally wounded Rall that his men will be spared—when Washington turns his back to fame—he embodies the humanist virtues that Marcus Aurelius wrote about so compellingly in his *Meditations*. "Magnanimity," as the emperor famously defined it, "is the elevation of the intelligent part above the pleasurable or painful sensations of the flesh, and above that poor thing called fame, and death, and all such things."[43]

Across Trumbull's Revolutionary suite, conquest and clemency went hand in hand. As John Adams advanced that concept a few weeks after Trenton and Princeton, "Is there any Policy on this side of hell, that is inconsistent with Humanity? I have no Idea of it. I know of no policy, God is my witness but this—Piety, Humanity and Honesty are the best Policy. Blasphemy, Cruelty, and Villany have prevailed and may again. But they wont prevail against America, in this contest."[44] Washington was the one who put that policy into practice.[45] However brutal the English might be, both in and after battle, the Americans, and especially Washington, prided themselves on their fairness in the field. After Trenton, Washington issued a broadside stating that the Hessians "were innocent people in this war," and that they should be considered friends, rather than enemies.[46] The Hessian prisoners were at first paraded through the streets of Philadelphia where they were jeered, shoved, and pelted with dirt.[47] But soon after they were sent to central Pennsylvania and western Virginia, often unattended, and many stayed in America after the war.

❧

Trumbull continued to push physically and mentally to finish the array of pictures he was juggling simultaneously. If those projects were not already overwhelming, he began to work in earnest in 1787 on the siege of Yorktown, a subject that needed to be painted because of its magnitude, but that was especially challenging because of the thirty-six portraits required for the picture.[48] As a result, Trumbull did not finish that painting for decades; it joined the back end of the growing queue of incompletions.

After one final trip to Paris in August of 1789, full of enthusiasm for the "Splendid Scene" of the French Revolution, he sailed to America from Gravesend on October 26, 1789, on the same day Jefferson left from the Isle of Wight.[49] He arrived in New York on November

23, happy to breathe "the air of America."[50] Within a few days he was reunited with his family in Connecticut.

The America he stepped into had dramatically changed in the six years he had been abroad. His former commander was freshly installed as President; Jefferson, who arrived in America the same day as Trumbull, was the new Secretary of State; Adams was the new Vice President; and, most stunning of all, a Constitution had locked previously autonomous states into a federal system that replaced the Articles of Confederation which, had they not been retired, would have let the United States fall apart. Abigail Adams, who had resettled in New York, the capital city, with her husband in a house overlooking the Hudson, was particularly "happy to welcome [Trumbull] to his Native Land." She told her friends about his "amiable Character and his intention of painting the great and important Scenes and principal Actors from the Life, in the late Revolution," which she predicted "ought to ensure to him publick Patronage and I flatter myself he will meet with it before he returns to Europe."[51]

Abigail's optimism aside, Trumbull's checklist of things to be done in America was daunting, discouraging, and, as he discovered, completely impossible: figure out the final composition for four unfinished pictures, start traveling thousands of miles to sketch battlefield topography, and take portraits of legislators and military men who would all be needed to populate scenes. As Trumbull knew well, unfinished paintings by themselves did not make for a living wage. He needed to have prints made and sold for money—and soon—since the Revolution was fast receding into memory and so too might the urge to recall it. He thought he had finally found an engraver in Stuttgart for his *Death of General Warren*. But Johann Gotthard von Müller would not finish a print until 1797, though he did show Trumbull's picture to Johann Wolfgang von Goethe, who wrote about it approvingly.

Trumbull's grand project was beset with problems, both out of his control and created for himself. Nonetheless, only weeks into his time in New York he took out an advertisement in the newly founded *Gazette of the United States*, a Federalist mouthpiece, in which he unveiled an offer to sell subscriptions to the prints that he did not yet have. "No period of the history of man, is more interesting than that in which we have lived," announced Trumbull, "The memory of scenes in which were laid the foundation of that free government, which secures our national and individual happiness, must remain ever dear to us and to our posterity."[52]

These were bold words from an artist who had nothing ready to sell.

Besides offering the public nonexistent prints of Warren dying at Bunker's Hill and Montgomery at Quebec, he pitched prints of the other four paintings that were still in process, and promised future prints based on seven paintings he had not even started: Burgoyne's surrender at Saratoga in 1777, the treaty with France in 1778, the signing of the Treaty of Paris in 1783, the British evacuation of New York in 1783, the resignation of General Washington in 1783, the inauguration of President Washington in 1789, and the dedication of the memorial arch that a ladies' committee had built in Trenton in 1789.[53] To make matters more complex for himself, he entertained unrealistic thoughts of also painting the bloody American siege of British-held Savannah in 1779 and the equally heroic but failed American siege of Charleston in 1780.

When he ran the ad again in April of 1790, he added yet another picture, the 1781 Battle of Eutaw Springs, and he also embellished his salesmanship with a passage from an epic poem that Joel Barlow had published in 1787, *The Vision of Columbus*, in which Trumbull's *Death of General Warren* and *Death of General Montgomery* are described in effulgent verse:

> Fired with the martial toils, that bathed in gore
> His brave companions on his native shore
> Trumbull with daring hand the scene recalls,
> He shades with night Quebec's beleagur'd walls,
> Mid flashing flames, that round the turrets rise,
> Blind carnage raves and great Montgomery dies.
> On Charlestown's height, thro' floods of rolling fire,
> Brave Warren falls and sullen host retire;
> While other plains of death, that gloom the skies,
> And chiefs immortal o'er his canvass rise.[54]

Effulgence aside, Trumbull needed a magician to pull prints out of a hat if he were going to realize even half of his project or any of his anticipated profit.

Without the actual prints in hand, it did not make any difference that Trumbull was offering an attractive installment plan, "one half to be paid at the time of subscribing, the remainder on the delivery of the prints," because he was not going to be able to fulfill his orders. In the advertisement he could boast of already selling four subscriptions

to Washington, two each to Jefferson and Hamilton, and single sets to John Jay, James Madison, Henry Knox, Robert Morris, Horatio Gates, and another 331 subscribers. He could tout Washington's regard for "the greatness of the design and the masterly execution of the work," as well as the "honor" Trumbull was conferring on his profession and "his native country."[55] And he could depend on the President to prevail upon Lafayette to promote the project in France. But the successful marketing of subscriptions proved to be a zero sum game, not only because there were no prints, but because the paintings on which the prints were to be based were stalled in a dozen different stages that made any significant headway toward the completion of anything difficult.

Logically, he should have addressed the sixteen historical scenes one at a time or in groups of two or four, but instead of working incrementally he thought he should start collecting likenesses for all of the scenes at the same time, starting in 1790. Though "all the world," as he phrased it, was gathered in New York, allowing him to take many portraits, he would not put the finishing touches on the pictures of Yorktown, Trenton, Princeton, and the Declaration until the 1820s. For the surrender of General Burgoyne at Saratoga, he was successful at taking portrait studies and sketching the battlefield in 1791, but he would not begin work on the painting until 1821. For the resignation of General Washington, he took portraits of eight of the participants, including Arthur Lee, William Smallwood, and a fierce-looking Thomas Mifflin, but he would not start that painting until 1824.

All we have of the other intended pictures are some extraordinary four-by-three-inch portraits that are among Trumbull's most accomplished works. For the never-executed picture on the inauguration of President Washington, he took portraits of Oliver Ellsworth, Theodore Sedgwick, Fisher Ames, and others, including Ralph Izard,

John Trumbull, *John Adams*, 1792

Copley's old patron. For the Treaty of Paris, which was to pay homage to West's picture of the Provisional Treaty of 1782, Trumbull got as far as a rough sketch of the scene and portraits of five of the seven planned figures, including Adams, John Jay, the American secretary William Temple Franklin, and the British secretary George Hammond. For Adams, Trumbull could have taken a shortcut and copied from the portrait in his own *Declaration of Independence*. But instead he took a new portrait in 1792 showing Adams nattily dressed in a puce-colored suit and looking almost cherubic. For the battle of Eutaw Springs, he only got as far as painting the Irish-born Captain Laurence Manning. For the siege of Savannah and the attack on Charleston, he took portraits of Thomas and Charles Cotesworth Pinckney, John Rutledge, and William Moultrie. For the British evacuation from New York and the arch at Trenton, there is no evidence that he made any sketches or studies at all.

Trumbull was intent on chronicling his remarkable age, but what had begun as a tightly defined project to paint a few key scenes from the Revolution had now been transformed into a visual encyclopedia that was spinning out of control.

❦

With the historical scenes at an infuriating standstill until he could collect all the requisite materials, Trumbull was rescued from the financial corner he had backed himself into when he was offered commissions for epic portraits of the Founders, now assembled together, first in New York City, and after August of 1790 in Philadelphia. An attorney, a bank president, and three New York merchants wanted Trumbull to paint a life-size portrait of Alexander Hamilton, the new Secretary of the Treasury. It was unveiled to fanfare on July 4, 1792 at City Hall.[56] Another equally large commission came from the City of New York for a portrait of George Clinton. Though Clinton was governor of the state in 1792, Trumbull dialed the portrait clock back to 1777 when General Clinton's regiment had slowed the northward advance of the British juggernaut at Fort Montgomery, a strategic American installation on the lower Hudson.

Of all the Founders, though, Washington was the most desirable of subjects. Statehouses and city halls across the country clamored for grand portraits in their legislative buildings, as replacements for the portraits of George III that had been taken down or destroyed.

Pennsylvania already had Peale's impressive *Washington at Princeton* in the State House and Maryland had Peale's *Washington at Yorktown*. Virginia had contracted with Houdon for a large sculpture, on Jefferson's advice.

Because of his extraordinary access to Washington, Trumbull was invited to dine with the President in New York only weeks after his arrival in the city, whereupon he took the occasion to describe his Revolutionary War paintings. On January 23, 1790, the President and Martha Washington went "in the Forenoon to see the Paintings of Mr. Jno. Trumbull," and a few days later Martha commissioned Trumbull to paint her husband for Mount Vernon.[57] Washington sat for Trumbull thirteen times in two-hour sessions that stretched into the summer. In addition to the sittings, which took place in the "painting-room" of the President's mansion on 39 Broadway, Trumbull arranged for "*standings* as well as sittings—the white charger, fully caparisoned, having been led out and held by a groom, while the chief [Washington] was placed by

the artist by the side of the horse, the right arm resting on the saddle."[58]

For the setting, Trumbull drew from his own experiences when he was stationed at New Windsor, sixty miles north of the city, working at the Continental Army depot after his expulsion from Britain in 1781. In 1782, Trumbull had watched Washington's army arrive at Verplanck's Point on the Hudson River, twenty miles farther south, freshly victorious after Yorktown. The Continentals had camped and conducted military exercises in expectation of a final assault on the British stronghold in Manhattan, which turned out to be unnecessary when Parliament authorized peace negotiations. In Trumbull's painting, Washington does not look down to the massive

John Trumbull, *Washington at Verplanck's Point*, 1790

display of troops on the distant plain, but turns away, as if taking this moment to reflect, perhaps on the magnitude of the moment at hand.

While Trumbull was painting that picture, the Common Council of the City of New York instructed the mayor, Richard Varick, to acquire a much larger version of the painting "to be placed in the City Hall as a Monument of the Respect which the Inhabitants of this City bear towards him."[59] There was a growing sense of urgency that Washington's likeness be captured immediately. Franklin had died in April of 1790 and in the next month Washington came down with a savage case of influenza that nearly killed him. A year earlier he had had a large tumor surgically removed from his thigh. And since he had come from a line of male ancestors who all died young, the concern existed that the time for painting him might be running out, even though he was only in his late fifties.

Full-length and nine feet in height, the City Hall portrait was on a scale that Trumbull had never attempted before. That had something to do with his compromised eyesight. Blind in one eye since childhood, he had been told by Benjamin West never to attempt large-scale painting. For the most part he had taken his master's advice, but he felt compelled to confess to West that he was now going "to disobey one of your injunctions."[60]

The portrait needed an appropriate historical context, some aspect of the Revolution involving Washington in New York. But New York did not figure much as a battle site because the British had routed Washington and his army from the city in 1776 and then occupied it to the last day of the war. The logical subject for Trumbull to paint was Washington's triumphal entry into the city when the British evacuated in 1783, a flamboyant event at which Washington, accompanied by Generals Henry Knox and George Clinton, along with other officers and soldiers of the Continental Army, had paraded through the city. A mass of overjoyed citizens, wearing sprigs of laurel on their hats, had followed as he rode along the Bowery. Hundreds of others had lined the street all the way down to the Battery. For a week afterward, bonfires, feasts, firework displays, and toasts had honored Washington and all the "heroes, who [had] fallen for our Freedom."[61]

Trumbull realized that if he had chosen to paint the actual entry into the city, his picture would merely be a show of Washington's ultimate victory. Instead, he adapted the picture he was painting for Martha Washington by moving the setting from Verplanck's Point to upper

Manhattan. Washington is in the same pose with the same horse, but the background depicts "a view of Broadway in ruins . . . the old fort at the termination; British ships and boats leaving the shore, with the last of the officers and troops of the evacuating army, and Staten Island in the distance."[62] Washington does not actually look down to the harbor or watch the evacuation or size up the destroyed city. Instead, as in the Verplanck's Point picture, he turns away, as if taking this moment to reflect on his own escape from the city seven years earlier. Standing on a hill that is probably Harlem Heights (present-day Morningside Heights), he might be recalling the valiant stand his troops had made on this site against the British in 1776.

All along, Trumbull had been more interested in showing Washington's character than in cataloging his achievements. By choosing this scene or Verplanck's Point, Trumbull was able to produce a character study in contemplation. And to reinforce that point Trumbull literally put Washington's head in front of a bank of clouds, the shape of which echoes the contours of his white-haired profile. Among Trumbull's most impressive pictures, the image catches Washington amid his own thoughts, anticipating the final chapter of the Revolution, while quietly reviewing all that had led up to this fine moment.

In 1792, the city of Charleston also commissioned Trumbull to paint Washington in commemoration of his visit there in 1791, which was part of a grueling two-thousand-mile presidential tour of the South. Trumbull logically adapted the New York painting, but in doing so he made a crucial miscalculation when he depicted Washington before the Battle of Princeton. Trumbull's intentions were good. He said he had approached the Charleston commission "*con amore.*" He again aimed to reveal the character of "the *great man* . . . in the most sublime moment of its exertion—the evening previous to the battle of Princeton; when viewing the vast superiority of his approaching enemy, and the impossibility of again crossing the Delaware, or retreating down the river."[63]

The picture focused on Washington's strategic reckoning after the surprise attack on the Hessians in Trenton on December 26, 1776, and before the Battle of Princeton on January 3, 1777. On the evening of January 2, Washington had to decide what to do after learning that Cornwallis was leading nine thousand troops from New York to engage Washington's army: stand and fight, cross back over the Delaware River, or slip away and attack the British rear guard at Princeton. Using deception and the cover of darkness, Washington made the right decision to

press northward around Cornwallis's main force and attack the Princeton garrison.

Trumbull interviewed Washington for the picture. The conversation struck a chord with the President, he said, even fifteen years after that moment of decision-making. Washington "talked of the scene, its dangers, its almost desperation. He *looked* the scene again," and Trumbull tried to capture on canvas "the lofty expression of his animated countenance, the high resolve to conquer or to perish."[64]

In the painting, Trumbull showed Washington calm and focused as chaos encircles him. His skittish charger pulls against the reins held by its groom. Piles of broken cannons and carriages litter the foreground, and in the distance, beneath a fluttering American flag, soldiers move around haphazardly under a winter sky, building fires meant to fool Cornwallis into thinking the Americans had settled into camp. To the right a gnarled tree stands to the side of Washington, one broken stub of a branch ominously pointing at his head. The thoughtful, classically thinking Trumbull used a print of Apollo for Washington's pose, and he included precise details, such as Washington's gilt-trimmed field glasses and the leopard-skin saddle-cloth he liked to put on his horse.

But however smart and accurate the picture was, it did not appeal to Charlestonians because Washington had never fought south of Virginia. The South Carolinians understandably could not countenance a battle that took place in New Jersey. One Federalist congressman from Charleston, William Loughton Smith, told Trumbull that "the city would be better satisfied with a more matter-of-fact likeness," one less battle-oriented.[65] Trumbull was forced to take back his picture, which he kept in his studio until 1806, and then painted an equally large picture for Charleston later in 1792, one that simply showed Washington during his 1791 tour of the city, with St. Michael's parish in the background.

❦

Trumbull was the most politically engaged artist of the early republic. Almost every emerging event in the first two capitals, New York and Philadelphia, attracted his attention and offered the possibility that he could convert affairs of state into pictures. Among the most compelling, colorful, and exotic events to emerge in the capitals were the negotiations that took place between the federal government and the

John Trumbull, *General Washington at Trenton*, 1792

Indian tribes of the south and northwest.

The biggest extravaganza, the one that riveted the attention of Washington and Secretary of War Henry Knox in 1790, involved a delegation from the Creek confederacy that included Cherokees, Chickasaws, and Choctaws, who lived and hunted on homelands stretching across present-day Georgia, Alabama, and eastern Mississippi. Their federation was led by the supremely charismatic Creek Hopothle Mico, known in the white world as Alexander McGillivray. The son of a prosperous Scottish trader, Lachlan McGillivray, and his Creek-French wife, Sehoy Marchand, he had been sent to school in Charleston, where he had acquired a classical education in Latin and Greek. He was fluent in English and Spanish, wrote in exquisite prose, and understood how geography, demographics, and imperial designs were squeezing his nation into an impossible bind. To the south and west were the Spanish, who had designs on Creek territory. To the east were white settlers, who were gathering themselves into a tidal wave that threatened to push the Creeks toward the Mississippi or to extinguish them altogether. The expansionist goals of the state of Georgia cemented Creek fears in 1790 when it started selling off twenty million acres of Indian lands to speculators who had organized themselves into the Yazoo Companies.

The stakes for the federal government in New York were equally high. Under the new Constitution, Georgia did not have the authority to sell off Creek lands but did so anyway, which meant that the Washington administration had to halt the renegade actions of the state and at the same time initiate its own political and economic arrangements with the Creeks. The Constitution made clear that the executive branch was to have full control over Indian policy, but that was a power the federal government needed to seize and make operational. Knox was intent on a square deal for both sides, and he resolved that alliances with the Indians were smarter and cheaper than outright confrontations, which could cost the United States fifteen million dollars a year in military expenses that the heavily indebted nation could ill afford to spend.

To accomplish those goals, Washington and Knox invited McGillivray to New York for negotiations. In April of 1790, they sent Colonel Marinus Willett as their envoy to the Tallapoosa River, where McGillivray greeted him, escorted him to Creek towns, and regaled him with feasts and ceremonies. Willett assured the assembled Creeks that Washington wanted to sign a treaty guaranteeing that Creek territory would

be preserved, trade would be encouraged, and Georgia would be stopped in its tracks.[66] McGillivray knew perfectly well that all treaties with whites were barely worth the paper they were written on, but he left for New York with the hope that at the end of the day the white invasion of Creek lands would be slowed. Willett's diplomatic coup was memorialized by the American artist Ralph Earl, who painted the colonel literally pointing the way to New York while in the background three armed but unthreatening Creeks line the ridge.

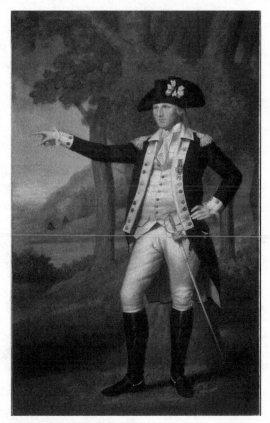

Ralph Earl, *Marinus Willett*, 1791

Willett and his troops traveled a thousand miles with McGillivray and his entourage of twenty-seven Creeks to the New Jersey coast, where a sloop carried them to the Battery in New York. The newly formed Tammany Society, founded as a white club for "pure Americans," greeted them in full Indian regalia and escorted them, to the astonished eyes of New Yorkers, up Wall Street to Federal Hall, where Congress came out to cheer. McGillivray boarded with Knox, and the remainder stayed at an inn near the Richmond Hill home of John Adams. Abigail Adams told her sister about "my Neighbours the Creeck Savages who visit us daily . . . last Night they had a great Bond fire dancing round it like so many spirits hooping, singing, yelling, and expressing their pleasure and Satisfaction in the true Savage Stile." She said they were "very fine looking Men placid countanances & fine shape." McGillivray "dresses in our own fashion speaks English like a Native, & I should never suspect him to be of that Nation, as he is not very dark he is grave and solid, intelligent, and much of a Gentleman." She added a few words about Trumbull, who was part of the scene at the Adams household and

John Trumbull, *Alexander McGillivray (Hopothle Mico)*, 1790

who was sizing up the Creeks for artistic purposes. "Mr. Trumbull says, they are many of them perfect Models."[67]

Trumbull's pencil sketch of McGillivray is one of the great character studies of the era. His face, a mixture of pride, resolve, and pathos, is highly finished in lights and darks that sculpt the contours of his broad head. He wears an unbuttoned military jacket that might be the gift of the United States, which awarded him the rank of Brigadier General as a token of friendship.[68] Around his neck he wears a silver gorget that was a mark of the esteem in which he was held by western powers.

Below the neck, the study of McGillivray is sketched in a cursory way, the result of Trumbull having to draw surreptitiously because the Creeks did not trust the trickery of western art. In his autobiography, Trumbull explained the need for stealth by telling the story of Washington's evening with the Creeks. Before dinner, the President instructed Trumbull to set up his just-completed life-size portrait of Washington in an adjacent "painting-room," in such a way that it would be the first thing a person would see upon opening the door. After dinner, Washington, dressed in full military uniform, led the Creeks to the portrait, in which he was also in full uniform.

According to Trumbull's account, the Creeks were confused by the second Washington. "They were for a time mute with astonishment." One touched the picture and was met by "a flat surface, cold to the touch." Another put one palm on the surface of the canvas and the other on the backside of the canvas, only to realize that "his hands almost met."[69] The illusion of a full-length figure might have been the goal of a western artist keen on verisimilitude, but to the Creeks it was a sleight of hand, a false double, the dubious workings of magic, and thus it was inherently untrustworthy and maybe dangerous.

Trumbull never stated the precise purpose for sketching a number of the Creeks, but he understood the historical significance of Washington's negotiations with McGillivray and could have had in mind a picture about the treaty of peace and friendship signed in New York on August 7, 1790. Having lived in Jefferson's embassy and harboring diplomatic aspirations of his own, he knew that the treaty was a momentous enactment of Constitutional power. That in itself made the Creeks an attractive subject for a painting. In addition, the occasion of the treaty signing was visually rich. At Federal Hall, in the presence of "a large assembly of citizens," Washington, McGillivray, Adams, Governor Clinton, various congressmen, and the "kings, chiefs, and warriors of the Creek nation" listened to the treaty as it was read aloud. Washington gave McGillivray "a string of beads as a token of perpetual peace" and some tobacco to smoke in confirmation of it. Every one of the Creeks shook Washington's hand Creek-style by grabbing forearms, and then they sang "a song of peace."[70]

Trumbull did not pursue the subject, which, as it turned out, was a wise decision. All those good intentions in 1790 lasted about one year, when it became crystal clear that the federal government could not possibly stop the surge of white settlers marching over the Cumberland Plateau into Creek territory. Its inability to police the treaty and impose its will forced McGillivray into the waiting arms of Spain. After McGillivray died in 1793, the Creeks simply crumbled under the weight of the demographic avalanche that had reached their front door.

Trumbull returned to Indian subjects in 1792, when the capital was in Philadelphia. Representatives of the Six Nations, a confederation of Iroquois tribes in what is now upstate New York, were conferring with Washington and Knox with the aim of making peace between former enemies. The Treaty of Paris had been a disaster for all Native Americans because no provisions had been made for the protection of their lands. To the contrary, their lands were now opened up to westward migration, and the Iroquois were especially vulnerable because of their location near white population centers and because of their alignment with the British during the Revolution. The Iroquois blamed Washington personally for unwarranted murders and ruthless land grabs, reminding him, "Your promise to us was that you would keep all your people quiet; but, since we came here, we find that some of our people have been killed—the good honest people who were here trading."[71]

For the federal government, the issues remained the same as they

were with the Creeks: assert executive authority over Indian policy, control western migration, use diplomacy instead of guns, and, in this case, counter lingering British influence over the Iroquois, whose lands stretched into southern Canada. The need for a deal with the Iroquois was being underscored at that moment by the escalating attacks on white settlers farther to the south, in the Ohio River Valley, where tribes decided to band together to eradicate the foreigners encroaching on their lands. Because efforts by the United States Army to quell the violence were proving to be catastrophic failures, the Washington administration knew that diplomacy was its next best option.

Washington and Knox invited an Iroquois delegation to be led by the Mohawk chief Theyendanegea, widely known as Joseph Brant. But Brant decided he would not become a spectacle for all the whites lining the road to Philadelphia, nor did he intend to alienate the Ohio tribes by dealing with the American government. For the fifty chiefs from the Seneca and Oneida who did make the trek to Philadelphia in March of 1792, the Washington administration rolled out the red carpet.[72] Over the course of six weeks they were wined and dined, showered with gifts, and cajoled into compliance with federal goals. They twice met with Washington, whose Seneca name was Conotocaurious, or Town Destoyer, in recognition of his order in 1779 to send General John Sullivan to Iroquois country to burn forty settlements.[73] When negotiations were finally over, the Iroquois came away with a guarantee that their sovereignty would be respected, plus fifteen hundred dollars' worth of goods and animals and a special envoy dedicated to the Seneca. In return, the Indians said they would not enter the Ohio tribes' war with whites, but that they would try to bring their fellow Indians to the peace table, a pledge they actively carried out.

Trumbull stayed around the

John Trumbull, *Onnonggaiheko, The Infant, Chief of the Seneca*, 1792

perimeter of the negotiations and painted three of the Indians, among them Governor Blacksnake (Thaonawyuthe), an esteemed and venerable Seneca, and Good Peter (Agwelondongwas), an eloquent Oneida warrior.[74] The most striking of Trumbull's Seneca portraits was of the warrior-chief Onnonggaiheko, known as the Infant, an imposing man whom Trumbull described as "Six feet.Four inches high" and wearing his "War Dress."[75] Unlike the Creeks, whom Trumbull made into dashing figures, Chief Infant is proud and fierce, bordering on bellicose. His reputation was not for diplomacy. In the account of one missionary, Chief Infant once encountered a drunken white man who was "very noisy and quarrelsome." After numerous attempts to silence his "swearing and threatening and boasting, . . . Chief Infant arose once more, went to him, and with great dignity and forbearance commanded him to go away." Failing to dislodge or silence the drunk, Chief Infant then "took hold of the man's arms below the elbows and squeezed them till the blood ran through his fingers."[76] The drunk cried for mercy and was released, and "Chief Infant walked calmly back to his seat in the council."[77]

In Trumbull's formidable portrait, Chief Infant matches that anecdote with his fuming expression and sullen dignity. His eyes dart to his right, his mouth turns downward, and he wears none of the gorgets, medals, ear cuffs, nose jewels, or other symbols of loyalty that Knox regularly handed out to Indian delegates. Chief Infant would have made a colorful character in a historical narrative dedicated to the 1792 negotiations. Trumbull could well have painted a picture of the Iroquois shaking hands and exchanging gifts with Washington, or performing war dances for the Americans in Philadelphia.[78] But once again, as in the case of McGillivray and the Creeks, he never got around to formulating anything concrete for a painting.

Thomas Jefferson was mostly boxed out of Native American policy-making because Indian affairs fell under the jurisdiction of the War Department. Instead, he focused his attention elsewhere, on trade policy, on the development of the District of Columbia, and on thorny issues left over from the Treaty of Paris. That did not prevent Trumbull and Jefferson from frequently crossing paths in New York and Philadelphia.

The excesses of the French Revolution had, to Trumbull, besmirched "the beautiful theory" of America's revolutionary struggle

against monarchy. The revolution had looked promising when he was in Paris in 1789, but since then French elections had become corrupt, civil order had spun out of control, and the idea of a principled and idealistic reform of government was now a memory. The guillotine was engulfing France in blood, Lafayette was incarcerated in an Austrian dungeon, and Louis XVI, former friend and benefactor of the United States, had been beheaded in 1793 in the Place Louis XV—renamed Place de la Révolution—the regal square in which Trumbull and Jefferson had once strolled while admiring the architecture of a great civilization.

The "hideous frenzy . . . meteoric glare and horrible blaze" of the Reign of Terror had eclipsed "the calm splendor of our own Revolution," Trumbull observed. It was as if France had single-handedly redefined revolution to mean total chaos, monstrous suffering, and fevered insanity. At one time, Trumbull had thought that the American Revolution was going to be the curtain-raiser for the French Revolution, and that those two events would lead to a worldwide transformation of society, up from the depths of feudalism into the heights of republicanism. But if anything, the opposite was becoming true, and Trumbull knew it.

Jefferson, however, never lost his faith in France, even during the barbarities committed during the Reign of Terror. Trumbull, confessing his "whole soul revolted from the atrocities of France," wondered how Jefferson could remain a Francophile. It began to dawn on him in 1793 that Jefferson was in fact "the apologist of France." In Trumbull's moral universe, Jefferson's love of murderous France was inexcusable. But in Jefferson's, the tens of thousands of beheadings in the jaws of the guillotine were a fair price to be paid for the end of monarchy. Trumbull was not only outraged by what was happening in France, he was also appalled by the endorsement of violence in Jefferson's head and heart.

The crisis in France helped trigger partisan politics in America at the end of Washington's first term. The emerging political schism pitted Washington, Adams, and Hamilton on the Federalist side and Jefferson and Madison on the Republican side. Its dimensions were so great and its divisiveness was so "violent," as an alarmed Trumbull described it, that "the whole country seemed to be changed into one vast arena, on which the two parties, forgetting their national character, were wasting their time, their thought, their energy." Trumbull thought that political and personal animosities were destroying the original promise of the American Revolution and Constitution, leading him to ask a defining question as to "what hope remained for the arts," and specifically, what

hope remained for Trumbull's paintings of the American Revolution. The obvious answer, for Trumbull, was "None." The overheated politics of the 1790s led him to believe "my great enterprise was blighted."[79] And the bloodletting in France further threatened Trumbull's project to depict lofty revolutionary idealism.

He had originally presumed that his pictures would be a lightning rod for consensus and fraternity in an America not easily coalescing into a nation after the Revolution. Even under the Constitution of 1787, every state continued to think of itself as sovereign and unique, making the forging of a unified national purpose and common history difficult. Trumbull's pictures stood to counteract that by being something that everyone could agree upon. All Americans would be brightened by the sight of Washington's entry into the Battle of Princeton, stirred by Montgomery's sacrifice at Quebec, warmed by Washington's compassion at Trenton, and uplifted by the Committee of Five delivering the Declaration of Independence. Trumbull wanted his pictures to ring true to Virginians and New Englanders, reminding them that heroes had emerged from every state to defeat Britain with swords and pens, and that as long as Washington stood at the prow of the ship of state the union would be safe. But all he could see was a nation at war with itself, and even Washington was not able to stanch the political bleeding.

He imagined he might at least reach reconciliation with Jefferson when he was invited to the Secretary of State's house for dinner in 1793, just before Jefferson resigned from the Washington administration. As Trumbull recounted that disastrous evening years later, he believed that Jefferson purposefully had set him up for humiliation in front of the other dinner guests. William Branch Giles, a congressman from Jefferson's home state, opened the evening with an attack on Trumbull's religion, in which he grilled the artist on the peculiar "puritanical ancestry and character of New England." Thrown unexpectedly on the defensive, Trumbull fumbled as he tried to explain himself and his religion. But Giles, instead of backing down, raised the stakes when he proceeded to "ridicule the character, conduct, and doctrines of the divine founder of our religion," much to Trumbull's discomfort, annoyance, and anger. Christ, Trumbull was told, was a "miserable delusion." Undeterred by Trumbull's protestations or by his own impoliteness, Giles mauled the artist during the entire dinner, provoking him with escalating insults and taunts. Finally, as the last straw, Giles dismissed God, telling Trumbull not to believe "one word of a Supreme Being."

Jefferson, as the evening's host, would have been expected to deflect the attack on Trumbull, his trusted old friend from Paris who had been the go-between in his romantic pursuit of Maria Cosway. But instead of behaving like a gentleman, by either chastising Giles or turning the conversation in another direction, he sat there "smiling and nodding approbation" on the congressman, who continued his screed. Trumbull recalled turning directly to Jefferson to request an intervention. "Sir, this is a strange situation in which I find myself; in a country professing Christianity and at a table with Christians, as I supposed, I find my religion and myself attacked with severe and almost irresistible wit and raillery."[80]

At that point, feeling that Jefferson had deliberately designed the evening around his evisceration, Trumbull got up from the table and left the Secretary's house. This was the last straw, the moment that helped Trumbull to "elucidate the character of Mr. Jefferson," a former friend who gleefully assented "to all the virulence" of the evening. "From this time" onward, Trumbull noted, "my acquaintance with Mr. Jefferson became cold and distant."

At the same time that his friendship with Jefferson was dissolving and his idealistic vision of the American Revolution was slipping into irrelevance, the woman Trumbull was courting, Harriet Wadsworth, shockingly died from consumption in 1793. Out of the swamp of his feelings, he was tempted by the offer of John Jay, the Chief Justice whom Washington had appointed to the position of special envoy to Britain, to make him his diplomatic secretary. Jay was going to negotiate a new treaty with Britain, one that would demand the withdrawal of British army units from forts in the Northwest Territory, stop British piracy on the Atlantic, settle a border dispute with Canada, and resolve issues around wartime debts. Trumbull gladly accepted Jay's offer, and with him he sailed for London on May 12, 1794, where he renewed his friendship with West and began a diplomatic career. He would become a commissioner of the Jay Treaty, entrusted with the execution of its terms.

Shortly before Trumbull left, Gilbert Stuart, his "old friend and fellow student" from London, arrived in America after an eighteen-year absence. Trumbull and Stuart overlapped for about a year, during 1793 and 1794.[81] Trumbull could easily have been apprehensive that Stuart's considerable talents posed a threat to his own position as the most respected artist in the nation's capital. But Trumbull was already

backing away from his painting career, and evidence suggests that he actually helped get Stuart established in America. When the well-traveled South Carolinian Gabriel Manigault had his portrait painted by Stuart in New York, he declared Stuart "the best portrait painter who has ever been in America," an opinion he said was not just his own but was also that of "Mr. Trumbull the painter."[82]

In many respects, Stuart was better suited to the position of "national painter" than Trumbull was. Trumbull's political idealism and romantic sensibilities did not equip him for the bruising politics of the 1790s. But Stuart was perfect for the job. He was an extreme talent for whom painting was like breathing, and art was his one and only focus in professional life. His politics were conveniently opaque. He seems not to have formulated any sort of an opinion about Jefferson, Hamilton, France, Britain, Federalists, Republicans, Indians, or religion. But the opportunistic Stuart did believe the prospect of painting Washington was going to be the chance of a lifetime. Trumbull's departure for London with Jay opened the door that allowed Stuart to step onto center stage in the theater of American politics, where he would steal the spotlight from all his artistic rivals. The 1790s would belong to him.

9 ⌒⌒

Gilbert Stuart's Washington

CARELESS TO THE EDGE OF RECKLESS, IMPULSIVE BORDERING on erratic, unpredictable at best, untrustworthy at worst, Gilbert Stuart was the master artist of the early republic. Gifted and garrulous, charming and witty, intelligent and prolific, he was always opinionated, frequently profane, and sometimes volatile, manic, and morose, but never boring.

One woman familiar with Stuart's character said he was "as eccentric, as dirty, and as entertaining as ever."[1] Abigail Adams wrote that she was at a loss over what to do about "that strange man."[2] Hoping Stuart would finally finish his portraits of the Adamses, she puzzled over "knowing how to take hold of this Man . . . Genius is always eccentrick."[3] Two chroniclers of the period praised him as a painter in whom nature had endowed "her choicest gifts." They thought that Stuart commanded "every sense"—except one, "common sense."[4] The architect of the United States Capitol, Benjamin Henry Latrobe, to whom Stuart owed an unpaid debt, told Thomas Jefferson that Stuart was an "admirable artist," and in the same breath castigated him as a "worthless man."[5] His older colleague Charles Willson Peale was so awed by Stuart's talent that he painted his portrait for the gallery of American worthies, to hang alongside George Washington and Benjamin Franklin. But Peale could not disagree with the opinion of an acquaintance who considered Stuart an "indolent, thoughtless being."[6]

All of that personality was wrapped around a brilliant talent never before seen in America. His portraits of the Founders cast a long cultural shadow and were essential to the new nation's sense of itself. In particular, his portraits of Washington, more than one hundred of them painted between 1795 and 1825, came to define the man and the office of the presidency. Converted into thousands of prints, eventually adorning tens of trillions of one-dollar bills, hung in homes and statehouses, and installed within eyeshot of every subsequent President living in the White House, Stuart's portraits helped enshrine Washington as the father of the country.[7]

In fact they did more than that. During the early republic they were the inescapable visual reminders of every citizen's shared national identity during an anxious moment of transition when political factions and public rancor threatened to break up the new political union. They helped steady the still-rocky United States by being an unwavering signpost for all the Americans perplexed by, and often resistant to, the urgent demands of a federal government that requested they set aside their entrenched local allegiances, or at least unlock regional identities enough to allow a sense of national purpose to enter their minds and hearts. In a world ruled by disagreement, everyone could agree on the transcendent stature of Washington, which was on display for the world, thanks to Stuart.[8]

Stuart's origins were as humble as Peale's. Born in 1755, he was the youngest of three children born to Elizabeth Anthony and Gilbert Stuart senior, a millwright said to be "remarkable for his ingenuity and his quiet, inoffensive life," who had emigrated from Perth, Scotland, to North Kingston, Rhode Island.[9] Stuart's father at first operated a snuff mill on the Mattatuxet River, but when it failed he moved the family to Newport where he sold tobacco, fabrics, paper, earthenware, and shoe buckles and advertised that he "Continues to Make and Sell, Superfine Flour of Mustard."[10]

Young Stuart studied at an Episcopal grammar school, where he was known as a prankster prone to mischief. He had a talent for music and played a number of instruments well, including the organ, harpsichord, and flute, and he showed an early interest in painting. Neptune, an African slave working as a cooper and barrel maker for Edward Thurston, taught him how to sketch faces. Stuart was said to recall, "The first idea I ever had of painting the human features, I received from seeing that old African draw a face with red ochre, chalk and charcoal on the head of a hogshead [a cask] he was at work upon," adding that if Neptune's "mind and natural talent had been properly cultivated, he would have made a much more celebrated artist than his pupil."[11] When Stuart was fourteen, Cosmo Alexander, an itinerant Scot passing through Newport in 1769, took him on as a traveling apprentice. After Alexander died in 1772, it was said that Stuart studied the human figure so diligently that he hired a blacksmith to model because his muscles were so visible. Eventually, in the early 1770s, he got commissions to paint some of the leading citizens in Newport society.[12]

❖

Stuart, like everyone else, was aware of the growing tension between Britain and its colonies, especially since Newport was a scant seventy miles from the epicenter of dissent in Boston. But other than a flip comment, "Hang the King . . . he lives too far off to do us any good,"[13] and some evidence that he was in Boston during the skirmishes at Lexington and Concord, nothing specific is known of his political leanings.[14] However, his parents were Loyalists who fled Newport for Nova Scotia in the summer of 1775, in the wake of the Battle of Bunker's Hill.

Nineteen years old, Stuart stayed behind in Newport, but he too saw the handwriting on the revolutionary wall. On September 8, 1775, two weeks after George III issued an official proclamation declaring the American colonies to be in open rebellion, and two months after Washington assumed formal command of the Continental Army, Stuart abandoned Rhode Island for England. That might suggest he was a Loyalist like his parents. Clearly it shows that he had no interest in following in the path of Peale or Trumbull, who were embracing the revolutionary cause at that time.

Because Stuart never recorded his political opinions, the task of locating him somewhere on the spectrum between radical revolutionary and royalist stalwart is an exercise in guesswork. But it is telling that he did not take the obvious step of joining his parents in Loyalist Nova Scotia, where they owned land and where he would have been safe from the storm. Tempting as that might have been, he must have realized that he could not have much of an artistic future there. Instead, he chose London, the destination richest in professional possibilities, and yet the poorest in potential for success because of the stiff competition at every level of artistic training.

Unlike Peale, Copley, and Trumbull before him, Stuart arrived in London clueless. He did not carry the requisite letters of introduction; in fact, he had no meaningful contacts and possessed no apparent plan of action. Initially, he made some money as an organist at St. Catherine's, an easy-to-overlook church near St. Paul's Cathedral, which did little to alleviate his "beggarly appearance and absolute starvation."[15] By the autumn of 1776, at a moment when Peale was about to join a Philadelphia militia company and Trumbull was under the command of General Horatio Gates in the Northern Department, Stuart started painting portraits, which as a category of art was the primary stock and

trade of the London art world. As it turned out he was a prodigy waiting to be discovered. But he quickly got into the bad habit of accepting money and then not finishing paintings, an unprofessional practice a childhood friend from Newport, then studying medicine in London, rectified by paying off the sitters. This would become a chronic problem that eventually provoked John Quincy Adams to complain to Copley that "Mr. Stuart thinks it the prerogative of genius to disdain the performance of his engagements."[16]

What the directionless Stuart did have in his favor was talent, charm, and lots of temerity. He finally contacted West in a maudlin letter that shamelessly tugged on the sentiments of the good-hearted master. "Pitty me," Stuart pleaded, claiming he was "Ignorant without Business or Friends, without the necessarys of life . . . I have been reduced to one miserable meal a day & frequently not even that, destitute of the means of acquiring knowledge, my hope from home Blasted & incapable of returning thither, pitching headlong into misery I have this only hope; I pray that it may not be too great, to live & learn without being a Burthen."[17] Early in 1777, West invited Stuart into his house on Newman Street where, it was said, he "was welcomed with true benevolence, encouraged and taken into the family."[18]

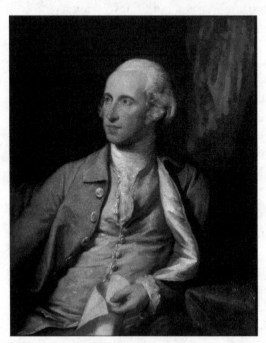

West made the young man his assistant and put him to work finishing backgrounds and draperies on what his student called "*ten-acre* pictures."[19] Stuart stayed with West for about six years, during which time they developed a mutual admiration recognized around London. One commentator jokingly reported in the *St. James's Chronicle* that he had been told "by Mr. West that Mr. Stuart is the only Portrait Painter in the World; and by Mr. Stuart that no Man has any Pretentions in History Painting but Mr. West."[20]

Stuart felt so comfortable around West that he could affectionately joke about his mentor's

Gilbert Stuart, *Benjamin West*, 1781

technical flaws as a painter and poke fun at his groomed appearance. In Stuart's account, one mock fencing match with West's son Raphael was so rowdy that "the old gentleman, as neat as a lad of wax, with his hair powdered, his white silk stockings, and yellow morocco slippers, popped into the room, looking as he had stepped out of a bandbox."[21] On other occasions Stuart roped in Trumbull as a foil for gently provoking the master.[22] Stuart's great debut came at the Royal Academy in 1782. Because of West's stature and influence, Stuart was awarded commissions he otherwise would never have received on his own. One was a spectacular eight-foot portrait of the Scot William Grant elegantly skating along the Serpentine in St. James's Park on a winter's day. The picture aroused such critical and popular acclaim that Grant was mobbed when he made an appearance at the Academy, not because of his own significance but

Gilbert Stuart, *The Skater, William Grant,* 1782

because of Stuart's captivating image of him. Grant was "compelled to make a retreat" from the gallery and did not visit again.[23]

The London press hailed Stuart "the Vandyke of the Time," in honor of the great seventeenth-century portraitist Anthony Van Dyke. By the time that Trumbull rejoined West's studio in 1784, after his imprisonment and deportation, Stuart had moved into his own practice, at first a few doors down from his master, and then in 1785 to New Burlington Street, near fashionable Savile Row. That same year he exhibited an impressive portrait of Captain John Gell in the Great Room of the Royal Academy. Measuring a commanding eight feet in height, the portrait shows Gell on a rocky shore, pointing to one of the British frigates that he had captained during the American Revolution. The London press took note of the picture, this time placing Stuart with "the ingenious American artists," a group that included West, Copley, and the young Trumbull.[24]

Gell was one of many British heroes being lauded in London after the war. He had commanded the *HMS Thetis* off the coast of New England, where he captured two American ships, and then served in the West Indies. By portraying Gell as a national hero, on such a large scale and in such a prominent venue, Stuart spoke to the British as they were trying to revitalize their pride after losing the Revolutionary War to the Americans. But the portrait of Gell was, to him, just another job, a particularly good one that had been arranged by Sir Joshua Reynolds in order to help out his young friend. During his time in England, from 1775 to 1787, Stuart seems not to have been moved by politics. He observed West struggling during the Revolution, trying to maintain his balance as court painter to George III while feeling sympathy for the Patriot cause. He watched Trumbull painting Washington's portrait in West's studio, visited him in prison when he was accused of treason, and painted his portrait there behind bars. After the war he saw Trumbull foray into Revolutionary subjects, beginning with the *Death of General Warren*. He knew of Copley's portraits of John Adams, Henry Laurens, and Elkanah Watson. And he observed his own teacher emerge confidently from war when he began his painting of the commissioners of the Provisional Treaty of Peace.

But Stuart was politically apathetic. He did not gravitate to American subjects, except for an unfinished portrait of John Jay. His stance of showing no political loyalties was, however, subtly different than Copley's position. Regretting the war and feeling torn, Copley put on a mask of neutrality, covering a well of sentiment that would only have

thrown obstacles in his career path. Stuart, by contrast, seems to have been completely unaffected by the magnitude of contemporary events, exhibiting no signs that he identified with Tories or with Whigs, that he was troubled by the conflict or concerned for his native Rhode Island or his exiled family in Nova Scotia, or that he was delighted or sad to see an independent United States.

Instead, Stuart was perpetually in the moment, painting and talking and drinking. Because he was prodigiously talented his business boomed, peaking in 1786 when he earned £1,500 from portraits alone, enough to propose to Charlotte Coates, an accomplished contralto. Stuart's daughter Jane said, years later, that the Coates family had been "perfectly aware" of Stuart's "reckless habits," and had "opposed the match violently."[25] Nonetheless they married in May of 1786.

The Coates family was right to be concerned for their daughter. For all the praise and pounds sterling that came his way, Stuart could never make ends meet. "He spent it as lavishly" as he earned it, "never giving heed to the morrow, nor cared he what became of his earnings."[26] A "stranger to prudence," whose appetites were "uncontrollable," as William Dunlap, a chronicler of the era, politely phrased it, he thoughtlessly bought property he could not pay off, lived too well for his means, had more children—eventually twelve—than he could afford on his sales, and had trouble finishing portraits and thus collecting money.[27] Stuart's tenure in London was an astonishing artistic triumph, and a completely financial disaster.

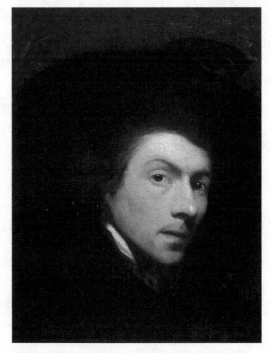

Stuart's complexity reveals itself in a self-portrait painted early in his London tenure. Like all self-portraits it required the artist to repeatedly turn his head away from the easel in order to look into a nearby mirror, and then turn back to the easel, resulting in hours of intense self-scrutiny. Whenever

Gilbert Stuart, *Self-Portrait*, 1778

Benjamin West painted his own self-portrait, he always came across as a man of learning, a respectable gentleman replete with groomed wig, porcelain skin, complacent expression, and refined gestures, all of which suggest a person wishing to be perceived as a public figure in the cultural firmament of London. But Stuart showed something else entirely in his own portrait. Instead of making himself into a disciplined professional, he lets us see his pasty skin, arched eyebrow, open mouth, un-wigged hair, and five-o'clock shadow. As he emerges from the darkened background he looks furtive, almost shifty—an artist in the midst of a probing self-examination, striving to figure out that character in the mirror, a man emerging from darkness, but about to turn back from the light and slip again into the shadows.

Throughout his life, Stuart was a restive, pulsing man, lurching from delight to discontent, and then dropping into despair, which often led to disaster. Were he not so talented, he could easily have become something else, perhaps a grifter dodging responsibility and the law, cleverly applying the painter's craft of deception to small-time confidence schemes.

❖

Stuart and his family abruptly left London for Ireland in August of 1787. His reasons for leaving the epicenter of an art world in which he had been triumphant are vague. In one account, Reynolds had gotten him work in Dublin and then he decided to stay there. But in no way was Dublin like London for an artist. He could have done his job in Ireland and returned to the scene of his galloping success in London. In another school of thought, Stuart's "pecuniary embarrassments," as he phrased the problem, forced him to escape London creditors that he could no longer outfox or outtalk. [28]

Whatever the motivation, in the end he spent six fruitful years in Ireland painting both sides of the political divide. On the one hand, he executed a full-length portrait of Henry Grattan holding the Irish Bill of Rights as he addresses the House of Commons. On the other, he painted a full-length of Grattan's fierce opponent, John FitzGibbon, the Lord Chancellor of Ireland, who was Protestant and against Irish sovereignty.

Stuart's social life in Dublin was marked by endless dinner parties and other forms of what he called "reckless extravagance." [29] He

was confident that "with his brush he could in a few hours wipe out a debt," but he had to spend the summer of 1789 consigned to Marshalsea Prison for unpaid bills.[30] In one of his more flamboyant stories, Stuart said he got out of prison by painting portraits of his jailors. In another, he claimed to have been chased down the streets of Dublin by wardens and then forced to pay them off so lavishly that "it has cost me more to bailiffs for my liberty than would pay the debt for which they were to arrest me."[31]

During his time in Dublin, between 1787 and 1793, Ireland was in the afterglow of its own revolt against English authority. Encouraged by the American Revolution, the Irish had fought to free their government from the British Privy Council, which had overseen Ireland since 1495. One of the most inspirational figures in that struggle had been Washington, "the idol of every lover of liberty." Though there is no evidence that Stuart ever talked about the signal events occurring in America, he had to appreciate, like everyone else in Ireland, the magnitude of the Constitution and the significance of Washington's rise to the office of the presidency. Free of war, America now beckoned him.

Though Stuart's motivations to go home are largely unknown, everything about his decision to recross the Atlantic and his actions when he got to America suggest that the move was driven by economic opportunity, not patriotic pride or political passion. He told an Irish artist, perhaps only half-jokingly, "When I can nett a sum sufficient to take me to America, I shall be off to my native soil. There I expect to make a fortune by Washington alone. I calculate upon making a plurality of his portraits, whole lengths, that will enable me to realize that; and if I should be fortunate, I will repay my English and Irish creditors."[32] Having burnt his fiscal bridges in England and Ireland, he saw that a new market had opened up in America and imagined a profitable place for himself in it.

Stuart was alert to the singularity of the historical moment. He logically should have arrived in America, after eighteen years abroad, completely oblivious, lost in the political and artistic landscapes, misjudging the public mood and underestimating national needs. Like a Rip Van Winkle, he should have been estranged and disoriented because of the swift and fundamental transformations that had occurred in his

absence. Instead, it seemed as though the events of the previous two decades in America had attractively set the table for the returning artist, who could now enter in the defining moment of his career by painting the defining figures of the era, now ready to be enshrined in the American Olympus.[33]

Stuart sailed on the *Draper* in March of 1793, arriving in New York, where he took rooms for himself and his family on Stone Street, near the Battery. He had a few connections in America. Anne and William Bingham of Philadelphia, who had met Stuart in London a decade earlier while he was brokering trade deals with the British after the Revolution, would help provide Stuart with access to Washington. Another American connection was Trumbull, who had returned to America in 1789. They had both worked in West's studio and remained close friends. When Stuart arrived in New York, Trumbull was painting in Philadelphia, and thus Stuart had no competitor in a city fast emerging from the economic panic of 1792, hungry for a first-rate portraitist to patronize.

Stuart's other connection was John Jay, Chief Justice of the Supreme Court. Ten years earlier, after concluding his work in France on the Treaty of Paris, Jay had traveled to London, where Stuart worked on four portraits that marked Jay's role in the successful conclusion of the Revolution. Stuart finished Jay's head in two of them. But he had abruptly stopped, and then pawned them for cash in order to pay debts.[34] Years later, Trumbull tracked down the pictures, bought them from a broker, and finished painting what Stuart had started.

Jay, who remained in Manhattan when the capital moved to Philadelphia, had not soured on Stuart in the ten intervening years. Instead, he welcomed Stuart into his home and commissioned him to paint a large-scale portrait in which he is draped in

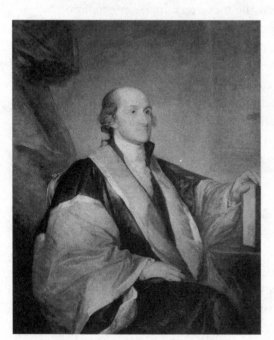

Gilbert Stuart, *John Jay*, 1794

the academic robes that he wore when Harvard College awarded him an honorary degree in 1790. Stuart's connection with Jay naturally piqued the interest of other prominent New Yorkers. William Dunlap said that Stuart "favored the renowned, the rich, and the fashionable, by exercising his skill for their gratification, and he gave present éclat and a *short-lived immortality* in exchange for a portion of their wealth."[35] That portion of wealth turned out to be much smaller than it had been in more affluent London and Dublin, forcing him to adjust to New York frugality. "His prices are not so great as He had in England," wrote the English diarist Joseph Farington, "but his expenses are proportionally more reasonable."[36]

The list of men and women lining up at Stuart's studio reads like a who's who of New York's civic and military elite: Elizabeth and William Bayard, from one of the city's leading families; General Matthew Clarkson, who had been involved with the defeat of Cornwallis at Yorktown; Stephen Van Rensselaer III, who owned 800,000 acres upstate; Aaron Burr, then a United States Senator; Robert Livingston, Chancellor of the state and a member of the drafting committee of the Declaration of Independence; Livingston's mother, Margaret, who was from the prominent Beekman family; Judge William Cooper, shown holding the street plan to Cooperstown, his utopian upstate community; and John Jacob Astor, who was making his fortune trading furs.

Stuart painted a luxurious portrait of the visiting Spanish diplomat Josef de Jaudenes y Nebot, who came to the studio with his sixteen-year-old American bride, Matilda Stoughton. Stuart decked her out in a bejeweled coiffure topped with feathers and adorned with a seed-pearl necklace. A revealing low-cut silk dress billows out so far in back that she needs to sit on the edge of her chair. Wishing to make an impression on the city, the Jaudeneses wisely chose Stuart, who could, when called upon, manufacture pomp and extravagance like no other painter.

The best portrait Stuart painted in New York was of General Horatio Gates, leader of American forces against the British at Saratoga in 1777. He sold his Virginia plantation, Traveller's Rest, in 1790 and on the recommendation of John Adams he freed his slaves before moving to New York, where he bought Rose Hill Farm, which encompassed ninety acres around present-day Twenty-Third Street. Ebenezer Stevens, formerly a colonel in the Continental Army and now a New York merchant, paid Stuart for the picture. Gates sat for the artist in 1793,

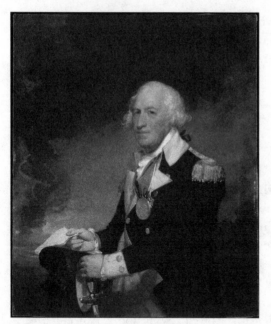

Gilbert Stuart, *Horatio Gates*, 1793–94

at the age of sixty-six, and by one account he enjoyed every minute of Stuart's company as they drank "glass after glass of the celebrated painter's plentiful Madeira!"[37]

Stuart pulled out all the stops in order to create a vividly dramatic portrait. Though Gates had retired from the Army in 1784, he once again wears the blue and buff uniform of an American major general. In fact he appears to be standing on some imaginary battlefield as the smoke of cannon fire, slashed with vermillion pigment, lifts on the left, leaving the general's aged face glowing in the emerging daylight. With his left hand Gates confidently grabs his field saber, and with the right he holds a document that reads "Convention / Saratoga 1777," which refers to the surrender of General John Burgoyne's six-thousand-man Convention Army, an event that had sent shockwaves through Britain. Gates wears a large medal on a blue ribbon that Stuart has intentionally lifted off his shirt and onto the lapel of his jacket. Meant to be noticed, it is the congressional medal that had been struck to commemorate victory at Saratoga.

After little more than a year showcasing his spectacular talent in New York, Stuart pushed on to Philadelphia, his target city, in November of 1794. Jay had provided him with a formal letter of introduction that gave Stuart access to the administration and to Washington himself.[38] The timing was perfect. At that juncture, Jay had the President's ear as he was about to pursue potentially controversial negotiations with Britain over unresolved issues left over from the Revolution. Appointed chief envoy, Jay's difficult assignment was to hammer out a new treaty of amity and commerce with America's recent enemy. Equally perfect for Stuart, Trumbull, already the great interpreter of the Revolution, had left Philadelphia in May, accompanying Jay to London. Trumbull's departure became Stuart's opportunity to assume the mantle of National Artist.

❖

Philadelphia was Charles Willson Peale's city. No one was more enmeshed in all the affairs of the city. No one was a more committed American citizen. And no painter could claim to be closer to Washington. But Stuart was decidedly the flashier talent of the two. Peale had been slowly drifting away from painting when Stuart arrived. His collection of specimens had outgrown the gallery attached to his house, forcing a move to leased rooms at the American Philosophical Society, next to the State House. Peale's attention was also focused on developing designs for improved bridge and fireplace safety, and he was also a leader in establishing an art academy, the well-intended but short-lived Columbianum. As a result, Peale offered no impediment to Stuart's ascent.

After Stuart dropped his card and Jay's letter at Robert Morris's house on Market Street, which served as the Executive Mansion, Bartholomew Dandridge, Washington's private secretary, offered him an invitation to the President's weekly reception. The normally glib Stuart was unprepared for the enormity of the experience. "The president, from a distant corner of the room, left a group of gentlemen, with whom he had been conversing." According to the same account, Washington "came up to Mr. Stuart and addressed him by name . . . and finding his guest much embarrassed, he entered into easy conversation with him until he recovered himself."[39] Stuart gathered the wherewithal to pitch his idea for a portrait, and the President, who may have known of Stuart's talent from William Bingham, a personal friend, agreed to it. Stuart quickly secured a house for his family and set up a studio on Chestnut Street and Fifth, next to Peale's museum and conveniently close to the Executive Mansion and State House, where in all likelihood the sixty-three year-old Washington came for his first sittings early in 1795.[40]

Because Washington was of such impressive stature and emotional reserve, the first session in the studio must have been formal, even awkward, and not at all like the rollicking, joke-filled, wine-laced atmosphere that the artist preferred. Stuart could hardly continue with his usual procedure, as narrated by one visitor, in which the artist "insisted on my emptying a tumbler of old East Indian Madeira, which poured out from a half-gallon ewer, like cider or switchel in haying-time. And this at an early hour of the day."[41]

Over the previous twenty years Stuart had developed a method for getting his clients "talking who were sitting to him for their portraits,

each in his own way, free and easy."[42] Usually, he "could draw out the minds of his sitters" with his considerable "colloquial powers." If the sitter were a military man, Stuart "spoke of battles by sea and land; with the statesman, on Hume's and Gibbon's history; with the lawyer, on jurisprudence or remarkable criminal trials; with the merchant in his way; with the man of leisure, in his way; and with the ladies, in all ways . . . He had wit at will. Always ample."[43]

His studio was an experimental laboratory of sorts. With the world boxed out, sitters were subjected to a barrage of Stuart's special effects: sparkling conversation, outrageous opinions, countless stories, and wincing puns, all lubricated by liberal amounts of Madeira. Considering himself to be "inferior to no man" in "conversation and confabulations," and by "banishing all restraint" in the studio, he created an environment in which he could effectively call forth the "natural character" of his sitters.[44] Over time, their defenses would crumble, giving Stuart the opening he needed to "dive into the thoughts of men" and perhaps discover, as a fellow artist put it admiringly, "the transient apparitions of the soul."[45]

But Washington was a special case. Jane Stuart, the artist's daughter, reported that Washington exuded an aura of otherworldliness when he arrived for a sitting, "dressed in black velvet, with white lace ruffles." Stuart's stunned wife thought him "the most superb-looking person she had ever seen."[46] Undoubtedly, that impression was doubled by an entourage that sometimes included General Henry Lee and Secretary of War Henry Knox.[47] Dunlap wrote that Stuart was flummoxed at first, "awed into a loss of his self-possession."[48] In one account, Stuart said that "there are features in his face totally different from what he ever observed in that of any other human being; the sockets of the eyes, for instance, are larger than what he ever met with before, and the upper part of the nose broader." It was as if he had encountered an exotic species, a rarity whose "judgment and great self-command have always made him appear a man of a different cast in the eyes of the world."[49]

Dunlap said that in Stuart's studio, "Washington's mind was busied within," distracted by other thoughts and affectively unavailable.[50] In Trumbull's opinion, "Mr. Stuart's conversation," which might have pleased everyone else, "could not interest General Washington—he had no topic fitted for his character—the president did not relish his manners."[51] In one account of the scene, "Washington was apt to fall into a train of thought, and become abstracted from the things around him . . . An apathy seemed to seize him, and a vacuity spread over his countenance

most appalling to the painter." Bored, if not jaded, by having already spent hundreds of hours in painters' chairs, Washington's mind drifted.

Desperate, Stuart "made several fruitless attempts to awaken the heroick spirit in him, by talking of battles, but in vain; he next tried to warm up the patriot and sage, by turning the conversation to the republican ages of antiquity; this was equally unsuccessful."[52] To be sure, the stakes were high. "The best portrait painter of the age," one commentator wrote, "was now to take the likeness of the greatest man of all ages." And an aspiring American nation, in need of a centerpiece that could gather in its sprawling energies, might be denied its one best focus. Failure "in getting a good likeness would have been death to the artist's fame."[53]

Ultimately, stale jokes worked for Stuart. Late in life he told a visitor that "he found it such hard work to make General Washington speak on light subjects" that he had to resort to an "old Joe Miller story," taken from a published compilation of jests. It was a farcical tale of how a small-town mayor, upon meeting King James II, was so tongue-tied that he spat out one embarrassing comment after another.[54] This "stupid story" had the desired effect on Washington, Stuart admitted, "and from that time . . . I had him on a pivot and could manage him nicely."[55]

Washington had already posed countless times for Peale, Trumbull, and other artists, once quipping, "I am now so hackneyed to the touches of the Painters pencil, that I am now altogether at their beck . . . Now, no Dray-horse moves more readily to the thill, than I to the Painter's Chair."[56] But for much of his presidency he had nimbly avoided artists' requests. Compared to Peale's portraits of the 1770s and 1780s, Stuart's Washington shows the same bone structure, and his eyes are still so penetrating that onlookers plausibly shrink in his presence. But Stuart's Washington is a venerable older man, distinguished and grand, yet also solemn and careworn, quite changed from the swaggering general that Peale depicted after the Battle of Princeton. Nor is he the introspective battlefield commander or the fierce mounted warrior that Trumbull depicted in his paintings. Washington's jawline is also changed, the result of a set of artificial teeth built by James Gardette that resulted in "pouting and swelling."[57] As a result of time's ravages, Stuart's Washington calls to mind a new set of qualities—grave, temperate, and wise—which mark the man as President.

Stuart's first portrait of Washington from 1795 set in motion an avalanche of commissions for more portraits. To Stuart's satisfaction, if not outright glee, within a few weeks he received orders for thirty-two

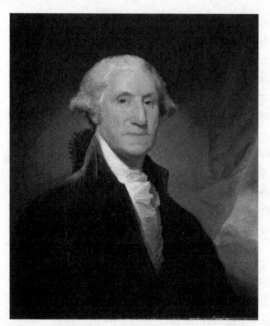

Gilbert Stuart, *George Washington*, 1795–96

more portraits of Washington. John Jay wanted one, as did Aaron Burr and General Lee. Benjamin West sent in a request from London. Samuel Williams, the Boston flour magnate who became a prominent banker in Britain, wanted one for his London townhouse. Gift portraits were to be sent to France and Spain. Authorized and unauthorized prints were produced in the thousands. One copy was given as a token of appreciation by a group of American traders to Ramdulal Dey of Calcutta, a businessman and cultural broker who had opened Indian markets to the West.[58] Chinese artisans started painting copies on glass for export to the United States. Stuart's portrait appeared on stoneware pitchers, wallpaper designs, and engraved prints. One print after a Stuart painting actually made it into a book on the "scientific" relationship between body and mind, as if Washington's distinctive features were, in and of themselves, proof of what the author called "probity, wisdom, and goodness."[59]

Over the next thirty years Stuart painted more than a hundred portraits of Washington. Most were copies of his own originals, derived from the occasions when Washington actually went to Stuart's studio in 1795 and 1796, allowing him to mass-produce them and live out his dream of making a fortune by converting Washington's face into the ultimate patriotic commodity. Stuart jokingly referred to the pictures as his hundred-dollar bills, the price he typically charged.

Stuart's project was so successful, word of it spreading quickly and Stuart becoming famous so fast, that in order to avoid the crush of well-wishers and curiosity-seekers he had to move away from Chestnut Street to the relative peace of Germantown, north of Philadelphia. "In England, my efforts were compared with those of Vandyck, Titian and other great painters," Stuart bragged, "but here! They compare them to the works of the Almighty!"[60]

❧

All the portraits that Stuart painted of Washington fell into three basic types that he varied from picture to picture. The earliest ones, bust-length, show the right side of the President's face, while a slightly later and more frequent type shows the left side. Both types were set against a background that was sometimes green and at other times red. A third type shows Washington standing in a rich interior. Eight feet tall and full-length, it presents Washington to the world for the first time as the American republic's chief of state. Serious, like a Roman orator, and simple, like an American minister, Washington is set forth as a man of exemplary character emanating unpretentious dignity and moral gravitas.

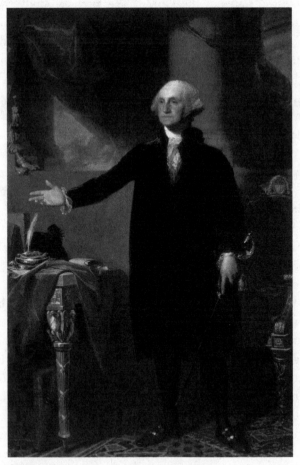

Gilbert Stuart, *George Washington*, 1796

In Stuart's vision, Washington is standing to deliver an address, his right hand extended to make a point, and his left hand resting on the hilt of a sword. Stuart has surrounded him with copious instruments and emblems of power all within his reach: Directly below his right hand, on a table top cluttered with documents, sits an inkwell in the shape of a boat, out of which stands a bright quill pen that he used to sign legislation. Behind it is a copy of the *Journal of Congress*, which contains the daily records of that branch of government. Leaning against that volume is *The Federalist*, the essays that persuasively argued for three branches of government and that helped push the Constitution toward ratification.

Stuart pulled up a corner of the red cloth covering the table to reveal a gilt leg carved in the shape of fasces, a cluster of rods lashed together like the states of the Union. The fasces embody the Constitution and refute all the anti-federalist voices opposing Washington. The leg is topped by symbolic eagles, each vigilant bird holding in its claw a bundle of arrows. The books strewn about the foot of the leg continue the theme of Washington's lifelong achievement. One, *General Orders*, contains the directives that Washington issued during the Revolution to create order and discipline within the Continental Army. The middle book, *American Revolution*, may be David Ramsay's early history of the war, published in 1789 in the wake of the Constitution. The third volume contains the *Constitution & Laws of the United States*. Behind Washington, a gilt chair decorated with the stars of the states is crowned with the Great Seal of the United States. And above the chair, arcing across the sky, a rainbow prophecies a bright future for the nation that Washington had set in motion. His nonpareil accomplishments from 1775 to 1795 reside in every nook and cranny of Stuart's painting, as if it were his visual résumé.

But it was really in the face and body of Washington that Stuart inscribed his moral character. Though the majestic setting recalls European courts, Washington himself is dressed in an unadorned black velvet suit that makes him look like a Protestant minister. His astringent wardrobe and stern expression give the impression that he is impervious to the abundant perquisites of his position that surround him. Though he may not radiate European charm and grace in the portrait, he makes up for it with American rectitude and solemnity, as if an old-fashioned New England Yankee had been magically transported into the court of Louis XVI. In Stuart's hands, Washington projects a Cato-like

republican austerity that rises above the enticements of office. Unlike every monarch in Europe, this picture wishes to say, our President remains morally unimpeachable.

❧

S tuart's portraits were artistic interpretations, not impartial docu-
ments. Like an authorized biography, they tell only the story that the subject wished to reveal. They are Stuart's image of the President, and they also represent Washington's well-orchestrated image of himself as President.

Washington had spent a lifetime assiduously cultivating the public figure that we see in Stuart's painting.[61] Though his military prowess was unmatched and came naturally, he had to practice prudence, modesty, and self-control when he was elected to the presidency in 1789. Always aware that he was in the unprecedented position of being the leader of the first and only modern republic, he continually pondered how "The President" should conduct himself as "a figure upon the stage."[62] He made it a point to take a daily walk through the streets of Philadelphia, mud and all, in order to demonstrate his ordinariness. He started his speeches with the phrase "My fellow citizens." He was fastidious about being seen wearing plain blue or black suits made out of American cloth. In his last years, Washington even went through his correspondence and destroyed those that made him seem arrogant or vulnerable, that did not square with the image he had taken decades to mold.

In his deepest self, he was someone else. He liked pomp and splendor and he affected a regal bearing. He bred horses and went fox hunting. He had his clothes tailored in London, as well as a coach outfitted with his crest on the door. In 1798 he designed for himself a gaudy military outfit adorned with yellow buttons, gold epaulettes, silver stars, embroidered cape, and plumed hat. For all his avowed humility and uprightness, he was ambitious and vain and possessed a large ego.

And he was not entirely mild-mannered. After Stuart met Washington for the first time in Philadelphia, looking at him face to face and reading into his character, he said to a friend that "all Washington's features were indicative of the strongest and most ungovernable passions, and had he been born in the forests, he would have been the fiercest man among the savage tribes."[63] On one occasion, Stuart walked into Washington's rooms for a sitting, only to watch the President "seize a man

by the collar and thrust him violently across the room."[64] Jane Stuart said that her father commented to General Lee that Washington "had a tremendous temper."[65] Thomas Jefferson confirmed that "his temper was naturally irritable and high toned; but reflection and resolution had obtained a firm and habitual ascendancy over it. If ever, however, it broke its bonds, he was most tremendous in his wrath."[66] And when he did get "into one of those passions," Jefferson added, he could no longer "command himself."[67]

The fuming man of raw emotions, the chief executive driven to paroxysms by Philip Freneau's frequent attacks in the *National Gazette*, the president who unleashed a torrent of vile language when he learned how Secretary of State Edmund Randolph had betrayed him by revealing disputes within the Cabinet, was even described in emotional terms at his own funeral in 1799.[68] In his eulogy, Gouverneur Morris pointed out that hidden beneath the surface calmness and the self-imposed statue-like self-control there was a man of "tumultuous passions" whose "wrath was terrible." There was "boiling in his bosom, passion almost too mighty for man."[69]

In Stuart's hands all that latent emotion was erased. In portrait after portrait, not the slightest residue exists of those "ungovernable passions" that Stuart observed. Indeed, Stuart's Washington does not resemble a person ever possessing the heart of a wild man. The critic John Neal, writing as his alter-ego, Molton, in the 1823 novel *Randolph*, said as much. To him, Stuart's portraits of the President were "less what Washington was, than what he ought to have been." Neal said that in developing the image of Washington, Stuart had "infused" a degree of "amplitude and grandeur" in a man better known for "passions" that "were tremendous."[70] Deciding against an incisive portrayal of the inner person, Stuart instead created, in Neal's phrase, the image of a "predestined statesman," someone innately great, as if by divine will.[71]

In fact, Washington was a man of "almost excessive self-command," a calculating leader "intentionally shaping his public and historic self."[72] This great man, "driven ceaselessly by ambition" and "obsessed with his honor and reputation," knew that he was the first figure of the nation, and he shaped his appearance, social relations, political discourse, and visual images accordingly.[73] As one of Washington's biographers put it, he was "determined to influence and, if possible, control posterity's judgment of him."[74]

Washington recognized that to become and eternally remain that

iconic man required not only self-control but also self-concealment (as any good portrait artist would also have understood). He once remarked with evident pride that "my countenance never yet betrayed my feelings."[75] The secretary of a British diplomat observed that Washington "possesses the two great requisites of a statesman, the faculty of concealing his own sentiments and of discovering those of other men."[76] Indeed, by overlooking the churning emotions hidden just beneath Washington's groomed exterior, Stuart emphasized a man possessing the wisdom of the ages.

Washington also understood that the arts were integral to his long-term project of reputation building. As he explained to Lafayette, artists and writers "hold the keys of the gate by which Patriots, Sages and Heroes are admitted to immortality. Such are your Antient Bards who are both the priest and door-keepers to the temple of fame." The work of these artists and writers, "my dear Marquis, are no vulgar functions."[77]

S tuart painted his great portraits in the last two years of the President's second term, when Washington's hold on day-to-day American politics was eroding. Though his stature remained unassailable, ferocious demagoguery threatened Washington's authority, presidency, and reputation. The specific locus of Washington's new vulnerability was the treaty with Britain that Jay negotiated in 1794 with the help of Trumbull. Ratified by the Senate in 1795, funded by the House of Representatives, and announced in 1796, it required that Britain give up its frontier forts in the Northwest Territory and put an end to its seizure of American merchant ships; and the treaty granted American merchants favored trading status with England.[78] In return, America was to be essentially complicit with Britain's naval dominion over the Atlantic.

Though there was legitimate good to much of the treaty, fierce antiadministration critics said it betrayed America's true ally, France; reunited America with its enemy, Britain; favored Federalist merchants; preferred British imports; and, most disturbingly, returned America to its demeaning status as a cog in the Britannic empire. A political firestorm ensued as Jefferson and James Madison denounced the treaty and attacked Washington and Treasury Secretary Alexander Hamilton, who had designed the terms of the treaty. Even Washington's own Secretary of State, Edmund Randolph, railed against the treaty, as did

his own nominee to replace Jay as Chief Justice, John Rutledge, who delivered a speech condemning it. James Monroe, Washington's minister to France, went so far as to publish a 473-page denunciation of the administration's foreign policy.

At the controversy's rhetorical extremes, crowds burned Jay in effigy on the Fourth of July, threw rocks at Hamilton in New York City, and openly cursed Washington. In Philadelphia, a mob surrounded the Executive Mansion, while Benjamin Franklin Bache's *American Aurora* newspaper called for the President's impeachment. Congressman Robert Livingston demanded that Washington turn over all documents related to the treaty, with the suggestion that the President had been up to something crooked or even conspiratorial.

The most frightening event, one that could not be overlooked, was an orchestrated parade through the city, in which five hundred Philadelphia artisans surrounded a cart with an effigy of Jay holding up the scales of justice. Mocking his position on the Supreme Court, the caricatured Jay had piled British gold onto a scale that tilted downward on one side, while the other was feather-light on "virtue, liberty independence."[79] It was a haunting sequel to a similar parade that Charles Willson Peale had coordinated in 1780 to condemn Benedict Arnold.

The Jay Treaty was the most partisan and most savage drama of the age, one that gravely weakened Washington personally and jeopardized his presidency politically. To Jefferson and his angry Republican cohort, Washington was, by one historian's account, "a marvelously well-intentioned but quasi-senile front man for a Federalist conspiracy, inadvertently lending his enormous credibility to the treacheries being hatched all around him."[80] Even though he thought he had seen it all over the previous twenty years, Washington admitted the ugly affair had "worn away my mind more than my body." He spoke of his "serious anxiety" for the future, and feared that the bitterness and invective of partisan politicking had not only "brought the Constitution to the brink of precipice, but the peace, happiness and prosperity of the Country into eminent danger."[81]

Washington walked into Stuart's studio precisely at the moment when partisan politics were exploding. On the streets, rancorous protesters circulated petitions claiming the treaty was a travesty of statecraft. But inside the studio, Stuart began work on the great portrait, which would reveal no political tensions or personal anxieties.[82] From

the outset, Stuart's job, as he understood it, was to restore the President's lost luster, even at his nadir, and to cement his reputation for posterity. Though the America that Washington had helped create was coming apart at the seams, the Stuart images—and all the thousands of versions in paint and print—showed the President, repeatedly and unwaveringly, as the master statesman, the unbowed and unquestioned emblem of high character, honor, greatness, simplicity, selflessness, stability, and nonpartisanship. In a divisive era, Stuart's pictures can be understood as a kind of paste or compound filling and ultimately covering the fissures and cracks eroding Washington's honor and threatening to bring down the whole federal edifice.

Even with benefit of Stuart's portraits, Washington's road to imminent retirement would still be rocky. Newly elected congressman Andrew Jackson, enraged by the Jay Treaty, openly rebuffed Washington during his final address to Congress in 1796. Jefferson, who may have been cordial in person, whispered in private to Madison that he thought Washington was an incompetent, "leaving others to hold the bag."[83] The *American Aurora* ranted that "if ever a nation was debauched by a man the American Nation has been debauched by WASHINGTON. If ever a nation has suffered from the improper influence of a man, the American Nation has suffered from the influence of WASHINGTON. If ever a nation was deceived by a man, the American Nation was deceived by Washington . . . No man may be an idol."[84]

Even Tom Paine, the inspiring voice of the Revolution, turned against Washington in 1796. In the form of an open letter—more like a public screed—he mounted a devastating attack, accusing the President of being an apostate and an imposter, guilty of everything from fraud and corruption to treachery and hypocrisy. Cutting close to the bone of Stuart's vast project to spread the President's portrait far and wide, Paine detected inside Washington a sordid egotism, "encouraging and swallowing the grossest adulation"[85]

But none of that mattered to the vast majority of Americans who thought that Washington was above reproach. Archibald Stuart, Jefferson's law student, who knew full well that his teacher had masterminded the vilification of Washington, observed: "Such is the popularity of the President that the people will support him in whatever he will do, or will not do, without appealing to their own reason or to any thing but their feelings towards him."[86] Though Washington was being pilloried

in the political arena, Stuart and others were producing and selling images of Washington operating above earthly tempests, far from the political fray, the everlasting personification of the nation, the only safe port in the storm.

Stuart had created a transcendent Washington around whom ordinary citizens could unite, despite their considerable differences.[87] In the long run, Stuart's portraits not only helped save Washington's reputation and counter the debilitating political effects of the most rancorous period in America's early history, they also brought a measure of coherence to the fledgling republic. Unity, the most elusive aspect of America's nation-making, was the central topic of Washington's Farewell Address of 1796. He instructed Americans to move past their raucous political partisanship and embrace the idea that they were part of a collective with a common future. Washington never mentioned in his speech that he was himself the icon centering that national faith. And if his personal magnetism was the singular agent of unity—the "Man who unites all Hearts"—Stuart, more than anyone else, spread the gospel of Washington across the states and into the future. For a young and unsettled American republic, there was something secure and calming about Washington's majestically aged face.

Newspapers and diaries of the period often expressed the hope of citizens that one day they would see Washington.[88] Most likely, that would be in the form of a Stuart painting or replica, and not an in-person sighting. These were images that helped Americans make sense of what they were doing in their unprecedented—and at times incomprehensible—condition as citizens of the United States. In them, Americans shared a sense of themselves as compatriots. The images turned newfangled abstractions—the presidency, republican leadership, political authority—into memorable and meaningful form. They helped citizens from Massachusetts to Georgia, who would never meet in person and who were having a difficult time shedding their deep-seated regional identities, to share one essential image of their national leader. In the unchartered waters of the new republic, Stuart's vast network of images created an invisible bond of nationhood, a "deep, horizontal comradeship" that helped bind Americans to each other.[89] As Henry Knox succinctly remarked in 1793, in the United States "it is the President's character, and not the written constitution, which keeps it together."[90]

❖

S tuart created a stir in Philadelphia, not only with his iconic portraits
of Washington, but also with a large personality and exceptional tal-
ent that seemed to emit a magnetic field pulling leading citizens into
his studio. Over the course of nine years in the city, he painted the
President's family, the nation's political leaders, important educators,
prominent merchants, and other notables. In turn, as Dunlap noted, by
having Stuart paint their portraits, those sitters "achieved immortality
for themselves."[91]

Sarah Wentworth Apthorp Morton, an accomplished writer publish-
ing under the pen names Philenia and Constantia, went so far as to write
a forty-four-line poem in which she lavished praise on Stuart. It begins:

> STUART, thy portraits speak, with skill divine;
> Round the bright Graces flows the waving line.
> Expression in its finest utterance lives,
> And a new language to creation gives.
> Each varying trait the gifted artist shews,
> Wisdom majestic in the bending brows.

The editor of the Federalist magazine *The Port Folio*, in which the poem
was published, was so caught up in the sentiment that he acclaimed Stu-
art's portrait of Mrs. Morton as something "beautiful," "captivating,"
"spirited," "impassioned," and "ingenious," whereupon Stuart responded
in a thirty-four-line poem of his own dedicated to Mrs. Morton. It begins:

> Who would not glory in the wreath of praise
> Which M . . .n offers in her polish'd lays?
> I feel their cheering influence at my heart,
> And more complacent I review my art
> Yet, ah, with Poesy, that gift divine
> Compar'd how poor, how impotent is mine!

Stuart's sway over Philadelphia and the President irked Charles
Willson Peale, who had been, more than anyone else, Washington's
great imagist in the 1770s and 1780s. Stuart's triumph in Philadel-
phia left Peale "mortified to find his efforts forgotten or despised."[92]
His seventeen-year-old son Rembrandt, who privately admired Stuart's

technique, tried to defend the family brand by labeling Stuart a for-
eigner in Philadelphia whose work was "deficient in character."[93] Stuart
tried to placate the miffed Peales by persuading Washington to sit once
again for his old friend. Peale took that opportunity to take along to
the Executive Mansion his brother James and three sons, Raphaelle,
Rembrandt, and Titian, who all simultaneously painted and sketched
Washington.[94]

Stuart was a bright comet briefly passing over the city, but he never
rose to the Peale family's level of respectability. When wealthy Balti-
more merchant Robert Gilmor visited Stuart in his Germantown stu-
dio in 1797, he accurately noted, "As a portrait painter Stewart is not
excelled I believe by any man living." But in the same breath Gilmor
added, "He has the appearance of a man who is attached to drinking,
as his face is bloated & red."[95] Some of that excess is apparent in Peale's
later portrait of Stuart, one that he added to his gallery of American
worthies. Looking at it, Stuart thought that Peale had made him look
like "an awkward clown."[96]

When the capital moved to Washington City in 1800, Stuart at
first stayed in Philadelphia. But he changed his mind after a sheriff
seized all his property—includ-
ing his paintings—for a six-hun-
dred-dollar debt owed to one of
his old English creditors. Only
the intervention of George Helm-
bold, the editor of a Philadelphia
humor magazine known as *The
Tickler*, resolved the calamity
when he pleaded with Jefferson
for help. "The celebrated Portrait
Painter has by a strange fatality
of circumstances involved himself
and nine children in a situation
the most distressing that can be
conceived," Helmbold began the
sad tale. "As an acknowledged
patron of genius I appeal in behalf
of Mr. Stuart."[97]

The impending sale of Stu-
art's possessions was called off,

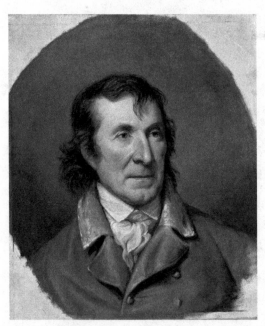

Charles Willson and Rembrandt Peale, *Gilbert
Stuart*, 1805

and subsequently Helmbold and Stuart notified Jefferson of their plans for a money-making venture to publish sets of engravings to be called the *"American Gallery"* of distinguished public figures. "Mr. Stuart and I shall visit the City [Washington] in October next for the purpose of obtaining paintings of Messrs. Madison, Gallatin &c. when we hope to have the honour of conversing with you in person."[98] Helmbold went as far as advertising the plan, which called for Stuart to take oil portraits of Jefferson, Madison, Adams, Burr, and others, and then have them engraved and sold by subscription.[99]

All of it was a familiar story: the reckless and desperate Stuart flee-ing from his debts, and the savvy and talented Stuart tracking a new market, thus rescuing himself from himself. Looking across the clut-tered landscape of his failures, debt was but one of its manifold fea-tures. He had long been in the habit of taking money for portraits and then failing to finish them, including portraits of the Washingtons that he kept for himself, despite pleas from Martha to deliver them. More than once he was guilty of perpetrating "fraudulent conversions," taking money for a portrait but then selling it to someone else. He even stiffed Peale, who tried to get Stuart to finish a portrait of the English theo-logian Joseph Priestly that was purchased by the Philosophical Society, but resold by the artist to someone else.[100]

Besides being an occasional felon, Stuart the alcoholic frequently veered into sordid language and embarrassing behavior. One person said "it is well known that Stuart's passions and appetites were of the kind said to be uncontrollable . . . as is the case with all men who plead temper as an excuse for folly."[101] More ominously, Dunlap said that "his fam-ily appeared to fear him."[102] And according to Jane Stuart, her mother looked back on her marriage to the artist as a time when she was given "pain to remember anything associated with his reckless extravagance, or what she called his folly."[103]

Long before his portrait of Washington started appearing on one-dollar bills in 1869, Stuart's presidential portraits were a kind of currency. They bailed him out of financial jams. There were authentic and counterfeit versions. They were purchased and given as gifts. They were used to gain political favor. Robert Gilmor, who bought the last of Stuart's Washingtons in 1825, said that the "circumstance is unique in the history of painting, that the portrait of one man should be sought after in such a degree as to be copied by the original artist such a number of times and for such an amount."[104]

Stuart's Washington seemed to push other portraits to the brink of extinction. The novelist and critic John Neal acknowledged in 1823 that Peale's Washington was "the *only* faithful likeness of the man, in the world." But that was irrelevant because Stuart's Washington had triumphed in the American mind. "How strange it is!" Neal elaborated, we "get accustomed to a certain image, no matter how it is created, by what illusion, or under what circumstances; and we adhere to it, like a lover to his mistress." If "a better likeness of him were shown to us, we should reject it," Neal argued, "for, the only idea that we now have of George Washington, is associated with Stuart's Washington." Even a spitting image of Washington "would be laughed at." In fact, Neal went on, "if George Washington should appear on earth, just as he sat to Stuart, I am sure that he would be treated as an impostor, when compared with Stuart's likeness of him, unless he produced his credentials."[105]

Stuart's Washington was so potent an image that it reached across time, becoming the "standard," as Neal put it, in the nineteenth century. He went on to admit that "Stuart's Washington, though untruthful, is grand, simple, and satisfying as a revelation."[106] Even Stuart himself, when called upon by the City of Boston in 1806 to paint a giant portrait of Washington at Dorchester Heights, set in 1776 when the general was forty-four years old, felt obliged to attach the presidential head, when Washington was sixty-four, to the younger man's body.

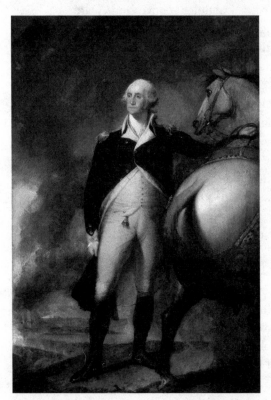

Gilbert Stuart, *George Washington at Dorchester Heights*, 1806

Eventually, in the twentieth century, Stuart's Washington drifted into the status of clichéd icon. Grant Wood's famous painting of 1939 was a send-up of Stuart's picture. In it, Parson Weems, Washington's first biographer, is raising a cherry-tasseled curtain on an entirely apocryphal event from Washington's

Grant Wood, *Parson Weems' Fable*, 1939

childhood when the boy confesses to his father, Augustine, that he had cut a cherry tree with his axe. Tongue-in-cheek, Wood tacked Stuart's presidential head onto the body of the six-year-old Washington.

S tuart left Philadelphia for the city of Washington late in 1803. He went alone, having stashed his impoverished family on a farm in Bordentown, New Jersey. The capital he entered was a frontier town set in a marsh. Though the urban plan was grandiose, the reality was a low-lying piece of empty land notable for its trapped humidity and voracious mosquitoes. It may have been promising, but at the moment it was nothing less than preposterous. "The citizens build houses where there are no streets," and the city "makes streets where there are no houses," wrote George Watterston, the Librarian of Congress. In "this magnificent metropolis," he sarcastically went on, "the streets are filled with mud in winter, and with dust in summer; and instead of splendid edifices you can see nothing but corn fields, arid plains, dry canals, and dirty marshes, where frogs make love in a most sonorous and exquisite strain, and bellow forth their attachment as if they were determined to

make no secret of it."[107] One character in a John Neal novel was even snider when she said the population was so sparse that people "make love by the penny post."[108]

With a fresh start, Stuart made sure that his new studio was close to all the congressional delegations three blocks away in the rising United States Capitol building. Borrowing a page from Peale, he started to paint portraits of the Founders. He even developed a scheme to open a gallery with examples of his work, including a portrait of Washington, with the intention of spurring interest and taking orders for copies. But unlike Peale's project of creating a hall of fame, there was nothing civic-minded about Stuart's work, no effort to do something noble for the city or country. He wanted to do it for the money. While the gallery never materialized, over the course of the next eighteen months he painted about forty original portraits, a blistering pace by any measure.[109] As one admirer put it, Stuart was "all the rage, he is almost worked to death."[110]

Stuart helped energize the desultory city with his wit and paintbrush. Dunlap wrote that he made a specialty of "the reigning belles."[111] That included Marcia Burnes Van Ness, Elizabeth Beltzhoover Mason, and Anna Payne Cutts, all of whom felt marooned in a raw town that

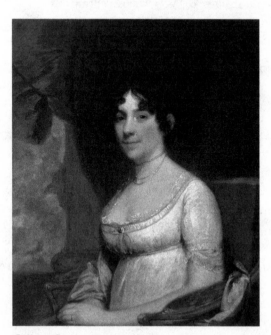

had pulled their husbands into the federal government. Dolley Madison was the most enthusiastic about Stuart, whom she pronounced "a man of genius."[112]

In Philadelphia, shortly before Stuart's arrival there, she had married her second husband, James, now Jefferson's Secretary of State, and she undoubtedly became well acquainted with the artist's portraits then. When the Madisons visited Stuart's studio in Washington, James was being groomed as Jefferson's heir apparent. But in order to win political support for a run at the presidency, the shy and intellectual Madison had to depend on Dolley's grace and

Gilbert Stuart, *Dolley Madison*, 1804

charm. Though she had suffered personal tragedies, they were bypassed in Stuart's portrait, which focuses instead on the outward projection of optimism and energy. Physically, she is a saucy presence, dressed in an empire-style dress marked by short sleeves, a plunging bodice, and a high-cut waist. Her dark hair is pulled back in a chignon and her blushed face and red lips are affectionately framed by cascading ringlets and four gold chains.[113]

At the same time that Stuart was painting "the reigning belles," he was of course attending to the "distinguished men of the time."[114] One of the first to walk into his studio on C Street was President Jefferson, whom Stuart painted at least five times.[115] He seems to have been one of the few clients to remain steadfast, despite having been himself victimized by Stuart's false promises to paint portraits for him. At one point, overlooking all the bad conduct, Jefferson mailed the artist a gold watch as a "mark of my esteem . . . presented to you from a friend who appreciated your great talent."[116]

Jefferson was the most accomplished student of the fine arts in the federal government. He had submitted designs for the new Capitol building and the White House, and had been involved in the plan of the city itself. He had used Trumbull to introduce him to the collections of Paris, where he had bought European works of art for Monticello, and over his lifetime he commissioned portraits for his own gallery of worthies. He not only had a discerning eye that could differentiate between good and bad art, he also knew from his experience as Minister to France how works of art profoundly shaped consciousness, how they could be used effectively as rhetorical tools in the projection of political personality.[117]

Instead of there being a singular iconic image of Jefferson, he emerges from the visual record as a multidimensional man for all seasons. He was the legislative leader in Trumbull's *Declaration of Independence*, a Roman senator in the Italian Giuseppe Ceracchi's marble bust from 1790, a wise philosopher in Jean-Antoine Houdon's marble and plaster busts, a shining exemplar of the modest American hero in Charles Willson Peale's portrait of 1791, an aging sage in Rembrandt Peale's portrait of 1805. Where Washington seemed to have had a stable image, Jefferson was always mutating from one characterization to another. Even Stuart painted different sorts of Jeffersons. In the most unusual one, the President is posed in a no-frills profile, as if he were an emperor or deity stamped onto an ancient Roman coin.

Jefferson paid just as much attention to the outward signs of his politics as Washington did, and like the first President he also recognized Stuart's prodigious talent and what it could do for him. But Jefferson used Stuart for his own very different ends. When he walked into the artist's studio shortly after his reelection to a second term, he had already made his stunning purchase of the Louisiana Territory, which was arguably the signal achievement of his presidency. The portrait Stuart was to paint had a specific political destination. It was to be carried, along with a companion portrait of Madison, to the court of Spain as part of James Bowdoin's diplomatic mission. Because of the high-level nature of the commission, the picture needed to be a synopsis of everything that Jefferson and his presidency exemplified. And clearly that meant a rejection of everything that Washington and his presidency had stood for.

Jefferson knew that the projection of personality was at the heart of politics and that for his term of office the operative phrase was "chaste republican character."[118] Where Washington, Adams, and the Federalists had stood for the interests of conservative urban merchants and bankers, believed in strong central government and elite rule, tilted toward Britain, and been distrustful of the public, Jefferson, Madison, and the Democratic-Republicans identified with rural farmers, believed in states' rights and personal freedom, and gravitated toward France.

Jefferson was determined to establish a radically new path for his presidency, which he immodestly described in retrospect as "the Revolution of 1800." "I feel a sincere wish, indeed, to see our Government brought back to its republican principles," he wrote in the weeks before the inauguration.[119] He wanted to erase what he thought was the misguided pomp and authoritarianism of the Federalist administrations of Washington and Adams, and in its place restore America to its "chaste" revolutionary core.

What that meant visually was a "purging of excess and a recovery of essence."[120] That agenda was already evident in Jefferson's first inaugural when he wore "plain cloth," refused to wear a ceremonial sword, and walked up to the Capitol in a "little parade" quite unlike the coach and sixes used by Washington and Adams. This was the shot over the bow announcing Jefferson's belief in "pure republicanism." Jefferson wanted to operate with a light touch, to be perceived as a leader among equals in a government in partnership with its citizens. He was going to be the modest administrative head of a republic of thirteen semi-sovereign states.

The Jefferson presidency was also manifest in the political theater operating within Stuart's portrait, begun in 1805, which expresses that "chaste republican character." In place of Stuart's template for Washington, in which the President is reserved amid a gaudy celebration of power, or contrasted against Copley's Baroque setting for plain-style John Adams, Jefferson assumes a totally minimalist executive style. Shown in his undecorated study in the traditional pose of a scholar, he is seated at a desk with his right hand resting on some papers, doing the people's work. This aesthetic of commonness is studied

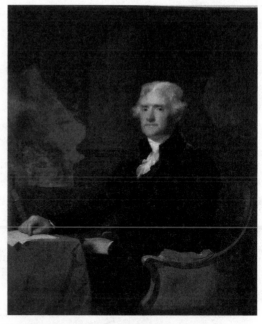

Gilbert Stuart, *Thomas Jefferson*, 1805–07

and it is political. Even the chair on which he sits speaks to Jefferson's thinking and affections. Unlike Washington's gilt throne, this chair is French, a plain bergère in which the back wraps around to include the arms, creating an enclosed effect.

The entire ensemble—in effect it was a stage design—expressed Jefferson's rejection of centralized power, a visual rebuke of Washington's presidency and its legacy, and at the same time an assertion of himself as the unadorned President intent on promoting republican values as they were widely manifest in his own behavior, dress, objects, and works of art. Style, Jefferson wished to say, was substance.

Ironically, Jefferson's presidency was not fundamentally different from those of his predecessors. His purchase of the Louisiana Territory was such an egregious expression of executive power that critics called Jefferson out as a constitutional hypocrite eagerly bypassing the rule of law so that he could accomplish his own goals. But rhetorically, in painting and public behavior, Jefferson made a point to deploy all visual means to signal himself and his administration as the avatars of the chaste republican order. Had Stuart's picture of Jefferson actually arrived at the official American residence in Madrid as intended (the mission was aborted because of diplomatic blunders), the Spanish no

doubt would have raised eyebrows, given how it contrasted with Francisco Goya's royal portraits of King Carlos IV, resplendent with ermine, crown, sword, medals, sashes, and satins. Stuart's Jefferson would have looked curiously Spartan and dangerously republican.

Stuart was more than willing to depict Jeffersonian political culture by promoting images shorn of official emblems and magisterial remoteness, and focused instead on good administrative habits and an admirable unpretentiousness.[121] Though Jefferson was a slaveholder lording over an impressive plantation in Virginia, and was a compulsive spender who bankrupted himself with his lifelong self-indulgences, in Stuart's portrait he puts on a show of being "a plain citizen, without any distinctive badge of office," according to one witness at his inauguration as President. "His dress and manners are very plain," one senator remarked, "he is grave or rather sedate; . . . without any tincture of pomp, ostentation, or pride."[122]

Sensing exhaustion in the market for portraits in the Federal City, Stuart left Washington in 1805 for Boston, where his sister and widowed mother lived, his wife and children arriving the next year. Parched citizens deprived of a first-rate artist since Copley's departure more than three decades earlier were willing to pay a hefty $120 for a portrait.

A few months before Stuart's arrival in Boston, John Trumbull returned to America after a decade abroad, one that had begun as Jay's diplomatic secretary. He had legitimate apprehensions about his homecoming. "I feel at times not a little anxiety on the Subject of *picture making*—I have by no means money eno: to live comfortably without business of some sort—I hate your nasty Squabbling Politics—they disgust me:—I know nothing of Farming—little of Trade & I fear I shall find that my Countrymen care very little for the only thing which I pretend to understand," namely art.[123]

Trumbull did in fact take the plunge into picture-making. After he and his new English wife landed in New York he hastened to Boston where, he figured, the populace surely would be in need of an accomplished artist. But he quickly discovered that citizens were already preparing for the arrival of someone else. "I soon observed that whenever I alluded to the idea of . . . pursuing my profession," recalled Trumbull of conversations with Bostonians, "a cloud seemed to pass over and to chill

the conversation. I could not, for a long time, account for this."[124] But in time Trumbull came to understand what reticent Bostonians would not bluntly tell him: that they wanted Stuart, and only Stuart.

Stuart would carry all of his flaws to Boston. He was still loose with money, slightly devious, always untrustworthy, and too fond of Madeira. "The defects in Stuart's character were marked, and often stood in his way," wrote an early biographer.[125] One visitor to his rooms in Boston lamented the "wayward capriciousness of genius which would frequently design without deigning to finish."[126] A friend once burned by Stuart considered him the "greatest of our Artists," but also the "most unprincipled of our Citizens."[127]

Nathaniel Hawthorne, living in nearby Salem when Stuart died in 1828, wrote about the legendary artist in a short story of 1837, "The Prophetic Pictures." Walter and Elinor, who are betrothed, start discussing the "preternatural" talents of an unidentified artist who, exactly like Stuart, "has the ability of adapting himself to every variety of character insomuch that all men—and all women too . . . shall find a mirror of themselves in this wonderful painter." On the eve of having their half-length portraits taken, they speculate that the artist is a wizard of sorts:

> He paints not merely a man's features, but his mind and heart. He catches the secret sentiments and passions, and throws them upon the canvas, like sunshine,—or perhaps, in the portraits of dark-souled men, like a gleam of infernal fire . . . In most of the picture, the whole mind and character were brought out on the countenance, and concentrated into a single look, so that, to speak paradoxically, the original hardly resembled themselves so strikingly as the portraits did.

Hawthorne's fictional artist, like Stuart, was also a flawed man, eccentric, undependable, with "no sympathies, but what were ultimately connected with his art; . . . he did not possess kindly feelings; his heart was cold." Hawthorne's artist begins work on the portraits, all the while engaging Elinor and Walter in conversation that "kindled up their faces." Before long the couple "beheld their phantom selves" on the canvases, and curious visitors came to the studio "day after day" to "study these painted faces like the pages of a mystic volume."

In time, the portraits in Hawthorne's story, which were deep and engrossing, started to acquire prophetic power. They possessed such

psychological pull that they threatened to swallow Walter and Elinor, who could not arrest the "step of Destiny" as they were gradually transformed into the dark and vulnerable figures depleted in the portraits. A haunted Walter "remained silent before the picture, communing with it, as with his own heart, and abandoning himself to the spell of evil influence."

Hawthorne had captured—and exaggerated—the magical aura that Stuart cast over Boston's populace, his characterizations in paint capable of penetrating, and ultimately seizing control of his sitters.[128] In his studio, visitors marveled at "the human countenance divine" that was taking shape on the canvas, "just beginning like a rosebud to unfold its perfections."[129] These starstruck Bostonians could hardly resist Stuart because, as Dunlap phrased it, his "best pictures are beyond all praise."[130]

10 ⌒꙳

John Trumbull's Second Act

As John Trumbull discovered after leaving America to become John Jay's secretary to treaty negotiations with Britain, the job came at a price. His pictures on the Revolution would have to be put aside, and they were by far his life's most important work. Arriving in London in 1794 after a five-year absence, he labored on the perimeter of the Jay Treaty negotiations, which he said were "difficult, complicated, and intricate in the extreme."[1] Once high-level talks ended in 1795 and Jay returned to America, Trumbull and others were left to iron out the details of the treaty's twenty-eight articles. On the side, Trumbull partnered with Benjamin West in a plan to sell old master paintings and dabbled in speculative brandy and tobacco ventures. He even competed with John Quincy Adams for the affections of Louisa Catherine Johnson, whose father was American consul-general in Britain. Trumbull used "flirtatious inside jokes" and "art lessons" to woo her, but in Louisa's words that was "about all that could be tortured into love." She eventually married John Quincy.[2]

Trumbull was sent to Paris in 1797 to shadow an American legation led by Charles Cotesworth Pinckney, John Marshall, and Elbridge Gerry, who were pursuing redress against the French for the interdiction and seizure of American ships trading with Britain (316 seized in 1794 alone). Trumbull's directive was to learn what he could about the arduous negotiations and then to ferry dispatches of the XYZ Affair, as it was eventually known, out of France. It seemed like a simple task.

However, the American envoys quickly learned that the French were incensed by the Jay Treaty because it put the United States back into the British orbit. As a result, Foreign Minister Charles-Maurice de Talleyrand was intransigent with Pinckney, Marshall, and Gerry, insisting on bribes and loans as preconditions to any negotiations. Pinckney flatly refused to go along with Talleyrand's demands, putting the two sides at a stalemate, and that in turn pushed President John Adams into the Quasi-War of 1798, a conflict that saw the United States Navy engaging French warships in the Caribbean.

Talleyrand made polite overtures to Trumbull, at first inviting him to dine with some high-profile friends. But then he thought he could use Trumbull as a tool to manipulate the high-principled American envoys by refusing him passage out of France, in effect holding him hostage until the diplomats came around to his ultimatums.[3] Pinckney was powerless to intervene, forcing Trumbull, desperate to find some way out of a potentially dangerous jam, into the Louvre studio of his old friend Jacques-Louis David, who had spent the Reign of Terror politically affiliated with Robespierre. When Trumbull arrived he could see David's stunning tribute to the dead Jean-Paul Marat, the man who had drawn up the lists of those to be guillotined. Though Trumbull no longer had any affection for France or for their revolution, nor for David's politics, he needed the French artist to rescue him from Talleyrand's trap.[4]

The two artists chatted about all that had happened since they had last spoken in 1789. Paris had changed in the intervening years, bearing little relationship to the inviting city that he and Jefferson had enjoyed a decade earlier. In the interval, Louis XVI had been guillotined, and the Committee of Public Safety had launched the Reign of Terror, executing thousands for their political opinion or for as little as harboring views antithetical to the Committee. Robespierre had been executed in 1794, a national constitution had created the Directory, and Napoleon was on his way back to the capital after a triumphant Italian campaign. France was now the dominant force on the Continent.

When the subject of the Terror came up, however, Trumbull was appalled by what David said. "True, much blood has been shed," David acknowledged. But not nearly enough. "It would have been well for the republic, if five hundred thousand more heads had passed under the guillotine."[5] Trumbull recalled in his memoir that his fate in France—possible "imprisonment or death"—had come to rest in the hands of a man possessing the "full belief that the blood of individuals was of no more value than water." But however much he thought that David's politics had "the imprint of a ferocious monster," no one, Trumbull appreciated, "could have taken a deeper or more ardent interest in the dangers of another than he had done in mine."[6]

David asked Trumbull if he had his painting of the *Death of General Warren at the Battle of Bunker's Hill* with him, which in fact he did, having picked it up a few weeks earlier in Stuttgart where it was being used to make engravings. David had Trumbull take it along to the

Ministry of Police. When they approached the French officials, David pulled out the painting and lectured the Secretary of Police, telling him "in the tone of a master" that Trumbull was a "grande artiste" and clearly not an enemy of the state. Moreover, because the *Death of General Warren* showed Americans battling to the death against the reviled British, it proved David's argument that Trumbull was "as good a revolutionist as we are." To Trumbull, this was a "horrid encomium."

The ruse worked. Apologies poured out from the French, a passport was immediately produced, and even the powerful Minister of Police, Jean-Marie Sotin de la Condìere, offered his own regrets and said only half-jokingly that Trumbull possessed such evident talent that maybe he ought to be "retained in the service of the republic." A stricken Trumbull demurred, took the passport, offered "sincere thanks to my friend David," and set out for London as fast as he could.

Back in Britain, Trumbull returned to international affairs, working as commissioner of the seventh article of the Jay Treaty, which dealt with compensation for ships confiscated by the British. He also worked with Rufus King, the Minister to Britain, developing a "Plan" to liberate South America from the yoke of European rule, which he imagined would create a New World utopia of modern republics. He tried to persuade Washington to stand behind it, but from Mount Vernon the retired President wrote back politely to explain that Trumbull's thinking was that of an armchair strategist. It was a nice idea, but unworkable. In the midst of his correspondence with Washington, Trumbull slipped the first prints from his Revolutionary War suite into a tin case and mailed them to "the Defender and Guardian of our Country."[7]

In 1800, Trumbull married an Englishwoman, Sarah Hope Harvey, and at the same time he tried to restart his career as an artist. With Jefferson's election in the fall, he knew that his career as a Federalist diplomat was at a dead end. But having not painted in six years, he had to confess to his brother "very severe mortification" upon discovering "how great a degree I had lost the powers I once possessed."[8] An arresting self-portrait from about 1801 made clear that not all was lost. Looking dignified and energetic, Trumbull holds up a portfolio marked "SKETCHES," thus announcing his return to the fine arts.

Trumbull's professional outlook, however, was sour. In 1800, a dewy-eyed young man from South Carolina, John Blake White, arrived in London "inthusiastically and rapturously in favor of painting, the profession from which I anticipated so much glory and happiness." Before

visiting Benjamin West, he went to Trumbull's house on Wardour Street in Soho, looking for sage advice. What he got was a bucket of cold water. Trumbull told him that painting "will never repay you for your pains. Painting is a profession, the encouragement of which depends alone upon *Fashion* which is the caprice and whim of mankind. It is not *necessary*." He recommended that White turn to law instead, or almost anything but art. "I would sooner make a Son of mine a Butcher or a shoemaker, than a Painter."[9] Perhaps at that moment Trumbull recalled his father's wise admonition in 1772 to study law and give up all romantic thoughts of pursuing the arts.

Quickening the pace of his comeback, Trumbull decided to return to the United States in 1804. He packed up eighteen rooms of belongings, including a library of 725 books, and arrived with his new wife just in time to witness Jefferson's landslide reelection to the presidency. Full of renewed optimism for his own prospects, he wrote to Benjamin West that New York and Philadelphia were about to become "the Athens, and Corinth in the western world." Had he consulted with Charles Willson Peale beforehand, however, he would have heard the opposite, that there were precious few signs of this yet.

Trumbull's paintings of the Revolution—and the remainder of the prints that he still owed to subscribers—were at the bottom of his list of things to do in New York. Figuring that interest in the Founding had waned to the point of indifference, he embraced portrait painting instead, a decidedly less heroic endeavor that he had once told Jefferson was "frivolous, little useful to society, and unworthy of a man who has talents for more serious pursuits."[10] After renting a house owned by Richard Varick at 128 Broadway, he started painting portraits of New York's elite: John Jay, DeWitt Clinton, Mayor Richard Livingston, Rachel and Robert Lenox, and most notably, he had orders for ten posthumous portraits of Alexander Hamilton, who had been shot and killed by Aaron Burr the week after Trumbull's arrival in the city.[11] None of the resulting paintings that Trumbull produced in New York were up to the standard that he himself had set more than a decade earlier, nor were they remotely as good as Gilbert Stuart's work. The critic and historian William Dunlap uncharitably dismissed all of them for their "dumb eloquence."[12]

Nonetheless, he made an impressive $4,000 in each of his first two years at home. That money quickly evaporated, however, when the Nonimportation Act of 1806 and the Embargo Act of 1807—both President

Jefferson's attempts to isolate the United States from the Napoleonic war with Britain—destroyed the American economy, as well as the market for portraits and every other nonessential. Facing bleak income prospects and remaining convinced that Jefferson's values were defective, Trumbull moved back to London in 1808, where once again Benjamin West, who was president of the Royal Academy, greeted him with warmth and kindness.

Trumbull fell under the seventy-year-old artist's sway, turning his attention away from portraiture and back to historical subjects. This time, however, Trumbull's historical pictures looked stilted and stiff, no longer full of the fluid color and live action seen in the *Death of General Warren*. He produced a solemn *Earl of Angus Conferring Knighthood on De Wilton* and a wooden *Lady of the Lake*, both illustrating scenes from Walter Scott's epic poetry. There followed a turgid eight-foot painting of a tragic couple from James MacPherson's *Ossian*, a dour *Christ and the Woman Taken in Adultery*, and an eight-foot painting of *Christ Blessing the Children*, the latter illustrating an obscure passage from the Book of Matthew.

The political timing of Trumbull's return to London was awful. He had arrived during the build-up to the War of 1812, which he thought provoked "coldness in the minds of Englishmen towards the people of the United States," and in particular toward him and his paintings because of "unfavorable passages of my preceding life"—his time as a dogged commissioner of the Jay Treaty and his former identity as a rebel once held for treason in a British prison.[13] One colleague commented on his situation with understatement: "I do not think this excellent Painter is duly appreciated in London."[14]

Trumbull brought some of that disregard upon himself. He did not mingle with the Royal Academy crowd, and found it difficult to connect with an appealing cohort of young American artists living nearby in Fitzroy Square: Washington Allston, Samuel F. B. Morse, Thomas Sully, Charles Robert Leslie, and Charles Bird King. They were the next generation, "many of whom displayed skill, which threw the waning talents of Mr. Trumbull in the shade."[15] Instead of engaging with them or working to his strength, small-scale painting, he mistakenly pursued big historical subjects that look leaden when compared to his earlier work. He could still be an effective artist at times. His London self-portrait was masterfully executed, but the man portrayed in it looks cold, unapproachable, and judgmental, a far cry from the rising star in West's studio thirty years earlier.

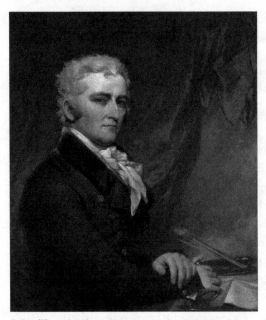

John Trumbull, *Self-Portrait*, ca. 1802

When war broke out in 1812, Colonel Trumbull uncharacteristically recoiled from it, as if he had had enough of conflict in his life. He became isolated in England and thought the war was destroying his career. To him, it was a "vile endeavor" to be viewed with "disgust."[16] Lacking work, feeling rejected, and unable to return to the United States because of a travel blockade, he drifted into deep debt and looked for someone else to blame besides himself for his disappointments. He went after West, confronting the old master at home and firing off a "battery of reproaches." Trumbull accused West of turning critical opinion against him, of orchestrating his failure, of poisoning the well. Dunlap thought Trumbull was miffed that he had not yet become heir apparent to the aging West's throne. "The pupil expected the master to have relinquished his mantel, and covered him therewith."[17]

Trumbull had burned his last bridge in London with that unspeakable offense. Hurtling toward failure, he and his wife boarded a ship for New York in August of 1815. As quickly as he arrived, he hatched a plan to visit Washington, D.C., and pitch his idea to paint large-scale versions of his Revolutionary War paintings for the United States Capitol building that had been looted and then burned by British regulars in August of 1814. For once Trumbull's timing was perfect. Repairing the gutted building and decorating it anew with historical subjects was a nationalistic mission as much as it was an architectural project.

Though the Revolution had been fading from memory, the War of 1812 reanimated it as a fractious country started showing signs of finally coming together as a union. Writing two months after the burning of the Capitol, Secretary of State James Monroe thought that the war had

"roused" the national spirit, helping "to unite our people . . . and to make us more truly an independent nation."[18] John Quincy Adams said that the war had served to "bring forth energies" strengthening "our national character."[19] For Albert Gallatin, delegate to the Treaty of Ghent, which ended the war in December 1814, it had "renewed and reinstated the national feelings and character which the Revolution had given." Like never before, people "are more American; they feel and act more as a nation."[20] Trumbull would tap into those nationalistic energies.

Though he could be spectacularly impolitic, Trumbull was adept at lining up support for a set of colossal pictures to line the interior of a huge rotunda about to rise from the ashes. Trumbull connected with an old friend from Paris, Charles Bulfinch, the newly appointed architect of the Capitol. He skillfully solicited the influence of many congressmen and senators. He even took the small-scale paintings of the *Declaration of Independence*, the *Death of General Warren*, the *Death of General Montgomery in the Attack on Quebec*, the *Surrender of Lord Cornwallis*, plus some of his miniature portraits to Washington so that legislators would have some idea of what they thought they were buying into.[21]

He wanted the job so much that he swallowed his considerable pride and wrote to former president Jefferson, asking for an endorsement. He reminded Jefferson of the time they had spent at the Hôtel de Langeac and how Jefferson had seen the original pictures evolve in Paris.[22] No mention was made of how Jefferson's henchman, William Branch Giles, had excoriated Trumbull at a dinner party in 1793 or of how much Trumbull despised Jefferson's foreign policy and his unwavering attachment to France, bloody guillotine and all.

Two weeks later, the seventy-three-year-old Jefferson replied. He remembered the old days, and spoke of Maria Cosway and "the charming *coterie* of Paris, now scattered and estranged, but not so in my memory or affection."[23] He promised to write to President-elect James Monroe and he gave assurances that President Madison had the highest estimation of Trumbull, though the opinion was not shared; Trumbull had the lowest opinion of Madison. He had once written that he wished on Madison "more disgrace and odium than he is destined to feel" for the folly of the war.[24] But for the moment, Trumbull needed Madison and Jefferson, the latter writing to the Senate that Trumbull "was superior to any historical painter of the time except David" and that it was "extremely desirable" that he be retained.[25]

The proposal to hire Trumbull was controversial, provoking a

congressional debate described by one observer as "interesting, amusing, and instructive." Everyone agreed that Trumbull was talented, based on the paintings from thirty years earlier. But it was "questionable how far it was just or proper for the Government of the United States to become the patron of the fine arts." Moreover, many felt the government should first pay off its "pecuniary obligations" from the Revolution and the War of 1812 before awarding money to individuals.[26]

Some existential questions were raised, as to whether paintings "in commemoration of liberty and of great events" had any "perceptible effect in preserving the liberty and independence of those nations" that commission them. Some bizarre congressional questions concerned the scale of the paintings. Invoking the fictional Vicar of Wakefield, who had commissioned a family portrait too big to hang, one congressman worried that a painting by Trumbull could be "so large, that, when it was brought home, the house would not hold it."[27]

The most trenchant questions came from a Baltimore journalist who accurately pointed out that the aging Trumbull was "a man *of a generation*." The writer, "expressive of a fear," cautioned that "the colonel" was a Federalist of such "strong and marked character of the party feelings," that he might twist history to match his political opinion. Will he "be led to give places in his pictures to the likenesses of individuals, more or less prominent than belongs to historical truth?" The journalist wondered whether Trumbull could be trusted to not politicize the most important subjects in all of American history. Many congressmen had seen the small 1787 version of the *Declaration of Independence*, which meant that Trumbull could not stray too far from it, but he could nonetheless make Jefferson less important by taking his hands off the document, or by pushing him back to stand with Benjamin Franklin, John Rutledge, and Robert Livingston, or by turning up the lights on Adams, and perhaps nudging him a step or two closer to the document. A few minor adjustments would have had massive implications.

The journalist pointed out that any such jiggering "would utterly destroy that permanency of renown the artist aims at."[28] He was justifiably concerned that in a partisan age paintings are especially political. He could have noted that the original Trumbull painting from 1787 was itself a semi-fiction in which everything from the décor and architecture to the presentation of the document was inaccurate. Ultimately, the Baltimore journalist, having waved a warning flag, backed down and advised Congress to proceed with "trust" that Trumbull surely would

"as nearly represent *things as they were*." Hiring him was worth the risk because the project stood to be "instrumental to the raising up of *national character*." The pictures would give "strength and efficiency to a people."[29]

Most of the qualms expressed in the congressional debates were also countered. The negotiated price tag—$32,000—was steep, but the devastated Capitol building needed to be rebuilt and redecorated anyway, so it was not truly a matter of government patronizing the arts. As for the impact the pictures might have on liberty and independence, "the moral effect of these paintings would be, independent of their intrinsic worth, of great value to the present and future generations, serving to recall to the attention of future legislators the events and principles of the Revolution, and to impel them to an imitation of the virtues of the men of those days." Moreover, now was the time to take action, "when a living artist of great ability, and a compatriot of the Revolutionary sages and heroes, could transmit accurate likenesses . . . to posterity."[30]

Feeling the spirit of 1776 and 1812, and eager to show the new national unity in a material way, congressmen—including John C. Calhoun and William Henry Harrison, both flag-waving hawks who had advocated war with Britain—voted for a resolution (114 to 50 votes in the House; 25 to 7 in the Senate) to hire Trumbull to paint four huge Revolutionary pictures—twelve feet high and eighteen feet wide.[31] Rufus King, the Federalist senator and presidential candidate, expressed the sentiment of the moment when he reported that Trumbull found "the Capitol a ruin." But "perhaps he may feel ambitious not only to restore, but like Pericles, to extend and adorn it."[32]

President Madison himself discussed the choice of subjects with Trumbull. They agreed to balance two military with two civil subjects. Because the pictures needed to celebrate American success in the Revolution, gruesome battle scenes of self-sacrifice were ruled out. That eliminated the *Death of General Warren* and the *Death of General Montgomery*, Trumbull's most dynamic paintings. Instead, they selected the *Surrender of General Burgoyne*, at Saratoga, and the *Surrender of Lord Cornwallis*, at Yorktown, which, unlike pictures stressing battlefield valor, highlighted the most civilized codes of warfare. The other two selections underscored civil achievement—the *Declaration of Independence* and *General George Washington Resigning His Commission*.[33]

Using the small version from the 1780s as a model, Trumbull undertook the large *Declaration* first, using a new studio on Park Place, near New York's City Hall. He finished it early in 1818 and then figured

out ways to multiply his good fortune by taking the 216-square-foot painting on a triumphant tour across the Northeast before its delivery in Washington, and then by selling subscriptions to the twenty-dollar engraved version to be cut by Asher B. Durand, a young printmaker.[34]

Citizens responded to his advertisement to view the GREAT NATIONAL PAINTING; admission was set at twenty-five cents. The attendance figures were remarkable: 6,374 people came out to see it in New York. Gilbert Stuart and 6,395 others saw it in Boston's Faneuil Hall. While Trumbull was in the city, Stuart painted his sixty-two-year-old friend's portrait. In Independence Hall, 5,189 braved the cold to see it in January of 1819. And in the Baltimore Court House, 2,734 visitors, including Charles Willson Peale, saw it over the course of one week. Peale thought it "a fine picture on a difficult subject"—difficult because the faces were from "42 years past" and viewers in 1818 had trouble recognizing them.[35] While the seventy-seven-year-old Peale was in Baltimore he painted Trumbull's portrait for his gallery of worthies.

In all, a total of 20,701 journeyed out to see the *Declaration of Independence*, as if they were on a pilgrimage to a holy shrine. Like a secular crèche, it reenacted the nativity of the United States, and because it was visual it had extra appeal. Seeing it for the first time, visitors could believe that 1776 had come to life before their eyes. For many, Trumbull's picture was etching history in the mind. "There is more history in the single canvass of Mr. Trumbull's *Declaration of Independence*," wrote one Republican weekly, "than can be crowded into a folio of descriptive history . . . Painting can show you things themselves."[36] Praise for the picture showered down on Trumbull like nothing he had previously experienced during his career. A New York newspaper said that "no inhabitant of this country can view it without experiencing a deep sense of the hazards which the members of that illustrious assembly thus voluntarily

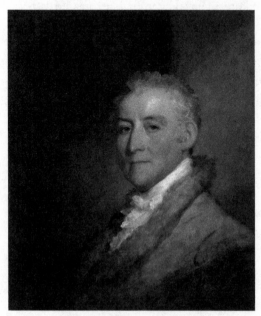

Gilbert Stuart, *John Trumbull*, 1818

assumed of the anxiety, the sufferings, and the triumphant success."³⁷
The *American Mercury* went farther: "We gaze, then, with a degree of
rapture on the exhibition . . . Every American ought to view this paint-
ing, and take his wife and children to see it."³⁸

Trumbull delivered the painting to the Capitol on February 16,
1819. The *Surrender of Lord Cornwallis* was delivered in November of
1820; the *Surrender of General Burgoyne* in March of 1822; and *Gen-
eral George Washington Resigning His Commission* in 1824. They were
all majestically installed with gilt-trimmed frames in the newly com-
pleted Capitol Rotunda in 1826, on the fiftieth anniversary of the
Declaration of Independence. This was now the symbolic center of the
United States.

For all the praise, public criticisms predictably emerged, espe-
cially regarding the *Declaration*, over whether the interior had been
decorated inaccurately and why twelve of the original delegates to
the Continental Congress had been omitted. If George Clinton,
Benjamin Rush, and George Clymer had not signed the document,
they should not have been in the picture when Caesar Rodney had
been excluded. Some wondered, correctly, whether the painting
depicted the actual signing, clearly forgetting that Trumbull had
commemorated the Committee of Five's submission of the document
on June 28, 1776. One critic identified only as "Detector" flatly stated
that the picture "is certainly no representation of the Declaration of
Independence." In fact, the errors, "with which it abounds, ought
to exclude it from the walls of the capitol, where its exhibition will
hereafter give to the mistake of the artist the semblance and author-
ity of historical truth."

Like other critics, this one felt that the proper goal of depicting the
Revolution was "to hand to posterity correct resemblances of the men
who pronounced our separation from Great Britain," not to indulge "the
fancy of the painter." Unfortunately, in his eyes the "Great National
Picture" by Trumbull "sinks from the grade of a great historical painting
into a sorry, motley, mongrel picture, where truth and fiction mingle,
but cannot be discriminated." As soon as it was installed in Washington,
the critic continued, the picture will become a public "satire," a kind of
buffoon rendition "of our own history."³⁹

Those questions were versions of the single overarching query as to
whether the *Declaration of Independence* was sufficiently accurate for view-
ers to feel confident putting their patriotic faith in it, or should it be viewed

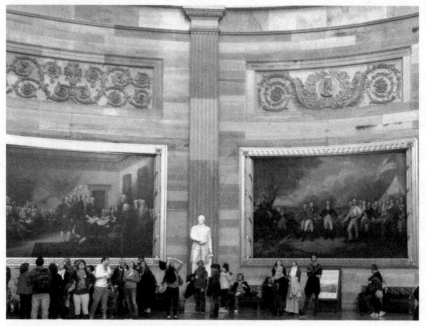

John Trumbull, *The Declaration of Independence* and *The Surrender of Burgoyne at Saratoga*, in the United States Capitol Rotunda

as a dramatization of 1776. While those were legitimate commentaries, the most penetrating observations about Trumbull's project came from someone who knew what had really occurred: John Adams.

❖

Trumbull had written to the eighty-one-year-old Adams on the same day that he had solicited Jefferson's support in December of 1816. Hoping for an unqualified endorsement, he instead had received something strikingly different from Jefferson's smooth blandishments. Adams opened his reply with expressions of pleasure at hearing from Trumbull, whom he had not seen since the 1790s when they had crossed paths in New York and Philadelphia. And then Adams offered "cordial Approbation and best Wishes" with the project.

After dispensing with the niceties, Adams then launched a frontal attack on Trumbull's paintings and on all forms of state art, past, present, and future. "You will please to remember," he lectured the artist, "that the Burin and Pencil, the Chisel and the Trowell, have in all Ages and

Countries of which We have any Information, been enlisted on the Side of Despotism and Superstition." For centuries, "Architecture Sculpture Painting and Poetry have conspir'd against the Rights of Mankind."[40] In Adams's moral universe, art was the supreme instrument of sophistry. He warned Trumbull, the great artist of American independence, that he might be on the threshold of becoming an enemy of human rights and an instrument of despotism.

Adams felt obliged to tell Trumbull that, "I am therefore more inclined to despair, than to hope for your Success in Congress."[41] He hungered for pictures that were "honorable and noble," but at the same time he worried about whether Trumbull understood the moral gravity of a project "destined to transmit to Posterity" the "most cel-ebrated" events from the American Revolution. Adams bluntly asked Trumbull, "Who, of your profession will undertake to paint a Debate or an Argument?" Recalling the 1770 confrontation between radicals and the British government in the wake of the Boston Massacre, he wondered if someone would be willing to "paint Samuel Adams at the head of ten thousand Freemen and Volunteers, with his quivering paralytic hand in the Council Chamber shaking the souls of Hutchin-son and Dalrymple?"[42] How, he inquired, would Trumbull capture the "spirit of prophecy?" Could a painting of the events of 1770 adequately foreshadow the eruptions of 1775? Adams concluded by saying that "I have taken the liberty of Friendship to preach to you." He advised Trumbull that "Truth, Nature, Fact, should be your sole guide. Let not our Posterity be deluded by fictions under pretense of poetical or graphic Licenses."[43]

The problem, as Adams saw it, was that all art by its very nature tells an imperfect story, and however strenuously an artist might research a subject, the result is always a semi-fiction, a storybook version, a nostalgic glance backward—or worse, a building block in some ideological agenda. As Adams knew well, history is so complex that it is never amenable to documentary painting. "Character and Counsels and Action," Adams advised Trumbull, "are always neglected and forgotten."[44] Nuance is lost. Art distorts. Truth lies vanquished. But given a subject as fundamental to the American republic as the Revolution, the burden on all artists to tell the whole truth and nothing but the truth was magnified. The colossal scale of Trumbull's pictures and their future placement in the United States Capitol Rotunda multiplied even further the artist's responsibility.

Trumbull's large-scale project to visualize the Revolution in pictures,

and then enshrine them in the centerpiece of the republic, brought to a boil all the frustration and anger that had been simmering in Adams's mind for years. Mythmaking, he thought, was a pernicious yet unstoppable force. Reflecting on how 1776 had been abridged into a single document and a single person, he confessed to Benjamin Rush, "The Declaration of Independence I always considered as a Theatrical Show . . . [in which] Jefferson ran away with all the stage effect . . . and all the Glory of it."[45] Peering through the gauze of his wounded pride, Adams could see that in the popular imagination all the tangled back-room maneuvering and day-to-day wrangling that actually had created independence was being condensed into a tidy document that was just the written public announcement of the resolutions that Congress had already enacted.

In fact, Adams felt that the entire history of the Revolution was on the brink of morphing into a cartoon of history, within his own lifetime. The process had started early. Already in 1790, the *Pennsylvania Packet* had trumpeted that the United States had been written into existence, as if by simple fiat—that is, created "*de novo*, out of thin air, freely and perfectly."[46] Hoping Trumbull would avoid that trap, Adams exhorted the artist to tell the truth, and shun the "stage effect" that was turning the Revolution—and the Declaration in particular—into what he called a "*coup de théâtre*."[47] If "historical Justice" should fall prey to the allure of "Fable," that would be a "Catastrophy."[48]

Adams had lived long enough to see his worst nightmare scenario emerge as the national reality. He predicted that the story of the Revolution would become "one continued Lye from one end to the other. The essence of the whole will be *that Dr. Franklin's electrical Rod, smote the Earth and out sprang General Washington. That Franklin electrified him with his rod—and thence forward these two conducted all the Policy, Negotiation, Legislatures and War.*"[49]

Oddly, Adams could forgive lots of European paintings that distorted in their own way. In a letter published in *Niles' Weekly Register*, he likened his Sisyphean efforts to organize his papers from the Revolution to a scene from Michelangelo's Sistine Chapel ceiling. There, God is "darting into chaos and buffeting its heterogeneous elements with his fists." Adams had no trouble in general with images of God and the Creation, nor with projecting himself into those images; but he felt the Revolution demanded something more documentary and less creative than Michelangelo's vision of Genesis.

In that same letter to the *Register*—written at the moment he

received Trumbull's request to support the Rotunda project—Adams ended with a grave opinion: "I consider the true history of the American revolution, and of the establishment of our present constitutions, as lost forever." In his despairing final sentence, perhaps with Trumbull's project in mind, he predicted that "nothing but misrepresentations, or partial accounts of it, ever will be recovered."[50]

A surprising editorial reply from Hezekiah Niles, however, countered Adams's desolation with the new tenor of the times. Even if the Revolution was indeed "lost forever," he wrote, it was still possible to "pourtray the character of some of the leading actors therein." And in fact, "these 'partial accounts,' in the absence of the 'true history,' must be acceptable to the people of the republic—and may serve as beacons for posterity." Four decades after the Revolution, Niles acknowledged that the values of history change in unexpected ways. Tradition was inherently unstable and America's history was deep into the process of being reinvented, semi-detached from its point of origin. Ralph Waldo Emerson perfectly captured this emerging perspective two decades later in his essay "History," when he wrote that "time dissipates to shining ether the solid angularity of facts."

An old and grieving John Adams tested his fear of history's demise when he went to see Trumbull's *Declaration of Independence* in Faneuil Hall on December 5, 1818, five weeks after the death from typhoid of his beloved Abigail. He previously had refused Trumbull's invitations to view it, but he reconsidered when Eliza Susan Quincy, a young relative, agreed to accompany him. In a letter to Jefferson, Adams said that Trumbull "drew me, by the cords of old friendship, to see his picture, on Saturday."[51] Whereupon Eliza and her family "carried me off by storm" to the building echoing with the voice of Samuel Adams.[52] As Eliza narrated the event, Trumbull "came to the carriage door when we arrived, assisted Mr. Adams to alight and offered his arm, to descend the step." But having none of that, Adams "pushed him away."

Inside, a crowd had gathered, "with the expectation of the visit of Mr. Adams to view the representation of the great historical scene in which he had born a conspicuous place." Those assembled saw "one of the last survivors" of 1776, standing "for the last time in the Hall which is indissolubly associated with the deeds and eloquence of Samuel Adams, Otis, Josiah Quincy, jr. and the leaders of the American Revolution."[53] Adams may have expected the courtesy of a private viewing, but what he got instead was a publicity event. Here visitors could see the

very man depicted in the center of the vast painting, now inadvertently validating Trumbull's version of history by dint of his showing up.

Adams's feelings that evening, after viewing the picture, are unknown. We will never know what Adams thought of himself in the picture, swaggering on center stage, or of Jefferson handling the document, or of all the congressional heads neatly lined up in a row, as if directed by some off-stage choreographer. But surely, after a lifetime observing great paintings and having had his own portrait painted, he recognized that as a work of art Trumbull's *Declaration* picture was a set piece designed to have an imposing effect. As an illustration of history, however, he likely thought it depicted American independence as it might have occurred in heaven instead of how it had happened on Earth—harmonious, poised, consensual, and scripted, not improvised, chaotic, contested, filled with rancor, demagoguery, and false starts. Trumbull had flattened the bumpy, curving road to independence, making it attractively smooth and straight. Adams no doubt would have agreed with a pained Walt Whitman reflecting fifty-seven years later about the Civil War: "The real war will never get in the books . . . Its interior history will not only never be written . . . it will never be even suggested."[54]

Samuel Wells, a grandson of Samuel Adams, was another visitor to Faneuil Hall in Boston. Writing to Jefferson shortly afterward, he shared his thoughts: "The painting executed by Col. Trumbull, representing the Congress at the declaration of independence, will I fear, have a tendency to obscure the history of the event which it is designed to commemorate."[55] Wells was deeply interested in historical facts because he was in the midst of writing a biography of his grandfather. He pumped Jefferson for detailed information on the committees of correspondence, on Joseph Galloway's reproaches, and on the vote for independence. Not surprisingly, he perceived a misalignment between history and art in Trumbull's painting. Wells said he was "much disappointed" by the "favorable reception which this badly executed performance has met from the public." People seemed excited by it despite the inaccuracies. Even "Historians" approved of it. Wells had to "frankly avow" that the "freedom" Trumbull had taken was not "worthy of the subject." Having hoped he would see a picture that time-traveled back to 1776, Wells was instead irritated by a painting that seemed to distract from the historical truth, or worse, impede the quest for the truth.

In his reply, Jefferson tried to explain to Wells that he was badly mistaken if he took the picture literally. Trumbull, he wrote, "has

exercised his licentia pictoris." Continuing with Latin, Jefferson quoted Horace: "Picturibus atque poetis, quidlibet audendi semper fuit aequa potestas."[56] Painters and poets have always had license to dare anything. For the Francophile Jefferson, trained in Paris by Houdon, David, and others, Trumbull had done precisely what a great artist ought to do: make history epic.

At least on that topic, Jefferson was in full agreement with Trumbull. "Without [license]," he wrote to the artist, "the talent of imagination would be banished from the art. Taste and judgment in composition would be of no value, and the mechanical copyist of matter of fact would be on the same footing with the first painters. [Your critics] might as well have criticized you because you have not given" Roger Sherman "his real costume."[57] In Jefferson's view, the point of a good painting was to stimulate strong sentiment, not to log the banal facts. Trumbull had admirably put his great canvas to the awesome task of arousing the patriotic feelings of viewers and of coaxing them to collectively imagine the dream that was American independence.[58]

The debate—between Adams and Trumbull, between Wells and Jefferson, between documentary and poetry—was as old as art-making itself. Adams and Jefferson were at its opposite poles, a case of the bookkeeper's balance sheet versus the idealist's vision. Each man, in his own way, was trying to uphold the ongoing values of the Revolution at a time when the Revolution was becoming hazy in the popular imagination. For Adams that meant holding on to the past with absolute authenticity and preventing it from descending into folklore. To him, Trumbull was distorting history, producing a "sublime deception," as eighteenth-century critics might have described it, because the painter had never witnessed the event.[59]

Indeed, the classically trained Trumbull admitted that he wanted to shape the delegates to the Continental Congress into Roman senators, "calmly, wisely, sternly adopting an Act."[60] His picture dignified 1776 by converting bickering congressmen into stoic republicans governing sagaciously. The incessant rancor inside Independence Hall dissolves into the timeless calm of the American Olympus. Trumbull deliberately polished history to an iconic sheen, and to Adams that was a tragedy.

For Jefferson, the equally daunting task of the present was to enshrine the republican values that had emerged during the Revolution so that they might be sustained and propagated. He understood and approved of Trumbull's project because it held fast to the idea of 1776.

In Paris, Jefferson had narrated that Philadelphia summer to Trumbull, helped him ferry facts onto the canvas, and seen himself emerge center stage as Founder among Founders. But throughout that process, Jefferson endorsed Trumbull's ultimate goal to create a patriotic fiction that has "slipped the constraints of temporal logic and sequence, to live outside time."[61]

❧

The seventy-year-old Trumbull arrived in Washington late in 1826 for the installation of the four paintings in the newly finished Capitol Rotunda. After dining with President John Quincy Adams and working with masons and carpenters who were fastening the canvases onto stretchers affixed to wall niches, he joined the President in viewing the majestic Rotunda, which had become the greatest public space in America.

By that date—November 28, 1826—Washington, Franklin, Adams, and Jefferson were dead. West and Copley had died; Peale would pass away three months later, and Stuart seventeen months after that. Even Trumbull's wife died in April of 1824, while he was finishing the last Rotunda painting. Trumbull, however, lived on to 1843. In that year, the United States was actively trying to annex Texas. John C. Frémont left Missouri to explore the Columbia River Valley and the central coast of California. Samuel Morse, a painter who had clashed with Trumbull over artistic leadership in New York City, was busy constructing an experimental thirty-eight-mile-long telegraph line between Baltimore and Washington. And in Charlestown, Massachusetts, the Bunker Hill Monument was officially dedicated on June 17, the sixty-eighth anniversary of the Battle of Bunker's Hill—and the fifty-eighth anniversary of Trumbull's historic painting *The Death of General Warren.*

The featured guest that day was President John Tyler, and the featured speaker was none other than Daniel Webster, the sixty-one-year-old constitutional lawyer, former senator, former Secretary of State, and powerful orator famous for an "ability to make alive and supreme the latent sense of oneness, of Union, that all Americans felt but few could express."[62] After the singing of hymns and the recitation of prayers, Webster moved to the front of a high podium as a crowd of fifty thousand spread out in front of him on the crest of the hill.[63] Above them stood the impressive 221-foot obelisk, built with thirteen million pounds of Quincy granite. While Trumbull was in New York nearing death, Webster was in Charlestown

speaking of liberty, justice, and unity. As giant American flags waved overhead, he honored Joseph Warren and the other martyrs whose "name and blood" are still "with us."[64] He spoke of human progress since the time of feudalism as if it were a ladder inevitably ferrying people upward from "despotism to liberty."[65] For Webster, the American Revolution was the first sign of an apotheosis soon to transform the world as he knew it. For proof of its power, he asked the crowd to look around at the signs of its effect in Boston: the free schools, the "free owners" of the soil "enjoying equal rights," the freedom of worship, the "profitable commerce" in the harbor, and the "personal independence" and "general knowledge" of the citizenry. Those are the liberties "which our fathers fought, and fell for, on this very spot."[66]

Not everyone in the crowd shared those euphoric sentiments, either about the Revolution as a completed task, or about the pervasiveness of rights, freedoms, and liberties in America. For African-Americans and abolitionists—and especially for three million slaves in the South—the Revolution had failed to deliver on its promise to create liberty. The pain of that fact was especially piercing at Bunker Hill because a hundred men of color had fought during the battle, shed their blood—and some of them had died.[67]

John Quincy Adams, the former President and now an antislavery congressman, who as a boy had watched Charlestown burning and heard the thunder of British guns in 1775, boycotted the dedication ceremony because he thought it was a sham. Instead of attending, he stayed in Quincy and wrote in his diary. He lauded the heroes of 1775: "What a name in the annals of mankind is Bunker Hill! What a day was the 17th of June 1775!" But, he wrote, "what a burlesque on them both is an oration upon them by Daniel Webster, and a pilgrimage of John Tyler, and his Cabinet of slave-drivers." President Tyler was nothing other than a "slavemonger," and Webster was "a heartless traitor to the cause of human freedom."[68] If the dedication ceremony was not enough to turn Adams's stomach, there was the compounding hypocrisy of the celebratory dinner "at Faneuil hall in honor of a President of the United States, hated and despised by those who invited him to it, themselves as cordially hated and despised by him."[69]

President Tyler, the honored guest at the dedication, was a Virginia slaveholder. For Adams, who had tried to impeach Tyler in Congress the previous year, the President was defiling a sacred site of liberty. Though Tyler did not speak at the event, he nonetheless presided over

it. Abolitionists justly hated him because he was a staunch supporter of states' rights, which in effect meant that the President of the United States was a sponsor of slavery. To those who ardently pressed for civil liberties, his presence was a stinging insult to the idea of freedom.

During Webster's speech—one that avoided the topic of slavery entirely—Tyler did something underscoring his own incongruity at an event honoring those who had fought and died for human rights: As the sun got stronger and Webster prophesized the triumph of freedom around the globe, Tyler instructed a black manservant to hold an umbrella over his head. In a city known for its abolitionism, this was a travesty. On an occasion so august, Tyler, his cabinet, and the slave system he represented made "sublime mockery" of the sacrifice of Joseph Warren and the other martyrs of 1775 and made the heroic sacrifice depicted in Trumbull's painting of Warren at Bunker's Hill look like a fool's errand.[70]

Abolitionists reviled Webster, Tyler, and the self-congratulatory falseness of the event. In an essay published in *The Liberator*, William Lloyd Garrison loudly rebuked the disgraceful "annihilation" of rights in America, insisting it incumbent upon a speaker standing at the foot of the Bunker Hill Monument, of all places, to say something about the people who "lie crushed and bleeding" from "injustice in its most dreadful form."[71] For Garrison the speech was nothing less than a "national hypocrisy," full of "cant, bombast, effrontery," a "biting satire on republican liberty, and a shameful insult to the memories of those who perished." Though Webster might be renowned as the "Defender of the Constitution," in Garrison's eyes he distinguished himself in Charlestown as "a colossal coward."

While Garrison condemned Webster and exposed all the sectional and racial divisions that afflicted the Union, he was careful not to invalidate the Revolution. Rather, Garrison, Wendell

Nathaniel Currier, *View of Bunker Hill & Monument, June 17, 1843*

Phillips (who had once likened Webster to Satan), and other abolitionists took the dedication ceremony as an occasion to exhort everyone to assume the mantle of General Warren in the continuing fight against tyranny and oppression. Their strategy was to capture the energy being generated at the Bunker Hill dedication and transmit it directly into the abolitionist cause. In their political logic, a long-festering national disgrace might be confronted squarely if they asked Americans to think of the Revolution as a work in progress, not as a calcified artifact of history. Garrison said that the American battlefield today "is a struggle to secure to all the full enjoyment of those rights which the patriots of 1776 fought and bled in vain to establish."[72] The goal now was to extend the liberties won during the Revolution. There was still time to fulfill the promise of 1776.

Trumbull's *Death of General Warren* was part of that strategy. On the right side of the painting he had included an African-American gripping a musket and standing behind Lieutenant Thomas Grosvenor of Connecticut. Because Grosvenor owned slaves, this unidentified man was probably one of them and the musket he carried surely belonged to his master. Though Trumbull did not identify the black man by name, he must have known, probably from his military post near the battle, that men of color were fighting that day. The only description Trumbull ever provided for that man was simply "faithful Negro."[73]

By the time of the dedication ceremony in 1843, abolitionists were already adopting Trumbull's painting as their own and were ascribing a specific name to Trumbull's African-American, either Peter Salem or Salem Poor, both of whom were recorded as participants at the battle.[74] Almost six decades after it was painted, Trumbull's picture was being incorporated into a new age.

Daniel T. Smith and Paul R. B. Pierson, *Peter Salem, the Colored American*, at Bunker Hill, 1855

In 1845, Henry Ingersoll Bowditch, a Christian abolitionist, pointed out that in the eighteenth century "no objection was made to the appearance of the colored man" in Trumbull's picture because "in those times there was less prejudice than exists now, for the negro marched shoulder to shoulder with the white man in the armies of the revolution."[75] Another abolitionist wrote that "Trumbull added dignity to his canvass by portraying colored men rendering patriotic service."[76]

Trumbull himself would have been baffled by the new meanings being extracted from his painting. It never would have occurred to him that there was something latently egalitarian about that black man in his Bunker's Hill painting, because Trumbull was deeply rooted in eighteenth-century conventions of art, elite rule, and limited republican government. To him, heroes had made America, not common men. And among those heroes, Washington was God. When Washington died in 1799, Trumbull took a piece of light blue paper and sketched an image of the great man being lofted through the clouds by an angel who points the way to heaven.[77] Tellingly, at Trumbull's own death on November 10, 1843, he was buried at Yale in a tomb positioned, according to his wishes, "at the foot of my great Master"—beneath a portrait of Washington.[78]

As the story of the Revolution continued to be revised during the ramp-up to the Civil War, that black man in Trumbull's picture was further thought to be the person responsible for having killed Major Pitcairn, the British officer seen falling backward in the center. The motivation to invent that story came largely from the regressive Fugitive Slave Act of 1850 that had pushed desperate abolitionists to put a heroic black man at the heroic center of Revolutionary action. As escaped slaves were being captured in the North and forced to return to bondage in the South, William Cooper Nell, a Boston abolitionist, published an illustrated book in 1855, *Colored Patriots of the American Revolution*. Nell hired the Boston engravers Smith and Pierson to adapt Trumbull's *Death of General Warren* so that Lieutenant Grosvenor would be eliminated from the picture while Peter Salem would stand alone, amplified in the foreground. As he grips his own musket and looks back over his right shoulder at the action, the clear implication is that he has shot Major Pitcairn. That was a small but tectonic change.[79]

When the Civil War finally came, Trumbull's four great Rotunda pictures of the Revolution spent most of it under wraps, as the Massachusetts Eighth Infantry soon discovered. Three days after the fall of

Fort Sumter on April 13, 1861, the 705 men of the Eighth were told
to gather at Faneuil Hall in Boston. Theirs was a unit with a distin-
guished history dating to the Revolution when the Eighth had fought
at Bunker's Hill, Trenton, and Princeton. Now, President Lincoln was
requesting twenty companies from the state, each charged with the task
of protecting the Capitol. The Eighth was among the first to respond.

Because so many soldiers from so many regiments converged simulta-
neously on the capital city (approximately 11,000 men), some unusual places
had to be used as barracks. The Eighth was told to bivouac in the Rotunda
of the Capitol. When they got there they found a construction site. Charles
Bulfinch's dome had been demolished in 1855 to make way for a higher
dome that would better balance a building that doubled in width under the
direction of Thomas Ustick Walter, the new architect of the Capitol.

A print appearing in *Harper's Weekly* in May of that year recorded the
scene. To the left, an enormous construction scaffold stretches upward,
while down below the soldiers mill about, some conversing as others rest
or take a swig from a mug. Mattresses stack up in messy piles across the

THE EIGHTH MASSACHUSETTS REGIMENT IN THE ROTUNDA OF THE CAPITOL, WASHINGTON.—[See Page 351.]

The Eighth Massachusetts Regiment in the Rotunda of the Capitol, Harper's Weekly, May
25, 1861

foreground. And on the back wall two of Trumbull's four Revolutionary War pictures can be seen covered with cloth. Because they were national treasures, they were prudently protected from the construction work and the soldiers' weapons.

❖

While that is the practical explanation for the coverings, there is a poetic one, too. Trumbull's idealistic images, hopelessly anachronistic when set against America's most self-destructive war, might as well be covered up for some possible future use, like the furniture in an old house that has been closed for the season. Had they been uncovered instead, the images—and all they stood for: virtue, civility, and noble purpose—might have otherwise faded away, been stained, or suffered irreparable damage from the ravages that surrounded them.

That would have been a tragic loss. Unlike European states that could rely on ethnic bloodlines, class kinship, monarchic paternalism, and age-old systems of patronage to help people understand who they were, where they came from, and how they figured into the nation, America, with its fluid classes, immigrant influxes, unruly habits, individual rights, mixed histories, and differing religious, moral, political, social, and racial character, needed a single event—the Revolution—to create the bonds that might tie citizens to each other.[80]

After the deaths of Adams and Jefferson and the loss of all living eyewitnesses to 1776, Americans could remain connected to the Revolution, and thus linked to each other, via material artifacts, historic sites, public monuments, original documents, and visual images. The Civil War had destroyed some of them, desecrated others, and consigned many to moral limbo, but in 1866 Trumbull's Rotunda paintings were finally unveiled, and once again took their position as sacred touchstones to America's honored past. Along with the works of Peale, Copley, West, and Stuart, they tie Americans to Americans and fasten together the nation's disparate parts. They are key elements in a visual repertory that Americans can call upon in order to understand where the nation came from and in what direction it ought to be going. Whatever struggles Americans encounter, these images offer a firm foundation for stepping into the future.

Acknowledgments

I have been the happy beneficiary of the outstanding work of colleagues, both present and past, who collectively constitute my Hall of Fame: Charles Coleman Sellers, David Ward, Lillian Miller, David Steinberg, Wendy Bellion, Jules David Prown, Carrie Rebora Barrett, Susan Rather, Gordon Wood, Neil Harris, Margaretta Lovell, Dorinda Evans, Maurie McInnis, Ellen Gross Miles, Irma Jaffe, Helen Cooper, and Theodore Sizer.

More to the moment, while writing the book I had many rich and revealing conversations with David Jaffee, Christopher Bryant, Pauline Maier, and Terry Karl. Yingxi Gong was my dogged photo researcher.

Joseph Ellis not only helped me shape the contours of the book over many lunches, but he also read the manuscript, shouted encouragement ("keep going!"), and kept me on the literary straight and narrow ("what's the story here?"). Donald Weber read the entire manuscript and used his exquisitely deft hand to refine the prose and the product.

My editor at Bloomsbury, George Gibson, instantly believed in the book, and in turn I instantly believed in him. He has walked the manuscript through its final paces, and throughout the process he has conducted himself and his house with integrity, discipline, and intelligence.

Katherine Flynn, my literary agent at Kneerim and Williams, picked up the project and ran with it. She adeptly navigated the Venice-style back alleys of the publishing world with her own special GPS.

My artists became the natural material for endless dinnertime conversations with my partner, Monika Schmitter. Because she is a specialist in the art and culture of sixteenth-century Italy, rather than eighteenth-century America, she was the perfect audience for—as well as the astute auditor of—developing ideas. Along the way, as I talked to her about what I was doing, I also got to hear lots about Lorenzo Lotto, the Venetian home, and the politics of identity. Thank you!

Image Credits

Pages ii–iii, 179, 180, 181, and plate 10; 189 and plate 12 (bottom); 196; 211 and plate 11; 212; 214 and plate 12 (top); 219; 230: Yale University Art Gallery. Trumbull Collection.

Page 2: American Philosophical Society.

Pages 4, 39 and plate 1: Pennsylvania Academy of the Fine Arts. Gift of Maria McKean Allen and Phebe Warren Downes through the bequest of their mother, Elizabeth Wharton McKean.

Page 9: United States Navy.

Pages 15, 17, 262: New-York Historical Society. Gift of Thomas Jefferson Bryan. Bridgeman Images.

Page 20: National Gallery of Art, Washington, D.C. Gift of the Barra Foundation, Inc., 1984. Bridgeman Images.

Page 23: Philadelphia Museum of Art. Gift of the Barra Foundation, Inc. Wikimedia Commons.

Page 24: Brooklyn Museum. Dick S. Ramsay Fund. Bridgeman Images.

Page 29: John Carter Brown Library.

Page 31: Metropolitan Museum of Art. Dale T. Johnson Fund, 2006.

Page 32: Private collection. Author photograph.

Page 40: Pennsylvania Academy of the Fine Arts. Gift of Mrs. Joseph Harrison Jr.

Page 44: Private Collection. Bridgeman Images.

Page 52: Pennsylvania Academy of the Fine Arts. Bequest of Mrs. Sarah Harrison.

Page 53 (left and right) and plate 3 (top): Independence National Historical Park, Philadelphia.

Page 56 and plate 2 (top): Detroit Institute of Arts. Founders Society Purchase, Director's Discretionary Fund. Bridgeman Images.

Page 57 and plate 2 (bottom): Museum of Fine Arts, Houston. The Bayou Bend Collection. Gift of Miss Ima Hogg. Bridgeman Images.

Page 67 and plate 3 (bottom): National Gallery of Canada, Ottawa. Wikimedia Commons.

Pages 74, 76, 82, 93 (top), 206, 292: Library of Congress.

Page 81 and plate 4: Winterthur Museum. Gift of Henry Francis du Pont.

Page 90: Rijksmuseum, Amsterdam.

Pages 91, 102: Yale Center for British Art. Paul Mellon Collection.

Page 93 (bottom): Lewis Walpole Library, Yale University.

Pages 100 and plate 5 (bottom): Museum of Fine Arts, Boston. Deposited by the City of Boston.

Page 106: Museum of Fine Arts, Boston. Edward Ingersoll Brown Fund. Bridgeman Images.

Page 108 and plate 6 (top): National Gallery of Art, Washington, D.C. Ferdinand Lammot Belin Fund.

Pages 112 and plate 6 (bottom); 157; 240 and plate 5 (top): Tate Britain.

Page 113 and plate 7 (top): Princeton University Art Museum. Gift of the estate of Josephine Thomson Swann.

Page 119: British Library. Wikimedia Commons.

Pages 120, 199: National Portrait Gallery, Smithsonian Institution.

Page 121 and plate 9 (top): National Portrait Gallery, Smithsonian Institution. Transfer from the National Gallery of Art. Gift of the Andrew W. Mellon Trust.

Page 126 and plate 7 (bottom): National Portrait Gallery, Smithsonian Institution. Gift of the Morris and Gwendolyn Cafritz Foundation.

Page 129: Leeds Museums and Art Galleries. Bridgeman Images.

Page 133: Gëmaldegalerie, Berlin.

Page 138: Metropolitan Museum of Art. Gift of John Bard, 1872.

Page 139: Metropolitan Museum of Art. The Friedsam Collection, Bequest of Michael Friedsam, 1931.

Page 146 and plate 8: Harvard University Museum. Bequest of Ward Nicholas Boylston.

Page 151: Metropolitan Museum of Art. Harris Brisbane Dick Fund, 1960.

Page 155: Museum of Fine Arts, Boston. Bequest of Charles Francis Adams.

Page 166 and plate 9 (bottom): Museum of Fine Arts, Boston. Bequest of George Nixon Black.

Page 176: Virginia Museum Fine Arts, Richmond. Adolph D. and Wilkins C. Williams Fund.

Page 184: Palazzo Pitti, Florence. Bridgeman Images.

Page 185: Museum of Fine Arts, Boston. Gift of Buckminster Brown, M.D. through Carolyn M. Matthews, M.D., Trustee.

Page 194: Princeton University Library. Gift of Junius Spencer Morgan, Princeton University Class of 1888.

Page 204: Private collection. Wikimedia Commons.

Page 208: Yale University Art Gallery. Gift of Mr. Ernest A. Bigelow.

Page 221: Winterthur Museum. Gift of Henry Francis du Pont. De Agostini Picture Library. Bridgeman Images.

Page 225 and plate 13: Yale University Art Gallery. Gift of the Society of the Cincinnati in Connecticut.

Page 227: Metropolitan Museum of Art. Bequest of George Willett Van Nest, 1916.

Page 228: Fordham University Library. Charles Allen Munn Collection.

Page 241: National Gallery of Art, Washington, D.C. Andrew W. Mellon Collection.

Page 243 and plate 14 (bottom): Redwood Library and Athenaeum, Newport, Rhode Island. Bequest of Louisa Lee Waterhouse. Wikimedia Commons.

Page 246: National Gallery of Art. Gift of the Jay Family. Wikimedia Commons.

Page 248 and plate 16 (bottom): Metropolitan Museum of Art. Gift of Lucille S. Pfeffer, 1977.

Page 252: Metropolitan Museum of Art. Rogers Fund, 1907.

Page 253 and plate 15: National Portrait Gallery, Smithsonian Institution. Donald W. Reynolds Foundation. Wikimedia Commons

Page 264: Museum of Fine Arts, Boston. Deposited by the City of Boston. Wikimedia Commons.

Page 265: Amon Carter Museum of American Art, Fort Worth.

Page 266: Bridgeman Images.

Page 269 and plate 16 (top): Bowdoin College Museum of Art. Gift of the Honorable James Bowdoin III.

Page 278: Yale University Art Gallery. Gift of Marshall H. Clyde Jr.

Page 282: Yale University Art Gallery. Bequest of Herbert L. Pratt.

Page 284; plate 14 (top): United States Capitol Rotunda. Courtesy of Susan Magrini.

Page 293: From William C. Nell, *The Colored Patriots of the American Revolution, with Sketches of Several Distinguished Colored Persons.* With an introduction by Harriet Beecher Stowe. 1855. Schomburg Center for Research in Black Culture, New York Public Library, Astor, Lenox and Tilden Foundations.

Page 295: *Harper's Weekly*, May 25, 1861. Author photograph.

Notes

Chapter 1: Art and the American Revolution

1. "Resolve of the Supreme Executive Council to Commission a Portrait of Washington, Philadelphia, January 18, 1779," in Lillian B. Miller, ed., *The Selected Papers of Charles Willson Peale and His Family*, 5 vols. (New Haven, CT: Yale University Press, 1983–2000), 1:303.

2. George Washington to Joseph Reed and the Council of Pennsylvania, January 20, 1779, in Miller, *Selected Papers*, 1:303.

3. Peale went back to Trenton and Princeton, where he had fought, in order to sketch the terrain on February 22, 1779; Miller, *Selected Papers*, 1:304.

4. The act of defacement is technically called an *execution in effigie*. It was reported in *Freeman's Journal, or, The North-American Intelligencer* on September 12, 1781; see *Pennsylvania Magazine of History and Biography* 13, no. 1 (1889), 261; and Charles Henry Hart, "Peale's Original Whole-Length Portrait of Washington; A Plea for Exactness in Historical Writings," *Annual Report of the American Historical Association* (Washington: Government Printing Office, 1897), 194–95.

5. On this topic, see David Freedberg, *The Power of Images: Studies in the History and Theory of Response* (Chicago: University of Chicago Press, 1991); and Peter Shaw, *American Patriots and the Rituals of Revolution* (Cambridge: Harvard University Press, 1981), 177–232.

6. *Boston Evening Post*, May 8, 1769.

7. See Arthur S. Marks, "The Statue of King George III in New York and the Iconology of Regicide," *American Art Journal* 13, no. 3 (Summer 1981), 61–82.

8. John Adams to Hezekiah Niles, February 13, 1818, in Adrienne Koch and William Peden, eds., *The Selected Writings of John and John Quincy Adams* (New York: Knopf, 1946), 203.

Chapter 2: Charles Willson Peale's War

1. *Maryland Gazette*, January 21, 1762, in Lillian B. Miller, ed., *The Selected Papers of Charles Willson Peale and His Family*, 5 vols. (New Haven, CT: Yale University Press, 1983–2000), 1:32.

2. John Sanderson, Robert Waln, and Henry Dilworth Gilpin, *Biography of the Signers to the Declaration of Independence*, 9 vols. (Philadelphia: Pomeroy, 1820–27), 5:363–64.

3. The episode is discussed in Charles Coleman Sellers, *Charles Willson Peale* (New York: Scribner's, 1969), 38-39.

4. Charles Willson Peale, Autobiography, in Miller, *Selected Papers*, 5:22. Sellers, *Peale*, 45.

5. Miller, *Selected Papers*, 1:45. See Robert J. H. Janson-LaPalme, "Generous Marylanders: Paying for Peale's Study in England," in *New Perspectives on Charles Willson Peale*, ed. Lillian B. Miller and David C. Ward (Pittsburgh: University of Pittsburgh Press, 1991), 11-27.

6. David C. Ward, *Charles Willson Peale: Art and Selfhood in the Early Republic* (Berkeley: University of California Press, 2004), 26-28, 32–33.

7. Miller, *Selected Papers*, 1:60-66. For Peale's supplies and his entire trip to London, see Jules David Prown, "Charles Willson Peale in London," in Miller, *New Perspectives*, 29-50.

8. E. P. Richardson, Brooke Hindle, and Lillian B. Miller, *Charles Willson Peale and His World* (New York: Abrams, 1983), 33.

9. Peale, Autobiography, in Miller, *Selected Papers*, 5:36.

10. Ibid., 5:34.

11. Charles Henry Hart, "Charles Willson Peale's Allegory of William Pitt" (Boston: Massachusetts Historical Society, 1915), 9. On Peale in the period, see David Steinberg, "A Quiet Year's Clash over Art, Painters, and Publics," in *Shaping the Body Politic: Art and Political Formation in Early America*, ed. Maurie D. McInnis and Louis P. Nelson (Charlottesville: University of Virginia Press, 2011), 48–88.

12. Hart, "Pitt," 10.

13. Peale, Autobiography, in Miller, *Selected Papers*, 5:47.

14. Given all the harmony abundantly on display in the picture, it would not come as a surprise that one day Peale would write and publish a guidebook to what constitutes a rewarding family life: "An Essay to Promote Domestic Happiness" (Philadelphia: Kimber and Conrad, 1812).

15. *Maryland Gazette*, September 22, 1774, in Miller, *Selected Papers*, 1:133.

16. See Karol Ann Peard Lawson, "Charles Willson Peale's *John Dickinson*: An American Landscape as Political Allegory," *Proceedings of the American Philosophical Society* 136 (December 1993), 455–86.

17. John Dickinson, *Letters from a Farmer in Pennsylvania to the Inhabitants of the British Colonies* (Boston: Mein and Fleeming, 1768), 32.

18. For the fullest account of the picture, see Ellen G. Miles, *American Paintings of the Eighteenth Century* (Washington: National Gallery of Art, 1995), 113–17.

19. See Sidney Hart, "A Graphic Case of Transatlantic Republicanism," *Pennsylvania Magazine of History and Biography* 80 (1985), 203–13.

20. Charles Willson Peale to Thomas Allwood, August 30, 1775, in Miller, *Selected Papers*, 1:144–45.

21. Sellers, *Peale*, 111.

22. Kristen A. Foster, *Moral Visions and Material Ambitions: Philadelphia Struggles to Define the Republic, 1776–1836* (Lanham: Lexington Books, 2004), 9–10.

23. Charles Willson Peale to Benjamin West, August 31, 1775, in Miller, *Selected Papers*, 1:146.

24. Charles Willson Peale to Edmund Jenings, August 29, 1775, in Miller, *Selected Papers*, 1:141.

25. Charles Willson Peale, Diary, November 8, 1775, in Miller, *Selected Papers*, 1:154.

26. John Adams to Abigail Adams, August 21, 1776, Adams Family Papers, Massachusetts Historical Society, http://www.masshist. org/digitaladams/archive/ [hereafter cited as AFP].

27. Sellers, *Peale*, 124.

28. *Pennsylvania Packet*, November 10, 1778, in Frank Moore, *Diary of the American Revolution: A Centennial Volume* (Hartford: Burr, 1876), 627.

29. Eventually, the painting was made into prints that had astonishing reach, appearing in almanacs, magazines, books, broadsides, and schoolbook primers across the United States, and that were popular in England, of all places.

30. Charles Willson Peale, Diary, August 9, 1776, in Miller, *Selected Papers*, 1:192–93.

31. Peale, Diary, December 1, 1776, in Miller, *Selected Papers*, 1:206.

32. Quoted in David Hackett Fischer, *Washington's Crossing* (New York: Oxford University Press, 2004), 133.

33. Charles Willson Peale, Diary, January 3, 1777, in Miller, *Selected Papers*, 1:219.

34. Peale, Autobiography, in Miller, *Selected Papers*, 5:68.

35. Ibid., 5:63.

36. Ibid., 5:62.

37. Ibid., 5:69.

38. Ibid.

39. Charles Willson Peale, Diary, December 14, 1777, in Miller, *Selected Papers*, 1:259.

40. For miniature painting, see Charles Coleman Sellers, *Portraits and Miniatures by Charles Willson Peale* (Philadelphia: American Philosophical Society, 1952); and Anne Verplanck, "The Social Meaning of Miniatures in Philadelphia," in *American Material Culture: The Shape of the Field*, ed. Anne Smart Martin (Winterthur: Winterthur Museum, 1997), 195–223.

41. "Pennsylvania Rifle Regiment," *Pennsylvania Archives*, 5th ser., vol. 7:249.

42. Ibid.

43. Ennion Williams died in 1832, at the age of 80.

44. Charles Willson Peale, Diary, in Miller, *Selected Papers*, 1:201.

45. Ethel Armes, ed., *Nancy Shippen: Her Journal Book* (Philadelphia: Lippincott, 1935), 20.

46. Ibid., 30.

47. Ibid., 101.

48. Thanks to Elle Shushan for information on Peale's miniatures.

49. Armes, *Shippen*, 73.

50. Ibid., 118, 128.

51. Ibid., 140.

52. Peale, Autobiography, in Miller, *Selected Papers*, 5:277.

Chapter 3: Philadelphia's Founding Artist

1. The best overview of the situation is in Gary Nash, *First City: Philadelphia and the Forging of Historical Memory* (Philadelphia: University of Pennsylvania Press, 2002), 79–107.

2. Peale was first put in charge of confiscating Loyalist property in October of 1777. On confiscation, see Anne M. Ousterhout, "Pennsylvania Land Confiscations during the Revolution," *Pennsylvania Magazine of History and Biography* 102 (July 1978), 328–43.

3. Peale, Autobiography, in Lillian B. Miller, ed. *The Selected Papers of Charles Willson Peale and His Family*, 5 vols. (New Haven, CT: Yale University Press, 1983–2000), 5:58.

4. Peale, Autobiography, in Miller, *Selected Papers*, 5:71.

5. Grace Growden Galloway, *Diary of Grace Growden Galloway* (New York: The New York Times, 1971), 51.

6. Charles Coleman Sellers, *Charles Willson Peale* (New York: Scribner's, 1969), 165.

7. For Peale's account, see Miller, *Selected Papers*, 1:285–92.

8. Miller, *Selected Papers*, 1:410.

9. The most concise history of this period is Ronald Schultz, *The Republic of Labor: Philadelphia Artisans and the Politics of Class, 1720–1830* (New York: Oxford, 1993).

10. See A. Kristen Foster, *Moral Visions and Material Ambitions: Philadelphia Struggles to Define the Republic, 1776–1836* (Lanham: Lexington Books, 2004), 119–21.

11. Benjamin Rush to Charles Lee, October 24, 1779, *Collections of the New-York Historical Society for the Year 1873* (New York: New-York Historical Society, 1874), 381.

12. On the various versions, see Charles Coleman Sellers, "Portraits and Miniatures by Charles Willson Peale," *Transaction of the American Philosophical Society* 42 (1952), 221–341. Also see Wendy C. Wick, *George Washington, An American Icon: The Eighteenth-Century Prints* (Washington, D.C.: Smithsonian, 1982), 85.

13. Sellers, *Peale*, 173–76.

14. Sellers, *Peale*, 171.

15. See Schultz, *Republic of Labor*; and John K. Alexander, "The Fort Wilson Incident of 1779: A Case Study of the Revolutionary Crowd," *William and Mary Quarterly*, 3rd ser., 31, no. 4 (October 1974), 589–612.

16. "Arnold and the Devil," *Pennsylvania Packet*, October 3, 1780; in Miller, *Selected Letters*, 354–55. The best book on the character of the revolutionary crowd in America is Peter Shaw, *American Patriots and the Rituals of Revolution* (Cambridge: Harvard University Press, 1981).

17. Congressman William Churchill Houston, quoted in Benjamin H. Irvin, *Clothed in the Robes of Sovereignty: The Continental*

Congress and the People out of Doors (New York: Oxford University Press, 2014), 259.

18. Broadside, "A Representation of the Figures exhibited and paraded through the Streets of Philadelphia, on Saturday, the 30th of September, 1780," Library of Congress.

19. Peale, Autobiography, in Miller, *Selected Papers*, 5:83.

20. Charles Willson Peale to Samuel Chase, November 23, 1784, in Miller, *Selected Papers*, 1:424.

21. Charles Willson Peale to Edmund Jenings, December 28, 1800, in Miller, *Selected Papers*, 1:295.

22. Charles Willson Peale to Samuel Chase, November 23, 1784, in Miller, *Selected Papers*, 1:424.

23. "Celebration of the Surrender of Cornwallis," *Pennsylvania Packet*, Nov 1, 1781, in Miller, *Selected Papers*, 1:361–4.

24. "Celebration of the Arrival of George Washington in Philadelphia," *Pennsylvania Packet*, December 4, 1781, in Miller, *Selected Papers*, 1:365.

25. Ibid.

26. Miller, *Selected Papers*, 1:396.

27. "Report Recommending a Triumphal Arch," December 2, 1783, in Miller, *Selected Papers*, 1:398–99.

28. Extract from the *Diary of Jacob Hiltzheimer of Philadelphia, 1765–1798*, ed. Jacob Cox Parsons (Philadelphia: W. R. Fell, 1893), 60–61.

29. Rembrandt Peale, Reminiscences, in Miller, *Selected Papers*, 1:407.

30. *Diary of Jacob Hiltzheimer*, 60–61.

31. Peale, Autobiography, in Miller, *Selected Papers*, 5:93.

32. Charles Willson Peale to George Weedon, February 10, 1784, in Miller, *Selected Papers*, 1:405–6.

33. See Elaine Rice Bachmann, "Charles Willson Peale's Portrait of George Washington for the Maryland State House: 'Something Better than a Mere Coppy,'" *The Magazine Antiques* (February 2007), 66–70.

34. Charles Coleman Sellers, *Mr. Peale's Museum: Charles Willson Peale and the First Popular Museum of Science and Art* (New York: Barra Foundation, 1979), 38.

35. Sidney Hart and David C. Ward, "The Waning of an Enlightenment Ideal: Charles Willson Peale's Philadelphia Museum, 1790– 1820," in *New Perspectives on Charles Willson Peale*, ed. Lillian B. Miller and David C. Ward (Pittsburgh: University of Pittsburgh Press, 1991), 221. Charles Willson Peale, "My Design in Forming this Museum," Miller, *Selected Papers*, 2:15.

36. Sellers, *Mr. Peale's Museum*, 45.

37. Elizabeth Willing Powel to George Washington, November 17, 1792, Washington Papers, Library of Congress (http://memory. loc.gov/cgi-bin/query/P?mgw:8:./temp/~ammem_qJAN::).

38. The leading book on this topic is Ruth H. Bloch, *Gender and Morality in Anglo-American Culture, 1650–1800* (Berkeley: University of California Press, 2003).

39. Charles Willson Peale to Rembrandt Peale, June 16, 1817, in Lillian B. Miller, *In Pursuit of Fame: Rembrandt Peale, 1778–1860* (Seattle: University of Washington Press, 1992), 123.

40. See David Steinberg, "Charles Willson Peale Paints the Body Politic," in *The Peale Family: Creation of a Legacy, 1770–1870*, ed. Lillian B. Miller (New York: Abbeville Press, 1996), 124–25.

41. David C. Ward, *Charles Willson Peale: Art and Selfhood in the Early Republic* (Berkeley: University of California Press, 2004), 120–21.

42. Jay Fliegelman writes about the theatricality of looking natural in *Declaring Independence: Jefferson, Natural Language and the Culture of Performance* (Palo Alto: Stanford University Press, 1993), 79–94.

43. Charles Willson Peale to Andrew Ellicott, February 28, 1802, in Miller, *Selected Papers*, 2:411.

44. Ward, *Peale*, 103.

45. Charles Willson Peale to Edmund Jenings, December 10, 1783 in Miller, *Selected Papers*, 1: 402–03.

46. Charles Willson Peale to Thomas Jefferson, January 29, 1808, in Miller, *Selected Papers*, 2:1056.

47. Whitfield Bell, Jr., "The Federal Processions of 1788," *New-York Historical Society Quarterly* 46 (January 1962), 4–39; "Account of the Federal Procession," *The Columbian Magazine, or, Monthly Miscellany* 2 (July 1788), 391–400. Peale was hardly the first major artist to become involved in designing floats. In *The Lives of the Artists*, Giorgio Vasari described in detail the effort of Jacopo da Pontormo and other Florentine artists to design floats for the celebration of the papacy of Leo X in 1513.

48. For this picture, see David Steinberg, "Charles Willson Peale: The Portraitist as Divine," *New Perspectives*, 131–43.

49. Charles Willson Peale to Benjamin Franklin, April 21, 1771, Franklin Papers, American Philosophical Society, Philadelphia (http://founders.archives.gov/documents/Franklin/01-18-02-0053).

50. For this topic, see Hart and Ward, "Waning of an Enlightenment Ideal," *New Perspectives*, 219–30.

51. Miller, *Selected Papers*, 1:445; and Ward, *Peale*, 98.

52. Peale, Autobiography, in Miller, *Selected Papers*, 5:368.

53. John Beale Bordley to Charles Willson Peale, July 8, 1785, in Miller, *Selected Papers*, 1:433.

54. Charles Willson Peale to Mrs. Crawford, November 28, 1786, Peale Papers, American Philosophical Society, Philadelphia.

55. Charles Willson Peale to William Pierce, June 17, 1787, in Miller, *Selected Papers*, 1:480.

56. Charles Willson Peale to Benjamin West, November 17, 1788, in Miller, *Selected Papers*, 1:544.

57. Charles Willson Peale to Benjamin West, April 9, 1783, in Miller, *Selected Papers*, 1:387–88.

58. Charles Willson Peale to George Washington, June 27, 1790, in Miller, *Selected Papers*, 1:589.

59. Charles Willson Peale, "Announcement of Retirement from Portrait Painting," *Dunlap and Claypoole's American Daily Advertiser* (April 24, 1794), in Miller, *Selected Papers*, 2:91.

60. Sellers, *Mr. Peale's Museum*, 101.

61. For Belfield, see Theresa O'Malley, "Charles Willson Peale's Belfield: Its Place in American Garden History," *New Perspectives*, 267–82.

62. Peale, Autobiography, in Miller, *Selected Papers*, 5:381–2; and James A. Butler, *Charles Willson Peale's 'Belfield:' A History of a National Historic Landmark, 1684–1984* (Philadelphia: La Salle University Art Museum, 2009), 31.

Chapter 4: Benjamin West's Peace

1. Benjamin West to Charles Willson Peale, June 15, 1783, Archives
 of American Art. The seminal essay on the topic is Arthur S.
 Marks, "Benjamin West and the American Revolution," *American
 Art Journal* 6, no. 2 (November, 1974), 15–35. Peale had collected
 war artifacts for his Philadelphia Museum; see David Brigham,
 Public Culture in the Early Republic: Peale's Museum and its Audience
 (Washington, D.C.: Smithsonian, 1995), 136–42.

2. Benjamin West to Charles Willson Peale, August 4, 1783, in
 Lillian B. Miller, ed., *The Selected Papers of Charles Willson Peale
 and His Family*, 5 vols. (New Haven, CT: Yale University Press,
 1983–2000), 1:393–94.

3. Probably the most viewed image of a parallel but different event
 was the print *The Preliminary Articles of Peace between Great Brit-
 ain & France and Great Britain and Spain, Signed at Versailles Jany.
 20, 1783*, which appeared in Edward Barnard's popular *Barnard's
 New Complete and Authentic History of England* (London: Edward
 Barnard, 1781–83).

4. William Dunlap, *History of the Rise and Progress of the Arts of Design
 in the United States*, 2 vols. (New York: George P. Scott, 1834), 1:75.

5. John Adams, Diary, October 10, 1774, and September 3, 1774,
 AFP.

6. John Adams to the President of Congress, October 31, 1780, AFP.

7. John Trumbull, *Autobiography, Reminiscences and Letters of John
 Trumbull, from 1756 to 1843* (New York: Wiley and Putnam,
 1841), 75.

8. Trumbull, *Autobiography*, 68.

9. John Almon, *The Remembrancer, or Impartial Repository of Public
 Events*, 14 vols. (London: J. Almon, 1780), 10:377.

10. Charles Warren, "A Young American's Adventures in England and France during the Revolutionary War," *Proceedings of the Massachusetts Historical Society*, 3rd series, 65 (October 1934), 248.

11. Richard B. Morris, *The Peacemakers: The Great Powers and American Independence* (New York: Harper and Row, 1965), 123.

12. Trumbull, *Autobiography*, 325.

13. Ibid., 75–76. In 1834, William Dunlap concluded that "the motive ascribed to Mr. West's prompt interference is *self*"; *Rise and Progress*, 1:354.

14. Trumbull, *Autobiography*, 76.

15. Ibid., 312.

16. Ibid.

17. Ibid.

18. Ibid., 317.

19. Ibid., 320.

20. There were other pictures, too, that seem covertly political in the context of West's repressed patriotism: *Daniel Interpreting to Belshazzar the Handwriting on the Wall* in which, again, a prophet foretells the demise of a tyrant; *St. Michael and Satan*, which shows a winged demon crushed by an armed angel; and, on a note of Anglo-American conciliation, *Fidelia and Speranza* of 1776, a painting from Edmund Spenser's *Faerie Queene* in which Faith and Hope remain steadfastly "Linked arme in arme," unperturbed by the snake that springs from Fidelia's cup; see Allen Staley, *Benjamin West: American Painter at the English Court* (Baltimore: Baltimore Museum of Art, 1989), 85–87; and Derrick Cartwright, *Benjamin West: Allegory and Allegiance* (San Diego: Timken Museum of Art, 2005).

21. John Galt, *The Life, Studies, and Works of Benjamin West, Esq. President of the Royal Academy of London Composed from Materials Furnished by Himself* (London: T. Cadell and W. Davies, 1816), 93. On the topic of Galt reconstructing West's life, see Susan Rather, "Benjamin West, John Galt, and the Biography of 1816," *Art Bulletin* 86, no. 2 (June 2004), 324–45.

22. The most incisive study of West's hidden politics and Anglo-American identity is Sarah Monks, "The Wolfe Man: Benjamin West's Anglo-American Accent," *Art History* 34, no. 4 (September 2011), 652–73.

23. Peter Pindar, *More Lyric Odes to the Royal Academicians* (London: T. Egerton, 1783), 9.

24. Pindar, *More Lyric Odes*, 9; Pindar, *The Works of Peter Pindar, Esq.* (Philadelphia: M. Wallis Woodward & Co., 1835), 159.

25. William Kingsford, *The History of Canada*, 10 vols. (Toronto: Roswell and Hutchinson, 1893), 6:60.

26. Roger Shanhagen, *The Exhibition, or a Second Anticipation: Being Remarks on the Principal Works to be Exhibited Next Month, at the Royal Academy* (London: Richardson and Urquhart, 1779), 30–31.

27. *Morning Post, and Daily Advertiser*, May 9, 1785.

28. *Morning Post, and Daily Advertiser*, July 2, 1785, and July 4, 1785.

29. Trumbull, *Autobiography*, 69.

30. Benjamin West to Charles Willson Peale, February 10, 1775, in Miller, *Selected Papers*, 1:152.

31. *The Phoenix, or the Resurrection of Freedom*, 1776; *Job Reproved by his Friends*, 1777; and *The Conversion of Polemon*, 1778; see William L. Pressly, *The Life and Art of James Barry* (New Haven, CT: Yale University Press, 1981), 77–79.

32. Elkanah Watson, *Men and Times of the Revolution: or, Memoirs of Elkanah Watson, Including Journals of Travels in Europe and America from 1777 to 1842, with His Correspondence with Public Men and Reminiscences and Incidents of the Revolution*, ed. Winslow C. Watson (New York: Dana and Company, 1856), 176–77. A few days earlier the King told West that he was thinking about abdication. He thought he might return to Germany and hoped that West would go with him.

33. Ibid., 177.

34. Ibid., 178.

35. Ibid., 179.

36. Troy Bickham, *Making Headlines: The American Revolution as Seen through the British Press* (DeKalb: Northern Illinois University Press, 2008), 158–82.

37. Ibid., 181, 236.

38. Ibid., 182.

39. Color engravings by William Sharp of George Washington in his buff and blue military dress were widely known in England.

40. Benjamin West to Charles Willson Peale, August 4, 1783, in Miller, *Selected Papers*, 1:393–94.

41. Bickham, *Making Headlines*, 185–205. Charles Willson Peale to Benjamin West, April 9, 1783, Peale Papers, American Philosophical Society, Philadelphia.

42. Charles Willson Peale to Benjamin West, December 10, 1783, American Philosophical Society, Philadelphia.

43. Mark Evans Bryan, "'Sliding into Monarchical Extravagance': *Cato* at Valley Forge and the Testimony of William Bradford Jr.," *William and Mary Quarterly*, 3rd ser., vol. 67, no. 1 (January 2010), 123–44.

Fredric M. Litto, "Addison's *Cato* in the Colonies," *William and Mary Quarterly*, 3rd ser., vol. 23, no. 3 (July 1966), 431–49.

44. Joseph Addison, *Cato, a Tragedy*, Act 2, Scene 1.

45. Charles Willson Peale to Benjamin West, December 10, 1783, American Philosophical Society.

46. Holger Hoock, *Empires of the Imagination: Politics, War, and the Arts in the British World, 1750–1850* (London: Profile Books, 2010), 117–29.

47. John Trumbull to Jonathan Trumbull Sr., March 15, 1785, Trumbull Papers, Connecticut Historical Society, Hartford.

48. Bickham, *Making Headlines*, 177–82.

49. Morris, *Peacemakers*, 300.

50. Richard Oswald, notes, August 7, 1782, in Walter Stahr, *John Jay: Founding Father* (New York: Bloomsbury, 2005), 152.

51. Jonathan Sewell to Joseph Lee, September 21, 1787, Lee Family Papers, Massachusetts Historical Society.

52. Morris, *Peacemakers*, 191.

53. Ibid., 356.

54. Ibid.

55. Ibid. Herbert E. Klingelhofer, "Matthew Ridley's Diary during the Peace Negotiations of 1782," *William and Mary Quarterly*, 3rd ser., vol. 20 (January 1963), 122–23.

56. Henry Laurens to Moses Young, August 10, 1782, in David R. Chesnutt, C. James Taylor, et al., eds., *The Papers of Henry Laurens*,

16 vols. (Columbia: University of South Carolina Press, 1968–2002), 15:563.

57. *Morning Herald*, March 14, 1782.

58. James A. Rawley, "Henry Laurens and the Atlantic Slave Trade," in *London: Metropolis of the Slave Trade* (Columbia: University of Missouri Press, 2003), 82–97.

59. Charles Coleman Sellers, *Benjamin Franklin in Portraiture* (New Haven, CT: Yale University Press, 1962), 415–18.

60. Morris, *Peacemakers*, 352.

61. Ibid., 261.

62. Ibid., 343.

63. Sellers, *Franklin*, 151.

64. James H. Hutson, "The American Negotiators: The Diplomacy of Jealousy," in *Peace and the Peacemakers: The Treaty of 1783*, eds. Ronald Hoffman and Peter J. Albert (Charlottesville: University of Virginia Press, 1986), 52–69.

65. Morris, *Peacemakers*, 355.

66. Ibid., 381.

67. But would West have known the architecture of that building? Just as plausible, West based his building on one of J.-A. Gabriel's wings of Versailles itself, which would have been enough to evoke a setting in France.

68. The historian William Dunlap does not fix a date but notes that Laurens visited West's studio and offered a small critique of the *Death of General Wolfe*; Dunlap, *Rise and Progress*, 1:64.

69. Robert C. Alberts, *Benjamin West: A Biography* (Boston: Hough-
 ton Mifflin, 1978), 151.

70. Benjamin Franklin, *The Works of Benjamin Franklin, Containing
 Several Political and Historical Tracts not Included in any Former Edi-
 tion, and Many Letters Official and Private not Hitherto Published*,
 ed. Jared Sparks, 10 vols. (Boston: Hilliard, Gray, and Company:
 1840) 9:493.

71. Sellers, *Franklin*, 420–21; Whitefoord's picture of Franklin is now
 in the Royal Society, London. The plaster is cited in James Hut-
 ton to Benjamin Franklin, March 2, 1784, Franklin Papers, Yale
 University (http://franklinpapers.org/franklin/framedVolumes.jsp
 ?tocvol=34).

72. John Quincy Adams, *Memoirs of John Quincy Adams, Comprising
 Portions of His Diary from 1795 to 1848*, 12 vols., ed. Charles Fran-
 cis Adams (Philadelphia: J. B. Lippincott and Company, 1874–77)
 3:559.

73. Helmut von Erffa and Allan Staley, *The Paintings of Benjamin
 West* (New Haven, CT: Yale University Press, 1986), 207.

74. John Adams, Diary, December 4, 1782, AFP.

75. See Jules David Prown, *Art as Evidence: Writings on Art and Mate-
 rial Culture* (New Haven, CT: Yale University Press, 2001), 117–
 27.

76. Gordon S. Wood, *The Radicalism of the American Revolution* (New
 York: Vintage, 1991), 145–68; see Edwin G. Burrows and Michael
 Wallace, "The American Revolution: The Ideology and Psychol-
 ogy of National Liberation," *Perspectives in American History* 6
 (1972), 167–308.

77. William Livingston, *The Independent Reflector: Or, Weekly Essays on
 Sundry Important Subjects* (Cambridge: Harvard University Press,
 1963), 80, 81.

78. Edmund Burke, *Edmund Burke: Selected Writings and Speeches*, ed. Peter James Stanlis (Piscataway, NJ: Transaction Publishers, 2006), 220.

79. Thomas Paine, *Common Sense*, ed. Isaac Kramnick (New York: Penguin Classics, 1982), 92.

80. John Adams, "A Dissertation on the Canon and Feudal Law," in Burrows and Wallace, "American Revolution," 194.

81. See Jay Fliegelman's brilliant discussion in *Prodigals and Pilgrims: The American Revolution against Patriarchal Authority, 1750–1800* (Cambridge: Cambridge University Press, 1982), 197–226.

82. Drawings for *Agrippina with Her Children Going through the Roman Camp* are at the Morgan Library in New York City and the Historical Society of Pennsylvania. The most finished version is at the Philadelphia Museum of Art.

83. Von Erffa and Staley, *Benjamin West*, 178.

84. The classical tales that were particularly pertinent to West's view of the Revolutionary War as a family rupture are the pictures that involve pleas to hold the family intact: In *Aeneus and Creusa*, a scene from Book II of Virgil's *Aeneid* that is set in the midst of Troy's fall to the Greeks, Creusa begs her husband, Aeneas, not to leave her and their son Iulus behind. In the *Continence of Scipio*, West chose a moment in Livy's *History of Rome* when the young Scipio Africanus magnanimously decides to return a captive Carthaginian maid to her fiancé and, while he is at it, to add gold to her dowry. And in a set of two pictures based on the *Iliad*, West treated the plight of Chryses, whose daughter has been taken by Agamemnon as a war prize during the Trojan War. In the first picture, Chryses prays to Apollo to intervene; and in the second, after Apollo has inflicted a plague on Agamemnon's army, Chryses is reunited with his daughter.

85. Morris, *Peacemakers*, 431.

Chapter 5: John Singleton Copley's Patriots

1. Elkanah Watson, *Men and Times of the Revolution; or, Memoirs of Elkanah Watson, Including Journals of Travels in Europe and America, from 1777 to 1842, with His Correspondence with Public Men and Reminiscences and Incidents of the Revolution*, ed. Winslow C. Watson (New York: Dana and Company, 1856), 176.

2. Watson, *Men and Times*, 79.

3. Jane Carson, "The First American Flag Hoisted in Old England," *William and Mary Quarterly*, 3rd ser., 11, no. 3 (July 1954), 434–40.

4. Watson, *Men and Times*, 176.

5. Ibid., 199.

6. Ibid., 176.

7. Ibid.

8. The broadside is reprinted in the *Boston Gazette* (January 15, 1774).

9. John Singleton Copley to Jonathan and Isaac Winslow Clarke, December 1, 1773, in *Letters and Papers of John Singleton Copley and Henry Pelham, 1739–1776*, ed. Guernsey Jones (Boston: Massachusetts Historical Society, 1914), 211.

10. John Singleton Copley to Jonathan and Isaac Winslow Clarke, December 1, 1773, in Jones, *Copley*, 212.

11. Christopher Bryant, in conversation and from his unpublished essay.

12. Frontispiece, *Royal American Magazine* (April 1774).

13. Christopher Bryant, in conversation and from his unpublished essay.

14. *Boston Evening Post* (May 8, 1769).

15. John Singleton Copley to Isaac Winslow Clarke, April 26, 1774, in Jones, *Copley*, 218.

16. Henry Pelham to Susanna Clarke Copley, July 23, 1775, in Jones, *Copley*, 345.

17. John Singleton Copley to Henry Pelham, July 15, 1775, in Jones, *Copley*, 343–44.

18. Henry Pelham to John Singleton Copley, May, 1775, in Jones, *Copley*, 316.

19. John Singleton Copley to Peter Pelham, September 12, 1766, in Jones, *Copley*, 47–48.

20. Captain R. G. Bruce to John Singleton Copley, June 25, 1767, in Jones, *Copley*, 60.

21. John Singleton Copley to Benjamin West or Captain R. G. Bruce, undated, in Jones, *Copley*, 65–66. On Copley's frustration, see Susan Rather, "Carpenter, Tailor, Shoemaker, Artist: Copley and Portrait Painting around 1770," *Art Bulletin* 79, no. 2 (June 1997), 269–90.

22. Henry Pelham to John Singleton Copley, May 16, 1775, in Jones, *Copley*, 320.

23. John Singleton Copley to Henry Pelham, August 6, 1775, in Jones, *Copley*, 348.

24. John Singleton Copley to Susanna Clarke Copley, December 4, 1775, in Martha Babcock Amory, *The Domestic and Artistic Life of John Singleton Copley, R. A.* (Boston: Houghton Mifflin: 1882), 41.

25. John Singleton Copley to Susanna Clarke Copley, July 2, 1775, in Amory, *Copley*, 58.

26. John Singleton Copley to Susanna Clarke Copley, July 22, 1775,
 in Amory, *Copley*, 62.

27. John Singleton Copley to Henry Pelham, March 14, 1775, in
 Jones, *Copley*, 301.

28. John Singleton Copley to Henry Pelham, August 6, 1775, in Jones,
 Copley, 348–49.

29. John Singleton Copley to Susanna Clarke Copley, July 22, 1775,
 in Amory, *Copley*, 62.

30. John Adams, Diary, April 21, 1778, AFP. John Singleton Copley
 to Mary Singleton Copley Pelham, June 25 1775, in Jones, *Copley*,
 330.

31. Maurie McInnis, "Cultural Politics, Colonial Crisis, and Ancient
 Metaphor in John Singleton Copley's *Mr. and Mrs. Ralph Izard*,"
 Winterthur Portfolio 34, no. 2/3 (Summer-Autumn, 1999), 105.

32. The arrangement of a couple across a table, with intervening object
 meant to reflect on them, was a type of picture first explored by
 Lorenzo Lotto in *Portrait of a Married Couple*, c. 1524, Hermitage
 Museum, St. Petersburg.

33. Maurie McInnis wrote the key political interpretation of the pic-
 ture in "Cultural Politics," 85–108.

34. Jules David Prown, *John Singleton Copley in England* (Cambridge:
 Harvard University Press and the National Gallery of Art, 1966),
 292. Copley's father-in-law was a nephew of Hutchinson.

35. Prown, *Copley*, 249.

36. Usher Parson, *The Life of Sir William Pepperell* (Boston: Little,
 Brown, 1855), 338. For the Pepperells, see Margaretta M. Lovell,
 "'To be Conspecuous in the Croud:' John Singleton Copley's *Sir
 William Pepperell and His Family*," *North Carolina Museum of Art
 Bulletin* 15 (1991), 29–42; and Emily Neff, *John Singleton Copley*

in England, exhibition catalog, Museum of Fine Arts, Houston (London: Merrell Holberton, 1995), 98–101.

37. "Royal Academy Exhibition," *St. James's Chronicle* (April 25, 1778).

38. Clarence J. Webster, *Sir Brook Watson, Friend of the Loyalists, First Agent of New Brunswick in London* (Sackville, New Brunswick: Mount Allison University, 1924), 13.

39. Ethan Allen, *Narrative of the Capture of Ticonderoga and of His Captivity and Treatment by the British* (Burlington, VT: C. Goodrich and S. B. Nichols, 1849), 17–19.

40. As Ann Abrams points out, there are no records of a commission, but we do know that Watson owned the picture until his death in 1807, which suggests he did commission it, paid for it, and continuously owned it; see Abrams, "Prints, Politics and Copley's *Watson and the Shark*," *Art Bulletin* 61, no. 2 (1979), 265–76.

41. See Ellen Miles, et al., *American Paintings of the Eighteenth Century* (Washington: National Gallery of Art, 1995), 62.

42. From Albert Boime, "Blacks in Shark-Infested Waters: Visual Encoding of Racism in Copley and Homer," *Smithsonian Studies in American Art* 3, no. 1 (Winter 1989), 32. Especially pertinent here is Louis P. Masur, "Reading Watson and the Shark," *New England Quarterly* 67, no. 3 (September 1994), 427–54. For a balanced summary of the various analyses of the picture, see Ellen Miles, "*Watson and the Shark*," in Neff, *Copley*, 102–5. Watson was elected to Parliament in 1784 and later was a director of the Bank of England, Lord Mayor of London, and chairman of Lloyds of London.

43. Cassandra Pybus, "Jefferson's Faulty Math: The Question of Slave Defections in the American Revolution," *William and Mary Quarterly*, 3rd ser., 82, no. 2 (April 2005), 243–64; and Pybus, *Epic Journeys of Freedom: Runaway Slaves of the American Revolution and their Global Quest for Liberty* (New York: Beacon, 2006). See Maya Jasanoff, *Liberty's Exiles: American Loyalists in the Revolutionary*

World (New York: Knopf, 2011), 114–15. Copley himself owned slaves in Boston. He was particularly fond of one young man named Snap.

44. William Dunlap, *A History of the Rise and Progress of the Arts of Design in the United States*, 2 vols. (New York: George P. Scott, 1834), 1:117.

45. Webster, *Brook Watson*, 11–13.

46. Dunlap, *Arts of Design*, 1: 117–18.

47. Mary Beth Norton, *The British-Americans: The Loyalist Exiles in England, 1774–1789* (Boston: Little, Brown, 1972), 81.

48. Prown, *Copley*, 285.

49. A letter from Watson's son identifies it as the court dress that Watson wore to the Château de Saint-Cloud, which was then the residence of the Duc d'Orléans (Charles Watson to New-York Historical Society, May 18, 1858, Princeton Art Museum files). Watson mentions the event in *Men and Times*, 93.

50. James Warren to John Adams, July 7, 1779, AFP.

51. David McCullough, *John Adams* (New York: Simon & Schuster, 2001), 267.

52. Peter Whiteley, *Lord North: The Prime Minister who Lost America* (London: Bloomsbury, 2003), 215.

53. Henry Laurens, "Journal and Narrative of Capture and Confinement in the Tower of London," in *The Papers of Henry Laurens*, David R. Chesnutt, C. James Taylor, et al., eds., 16 vols. (Columbia: University of South Carolina Press and the South Carolina Historical Society, 1968–2002), 15:355.

54. Laurens, *Papers*, 15:368.

55. Ibid., 15:397.

56. Ibid., 15:xviii.

57. *Morning Chronicle* (January 12, 1782); Prown, *Copley*, 293.

58. Eric Stockdale, *'Tis Treason My Good Man! Four Revolutionary Presidents and a Piccadilly Bookshop* (London: Oak Knoll Press and the British Library, 2005), 107.

59. He also knew the persuasive value of art for getting across his political agenda. Unprecedented in polite society, Laurens arranged to have his prison portrait taken by the English artist Lemuel Francis Abbott, who went to the Tower to paint it. Abbott had a national reputation for unadventurous portraits of British diplomats, statesmen, and naval officers. But in this unusual, American-slanted picture, Abbott painted Laurens as a prisoner of war, dramatically set against the shadowy backdrop of the Tower and holding a letter in his left hand that declares his true American loyalties, should there be any doubt: "I have acted the part of a faithful subject. I now go resolved still to labour for peace at the same time determined in the last event to stand or fall with my country."

60. Sheldon Samuel Cohen, *Yankee Sailors in British Gaols: Prisoners of War at Forton and Mill, 1777–1783* (London: Associated University Presses, 1995), 201.

61. Cohen, *Yankee Sailors*, 115.

62. John Boylston to John Adams, August 31, 1781, AFP.

63. Cohen, *Yankee Sailors*, 78–79. See Sheldon Samuel Cohen, *British Supporters of the American Revolution, 1775–1783: The Role of the 'Middling Level' Activists* (Woodbridge, UK: Boydell Press, 2004).

64. The *Morning Herald and Daily Advertiser* carried dozens of stories, some lurid, about Laurens's confinement in October and November of 1780; "Memoranda Book," Laurens, *Papers*, 15:419–20. See *The Gentleman's Magazine and Historical Chronicle* 50 (October 1780), 493.

65. *Morning Herald and Daily Advertiser* (November 2, 1780).

66. F. P. Lock, *Edmund Burke*, 2 vols. (Oxford: Clarendon Press, 1998), 2:493.

67. *London Chronicle* (July 22, 1780). On Washington's popularity, see Troy Bickham, *Making Headlines: The American Revolution as Seen through the British Press* (DeKalb: Northern Illinois University Press, 2008), 185–205.

68. Barbara E. Lacey, *From Sacred to Secular: Visual Images in Early American Publications* (Newark: University of Delaware Press, 2007), 126, 134.

69. *Westminster Magazine, or The Pantheon of Taste* 11 (November 1783), 563–64.

70. Wendy C. Wick, *George Washington, an American Icon: The Eighteenth-Century Graphic Portraits* (Charlottesville: University of Virginia Press and the Smithsonian Institution Traveling Exhibition Service, 1982), 18–19.

71. J. H. Plumb, "British Attitudes to the American Revolution," in Plumb, *In the Light of History* (Boston: Houghton Mifflin, 1973), 70–87.

72. William Hamilton, *Intrepid Magazine* (1784), 53.

73. Eric Stockdale, "John Stockdale, London Bookseller and Publisher of Adams and Jefferson," *The Libraries, Leadership, & Legacy of John Adams and Thomas Jefferson*, eds. Robert C. Baron and Conrad Edick Wright (Golden, CO: Fulcrum Publishing, 2010), 41–55.

74. Solomon Lutnick, *The American Revolution and the British Press, 1775–1783* (Columbia: University of Missouri Press, 1967), 224–25.

75. Henry Laurens to John Lewis Gervais, April 7, 1783, *Papers*, 16:181.

76. Thomas Jefferson, *The Life and Selected Writings of Thomas Jefferson*, eds. Adrienne Koch and William Peden (New York: Random House, 1944), 60.

77. Undated newspaper clipping, curatorial files for Henry Laurens, National Portrait Gallery, Washington, D.C.

78. Green was able to gain direct access to the Trumbull picture before it was acquired by the Dutch banker Leendert Neufville, whose family had offered the United States a large loan during the war.

79. *Journals of the American Congress, from 1774 to 1788*, 4 vols. (Washington: Way and Gideon, 1823), 2:522.

80. Ibid., 2:524.

81. John E. Ferling, *Almost a Miracle: The American Victory in the War of Independence* (New York: Oxford University Press, 2009), 265.

82. Henry Laurens to the Carlisle Commission, June 17, 1778, printed in *The London Magazine, or Gentleman's Monthly Intelligencer* 47 (August 1778), 384.

83. George C. Rogers Jr., "Changes in Taste in the Eighteenth Century: A Shift from the Useful to the Ornamental," *Journal of Early Southern Decorative Arts* 8 (May 1982), 1–24.

84. See the notes of Michelle Kloss, curatorial files for Henry Laurens, National Portrait Gallery, Washington, D.C. Copley had a strong Irish connection; his parents were Irish immigrants to Boston, and in 1783 he began preliminary work on a large picture on the Order of Saint Patrick, which the British initiated to placate Irish lobbying for constitutional rights.

85. According to Kloss, Laurens was known locally from two letters that he published in the *Clonmel Gazette* during and after his captivity in the Tower; December 27, 1781, and January 10, 1782.

86. On April 21, 1782, Bagwell wrote resolutions praising Grattan,
 Miscellaneous Works of the Right Honourable Henry Grattan (Lon-
 don: Longman, Hurst, Rees, Orme, and Brown; Dublin: R. Mil-
 liken, 1822), 176. As for Trumbull's portrait of Washington, in
 1783 a Dublin bookseller, John Exshaw, had prints for sale; see
 Fintan Cullen, *Visual Politics: The Representation of Ireland, 1750–
 1930* (Cork: Cork University Press, 1997), 63.

87. Prown, *Copley*, 292.

Chapter 6: John Adams's "Piece of Vanity"

1. For Adams in this period, see Richard A. Ryerson, "John Adams
 in Europe: A Provincial Cosmopolitan Confronts the Metropol-
 itan World, 1778–1788," in *Old World, New World: America and
 Europe in the Age of Jefferson*, eds. Leonard J. Sadosky et al. (Char-
 lottesville: University of Virginia Press, 2010), 131–54.

2. The key works on this topic are Wendell D. Garrett, "John Adams
 and The Limited Role of the Fine Arts," *Winterthur Portfolio* 1, (1964),
 243–55; and Neil Harris, *The Artist in American Society: The Formative
 Years* (Chicago: University of Chicago Press, 1966), 28–55.

3. John Adams to Abigail Adams, April 12, 1778, AFP.

4. John Adams to Abigail Adams, June 3, 1778, AFP.

5. John Adams to Abigail Adams, May 12, 1780, AFP.

6. The original painting, from 1712, had been made into a print by
 Simon Gribelin at the request of the Earl of Shaftesbury, who used
 it to illustrate his collected philosophical works, *Characteristicks
 of Men, Manners, Opinions, Times*, 5th ed. (Birmingham, UK:
 John Baskerville, 1773). Adams owned the print and it is now in
 his collection at the Boston Public Library. Shaftesbury used the
 word "pleasure," instead of "vice." G. J. Barker-Benfield discusses
 Adams's attraction to the choice of Hercules in *Abigail and John*

Adams: The Americanization of Sensibility (Chicago: University of Chicago Press, 2010), 240–45. See also Peter Shaw, *The Character of John Adams* (Chapel Hill: University of North Carolina Press, 1976), 37–38, 102–3. Livio Pestilli elaborately discusses the painting in *Paolo de Matteis: Neapolitan Painting and Cultural History in Baroque Europe* (Farnham, UK: Ashgate, 2013).

7. John Adams to Abigail Adams, April 1780, AFP.

8. John Adams to Abigail Adams, April 27, 1777, AFP.

9. John Adams to Abigail Adams, October 19, 1775, AFP.

10. John Adams, *A Defence of the Constitutions of Government of the United States of America* (London: John Stockdale, 1794), iii.

11. John Adams to Robert Livingston, June 23, 1783, *The Works of John Adams*, ed. Charles Francis Adams, 10 vols. (Boston: Little, Brown, 1856), 8:74.

12. John Adams to Abigail Adams, April 12, 1778, AFP.

13. John Adams to Abigail Adams, April 25, 1778, AFP.

14. "Discourses on Davila," Adams, *Works*, 6:243.

15. John Adams, Diary, January 16, 1766, AFP.

16. John Adams to Abigail Adams, August 21, 1776, AFP.

17. John Adams, Diary, April 11, 1778, AFP.

18. John Adams to François Teissèdre de Fleury, May 20, 1778, AFP.

19. John Quincy Adams, Diary, August 9, 1780, AFP.

20. John Adams to John Trumbull, March 18, 1817, in George Park Fisher, *The Life of Benjamin Silliman* (New York: Scribner and Company, 1866), 389.

21. John Adams, Diary, October 21, 1782, AFP.

22. John Adams to William Plumer, March 28, 1813, *Works of John Adams*, 10:35.

23. John Adams to William Tudor, April 15, 1818, *Works of John Adams*, 10:249.

24. John Adams to William Tudor, April 15, 1818, *Works of John Adams*, 10:249.

25. John Adams to William Tudor, April 15, 1818, *Works of John Adams*, 10:249.

26. See Brandon Brame Fortune, "Portraits of Virtue and Genius: Pantheons of Worthies and Public Portraiture in the Early American Republic, 1780–1820," doctoral dissertation, University of North Carolina at Chapel Hill, 1986.

27. On Peale's collection, see David Brigham, *Public Culture in the Early Republic: Peale's Museum and Its Audience* (Washington, D.C.: Smithsonian Institution Press, 1995).

28. It appeared in the *Mercure de France* on February 24, 1781. For Simitière, see John C. Van Horne, *Pierre Eugène Du Simitière: His American Museum 200 Years After* (Philadelphia: Library Company, 1985); Hans Huth, "Pierre Eugène Du Simitière and the Beginnings of the American Historical Museum," *Pennsylvania Magazine of History and Biography* 69, no. 4 (October 1945), 315–25.

29. *Portraits of the Generals, Ministers, Magistrates, Members of Congress, and Others who have Rendered Themselves Illustrious in the Revolution of the United States of America* (London: R. Wilkinson and J. Debrett, 1783).

30. Harold Dickson, "'Th. J.' Art Collector," in *Jefferson and the Arts: An Extended View*, ed. William H. Adams (Charlottesville: University of Virginia Press, 1976), 111.

31. Dickson, "Th. J.," 114. The best overview is Susan Stein, *The Worlds of Thomas Jefferson at Monticello* (New York: Harry N. Abrams, 1993), 70–93. Also, Leanne Zalewski, "Fine Art for the New World: Thomas Jefferson, Collecting for the Future," *Journal of the History of Collections* 27 (2015), 49–55.

32. Thomas Jefferson to the Reverend James Madison, February 8, 1786, Thomas Jefferson Papers, Library of Congress (https://www.loc.gov/collections/thomas-jefferson-papers).

33. John Adams to Richard Cranch, July 4, 1786, AFP.

34. At the same time Adams had Vinkeles's colleague, Isaak Schmidt, paint a watercolor portrait of John Quincy Adams; Andrew Oliver, *Portraits of John and Abigail Adams* (Cambridge, MA: Belknap Press, 1967), 14–16. The picture is now in the National Portrait Gallery, Washington, D.C.

35. For more on the poem, see John L. Brown, "Revolution and the Muse: The American War of Independence in Contemporary French Poetry," *William and Mary Quarterly*, 3rd ser., 41, no. 4 (October 1984), 592–614.

36. John Adams to Abigail Adams, April 16 and May 18, 1783, AFP.

37. John Adams to Abigail Adams, April 16, 1783, AFP.

38. Ibid.

39. John Adams to James Warren, December 2, 1778, AFP.

40. Ibid.

41. Benjamin Franklin to Samuel Huntington, August 9, 1780, Benjamin Franklin Papers, National Archives, Washington D.C. (http://founders.archives.gov/documents/Franklin/01-33-02-0129).

42. See William B. Evans "John Adams' Opinion of Benjamin Frank-
 lin," *Pennsylvania Magazine of History and Biography* 92, no. 2
 (April 1968), 220–38.

43. David McCullough, *John Adams* (New York: Simon & Schuster,
 2001), 192.

44. There are numerous books on Franklin's fame, most recently Stacy
 Schiff, *The Great Improvisation: Franklin, France, and the Birth of
 America* (New York: Henry Holt, 2005); and Brandon Brame For-
 tune, *Franklin and His Friends* (Philadelphia: University of Penn-
 sylvania Press, 1999). For celebrity in France, see Antoine Lilti,
 Figures Publiques: L'Invention de la Célébrité (Paris: Fayard, 2015).

45. See Ellen G. Miles, "The French Portraits of Benjamin Franklin,"
 Reappraising Benjamin Franklin: A Bicentennial Perspective, ed. J.
 A. Leo Lemay (Newark: University of Delaware Press, 1993),
 272-89.

46. See Charles Coleman Sellers, *Benjamin Franklin in Portraiture*
 (New Haven, CT: Yale University, 1962).

47. François Boucher and Frances Wilson Huard, *American Footprints
 in Paris* (New York: Doran, 1921), 104.

48. "Monograph from an Old Note-Book," *Atlantic Monthly*, 12, no.
 73 (November 1863), 657.

49. Reported in *American Aurora*, November 12, 1798.

50. John Adams, Diary, May 10, 1779, AFP.

51. Benjamin Franklin to Sally Franklin Bache, June 3, 1779, *The
 Private Correspondence of Benjamin Franklin*, ed. William Temple
 Franklin, 2nd ed., 2 vols. (London: 1817) 1:43.

52. John Adams, Diary, October 26, 1782, AFP.

53. John Adams, Diary, October 27, 1782, AFP.

54. John Adams, *Diary and Autobiography of John Adams*, ed. L. H. Butterfield (Cambridge, MA: Harvard University Press, 1961), vol. 3, p. 48.

55. John Adams, Diary, November 10, 1782, AFP.

56. John Adams, Diary, November 12, 1782, AFP.

57. John Adams to Abigail Adams, June 10, 1783, AFP.

58. John Adams to Abigail Adams, September 7, 1783, AFP.

59. John Adams to Abigail Adams, June 10, 1783, AFP.

60. John Adams to Abigail Adams, May 18, 1783, AFP.

61. John Adams to Abigail Adams, February 27, 1783, AFP.

62. John Adams to Abigail Adams, June 9, 1783, AFP.

63. John Adams to Abigail Adams, February 26, 1783, AFP.

64. John Adams to Abigail Adams, February 27, 1783 and April 16, 1783, AFP.

65. John Adams to Abigail Adams, February 27, 1783, AFP.

66. John Adams to Abigail Adams, September 4, 1783, AFP.

67. John Adams to Abigail Adams, April 16, 1783 and December 24, 1783, AFP.

68. John Adams to Abigail Adams, November 8, 1783, AFP.

69. John Adams to Abigail Adams, September 7, 1783, AFP.

70. In 1781 Stockdale published Adams's *A Translation of the Memorial to the Sovereigns of Europe upon the Present State of Affairs between the Old and New World into Common Sense and Intelligible English.*

71. John Adams to Abigail Adams, April 16, 1783, AFP.

72. John Adams to Abigail Adams, February 13, 1779, AFP. A version of the same rant appears in his diary entry of February 11.

73. John Adams to Abigail Adams, November 18, 1783, AFP.

74. McCullough, *Adams*, 344–45. On Adams in London, see Colin Bonwick, *English Radicals and the American Revolution* (Chapel Hill: University of North Carolina Press, 1977), 173–75.

75. John Adams, Diary, February 11, 1779, AFP.

76. Troy Bickham, *Making Headlines: The American Revolution as Seen through the British Press* (DeKalb: Northern Illinois University Press, 2008), 185–205.

77. *London Chronicle* (January 5, 1782).

78. Adams talks about Copley in a letter to Mercy Otis Warren, dated January 8, 1776; AFP.

79. Diary of John Adams, August 11, 1769, AFP.

80. McCullough, *Adams*, 345.

81. John Adams to Abigail Adams, November 8, 1783, AFP.

82. John Quincy Adams, Diary, November 1, 1783, AFP.

83. John Quincy Adams, Diary, November 24, 1783, AFP.

84. "London Dec'r 10, 1783 Rec'd of John Adams esquire one hundred guineas in full for his portrait. J S Copley," *Letters and Papers of John Singleton Copley and Henry Pelham, 1739–1776*, ed. Guernsey Jones (Boston: Massachusetts Historical Society, 1914), 374.

85. Abigail Adams to Mary Smith Cranch, July 25, 1784, AFP.

86. Abigail Adams said that he has "the Map of Europe in his hand." But the document in his right hand is unmarked and the map on the table is clearly of North America; Abigail Adams to Elizabeth Smith Shaw, July 28, 1784, AFP.

87. Abigail Adams said that she saw "at a distance 2 female figures representing Innocence, and Peace"; Abigail Adams to Elizabeth Smith Shaw, July 28, 1784, AFP. It is now possible to detect the pentimento of a second figure that Copley painted over at some later point. That indicates that Copley either eliminated the figure of Innocence, or he shifted the figure of Peace to the left.

88. Cornelius Vermeule, *Numismatic Art in America: Aesthetics of the United States Coinage* (Cambridge, MA: Belknap Press, 1971), 5; Cesare Ripa, *Iconologia, or, Moral Emblems* (London: Benjamin Motte, 1709), 54.

89. John Adams to Mercy Otis Warren, January 8, 1776, AFP.

90. "Thoughts on Government," in Adams, *Works*, 4:199.

91. John Adams to Mercy Otis Warren, January 8, 1776, AFP.

92. John Adams, Diary, October 26, 1782, AFP.

93. *Journal and Correspondence of Miss Adams, Daughter of John Adams* (New York and London: Wiley and Putnam, 1841), 14.

94. Abigail Adams to Mary Smith Cranch, September 5, 1784, AFP.

95. John Adams, Diary, December 9, 1779, AFP.

96. Personal expenditure accounts for February 1778; October 1, 1778; February 13, 1780; and July 1780; AFP.

97. David Shi, *The Simple Life: Plain Living and High Thinking in American Culture* (New York: Oxford University Press, 1985). On the topic of American simplicity, see Kate Haulman, *The Politics of Fashion in Eighteenth-Century America* (Chapel Hill: University of

North Carolina Press, 2011); Linzy Brekke, "'To Make a Figure': Clothing and the Politics of Male Identity in Eighteenth-Century America," *Gender, Taste, and Material Culture in Britain and North America, 1700–1830*, eds. John Styles and Amanda Vickery (New Haven, CT: Yale Center for British Art, 2006), 225–46.

98. John Adams to Elkanah Watson, April 10, 1778, in Elkanah Watson, *Men and Times of the Revolution, or, Memoirs of Elkanah Watson, Including Journals of Travels in Europe and America from 1777 to 1842, with His Correspondence with Public Men and Reminiscences and Incidents of the Revolution*, ed. Winslow C. Watson (New York: Dana and Company, 1856), 103.

99. John Adams, Diary, April 10, 1778, AFP.

100. George Washington to Bushrod Washington, January 15, 1783, Washington Papers, Library of Congress (http://memory.loc.gov/cgi-bin/query/P?mgw:1:./temp/~ammem_UyIG::).

101. Shi, *Simple Life*, 80; Benjamin H. Irvin, *Clothes in Robes of Sovereignty: The Continental Congress and the People out of Doors* (New York: Oxford University Press, 2011), 23–51.

102. Robert Ralph Davis Jr., "Diplomatic Plumage: American Court Dress in the Early National Period," *American Quarterly* 20, no. 2 (Summer 1968), 164.

103. Abigail Adams to Catharine Sawbridge Macaulay, 1774, AFP.

104. Thanks to Christopher Bryant for numerous conversations on swords and suits.

105. John Adams to Abigail Adams, February 13, 1776, AFP.

106. John Adams to Abigail Adams, May 29, 1775, AFP.

107. John Adams to Abigail Adams, August 19, 1777, AFP.

108. John Adams to William Tudor, April 27, 1777, AFP.

109. John Adams to Abigail Adams, June 23, 1775, AFP.

110. Abigail Adams to John Adams, July 16, 1775, AFP.

111. John Adams to Cotton Tufts, August 1782, AFP.

112. John Brewer Brown, *Swords Voted to Officers of the Revolution by the Continental Congress, 1775–1784* (Washington, D.C.: Society of the Cincinnati, 1965); Irvin, *Clothed in the Robes*, 219.

113. A pentimento in the drawing shows that Copley originally had Adams's right hand lifted to touch the figure of Peace.

114. Mary Healy Bigot, *Life of George P. A. Healy* (Chicago: privately published, 1912), 52–53.

115. On this topic, see Christopher J. Lukasik, "The Face of the Public," *Early American Literature* 39, no. 3 (2004), 413–64.

116. Abigail Adams to Mary Smith Cranch, July 25, 1784, AFP.

117. John Adams to John Quincy Adams, June 6, 1784, AFP.

118. Adams, *Davila*, in Adams, *Works*, 6:32.

119. John Adams to Thomas Jefferson, May 6, 1818, in *Works*, 10:216.

120. Oliver, *Portraits of John and Abigail Adams*, 33.

121. John Adams to John Stockdale, May 12, 1793, the British Museum, reprinted in *The Gentleman's Magazine* 35 (April 1851), 366.

122. Anthony Pasquin, *A Critical Guide to the Exhibition of the Royal Academy for 1796* (London: H. D. Symonds, 1797), cover.

123. Abigail Adams to John Adams, December 9, 1781, AFP.

124. Abigail Adams to Elizabeth Smith Shaw, July 28, 1784, AFP.

125. Martha Babcock Amory, *The Domestic and Artistic Life of John Singleton Copley* (Boston: Houghton Mifflin, 1882), 104.

126. Abigail Adams to Mary Smith Cranch, March 21, 1786, AFP. A poem about Copley's portrait appeared in Nabby's memoirs; "Lines Addressed in 1838, to a Portrait of Mrs. Smith, taken by Copley in 1787," *Journal and Correspondence of Miss Adams*, 97.

127. Abigail Adams to Mary Smith Cranch, June 13, 1786, AFP.

128. Oliver, *Portraits*, 40.

129. Quoted in Phyllis Lee Levin, *The Remarkable Education of John Quincy Adams* (New York: St. Martin's, 2015), 275.

130. Oliver, *Portraits*, 38.

131. Abigail Adams to Anna Quincy, September 4, 1784, AFP.

132. Abigail Adams to Elizabeth Smith Shaw, August 15, 1785, AFP.

133. Samuel Cooper to John Adams, July 22, 1782, AFP.

134. Some of the best treatments of this topic are: Martin Myrone, *Bodybuilding: Reforming Masculinities in British Art, 1750–1810* (New Haven, CT: Yale University Press, 2005), 191–305; Eliga Gould, "American Independence and Britain's Counter-Revolution," *Past & Present* 154 (February 1997), 107–41; J. H. Plumb, "British Attitudes to the American Revolution," *In the Light of History* (London: Allen Lane,1972), 70–89; Holger Hoock, *Empires of the Imagination: Politics, War, and the Arts in the British World, 1750-1850* (London: Profile Books, 2010).

135. Hoock, *Empires*, 117–29.

136. Even some relatively minor military figures, such as Rear Admiral Richard Kempenfelt, were painted monumentally by Tilly Kettle and by the American loyalist Ralph Earl.

137. See Jules David Prown, *John Singleton Copley*, 2 vols. (Cambridge: Harvard University Press, 1966), 2:302–10; and Emily Neff, *John Singleton Copley in England* (London: Merrill Holberton, 1995), 60–90.

138. *General Evening Post*, May 25, 1784.

139. Abigail Adams to Mary Smith Cranch, July 25, 1784, AFP.

140. Amory says that Susanna Copley mentioned "her husband's desire to return to America"; Amory, *Copley*, 127. The London diarist Joseph Farington confirmed that everyone "understood that Copley would go to America," Prown, *Copley*, 2:340.

141. Amory, *Copley*, 125; Prown, *Copley*, 2:340–41.

142. Amory, *Copley*, 36.

143. Ibid., 142.

144. Ibid., 144.

145. John Quincy Adams to John Singleton Copley, April 9, 1811, in Amory, *Copley*, 89.

146. See Susanna Copley to Elizabeth Copley Greene, June 5, 1817, in Amory, *Copley*, 328.

Chapter 7: John Trumbull's Martyrs

1. George Washington to Jonathan Trumbull Jr., October 1, 1785, Washington Papers, Library of Congress (http://memory.loc. gov/cgi-bin/query/P?mgw:4:./temp/~ammem_dngx::). Governor Trumbull was elected by the citizens of Connecticut, which was one of the rare colonies not to have a governor appointed by the Crown.

2. John Trumbull, *Autobiography, Reminiscences and Letters of John Trumbull, from 1756 to 1841* (New York: Wiley and Putnam, 1841), 11.

3. Jonathan Trumbull to William Kneeland, August 10, 1772, in Trumbull, *Autobiography*, 298.

4. Trumbull says that he studied William Hogarth's *Analysis of Beauty*, Charles du Fresnoy's *De Arte Graphica*, Roger de Piles's *Cours de Peinture*, Charles Le Brun's *Méthode pour apprendre à dessiner les passions*, and Horace Walpole's *Anecdotes of Painting in England*, as well as a set of prints by Piranesi. Art books accounted for less than one percent of Harvard library circulation in Trumbull's era; see Mark Olsen and Louis-Georges Harvey, "Book Borrowing from the Harvard College Library, 1773–1782," *Harvard Library Bulletin*, n.s. 4, no. 2 (Fall 1930), 69.

5. Trumbull, *Autobiography*, 13.

6. Ibid., 15–16.

7. Ibid., 17.

8. Ibid., 21.

9. Abigail Adams to John Adams, June 18, 1775, AFP.

10. Trumbull's appointment is in Washington's "General Orders," July 27, 1775, Washington Papers, Library of Congress (http://mem ory.loc.gov/cgi-bin/query/P?mgw:8:./temp/~ammem_sO6k::).

11. Trumbull, *Autobiography*, 42.

12. James Lovell to John Trumbull, March 17, 1777, *Letters of Delegates to Congress, 1774–1789* (Washington, D.C.: Library of Congress, 1976–2000), 6:452, 481; Elbridge Gerry referred to the "disrespectful Freedom" of Trumbull's accusation in Gerry to Joseph Trumbull, *Letters of Delegates to Congress*, 6:494–95; Trumbull, *Autobiography*, 43.

13. Trumbull, *Autobiography*, 46. There was speculation that if "Jack had really an Inclination to have continued in the Army" he could have become a Brigadier General; William Williams to Joseph Trumbull, *Letters of Delegates to Congress*, 8:343.

14. John Hancock to George Washington, April 20, 1777; *Letters of Delegates to Congress*, 6:628.

15. In an edited version of Trumbull's *Autobiography*, Theodore Sizer speculates that Trumbull was looking for some excuse to leave the military; Theordore Sizer, *The Autobiography of Colonel John Trumbull Patriot–Artist, 1756–1843* (New Haven, CT: Yale University Press, 1953), 41; as does Irma B. Jaffe, *John Trumbull: Patriot-Artist of the American Revolution* (Boston: New York Graphic Society, 1975), 30. William Dunlap said that "I cannot but think that the young gentleman made a great mistake even upon the narrow calculation of self-interest"; *History of the Rise and Progress of the Arts of Design in the United States*, 2 vols. (New York: George P. Scott, 1834) 1:350.

16. Richard H. Saunders, *John Smibert: Colonial America's First Portrait Painter* (New Haven, CT: Yale University Press, 1995), 125.

17. John Trumbull to David Trumbull, April 26, 1779, Trumbull Papers, Connecticut Historical Society, Hartford.

18. The popularity of Belisarius is discussed in Michael Fried, *Absorption and Theatricality: Painting and Beholder in the Age of Diderot* (Chicago: University of Chicago Press, 1988), 147–50. Trumbull's painting is discussed in Jaffe, *Trumbull*, 37.

19. Trumbull, *Autobiography*, 54.

20. He had failed in his attempt to become secretary to John Adams on his diplomatic mission abroad; *Letters of the Delegates to Congress*, 13:587.

21. Trumbull, *Autobiography*, 59.

22. John Trumbull to Jonathan Trumbull, February 2, 1780, in Trumbull, *Autobiography*, 308–9.

23. John Trumbull to Jonathan Trumbull, June 15, 1780, in Trumbull, *Autobiography*, 310. Jaffe, *Trumbull*, 44–49.

24. Wendy C. Wick, *George Washington, An American Icon: The Eighteenth-Century Graphic Portraits* (Washington, D.C.: Smithsonian, 1982).

25. The figure of Peace also holds a shield that has small profiles of Henry Laurens and John Adams.

26. For the André phenomenon, see Robert D. Arner, "The Death of Major André: Some Eighteenth-Century Views," *Early American Literature* 11, no. 1 (Spring 1976), 52–67.

27. *London Courant* (January 19, 1781); see *Letters of Thomas Attwood Digges (1742-1821)* ed. Robert H. Elias and Eugene D. Finch (Columia, SC: University of South Carolina Press, 1982), 337, 338. One of the accusers was John Grey, formerly of Boston, who had once called for lynching John Adams. Even though the Doctor was in Paris, he had the capacity to arouse suspicion in British government circles. His name had already surfaced as a threat a few months before Trumbull's arrest, during the Gordon riots that ravaged the city in the summer of 1780. At the most paranoid moments of the uprising there had been accusations that Franklin was the mastermind of the eight days of looting and burning. Already one American, James Smith, had been arrested as Franklin's secret agent, and another, the American art dealer and former painter John Greenwood, was under suspicion; Richard B. Morris, *The Peacemakers: The Great Powers and American Independence* (New York: Harper and Row, 1965), 85. Horace Walpole thought that the Ministry was trying to connect Trumbull to the Gordon riots; Charles Warren, "A Young American's Adventures in England and France during the Revolutionary War," *Proceedings of the Massachusetts Historical Society*, 3rd series, 65 (October 1934), 248.

28. Thomas Digges to John Adams, November 22, 1780, AFP.

29. John Adams to Benjamin Franklin, November 30, 1780, AFP.

30. John Almon, *The Remembrancer, or Impartial Repository of Public Events*, 14 vols. (London: J. Almon, 1780), 10:377.

31. Thomas Digges to John Adams, November 22, 1780, AFP.

32. Trumbull, *Autobiography*, 317.

33. Ibid., 323.

34. Ibid., 328.

35. *Royal Gazette* (March 10, 1781); in Warren, "A Young American's Adventures," 246.

36. Trumbull, *Autobiography*, 316.

37. Trumbull, *Autobiography*, 69. Ironically, Trumbull would design the mahogany casket used to transport André's remains back to England in 1821; see Theodore Sizer, "The Perfect Pendant: Major André and Colonel Trumbull," *The New-York Journal of American History* 65 (2003), 42–46.

38. Trumbull, *Autobiography*, 316–17.

39. Warren, "A Young American's Adventures," 247.

40. Ibid., 249.

41. John Trumbull to Jonathan Trumbull, September 12, 1780, in Trumbull, *Autobiography*, 311.

42. The letter was reported in the *London Evening Post*; see Digges, *Letters*, li. For Digges's position, see William Bell Clark, "In Defense of Thomas Digges," *Pennsylvania Magazine of History and Biography* 77, no. 4 (October 1953), 402–03, 420–24. Jaffe, *Trumbull*, reprints the mysterious letter, 48–49. In court, Trumbull identified the mysterious author of the letter as Thomas Digges; *The London Chronicle*, November 21–23, 1780.

43. *The Political Magazine*, quoted in Digges, *Letters*, li. Washington interviewed Trumbull about Digges in 1794, whereupon Trumbull admitted he was well acquainted with Digges; Digges, *Letters*, lxviii.

44. Thomas Digges to John Adams, February 11, 1781, in Digges, *Letters*, 350. Leendert de Neufville to Benjamin Franklin, February 8, 1781, Franklin Papers, American Philosophical Society (http://franklinpa pers.org/franklin/framedVolumes.jsp?tocvol=34).

45. Digges, *Letters*, 344–45.

46. Jaffe, *Trumbull*, 49–50.

47. John Adams to Arthur Lee, December 6, 1780, AFP.

48. Thomas Digges to John Adams, February 11, 1781, AFP.

49. John Adams to John Bondfield, December 6, 1780, AFP.

50. Abigail Adams to John Thaxter, May 23, 1781, AFP.

51. When Trumbull came to write his autobiography in 1841, he never once mentioned Digges or the plan to buy British goods and ship them to the Continental Army.

52. Joseph Farington, *The Farington Diary*, ed. James Greig, 8 vols. (New York: Doran, 1922–24), 1:279.

53. It was acknowledged at the time that Trumbull's arrest was in "retaliation for Major André's death," and that Trumbull was "exactly of André's rank, and is therefore thought a proper person to retaliate upon"; Thomas Digges to Benjamin Franklin, November 21, 1780, Benjamin Franklin Papers, University of Pennsylvania Library (http://franklinpapers.org/franklin/framedVolumes.jsp?tocvol=28).

54. Located in Pilgrim Hall Museum, Plymouth, Massachusetts. Trumbull's drawing of ca. 1784-86, *I Was in Prison and Ye Came Unto Me*, a passage from the Book of Matthew, was a tribute to those who did visit Trumbull in prison; Yale University Library.

55. One example is at Fordham University Library, inscribed "Jn. Trumbull June 1783 No 16."

56. Robert Stewart, *Robert Edge Pine: British Portrait Painters in America, 1784–1788* (Washington: National Portrait Gallery, 1979), 24. Washington to George William Fairfax, June 30, 1785, Washington Papers, Library of Congress (http://memory.loc.gov/cgi-bin/query/P?mgw:7:./temp/~ammem_WgDt::).

57. Martin Myrone, *Bodybuilding: Reforming Masculinities in British Art, 1750–1810* (New Haven, CT: Yale University Press, 2005), 202–9.

58. John Quincy Adams to Elizabeth Cranch, April 18, 1784, AFP.

59. Trumbull carried a few letters from America, one from Abigail Adams to her husband—who had helped ease Trumbull's passage from England to Amsterdam en route to America—and another, a letter of thanks, from Governor Trumbull to Burke, who had secured the young artist's release from prison and was now advising him to study architecture so that he might design new public buildings for the United States; Abigail Adams to John Adams, November 11, 1783, AFP. Trumbull, *Autobiography*, 90.

60. Anthony Ashley Cooper Shaftesbury, *Characteristicks of Men, Manners, Opinions, Times*, 5th ed., 3 vols. (Birmingham, UK: Baskerville, 1773), 3:362.

61. Nabby Adams to John Quincy Adams, September 21, 1785, Adams Papers Online, Massachusetts Historical Society; Nabby Adams to John Quincy Adams, January 22, 1786, AFP.

62. John Trumbull to Jonathan Trumbull Jr., August 2, 1785, Trumbull Papers, Yale University Library.

63. Dunlap, *History*, 1:356.

64. John Temple's Declaration to the Council of Massachusetts, "Bowdoin and Temple Papers," 465–67, 452; Leendert de Neufville to

James Bowdoin, May 1, 1781, "Bowdoin and Temple Papers," 451–53.

65. For the new British nationalism, see Myrone, *Bodybuilding*, 212–26; Holger Hoock, *Empires of the Imagination: Politics, War, and the Arts in the British World, 1750–1850* (London: Profile Books, 2010), 117–20; and Hoock, *The King's Artists: The Royal Academy of Arts and the Politics of British Culture, 1760–1840* (New York: Oxford University Press, 2005), 164–72.

66. Troy Bickham, *Making Headlines: The American Revolution as Seen through the British Press* (DeKalb: Northern Illinois University Press, 2008), 205. Washington's selfless civic virtue was recognized by the newly founded Society of the Cincinnati, which was inaugurated in May of 1783 by General Henry Knox near the Continental Army's final encampment in New Windsor, New York, at a time when Trumbull was working as a civilian for Knox. A copy of the original 1783 charter of the society is in Trumbull's handwriting; Charter of the Society of the Cincinnati, June 19, 1783, Gilder Lehrman Institute Archives (https://www.gilderlehrman.org/col lections/ec14ff2a-6c0e-4330-b631-678400880958?back=/mweb/ search%3Fpage%3D1%2526needle%3Dsociety%2520cincinnati). Trumbull's brother and brother-in-law were named founding members, and his father, who was a civilian, was named an honorary member in March of 1784. When Trumbull received news of his election to the society while he was in London, he looked forward to parading around the city with the medal on his chest.

67. John Trumbull to Jonathan Trumbull, March 10, 1784, Trumbull Papers, Connecticut Historical Society, Hartford.

68. Trumbull went with West's elder son, Raphael, to Kent to visit the Reverend Samuel Preston and settled into his extraordinary classical library containing 2,500 volumes of illustrated history, geography, and art.

69. Helen A. Cooper, *John Trumbull: The Hand and Spirit of a Painter* (New Haven, CT: Yale University Art Gallery, 1982), 248.

70. For more on the picture, see Cooper, *Trumbull*, 247–48. Numerous other sources have been proposed, from Trajan's Column to West's painting of Saint Stephen. Atalanta Baglioni of Perugia commissioned the picture from Raphael in honor of her fallen soldier-son, Grifonetto.

71. For example, the correspondence between past and present resurfaced in an ink drawing that shows Joshua and Death assaulting the Canaanites. Trumbull based the terrifying image on a passage from an epic poem by the American theologian Timothy Dwight. Though the poem and the drawing both derive from the Hebrew Bible, it was widely understood that the true subjects are Washington and the American Revolution. Dwight had written parts of the poem while serving as military chaplain under General Samuel Parsons and he had come to know Washington while he was stationed at White Plains. There he succeeded in persuading Washington to endorse the poem. When it was published in 1785, Dwight dedicated it to "his Excellency, GEORGE WASHINGTON . . . Commander in chief of the American Armies, the Saviour of his Country, The Supporter of Freedom, And the Benefactor of Mankind."

72. Kenneth Silverman, *Timothy Dwight* (New York: Twayne, 1969), 24–45.

73. John Trumbull to Jonathan Trumbull Jr., March 10, 1784, Trumbull Papers, Yale University Library.

74. John Trumbull to Jonathan Trumbull Jr., November 15, 1784, Trumbull Papers, Yale University Library.

75. John Trumbull to Jonathan Trumbull Jr., September 13, 1785, Trumbull Papers, Yale University Library.

76. John Trumbull to David Trumbull, January 31, 1786, Trumbull Papers, Yale University Library.

77. Abigail Adams to Elizabeth Smith Shaw, March 4, 1786, AFP.

78. Abigail Adams to John Adams, March 4, 1786, AFP. Abigail's daughter Nabby, seeing the picture six weeks earlier, said "I was frozen, it is enough to make ones hair to stand on End . . . the scene is dreadfully beautifull, or rather dreadfully expressive"; Nabby Adams to John Quincy Adams, Adams Papers Online, January 22, 1786.

79. On race, see Patricia M. Burnham, "John Trumbull, Historian: The Case of the Battle of Bunker's Hill," *Redefining American History Painting*, ed. Patricia M. Burnham and Lucretia Hoover Giese (Cambridge: Cambridge University Press, 1995), 47–48.

80. Abigail Adams to John Adams, March 4, 1786, AFP.

81. Farington, *Diary*, 4:151.

82. For the battle, see James L. Nelson, *With Fire & Sword: The Battle of Bunker Hill and the Beginning of the American Revolution* (New York: Thomas Dunne, 2011); W. J. Wood, *Battles of the Revolutionary War, 1775–1781* (Chapel Hill: Algonquin Books, 1990), 3–34.

83. Jaffe, *Trumbull*, 317.

84. Dunlap, *History*, 1:733

85. Benjamin Hichborn to John Adams, December 10, 1775, AFP; Abigail Adams to John Adams, July 31, 1775, AFP.

86. Lieutenant J. Waller to Undisclosed Recipient, June 21, 1775, Massachusetts Historical Society (https://www.masshist.org/bh/wallerp2text.html).

87. Jaffe, *Trumbull*, 88. See David Bindman, "Americans in London: Contemporary History Painting Revisited," *English Accents: Interactions with British Art c. 1776–1855*, eds. Christiana Payne and William Vaughan (Burlington, VT : Ashgate, 2004), 9–22; Burnham, "Trumbull," 49. On the sentimentality of honor, see Rebecca Bedell, "What is Sentimental Art?," *American Art*, 25, no. 3 (Fall

2011), 9–12.

88. John Adams acquired Copley's oil study for the final painting; Adams National Historical Park, Quincy, Massachusetts.

89. On the sword, see Samuel A. Forman, *Dr. Joseph Warren: The Boston Tea Party, Bunker Hill, and the Birth of American Liberty* (Gretna, LA: Pelican, 2012), 350-51.

90. Philip Davidson, *Propaganda and the American Revolution, 1763–1783* (New York: Norton, 1941), 197.

91. Eran Shalev discusses Warren's toga in *Rome Reborn on Western Shores: Historical Imagination and the Creation of the American Republic* (Charlottesville: University of Virginia Press, 2009), 114–41. See Sandra Gustafson, *Eloquence is Power: Oratory and Performance in Early America* (Chapel Hill: University of North Carolina Press, 2000), 182–94.

92. Davidson, *Propaganda*, 9.

93. James Warren to Mercy Otis Warren, June 18, 1775, Warren Papers, Massachusetts Historical Society.

94. Mercy Otis Warren, "To the Hon. James Warren, Esq., President of the Congress of Massachusetts, on the death of his friend, Major General Warren" in *Proceedings of the Bunker Hill Monument Association* (Boston: Bunker Hill Monument Association, 1907), 50.

95. See Sarah J. Purcell, *Sealed with Blood: War, Sacrifice, and Memory in Revolutionary America* (Philadelphia: University of Pennsylvania Press, 2002). Of course, Loyalists thought that Warren was just another fanatic. Copley's half-brother, Henry Pelham, said, "I have often passed Doct Warren's Grave. I felt a disagreab Sensation, thus to see a Townman and an old Acquaintance led by unbounded Ambition to an untimely death and thus early to realise that Ruin which a lust of Power and Dominion has brought upon himself and partly through his means upon this unhappy Country. I would wish to forget

his principles to Lament his Fate." Henry Pelham to Susanna Copley, July 23, 1775, in *Letters and Papers of John Singleton Copley and Henry Pelham, 1739–1776*, ed. Guernsey Jones (Boston: Massachusetts Historical Society, 1914), 346–47.

96. Shalev, *Rome Reborn*, 131.

97. *An Elegiac Poem, Composed on the Never-To-Be-Forgotten Terrible and Bloody Battle Fought at an Intrenchment on Bunker-Hill* (Salem: E. Russell, 1775).

98. It seemed as though Warren's life and death were being commemorated everywhere, even in the form of the new Warren Tavern in Charlestown that Captain Eliphalet Newell, who was one of the "Indians" who dumped tea in Boston Harbor, opened in 1780 not far from where the good doctor had fallen. Mention of Newell appears in *American Monthly Magazine* 11 (July-December, 1897), 326.

99. Norman etched Warren two more times. One print appeared in *An Impartial History of the Present War in America*, 2 vols. (Boston: Robert Hodge, 1783), 349; and another, after Copley's portrait, appeared in *The Boston Magazine* (April 1784), 221.

100. For an overview of the process of making Bunker's Hill epic, see Jason Shaffer, "Making 'an Excellent Die': Death, Mourning, and Patriotism in the Propaganda Plays of the American Revolution," *Early American Literature* 41, no. 1 (2006), 1–27; and Purcell, *Sealed with Blood*.

101. Michael P. Gabriel, *Major Richard Montgomery: The Making of an American Hero* (Madison, NJ: Fairleigh Dickinson University Press, 2001), 166.

102. Hunting shirts, belts, and buckskin leggings were like the togas and armored tunics worn by the Romans, and they were flagrantly not British. See Kevin Philips, *1775: A Good Year for Revolution* (New York: Viking, 2012), 3. In 1775 members of the Virginia House of Burgesses were asked to put aside their British clothing and instead wore "coarse linen or canvas over their Cloaths and a Tomahawk by

their Sides"; Rhys Isaac, "Dramatizing the Ideology of Revolution: Popular Mobilization in Virginia, 1774 to 1776," *William and Mary Quarterly*, 3rd ser., 33, no. 3 (July 1976), 381-82.

103. Cooper, *Trumbull*, 54.

104. John Adams to Henry Knox, June 2, 1776, AFP.

105. Gabriel, *Montgomery*, 175.

106. Ibid., *Montgomery*, 176.

107. Intended for Independence Hall, it was installed at St. Paul's Chapel in New York in 1787. See Purcell, *Sealed with Blood*, 26–33; and Sally Webster, *The Nation's First Monument and the Origins of the American Memorial Tradition: Liberty Enshrined* (Farnham, UK: Ashgate, 2015).

108. Gabriel, *Montgomery*, 178–9.

109. Ibid., 182–83.

110. See Shaffer, "Making 'an Excellent Die,'" 1–27.

111. Nathanael Greene to John Adams, May 2, 1776, AFP.

112. David Hackett Fischer, *Washington's Crossing* (New York: Oxford University Press, 2004), 332.

113. Benjamin Rush to Thomas Ruston, October 29, 1775, *Letters of Benjamin Rush*, 2 vols., ed. L. H. Butterfield (Princeton: Princeton University Press, 1951), 1:92.

114. See Theodore Sizer, "Trumbull's 'The Battle of Princeton,'" *Princeton Library Chronicle* 12, no. 1 (Autumn 1950), 1–5.

115. John Trumbull, *Catalogue of Paintings, by Colonel Trumbull* (New Haven, CT: Howe & Co., 1832), 22.

116. Thomas Jefferson to James Madison, April 25, 1786, *The Writings of Thomas Jefferson*, 20 vols. ed. Albert Ellery Bergh (Washington: Jefferson Memorial Association: 1907), 19–20:29.

117. For Jefferson as a collector, see Harold E. Dickson, "'Th.J.' Art Collector," in *Jefferson and the Arts: An Extended View, ed. by William Howard Adams (Washington*: 1976), 114–16; Gaye Wilson, "'Behold me at Length on the vaunted Scene of Europe': Thomas Jefferson and the Creaton of an American Image Abroad," in *Old World, New World: America and Europe in the Age of Jefferson* ed. Leonard J. Sadosky, Peter Nicolaisen, Peter S. Onuf, and Andrew J. O'Shaughnessy (Charlottesville: University of Virginia Press, 2010) 155–78; and Roger Stein, "Mr. Jefferson as Museum Maker," in *Shaping the Body Politic: Art and Political Formation in Early America*, ed. Maurie D. McInnis and Louis P. Nelson (Charlottesville: University of Virginia Press, 2011), 194–230.

Chapter 8: Thomas Jefferson's Invitation

1. Marie Kimball, *Jefferson: The Scene of Europe, 1784–1789* (New York: Coward-McCann, 1950), 116.

2. The figure of Liberty is much like Jefferson's description of a statue that he and Adams observed in England in April, 1786: "From one of these [ponds] there is a fine cascade; but it can only be occasionally, by opening the sluice. This is in a small, dark, deep hollow, with recesses of stone in the banks on every side. In one of these is a Venus pudique, turned half round as if inviting you with her into the recess"; Julian P. Boyd et al., eds., *The Papers of Thomas Jefferson*, 25 vols. (Princeton: Princeton University Press, 1950–2013), 9:372.

3. Jefferson said that he consulted with Copley, West, and Trumbull in London. Thomas Jefferson to George Washington, August 14, 1787, Washington Papers, Library of Congress (http://memory.loc.gov/cgi-bin/query/P?mgw:2:./

temp/~ammem_PE4Y::); see Maurie D. McInnis, "George Washington: Cincinnatus or Marcus Aurelius," in *Thomas Jefferson, the Classical World, and Early America*, eds. Peter S. Onuf and Nicholas P. Cole (Charlottesville: University of Virginia Press, 2011), 128–70; and Maurie D. McInnis, "Revisiting Cincinnatus: Houdon's *George Washington*," in *Shaping the Body Politic: Art and Political Formation in Early America*, eds. Maurie D. McInnis and Louis P. Nelson (Charlottesville: University of Virginia Press, 2011), 128–61.

4. James Monroe to Thomas Jefferson, April 12, 1785, Jefferson Papers, Library of Congress (https://www.loc.gov/collections/thomas-jefferson-papers).

5. Marie Kimball documented the picture's location in Jefferson's house on January 13, 1786; see Charles Coleman Sellers, "Portraits and Miniatures by Charles Willson Peale," *Transactions of the American Philosophical Society*, n. s., 42 (1952), 237.

6. Roger Stein discusses Jefferson's buying in "Mr. Jefferson, Museum Maker," *Shaping the Body Politic*, 194–230.

7. Thomas Jefferson to Maria Cosway, April 24, 1788; in *Papers of Thomas Jefferson*, 13:103–4. On Jefferson's interest in art, see Kenneth Hafertepe, "An Inquiry into Thomas Jefferson's Ideas of Beauty," *Journal of the Society of Architectural Historians* 59, No. 2 (June 2000), 216–31.

8. John Trumbull to Thomas Jefferson, June 11, 1789, Jefferson Papers, Library of Congress (https://www.loc.gov/item/mtjbib004330/).

9. Thomas Jefferson to Francis Hopkinson, August 14, 1786, Jefferson Papers, Library of Congress (https://www.loc.gov/resource/mtj1.006_0163_0165/?st=gallery).

10. Thomas Jefferson to Ezra Stiles, September 1, 1786, Jefferson Papers, Library of Congress (https://www.loc.gov/item/mtjbib002233/).

11. Kimball, *Jefferson*, 105.

12. John Trumbull to Thomas Jefferson, September 17, 1787, Jefferson Papers, Library of Congress (https://www.loc.gov/item/mtjbib002959/).

13. John Trumbull, *Autobiography, Reminiscences and Letters of John Trumbull from 1756 to 1841* (New York: Wiley and Putnam, 1841), 147.

14. Trumbull, *Autobiography*, 111. On Trumbull's admiration for Le Brun, see Theodore Sizer, "The John Trumbulls and Mme. Vigée Le Brun," *Art Quarterly* 15 (Summer 1952), 170–78.

15. Trumbull, *Autobiography*, 96.

16. Ibid., 113.

17. Thomas Jefferson, letter to Francis Hopkinson, August 14, 1786, Jefferson Papers, Library of Congress (https://www.loc.gov/resource/mtj1.006_0163_0165/?st=gallery).

18. Thomas Jefferson to Maria Cosway, October 12, 1786, Jefferson Papers, Library of Congress (https://www.loc.gov/item/mtjbib002293/).

19. Alastair J. L. Blanshard, *Sex: Vice and Love from Antiquity to Modernity* (Chichester, UK: Wiley, 2010), 66.

20. John Trumbull to Jonathan Trumbull, February 6, 1788, Trumbull Papers, Yale University Library.

21. Thomas Jefferson to Maria Cosway, October 12, 1786, Jefferson Papers, Library of Congress (https://www.loc.gov/item/mtjbib002293/).

22. Stephen Lloyd, *Richard and Maria Cosway: Regency Artists of Taste and Fashion* (Edinburgh: National Galleries of Scotland, 1995), 23.

23. Nabby Adams to John Quincy Adams, January 30, 1786, AFP.

24. Ted Jones, *Florence and Tuscany: A Literary Guide* (London: Tauris, 2012), 49.

25. Henry Adams quotes Edmund Randolph, in Adams, *History of the United States during the First Administration of Thomas Jefferson*, 2 vols. (New York: Charles Scribner's Sons, 1889), 409.

26. Thomas Jefferson to John Trumbull, February 23, 1787, Jefferson Papers, Library of Congress (https://www.loc.gov/item/mtjbib002569/). He is cited by Jefferson simply as "Trumbull" or "our friend Trumbull," never as Mr. Trumbull or what he would have preferred, Colonel Trumbull.

27. Thomas Jefferson to John Trumbull, August 28, 1787, Jefferson Papers, Library of Congress (https://www.loc.gov/item/mtjbib001503/).

28. Thomas Jefferson to John Trumbull, August 30, 1787, Jefferson Papers, Library of Congress (https://www.loc.gov/item/mtjbib001509/).

29. Ibid.

30. Trumbull said that it was in Jefferson's house that he "began the composition of the Declaration of Independence, with the assistance of his information and advice"; Trumbull, *Autobiography*, 96.

31. Garry Wills, *Inventing America: Jefferson's Declaration of Independence* (New York: Vintage, 1979), xxv, 324–60. According to Wills, Jefferson was not widely associated with the document in America until 1797, when he was Vice President.

32. Wills, *Inventing*, 327–79.

33. Thomas Jefferson, *Autobiography* (Mineola, NY: Dover, 2005), 79.

34. See Ronald Paulson, "John Trumbull and the Representation of the American Revolution," *Studies in Romanticism* 21, no. 3 (Fall 1982), 341–56.

35. Trumbull, *Autobiography*, 53.

36. Ibid., 418.

37. The definitive history of the document is Pauline Maier's masterful *American Scripture: Making the Declaration of Independence* (New York: Knopf, 1997). See Wills, *Inventing*, 339. Later in his life, Trumbull himself started saying that the picture depicts July 4, 1776, probably because the entire range of events from that revolutionary summer had been subsumed into the catchphrase "Fourth of July."

38. Trumbull, *Autobiography*, 165–66.

39. John Trumbull to Thomas Jefferson, December 28, 1817, Trumbull Papers, Yale University Library. Trumbull added the last portrait in December of 1817.

40. Trumbull, *Autobiography*, 420.

41. David Hackett Fischer, *Washington's Crossing* (New York: Oxford University Press, 2006), 248.

42. Capitoline Museum, Rome.

43. Marcus Aurelius Antoninus, *The Meditations of Marcus Aurelius*, 12 vols. (Cambridge, MA: Harvard Classics, 1909–14), 10, section 8. The Hessian defeat was depicted in pictures before Trumbull's: see Daniel Chodowiecki, *Die Hessen, Vom General Washington am 25ten Dec. 1776, zu Trenton Überfallen, Werden als Kriegsgefangne in Philadelphia Eingebracht*, engraving, 1784, Library of Congress.

44. John Adams to Abigail Adams, February 17, 1777, AFP.

45. Fischer, *Washington's Crossing*, 375.

46. Ibid., 378.

47. The fate of the Hessians is described in Daniel Krebs, *A Generous and Merciful Enemy: Life for German Prisoners of War during*

the American Revolution (Norman: University of Oklahoma Press, 2013) 95–101, 146–84.

48. He began making drawings in 1786 but none survive. At the time of the surrender, Trumbull was on his way back to America after his imprisonment in London.

49. John Trumbull to Jonathan Trumbull, September 7, 1789, Trumbull Papers, Yale University Library.

50. John Trumbull to Harriet Wadsworth, February 27, 1790, Trumbull Papers, Yale University Library.

51. Abigail Adams to Lucy Ludwell Paradise, September 6, 1790, AFP.

52. Trumbull, *Autobiography*, 339–40.

53. Irma B. Jaffe, *John Trumbull: Patriot-Artist of the American Revolution*, (Boston: New York Graphic Society, 1975), 154.

54. Joel Barlow, *The Vision of Columbus* (Hartford, CT: Hudson and Goodwin, 1787), 210.

55. George Washington to Lafayette, November 21, 1791, Washington Papers, Library of Congress (http://memory.loc.gov/cgi-bin/query/P?mgw:5:./temp/~ammem_pdwp::). An outline drawing of Lafayette's bedroom shows that he had hung Trumbull's *Declaration* and *Death of General Warren* in his bedroom, which also contained a print of Peale's *Washington at Princeton*; see Jules Cloquet, *Recollections of the Private Life of General Lafayette* (London: Baldwin and Cradock, 1835), 248–50. For the Peale, see Joseph Langlumé, *Lafayette's Bedroom at Château de La Grange*, lithograph, Cornell University Library.

56. *The Papers of Alexander Hamilton*, ed. Harold C. Syrett, 10 vols. (New York: Columbia University Press, 1961–87), 10:482.

57. *The Diaries of George Washington, 1748–1799*, ed. John C. Fitzpatrick, 4 vols. (Boston: Houghton Mifflin, 1925), 4:71

58. Trumbull refers to the "painting-room;" *Autobiography*, 165.

59. *Minutes of the Common Council of the City of New York, 1784–1831* (New York: City of New York, 1917), 565, 591.

60. Trumbull, *Autobiography*, 164.

61. James Riker, *"Evacuation Day," 1783: Its Many Stirring Events: with Recollections of Capt. John Van Arsdale* (New York: private, 1883), 19. See Judith L. Van Buskirk, *Generous Enemies: Patriots and Loyalists in Revolutionary New York* (Philadelphia: University of Pennsylvania Press, 2002), 183.

62. Trumbull, *Autobiography*, 164.

63. Ibid., 166–67.

64. Ibid., 167.

65. Ibid.

66. John Walton Caughey, *McGillivray of the Creeks* (Norman: University of Oklahoma Press, 1938) is the key biography. The best analysis of the negotiations is in Joseph J. Ellis, *American Creation: Triumphs and Tragedies at the Founding of the Republic* (New York: Knopf, 2007), 127–64.

67. Abigail Adams to Mary Smith Cranch, August 8, 1790, AFP.

68. The uniform could be from some other nation since Britain and Spain were also in the habit of giving out regalia as tokens of friendship. See Francis Paul Prucha, *Indian Peace Medals in American History* (Bluffton, SC: Rivilo Books, 1994), 3.

69. Trumbull, *Autobiography*, 164–65.

70. *Pennsylvania Packet and Daily Advertiser* (August 18, 1790); in Caughey, *McGillivray*, 278.

71. William L. Stone, *The Life and Times of Red-Jacket* (New York: Wiley and Putnam, 1841), 56.

72. In a message to Knox, Brant talked about the uneasiness this caused within the tribes; Isabel Thompson Kelsay, *Joseph Brant, 1754-1807, Man of Two Worlds* (Syracuse, NY: Syracuse University Press, 1984), 463–64.

73. Chainbreaker, *Chainbreaker: The Revolutionary War Memoirs of Governor Blacksnake as told to Benjamin Williams*, ed. Thomas S. Abler (Lincoln: University of Nebraska Press, 1989).

74. On Good Peter, see "Good Peter's Narrative of Several Trans-actions Respecting Indian Lands," *New York History* 84, no. 3 (Summer 2003), 237–73. On Governor Blacksnake, see Thomas S. Abler, "Governor Blacksnake as a Young Man? Speculation on the Identity of Trumbull's The Young Sachem," *Ethnohistory* 34, no. 4 (Autumn 1987), 329–51. In 1796 Trumbull was called upon by Rufus King to design presentation medals to be struck in silver (500) and in copper (200); see Prucha, *Indian Peace Medals*, 89–90.

75. Written on the verso of the painting; see Abler, "Blacksnake," 340–41.

76. Abler, "Blacksnake," 341.

77. Harriet S. Caswell, *Our Life among the Iroquois Indians* (Boston: Congregational Sunday-School, 1892), 66.

78. Another artist in Philadelphia, William Birch, also recognized the possibilities of the occasion when he depicted the Indian delega-tion walking down Fourth Street near the German Zion Church.

79. Trumbull, *Autobiography*, 168–69.

80. Ibid., 170–72.

81. Ibid., 245.

82. Carrie Rebora Barratt and Ellen G. Miles, *Gilbert Stuart*, exhi-
 bition catalog, The Metropolitan Museum of Art (New Haven,
 CT: Yale University Press and The Metropolitan Museum of Art,
 2004), 104.

Chapter 9: Gilbert Stuart's Washington

1. Sarah Cunningham to Griselda Clinch, August 5, 1825, Mor-
 ton-Cunningham-Clinch Papers, Massachusetts Historical Society.

2. Abigail Adams to Thomas Boylston Adams, June 12, 1801, AFP.

3. Abigail Adams to John Quincy Adams, December 30, 1804, AFP.

4. James Herring and James B. Longacre, *The National Portrait Gal-
 lery of Distinguished Americans*, 3 vols. (New York: Monson Ban-
 croft, 1834), 1:np.

5. Benjamin Henry Latrobe to Thomas Jefferson, May 19, 1811, in
 Lillian B. Miller, *The Selected Papers of Charles Willson Peale*, 5
 vols. (New Haven, CT: Yale University Press, 1991), 3:92. Stu-
 art's character is extensively discussed by Susan Rather, "Contrary
 Stuart," *American Art* 24 (Spring 2010), 66–93; Dorinda Evans,
 Gilbert Stuart and the Impact of Manic Depression (Farnham, UK:
 Ashgate, 2013); and Carrie Rebora Barratt and Ellen G. Miles,
 Gilbert Stuart, (New Haven, CT: Yale University Press and The
 Metropolitan Museum of Art, 2004).

6. Charles Willson Peale to Rembrandt Peale, May 8, 1805, in Miller,
 Selected Papers, 2:829–830; Charles Willson Peale to Rembrandt
 Peale, September 1, 1808, in Miller, *Selected Papers*, 2:1139. Peale
 hoped that his son Rembrandt could become as good as Stuart in
 painting portraits of women.

7. The portrait in the White House might be a copy by William
 Winstanley; conversation with Dorinda Evans. See Barratt and
 Miles, *Stuart*, 181–82.

8. See my essay "Gilbert Stuart's Presidential Imaginary," in *Shaping the Body Politic: Art and Political Formation in Early America*, eds. Maurie D. McInnis and Louis P. Nelson (Charlottesville: University of Virginia Press, 2011), 162–93.

9. William Dunlap, *History of the Rise and Progress of the Arts of Design in the United States*, 2 vols. (New York, George P. Scott, 1834), 1:164

10. *Newport Mercury* (November 17, 1763, and November 16, 1766).

11. Anecdote of Gilbert Stuart," *The New-Yorker: A Weekly Journal of Literature, Politics, Statistics, and General Intelligence*, vol. 6, no. 22 (February 16, 1839), 344.

12. George C. Mason, *The Life and Works of Gilbert Stuart* (New York: Charles Scribner's Sons, 1894), 8.

13. Benjamin Waterhouse, "Autobiography of Gilbert Stuart," undated manuscript, Countway Library, Harvard Medical School, 22.

14. Waterhouse, "Stuart," 19.

15. Dunlap, *History*, 1:176.

16. John Quincy Adams to John Singleton Copley, April 29, 1811, in *Writings of John Quincy Adams*, ed. Worthington Chauncey Ford, 7 vols. (New York: Macmillan, 1913–17), 4:71.

17. Gilbert Stuart to Benjamin West, undated, Miscellaneous Manuscripts, New-York Historical Society.

18. Mason, *Stuart*, 12.

19. Dunlap, *History*, 1:178.

20. Quoted in Barratt and Miles, *Stuart*, 27.

21. Dunlap, *History*, 1:179.

22. Mason, *Stuart*, 63.

23. Barratt and Miles, *Stuart*, 36.

24. Ibid., 64.

25. Mason, *Stuart*, 20.

26. Ibid., 18.

27. Dunlap, *History*, 1:193, 195.

28. Ibid., 1:188.

29. Jane Stuart, "The Youth of Gilbert Stuart," *Scribner's Monthly* 13 (March 1877), 645.

30. Mason, *Stuart*, 24.

31. Barratt and Miles, *Stuart*, 78.

32. John Dowling Herbert, *Irish Varieties, For the Last Fifty Years: Written from Recollections* (London: William Joy, 1836), 248.

33. For a sense of the already vast array of Washingtonia that existed before Stuart's return in 1793, see David Meschutt, "Life Portraits of George Washington," *George Washington, American Symbol*, ed. Barbara Mitnick (New York: Hudson Hills Press, 1999), 25–37; and William Ayres, "At Home with George: Commercialization of the Washington Image, 1776–1876" in *George Washington: American Symbol*, ed. Barbara J. Mitnick (New York: Hudson Hills Press, 1999), 91–107.

34. Barratt and Miles, *Stuart*, 121, 123.

35. Dunlap, *History*, 1:195.

36. Joseph Farington, *The Farington Diary*, ed. James Greig, 8 vols. (London: Hutchinson, 1922), 7:57.

37. Samuel White Patterson, *Horatio Gates: Defender of American Liberties* (New York: Columbia University Press, 1941), 373.

38. Dunlap, *History*, 1:197.

39. Ibid.

40. For a discussion of the sittings, see Barratt and Miles, *Stuart*, 134.

41. John Neal, "Our Painters," *Atlantic Monthly* 22 (December 1868), 641.

42. Mason, *Stuart*, 20.

43. Dunlap, *History*, 1:197–98

44. Mason, *Stuart*, 20.

45. Washington Allston, as reported in a review of Dunlap, *History*, in *The American Quarterly Review* 17 (March–June 1835), 154.

46. Jane Stuart, "Youth," 372.

47. Mason, *Stuart*, 55.

48. Dunlap, *History*, 1:197.

49. Isaac Weld, *Travels Through the States of North America, and the Provinces of Upper and Lower Canada, During the Years 1795, 1796, and 1797*, 4th ed. (London: John Stockdale, 1807), 105–06.

50. Dunlap, *History*, 1:191, 197–98.

51. Ibid., 1:197-98

52. Samuel L. Knapp, *Lectures on American Literature, with Remarks on Some Passages of American History* (New York: Elam Bliss, 1829), 194.

53. Knapp, *Lectures*, 194.

54. See *Joe Miller's Complete Jest Book, Being a Collection of the Most Excellent Bon Mots, Brilliant Jests, and Striking Anecdotes in the English Language* (London: H. G. Bohn, 1859), tale number 591.

55. Margaret Hunter Hall, *The Aristocratic Journey: Being the Outspoken Letters of Mrs. Basil Hall Written during a Fourteen Months' Sojourn to America, 1827–1828*, ed. Una Pope-Hennessey (New York: Putnam, 1931), 94.

56. George Washington to Francis Hopkinson, May 16, 1785, Washington Papers, Library of Congress (http://founders.archives.gov/documents/Washington/04-02-02-0411).

57. Mason, *Stuart*, 120.

58. The gift sent a message to the Indians that the United States was indeed independent from Britain, which was in the process of colonizing parts of India. See Susan B. Bean, *Yankee India: American Commercial and Cultural Encounters with India in the Age of Sail, 1784–1860* (Salem, MA: Peabody Essex Museum, 2002) 72–75.

59. See Dorinda Evans, *The Genius of Gilbert Stuart* (Princeton: Princeton University Press, 1999), 66; and Christopher J. Lukasik, *Discerning Characters: The Culture of Appearance in Early America* (Philadelphia: University of Pennsylvania Press, 2010), 11–30.

60. Review of Dunlap, *American Quarterly Review*, 17 (June 1935), 177.

61. Washington's character and personality are discussed at length in Joseph J. Ellis, *His Excellency, George Washington* (New York: Alfred A. Knopf, 2004); Paul K. Longmore, *The Invention of George Washington* (Berkeley: University of California Press, 1988); and Richard Brookheiser, *Founding Father: Rediscovering George Washington* (New York: Free Press, 1998), 107–20.

62. Longmore, *Invention of Washington*, 182; and 282, note 34.

63. Weld, *Travels*, 105–06.

64. Mason, *History*, 112.

65. Jane Stuart, "The Stuart Portraits of Washington," *Scribner's Monthly* 12 (July 1876): 371.

66. Longmore, *Invention of Washington*, 181.

67. James T. Flexner, *George Washington*, 4 vols. (Boston: Little, Brown, 1965–1972), 4:67. See Ellis, *His Excellency*, 3–39.

68. Stanley Elkins and Eric McKitrick, *The Age of Federalism: The Early Republic, 1788–1800* (New York: Oxford University Press, 1995), 431.

69. *Eulogies and Orations on the Life and Death of George Washington, First President of the United States of America* (Boston: Manning and Loring, 1800), 45.

70. John Neal, *Randolph, A Novel* 2 vols. (Baltimore: n.p., 1823), 2:63.

71. I paraphrase Neal, "Our Painters," 644.

72. David McCullough, *1776* (New York: Simon & Schuster, 2005), 64. Longmore, *Invention of Washington*, ix.

73. Douglass Adair, *Fame and the Founding Fathers* (New York: W. W. Norton, 1974), 6.

74. Ellis, *His Excellency*, 151.

75. Longmore, *Invention of Washington*, 181.

76. Brookheiser, *Founding Father*, 78, 79.

77. George Washington to Lafayette, May 28, 1788, Washington Papers, Library of Congress (http://memory.loc.gov/cgi-bin/query/P?mgw:4:./temp/~ammem_86wh::).

78. See Jerald A. Combs, *The Jay Treaty: Political Battleground of the Founding Fathers* (Berkeley: University of California Press, 1970); and Todd Estes, *The Jay Treaty Debate, Public Opinion, and the Evolution of Early American Political Culture* (Amherst: University of Massachusetts Press, 2006).

79. Cited by David Waldstreicher, *In the Midst of Perpetual Fetes: The Making of American Nationalism, 1776–1820* (Chapel Hill: University of North Carolina Press, 1997), 139.

80. Ellis, *His Excellency*, 229.

81. George Washington to Charles Carroll, May 1, 1796, Washington Papers, Library of Congress (http://memory.loc.gov/cgi-bin/query/P?mgw:3:./temp/~ammem_uFLw::).

82. Ellen Miles has made a persuasive case for the picture literally showing Washington at Congress arguing for the treaty in his Seventh Annual Address on December 8, 1795. Miles has exhaustively researched the principal figures involved in the Washington pictures; see Miles, "Gilbert Stuart's Portraits of George Washington," *George Washington: A National Treasure* (Washington, D.C.: Smithsonian Institution, 2002), 77–101; and Barratt and Miles, *Stuart*, 166–75.

83. Thomas Jefferson to James Madison, January 8, 1797, Madison Papers, Library of Congress (https://www.loc.gov/item/mjm013342/).

84. *Aurora*, December 23, 1796; quoted in Marcus Daniel, *Scandal and Civility: Journalism and the Birth of American Democracy* (New York: Oxford University Press, 2009), 109.

85. *The Writings of Thomas Paine*, ed. Moncure Daniel Conway, 4 vols. (New York: Putnam, 1895), 3:217.

86. Archibald Stuart to Thomas Jefferson, January 4, 1797, Jefferson Papers, Library of Congress (https://www.loc.gov/item/mtjbib008752/).

87. The notion that Washington was the symbolic center of the nation is discussed by Waldstreicher, *Perpetual Fetes*, 108–73. See Don Higgenbotham, *George Washington: Uniting a Nation* (Lanham, MD: Rowman and Littlefield, 2002); and Alison D. Howard and Donna R. Hoffman, "A Picture is Worth a Thousand Words: Building American National Identity through Art," *Perspectives on Political Science*, 42, no. 3 (July-September 2013) 142–51. Sandra Moats deals with the cultural expression of the republic: "A republican political culture would require symbols, rituals, and practices that animated and illustrated abstract principles, such as the government's authority, legitimacy, and scope"; in *Celebrating the Republic: Presidential Ceremony and Popular Sovereignty, from Washington to Monroe* (DeKalb: Northern Illinois University Press, 2009).

88. Waldstreicher, *Perpetual Fetes*, 119–20.

89. Benedict Anderson, *Imagined Communities: Reflections on the Origin and Spread of Nationalism* (London: Verso, 1991), 7. See Charles Taylor, *Modern Social Imaginaries* (Durham, NC: Duke University Press, 2002). In Mary E. Stuckey's words, "A people's identity . . . is largely imagined, based less on historical or geographical inevitability and more on the power of rhetoric to inform and focus allegiances"; in *Defining Americans: The Presidency and National Identity* (Lawrence: University of Kansas Press, 2004), 9.

90. Jefferson recorded Knox's words on February 28, 1793; *The Complete Anas of Thomas Jefferson*, ed. Franklin B. Sawvel (New York: Round Table, 1903), 113.

91. Dunlap, *History*, 1:196

92. Ibid., 1:206.

93. *New-York American*, September 7, 1824, quoted in Evans, *Genius*, 71.

94. Dunlap, *History*, 1:206.

95. Robert Gilmor, Jr. "Memorandums Made in a Tour to the Eastern States in the Year 1797," *Bulletin of the Boston Public Library* 11 (April 1892), 75.

96. Dunlap, *History*, 1:216.

97. George Helmbold to Thomas Jefferson, May 12, 1801, Jefferson Papers, Library of Congress (https://www.loc.gov/item/mtjbib010048/).

98. George Helmbold to Thomas Jefferson, July 30, 1801, Jefferson Papers, Library of Congress (http://founders.archives.gov/documents/Jefferson/01-34-02-0524).

99. *Philadelphia Gazette* (July 8, 1801; August 27, 1802); *Gazette of the United States* (July 20, 1801).

100. There is the possibility that Stuart was involved with William Winstanley in a fraudulent sale of a Washington portrait to the White House; conversation with Dorinda Evans; see Barratt and Miles, *Stuart*, 181–182.

101. Dunlap, *History*, 1:229.

102. Ibid., 1:253.

103. Mason, *Stuart*, 54.

104. Gilmor, "Memorandums," 75.

105. Neal, *Randolph*, 2:64.

106. Neal, "Our Painters," 645.

107. [George Watterson], *The L Family at Washington, or, A Winter in the Metropolis* (Washington, D.C.: Davis and Force, 1822), 21.

108. Neal, *Randolph*, 2:20.

109. Barratt and Miles, *Stuart*, 240.

110. Ibid., 255.

111. Dunlap, *History*, 1:207.

112. Dolley Madison to Anna Payne Cutts, June 5, 1804, in Allen Culling Clark, *Life and Letters of Dolley Madison* (Washington, D.C.: Roberts, 1914), 73.

113. On Dolley's character, see Catherine Allgor, *A Perfect Union: Dolley Madison and the Creation of the American Nation* (New York: Henry Holt, 2006).

114. Dunlap, *History*, 1:208.

115. See David Meschutt, "Gilbert Stuart's Portraits of Thomas Jefferson," *American Art Journal* 13 (winter 1981), 2–16. Mason says his studio was on F near Seventh; *Stuart*, 28.

116. Thomas Jefferson to Gilbert Stuart, May 30, 1806, quoted in Fiske Kimball, "The Stuart Portraits of Jefferson," *Gazette des Beaux-Arts* 23 (June 1943): 343. See Evans, *Gilbert Stuart and the Impact of Manic Depression*, for a detailed analysis of Stuart's complex character and erratic behavior.

117. Roger Stein, "Mr. Jefferson as Museum Maker," in *Shaping the Body Politic*, 194–230.

118. *National Intelligencer*, March 2, 1801, quoted in Waldstreicher, *Perpetual Fetes*, 190.

119. Thomas Jefferson to Maria Jefferson Eppes, February 15, 1801, in Henry S. Randall, *The Life of Thomas Jefferson*, 3 vols. (New York: Derby & Jackson, 1858), 2:600.

120. Joseph J. Ellis, *American Sphinx: The Character of Thomas Jefferson* (New York: Knopf, 1996), 202.

121. See Barratt and Miles, *Stuart*, 277–80; and Linda J. Docherty, "Original Copies: Gilbert Stuart's Companion Portraits of Thomas Jefferson and James Madison." *American Art* 22, (Summer 2008), 85–97.

122. Reported in the *National Intelligencer*, quoted in Noble Cunningham Jr., *The Inaugural Addresses of Thomas Jefferson, 1801 and 1805* (Columbia: University of Missouri Press, 2001), 1; Samuel Latham Mitchell to Catherine Mitchell, January 10, 1802, reproduced in Kevin J. Hayes, *Jefferson in His Own Time: A Biographical Chronicle of His Life Drawn from Recollections, Interviews, and Memoirs* (Iowa City: University of Iowa Press, 2012), 32.

123. John Trumbull to Daniel Wadsworth, September 7, 1803, Trumbull Papers, Yale University Library.

124. John Trumbull, *Autobiography, Reminiscences and Letters* (New York: Wiley and Putnam, 1841), 245.

125. Mason, *Stuart*, 30.

126. Barratt and Miles, *Stuart*, 290.

127. Benjamin Henry Latrobe to Charles Willson Peale, July 17, 1808, in Miller, *Selected Papers*, 2:866.

128. Stephanie Fay, "Lights from Dark Corners: Works of Art in 'The Prophetic Pictures' and 'The Artist of the Beautiful,'" *Studies in American Fiction* 13, no. 1 (Spring 1985).

129. Barratt and Miles, *Stuart*, 290.

130. Dunlap, *History*, 1:214.

Chapter 10: John Trumbull's Second Act

1. John Trumbull, *Autobiography, Reminiscences, and Letters of John Trumbull, from 1756 to 1841* (New York: Wiley and Putnam, 1841), 175.

2. Margery M. Heffron, *The Other Mrs. Adams* (New Haven, CT: Yale University Press 2014), 68. Trumbull's affections irritated Adams, who "Wish'd him at the D[evil]"; John Quincy Adams to Louisa Catherine Johnson, December 5, 1796, AFP. Trumbull also took to England his twenty-year-old illegitimate son, John Trumbull Ray.

3. Trumbull's account is in Joseph Farington, *The Farington Diary*, ed. James Greig, 7 vols. (London: Hutchinson, 1922), 4:227.

4. See Carl Ludwig Lokke, "The Trumbull Episode, A Prelude to the XYZ Affair," *The New England Quarterly* 7 (March 1934), 100–14.

5. Trumbull, *Autobiography*, 227.

6. Ibid., 229.

7. John Trumbull to George Washington, September 18, 1798, Washington Papers, Library of Congress (http://memory.loc.gov/cgi-bin/query/P?mgw:1:./temp/~ammem_CL6a::).

8. John Trumbull to Jonathan Trumbull, August 16, 1800, Trumbull Papers, Yale University Library.

9. John Blake White, "Journal of John Blake White," *The South Carolina Historical and Genealogical Magazine*, 42, no. 2 (April 1941), 63.

10. Trumbull, *Autobiography*, 158.

11. Theodore Sizer, ed., *The Autobiography of Colonel John Trumbull, Patriot–Artist, 1756–1843* (New Haven, CT: Yale University Press, 1953), 237.

12. William Dunlap, *History of the Rise and Progress of the Arts of Design in the United States*, 2 vols. (New York: George P. Scott, 1834), 1:371

13. Trumbull, *Autobiography*, 254.

14. Thomas Sully to Daniel Wadsworth, June 17, 1810, Wadsworth Papers, Connecticut State Library, Hartford.

15. Dunlap, *History*, 1:375.

16. Sizer, *Autobiography*, 250.

17. Dunlap, *History*, 1:375.

18. *Niles' Weekly Register* (October 22, 1814).

19. John Quincy Adams, *Writings of John Quincy Adams*, ed. Worthington Chauncey Ford, 7 vols. (New York: Macmillan, 1913), 5:314.

20. Albert Gallatin to Matthew Lyon, May 7, 1816, in Henry Adams, ed., *The Life of Albert Gallatin* (Philadelphia: Lippincott, 1879), 560.

21. Dunlap, *History*, 1:376. For Trumbull's ordeal in winning approval, see Egon Verheyen, "John Trumbull and the U.S. Capitol: Reconsidering the Evidence," *John Trumbull: The Hand and Spirit of a Painter* (New Haven, CT: Yale University Art Gallery, 1982), 260–71.

22. John Trumbull to Thomas Jefferson, December 26, 1816, Jefferson Papers, Library of Congress (https://www.loc.gov/item/mtjbib022693/).

23. Thomas Jefferson to John Trumbull, January 10, 1817, Jefferson Papers, Library of Congress (https://www.loc.gov/item/mtjbib022708/).

24. John Trumbull to Samuel Williams, January 16, 1814, Trumbull Papers, Yale University Library.

25. Thomas Jefferson to James Barbour, January 19, 1817, Jefferson Papers, Library of Congress (https://www.loc.gov/item/mtjbib022716/).

26. *Annals of Congress*, House of Representatives, 14th Cong., 2nd session, 762.

27. Ibid.

28. *Niles' Weekly Register* (February 8, 1817), 387.

29. *Niles' Weekly Register* (June 21, 1817), 264.

30. *Annals of Congress*, House of Representatives, 14th Cong., 2nd session, 762a.

31. As reported in *Thomas's Massachusetts Spy, or The Worchester Gazette* (February 5, 1817).

32. Rufus King to Christopher Gore, January 17, 1817, in Charles R. King, *The Life and Correspondence of Rufus King*, 6 vols. (New York: Putnam's, 1898), 6:45–46.

33. Congress authorized a fifth painting "to be placed in the Capitol," to "commemorate the patriotic conduct of Paulding, Williams, and Van Wart, in capturing Major André;" *Journal of the House of Representatives of the United States, 1815–1817* (February 28, 1817), 489. For a comprehensive discussion of Trumbull and the Rotunda, see Irma B. Jaffe, *Trumbull: The Declaration of Independence* (New York: Viking, 1976).

34. The story of the print is told by John Bidwell, "American History in Image and Text," *Proceedings of the American Antiquarian Society* 98 (October 1988), 246–302.

35. Lillian B. Miller, ed. *The Selected Papers of Charles Willson Peale and His Family*, 5 vols. (New Haven, CT: Yale University Press, 1983–2000), 3:654.

36. *American Mercury* (October 20, 1818).

37. *New York Daily Advertiser* (May 16, 1818).

38. *American Mercury* (October 20, 1818).

39. Detector, *Washington National Advocate* (October 20, 1818). A second version appeared in *The Port Folio* (July 1819), 84.

40. John Adams to John Trumbull, January 1, 1817, Trumbull Papers, Yale University Library. Adams's perspective was widely shared. For example, Abiel Holmes in 1805 said that American history "can now be accurately ascertained, without recourse to such legends as have darkened and disfigured the early annals of most nations." In *Annals of America*, 2 vols. (Cambridge, MA: Hilliard and Brown, 1829), iii.

41. John Adams to John Trumbull, January 1, 1817, Trumbull Papers, Yale University Library.

42. John Adams to John Trumbull, March 18, 1817, Adams Papers, Massachusetts Historical Society.

43. John Adams to John Trumbull, March 18, 1817, Adams Papers, Massachusetts Historical Society. Adams had his own ideas of what Trumbull should be painting instead. In a letter to William Tudor, he said that "my imagination runs upon the art, and has already painted, I know not how many, historical pictures; for instance, Samuel Adams's reaction to the Boston Massacre"; *The Works of John Adams*, ed. Charles Francis Adams, 10 vols. (Boston: Little, Brown, 1856), 10:249.

44. Adams, *Works*, 10:249.

45. John Adams to Benjamin Rush, June 11, 1811, Douglass Adair and John A. Schutz, eds. *The Spur of Fame: Dialogues of John Adams and Benjamin Rush* (San Marino, CA: Huntington Library, 1966), 182.

46. *Pennsylvania Packet* (July 8, 1790). These are the eloquent words of Christopher Looby, *Voicing America: Language, Literary Form, and the Origins of the United States* (Chicago: University of Chicago Press, 1996), 27.

47. Adair and Schutz, *Spur of Fame*, 42.

48. John Adams to Benjamin Rush, April 4, 1790, Alexander Biddle, *Old Family Letters Copied from the Originals* (Philadelphia: Lippincott, 1893), 55.

49. Biddle, *Family Letters*, 55.

50. John Adams letter dated January 3, 1817, *Niles' Weekly Register* (January 18, 1817), 337. Adams mistakenly said these pictures were by Raphael.

51. John Adams to Thomas Jefferson, December 8, 1818, Adams, *Works*, 10:364.

52. David McCullough, *John Adams* (New York: Simon & Schuster, 2001), 626.

53. Eliza Susan Quincy, "Journal," *The Articulate Sisters: Passages from Journals and Letters of the Daughters of President Josiah Quincy of Harvard University*, ed. M. A. DeWolfe Howe (Cambridge, MA: Harvard University Press, 1946), 33–34.

54. Walt Whitman, *Specimen Days* (Philadelphia: Rees Welsh, 1888), 80–81.

55. Samuel Wells to Thomas Jefferson, June 2, 1819, Jefferson Papers, Library of Congress (https://www.loc.gov/item/mtjbib023517/).

56. Thomas Jefferson to Samuel Wells, June 23, 1819, Jefferson Papers, Library of Congress (https://www.loc.gov/item/mtjbib023537/).

57. Thomas Jefferson to John Trumbull, November 11, 1818, Jefferson Papers, Library of Congress (https://www.loc.gov/item/mtjbib023320/).

58. Rebecca Bedell nicely put it this way: "John Trumbull, like many artists of the era, sought to use his art to foster the people's sentimental attachment to the new nation. He intended his great series of Revolutionary War paintings to create a community of feeling among his viewers, arousing in them shared emotions of affection and gratitude for those who had sacrificed to bring this country into being"; *American Art* 25, no. 3 (Fall 2011), 10; see Andrew Burstein, *Sentimental Democracy: The Evolution of America's Romantic Self-Image* (New York: Hill and Wang, 1999).

59. Horace Walpole is quoted in *Walpoliana* (London: John Sharpe, 1819), 123.

60. Quoted in Jaffe, *Declaration*, 108.

61. Garry Wills, *Inventing America: Jefferson's Declaration of America* (New York: Vintage, 1979), 345.

62. John F. Kennedy, *Profiles in Courage* (New York: Harper, 1956), 53.

63. Daniel Webster, *Address Delivered at the Completion of the Bunker Hill Monument, June 17, 1843* (Boston: Tappan and Dennet, 1843), 14.

64. Webster, *Address*, 5.

65. Ibid., 9.

66. Ibid., 15–16.

67. Margot Minardi, *Making Slavery History: Abolitionism and the Politics of Memory in Massachusetts* (New York: Oxford University Press, 2009), 51.

68. Allan Nevins, ed., *The Diary of John Quincy Adams* (New York: Longmans, Green, 1928), 551.

69. Nevins, *Diary*, 550.

70. William Lloyd Garrison, *Selections from the Writings and Speeches of William Lloyd Garrison* (Boston: Walcutt, 1856), 276.

71. Ibid., 277.

72. Ibid., 278; *The Liberator* (July 7, 1843).

73. Minardi, *Making*, 51.

74. Irma Jaffe says the figure is Peter Salem, but there is no proof of that; Irma B. Jaffe, *John Trumbull: Patriot-Artist of the American Revolution* (Boston: New York Graphic Society, 1975), 88.

75. *The Liberator* (June 25, 1845), 102.

76. Minardi, *Making*, 210.

77. Avery Library, Columbia University.

78. Benjamin Silliman to C. Edwards Lester, March 17, 1846, Trumbull Papers, Yale University Library.

79. Minardi, *Making*, 144.

80. Gordon Wood, *The Radicalism of the American Revolution* (New York: Knopf, 1992), 336. Jill Lepore phrased it this way: "When in doubt, in American politics, left, right or center, deploy the Founding Fathers"; *Whites of Their Eyes: The Tea Party's Revolution and the Battle over American History* (Princeton, NJ: Princeton University Press, 2011). On the potency of the Founding, see Pauline Maier, *American Scripture: Making the Declaration of Independence* (New York: Vintage, 1998).

Index

A Note on the Author

Paul Staiti teaches at Mount Holyoke College and is the author of several books and essays on American artists. He has co-curated exhibitions at the Metropolitan Museum of Art in New York City and the Museum of Fine Arts in Boston. The recipient of three fellowships from the National Endowment for the Humanities and a two-time Senior Fellow at the Metropolitan Museum of Art, Staiti has spoken internationally on the intersection of American art and history. He lives in South Hadley, Massachusetts.